THE ART OF SPACE

THE ART OF SPACE

THE HISTORY OF SPACE ART, FROM THE EARLIEST VISIONS TO THE GRAPHICS OF THE MODERN ERA

RON MILLER
FOREWORDS BY CAROLYN PORCO AND DAN DURDA

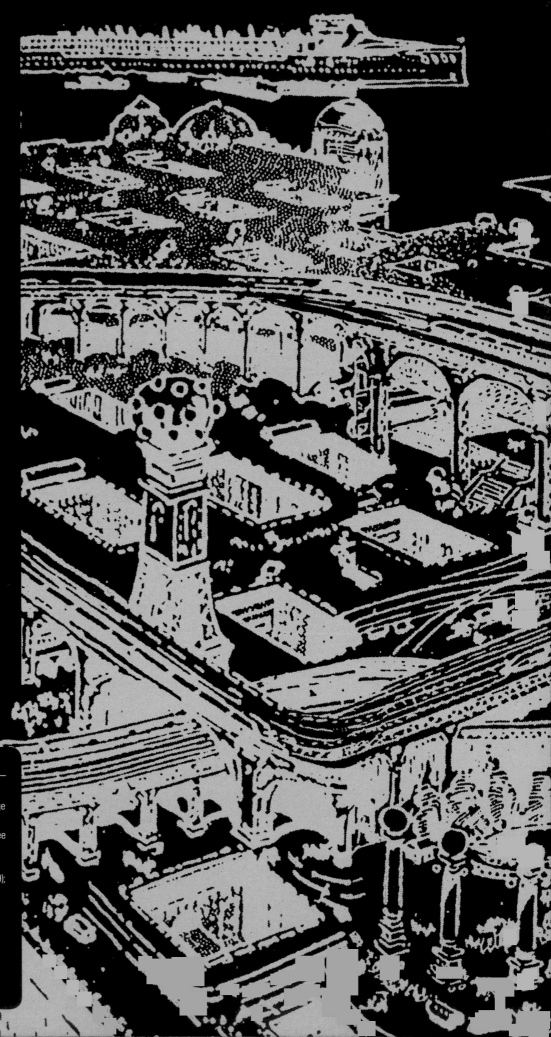

Zenith Press titles are also available at discounts in bulk quantity for industrial or sales-promotional use. For details write to Special Sales Manager at Quarto Publishing Group USA Inc., 400 First Avenue North, Suite 400, Minneapolis, MN 55401 USA.

To find out more about our books, visit us online at www.zenithpress.com.

ISBN-13: 978-0-7603-4656-3

Editorial director: Will Steeds
Project manager: Magda Nakassis
Executive editors: Laura Ward and Magda Nakassis
Book design: Paul Palmer-Edwards, www.gradedesign.com
Picture research: Susannah Jayes

Printed in China

10 9 8 7 6 5 4 3 2 1

FRONT COVER: Peter Elson, *The Rings of Saturn* © 2014 the estate of Peter Elson (see page 134)

PAGES 2–3: Thomas O. Miller, *Ringed Planet*, Courtesy Thomas O. Miller/ Atomic Art

BACK COVER: Clockwise from top right: Pat Rawlings, *The Pit* © SAIC (see page 34); Ron Miller, *The Birth of KOI 55-01 and KOI 55-02*, Courtesy Ron Miller (see page 83); Chesley Bonestell, *Raising Mars Rocket for Takeoff*, Reproduced courtesy of Bonestell LLC (see page 119); Aldo Spadoni, *Station 2*, Aldo Spadoni —Aerospace Imagineering (see page 175); Wayne Barlowe, *Elytracephalid* © Wayne Barlowe (see page 195). Background: Chesley Bonestell, *Exploring Mars*, Reproduced courtesy of Bonestell LLC (see pages 26–27).

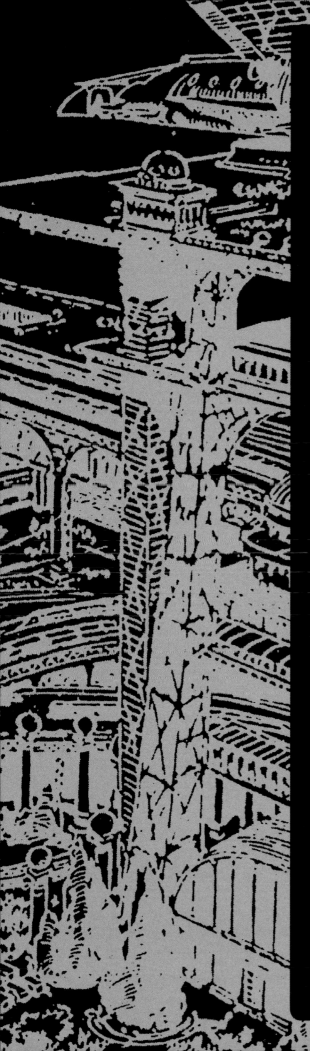

contents

FOREWORD:
Carolyn Porco

Ever since the mid-twentieth century, when Chesley Bonestell's first austere depictions of Saturn seen from the surface of Titan became an enticing invitation to explore the unknown, generations of astronomical artists following in his stead have transported us through space with finely crafted visions of alien worlds we could not otherwise have even imagined. Their captivating works nourished in the viewer a powerful longing for adventure, and inspired many an early astronomer and engineer to dream of a life exploring the solar system.

Sixty years later, we are fast becoming accustomed to the real thing. Our spacefaring machines and the imaging devices they carry have impressed upon our collective psyche an indelible tableau of the truly awesome sights to behold among the real worlds in orbit around our sun. The dramatic vistas and exotic landscapes we have been privileged to witness, for instance, around Saturn, the icon of planets, over the last ten years of Cassini's historic exploration of that system, are as wild, fantastic, and haunting as anything ever conjured by those attempting to portray the sublime and the unseen. Gazing upon any one of these images, we are instantly there, hovering above the rings or climbing the cliffs of Iapetus.

But before the days of real spaceships, all a would-be space traveler had were the captured imaginings of the astronomical artist. Even today, the hard realities of spacecraft trajectories and limited onboard resources restrict the photogenic opportunities that can be exploited, and the artist is still needed to sketch in the details and make visual—even understandable—what can't directly be observed.

Ron Miller's informed look at the history and highlights of this noble genre of art reminds us of the delight and inspiration we have been given by astronomical artists all over the world and throughout time. It is a marvelous celebration of their soaring imaginations, technical skills, and artistic talents, and for me, will hereafter be a means to recall the special bond that joins them to us scientists. For like scientists, astronomical artists are romantics, dreamers, and explorers… ever yearning, ever seeking, ever hopeful.

I salute them, kindred souls, one and all, and I know that once you, the reader, have spent some time touring the pages of this book, you will too.

Carolyn Porco

Carolyn Porco
Cassini Imaging Team Leader and Director, CICLOPS
Space Science Institute
Boulder, Colorado

[Originally published on www.ciclops.org/art_index.php]

FOREWORD:
Dan Durda

We humans have always been explorers. Our species was born from our deep-rooted need to learn more about the world around us—from the need to find that next source of food to, even if just occasionally, discover out of pure curiosity what is over that hill, or to figure out why that stick over there looks a bit weird. We are also artists, almost innately compelled to express our experiences and feelings and inner imaginings, be it through the sung word or the pigmented picture.

In discussing with others my work as both a scientist/explorer and an astronomical artist, I often encounter some reference to the "left brain/right brain" dichotomy, the seeming incongruity of mixing the technical and analytic with the creative and inspirational. I see no such artificial distinction between these two modes of interacting with the intricate and complex, yet wonderful and awe-inspiring cosmos around us. Art and exploration have been long and intimate partners, each inspiring the other through history as we expanded the frontiers of new lands and pressed the boundaries of human activity with novel technologies. Contemporary visions of aeronautical advances and space exploration, portrayed in sweeping murals by Robert McCall for example, stir the human spirit just as much as scenes of majestic beauty captured in paintings of the nineteenth-century American frontier by artists such as Thomas Cole, Albert Bierstadt, and Frederick Edwin Church.

In *The Art of Space*, Ron Miller brings us along on a beautifully illustrated tour through the history of astronomical art and the range of subject matter encompassed by the genre. From its beginnings before the era of telescopic astronomy to its inspirational and influential role during the dawn of the space age, space art allows us to see the unseeable and to go to places we cannot yet go or to places (or times) we could never go. It may be centuries before our technology allows some lucky and courageous humans to stand rapt, admiring the epic landscape of an earthlike moon around a gas giant planet orbiting a distant star light-years away, but astronomical artists can take us there today.

The pages that follow are a compelling compendium of works from the grandfathers of space art to today's digital artists, all beautifully presented in stunning arrangements grouped by subject matter and composition. They represent a lovingly illustrated travelogue through space and time. Enjoy the journey...

Dan Durda
Southwest Research Institute, Department of Space Studies
Boulder, Colorado

THE ART OF SPACE:
PAST, PRESENT & FUTURE

SPACE ART IS A RELATIVELY NEW ART FORM, DEVELOPING ITS DISTINCT IDENTITY JUST OVER A CENTURY AGO. BUT IT LAYS CLAIM TO A LONG AND RICHLY COMPLEX HISTORY—WITH ROOTS IN LITERATURE, ART, AND SCIENCE.

Constantly evolving, space art has kept pace with technological change and continued to pose philosophical questions even as it seeks an ever-more accurate representation of the stars and worlds of deep space. Yet perhaps surprisingly, its artistic origins do not lie far up in the heavens, but are buried deep in the landscape of the earth itself.

CHANGING LANDSCAPES

During the nineteenth century, artists developed a new way of looking at the world around them. Instead of the decorative, pastoral scenes of earlier centuries, landscapes took on a more emotional aspect. Artists such as John Martin (1789–1854) and Gustave Doré (1832–1883) created scenes of towering, rugged mountains, bottomless abysses, and apocalyptic cataclysms. At the same time, the Pre-Raphaelite school of painters and poets expressed their devotion to nature and its careful study.

In the United States these Romantic ideas produced the Hudson River School, whose practitioners were enamored with the American wilderness. Like their European counterparts, they looked for the grandiose and awe-inspiring, but like the Pre-Raphaelites they were also fascinated by naturalistic detail.

"EXPRESSION, SENTIMENT, TRUTH TO NATURE, ARE ESSENTIAL: BUT ALL THOSE ARE NOT ENOUGH. I NEVER CARE TO LOOK AT A PICTURE AGAIN, IF IT BE ILL COMPOSED; AND IF WELL COMPOSED I CAN HARDLY LEAVE OFF LOOKING AT IT."
John Ruskin, Modern Painters, 1860

In a real sense they were akin to the geologists and botanists of the time, who were exploring and surveying the unknown western territory beyond the Mississippi River. Artists accompanied these expeditions as a matter of course; Thomas Moran (1837–1926), for example, was the official artist with the first formal survey of the Yellowstone region. It is difficult to underestimate the effect these paintings had on the American people. Vast canvases, some measuring more than 13 feet (four meters) wide, traveled around the country, drawing crowds in the way that popular motion pictures do today. They revealed to an astonished public awesome wonders that no one had thought could exist outside the mind of the most imaginative poet or novelist.

"MAGIC HAS PAVED THE WAY FOR SCIENCE."
Sir James Frazer, The Golden Bough, 1890

Space art would become heir to this realistic Romantic-naturalistic tradition. What painters like Moran and Albert Bierstadt (1830–1902) had done for Yellowstone and Yosemite, space artists such as Lucien Rudaux and Chesley Bonestell would do for Mars and the moon.

LITERARY PIONEER

As nineteenth-century artists were reassessing their approach to the world around them, so authors of the time were turning their gaze up to the heavens. One writer in particular would lead the imaginative journey into space: the French author Jules Verne (1828–1905). The very first attempts to realistically depict a spaceflight and the conditions that exist beyond the earth's atmosphere appeared in the illustrations accompanying his 1865 novel *From the Earth to the Moon*. The realism of the illustrations owed as much to the author as it did his excellent illustrators—Verne was in the habit of providing his artists with reference materials and checking the final results for authenticity. He even went to the effort of having a map of the moon drawn specially for *From the Earth to the Moon* by Wilhelm Beer and Johann Heinrich von Mädler, the leading selenographers of his day. The illustrators Emile Bayard and Alphonse de Neuville also provided several

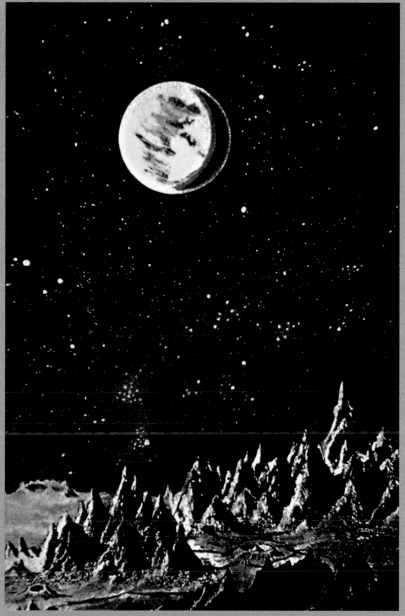

"THESE DRAWINGS [OF THE MOON] WERE AGAIN AND AGAIN REPEATED, REVISED, AND COMPARED WITH THE ACTUAL OBJECTS, THE EYE THUS ADVANCING IN CORRECTNESS AND POWER OF APPRECIATING MINUTE DETAILS, WHILE THE HAND WAS ACQUIRING, BY ASSIDUOUS PRACTICE, THE ART OF RENDERING CORRECT REPRESENTATIONS OF THE OBJECTS IN VIEW."

James Nasmyth and James Carpenter, *The Moon*, 1874

iconic images: the launch of a projectile, three astronauts enjoying weightlessness, and the splashdown in the Pacific. These images are still being reprinted in books on space travel 150 years later.

In 1877, Verne's novel *Hector Servadac* (perhaps better known as *Off on a Comet!*) contained illustrations by P. Phillipoteaux showing Jupiter and its satellites as seen from a passing asteroid, as well as a view of Saturn's rings as seen from the surface of that planet. The latter was probably the first such illustration attempted, and arguably the first true example of astronomical art. An accompanying passage from the novel provides a perfect example of the nineteenth century's evocative if occasionally uneasy blend of science and romance:

To any observer stationed on the planet, between the extremes of latitude 45 degrees on either side of the equator, these wonderful rings would present various strange phenomena. Sometimes they would appear as an illuminated arch, with the shadow of Saturn passing over it like the hour hand over a dial; at other times they would be like a semi-aureole of light. Very often…daily eclipses of the sun must occur through the interposition of this triple ring. Truly, with the constant rising and setting of satellites, some with bright disks at their full, others like silver crescents, in quadrature, as well as by the encircling rings, the aspect of the heavens from the surface of Saturn must be as impressive as it is gorgeous.

How evocative and exciting this must have been to the Victorian reader, who hitherto had recourse only to the dry descriptions of astronomers. From the latter they could only learn *about* Saturn, but from Verne and his illustrators they learned what Saturn was *like*. Verne and the art he inspired made the planet seem real.

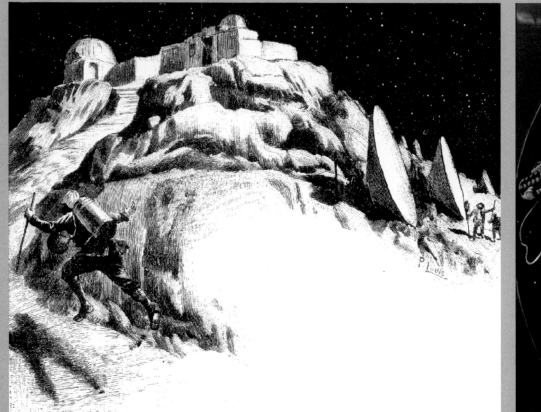

STRIKING ILLUSTRATIONS

As influential as his writings were, Jules Verne was only part of a wider literary movement that would help lay the foundations for space art. James Nasmyth and James Carpenter's book *The Moon: A Planet, A World, and a Satellite* (1874) was illustrated by photographs of meticulously constructed plaster models of the lunar surface. These photos were immensely influential, possessing both the inherent realism of the photograph and the academic cachet of its authors, two eminent astronomers. Images pirated, copied, or inspired by these photos continued to appear well into the twentieth century.

In 1884, the French astronomer and science popularizer Camille Flammarion (1842–1925) published *Les terres du ciel* (Lands in the Sky), the first of the three major landmarks of space art. This massive book contains hundreds of specially commissioned woodcut illustrations created by a team of more than half a dozen artists. Principal among these are the extraterrestrial scenes by Paul Fouché, Motty, Blanadet, Hellé, and others. These include views of Venus's desolate landscape, the seas and mountains of Mars, and the crescent earth over a rugged lunar terrain.

In 1887, "Letters from the Planets," a series of stories by the English curate Rev. Wladislaw Somerville Lach-Szyrma (1841–1915), began in Cassel's *Family Magazine*. The series took its readers to the sun, Mercury, Mars, and Jupiter. The accompanying illustrations by Paul Hardy included a close-up view of millions of meteorites falling into the sun (which, according to the best theory of the time, accounted for the sun's heat), a view of craggy lunar mountains, and a nighttime scene on Mars with the landscape illuminated by its twin moons.

Other interplanetary stories of the period were similarly lit up by their illustrations. The 1889 novel *The Conquest of the Moon*,

> "WE ARE ALL TIRED OF BEING STUCK ON THIS COSMICAL SPECK WITH ITS MONOTONOUS OCEAN, LEADEN SKY, AND SINGLE MOON THAT IS HALF USELESS. ITS POSSIBILITIES ARE EXHAUSTED, AND JUST AS GREECE BECAME TOO SMALL FOR THE CIVILIZATION OF THE GREEKS, SO IT SEEMS TO ME THAT THE FUTURE GLORY OF THE HUMAN RACE LIES IN THE EXPLORATION OF AT LEAST THE SOLAR SYSTEM!"
>
> John Jacob Astor, *A Journey in Other Worlds*, 1894

by André Laurie (pseudonym of occasional Verne collaborator Paschal Grousset), contained numerous views by artist George Roux of respirator-equipped explorers on a rocky lunar surface, as well as a striking illustration of an eclipse of the sun by the earth as seen from the moon.

A Journey in Other Worlds (1894), by American financier John Jacob Astor, was illustrated by Daniel Beard (who later founded the Boy Scouts of America). The novel begins with a tour of the world in AD 2000 and continues with a flight to Jupiter and Saturn, whose terrains are described with great accuracy, at least according to astronomical knowledge and theory of the time. Included is a remarkable description of "Cassandra," a trans-Neptunian planet that is not only poetically evocative, but highly prophetic considering the discovery of Pluto was still 30 years in the future:

The temperature of Cassandra's surface is but little above the cold of space, and no water exists in the liquid state, it being as much a solid as aluminum or glass. There are rivers and lakes, but these consist of liquefied hydrogen and other gasses, the heavier liquid collected in the deeper places, and the lighter… floating upon it without mixing, as oil on water…[W]ere there mortal inhabitants on Cassandra, they might build their houses from blocks of oxygen or chlorine.

ABOVE LEFT: André Laurie's 1887 novel, *The Conquest of the Moon*, featured lunar explorers wearing breathing gear and an inhabited base powered by solar energy. The book featured more than 100 illustrations by George Roux, who also illustrated many of Jules Verne's novels.

ABOVE RIGHT: The first color painting of a space station ever published in the United States depicts Hermann Noordung's 1929 design. The illustration is by the legendary science-fiction artist Frank R. Paul, and was published on the cover of *Science Wonder Stories*.

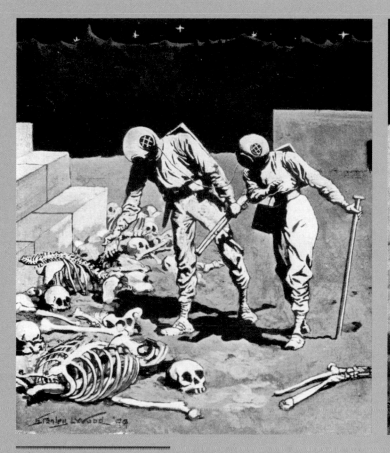

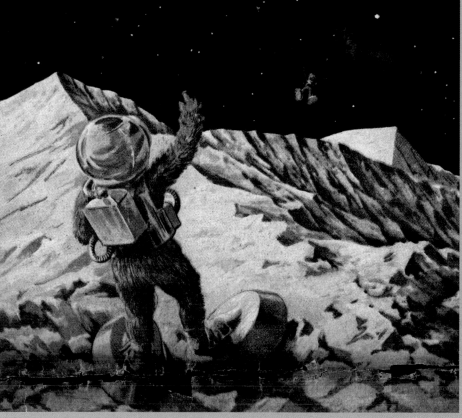

RED PLANET

Of all the planets visible in the night sky, Mars seemed to hold a particular fascination for writers and artists. *A Honeymoon in Space* by George Griffith was originally serialized as "Stories of Other Worlds" in 1900. It was illustrated by Stanley L. Wood, whose painting of a honeymooning couple holding space-suited hands while standing on the moon is one of the most heart-warming images of Victorian science fiction. The surfaces of the planets are shown in the light of contemporary science: a balmy Mars, volcanic Jupiter, ocean-covered Saturn, and so forth.

> "IF YOU ARE GOING TO TALK SCIENCE, DEAR, PERHAPS WE'D BETTER SIT ON DIFFERENT CHAIRS. I MAY HAVE BEEN MARRIED FOR A 150 MILLION MILES, BUT THE HONEYMOON ISN'T HALF WAY THROUGH YET, YOU KNOW."
> Zaidie in *A Honeymoon in Space*, 1900

Rivaling the portrait of Griffith's honeymooners for sheer charm are the illustrations that William R. Leigh provided for H. G. Wells's article "Is There Life on Mars?" This was published in *Cosmopolitan* in March 1908, at a peak of public interest in Mars following the close approach of the red planet to earth during the previous year. Leigh's atmospheric and meticulously rendered paintings show a traditional Victorian Mars in full flower.

The first two of Percival Lowell's books about Mars had already been published—the most recent in 1906—and were sensational best sellers. The public was enthralled by Lowell's description of an ancient, dying world, its inhabitants constructing a worldwide network of giant canals in a desperate battle for survival. This was the Mars that inspired Wells. In Leigh's evocative paintings, solar-powered waterwheels the size of the Woolworth Building keep the great Martian canals flowing, while spindly-legged birds and beasts congregate in Martian marshes. Towering cities bustle with gyroscope-equipped unicycles, racing along precarious aerial tracks, while sweet-faced winged Martians and their children watch wide-eyed from their soaring minarets.

AN EVOLVING ART

While the authors of "scientific romances"—a genre we now call "science fiction"—were creating more and more imaginative (and increasingly plausible) schemes for leaving the earth, a freestanding visual art was evolving that would eventually exist independent of the written word. By the first years of the twentieth century, certain artists were beginning to specialize in astronomical renderings. One of the first was British amateur astronomer and artist Scriven Bolton (c. 1888–1929). His work, appearing often in *The Illustrated London News*, was consistently dramatic, if not always accurate. He originated a special technique wherein he constructed model plaster landscapes, which he photographed and then retouched, adding stars, planets, and other effects. Bolten's work inspired a young American artist named Chesley Bonestell (see pages 26–29), who had provided architectural renderings for *The Illustrated London News*, to "indulge" in space painting.

Bolten's contemporary G. F. Morrell also created some splendidly expressionistic extraterrestrial landscapes—as well as making something of a specialty of depicting what other worlds might look like if they were to replace the earth's moon. For example, one Morrell painting shows Saturn as only 238,607 miles (384,000 kilometers) away—the moon's mean distance from the earth. Morrell's masterpiece might be his strikingly surrealistic illustration of Saturn's rings as they would appear from London, if that city were to be suddenly transported to Saturn.

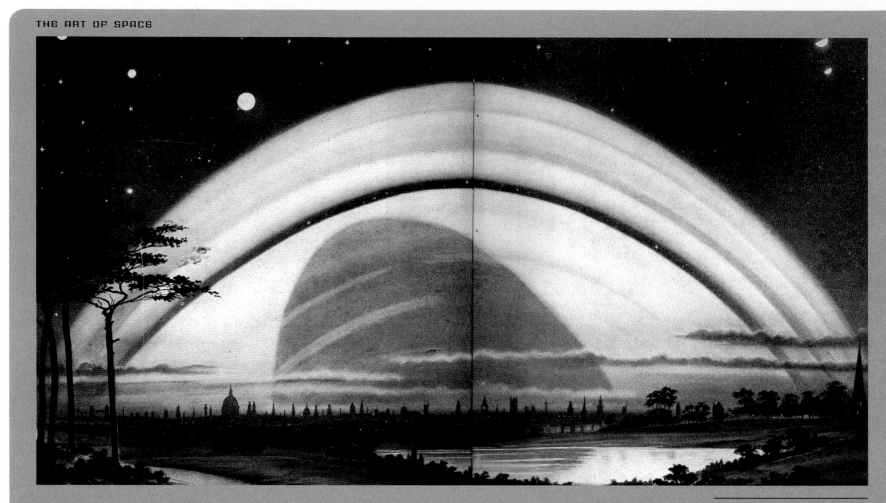

The French Abbé Théophile Moreaux (1867–1954), whose work first appeared in the late nineteenth century, also published his astronomical renderings widely. The first of the astronomer-artists, Moreux was the director of the Observatory of Bourges, France. Another key figure was Howard Russell Butler (1836–1934), who contributed paintings to the American Museum of Natural History in New York, one of which—a dramatic scene set near the central peak of a lunar crater—was later copied by artists working for a dozen different publications.

KEEN OBSERVER

However, the first real specialist in astronomical art, and the one who first brought both scrupulous scientific accuracy and fine art together, was the French illustrator-astronomer Lucien Rudaux (1874–1947). He can rightly be called the grandfather of astronomical art. Originally a commercial illustrator, he eventually became a highly respected astronomer: the Martian crater that bears his name was in honor of his work as an astronomer, not an artist. Rudaux created hundreds of illustrations to accompany his books and articles, as well as those written by others. His masterwork though is probably the deluxe 1928 volume *Sur les autres mondes* (On Other Worlds). It contains more than 400 illustrations, including 20 full-color plates which give readers an unprecedented look at the solar system. These paintings achieved not only a level of accuracy but—perhaps more importantly—of believability that was not to be challenged for nearly 20 years. A careful astronomer and superlative observer, Rudaux knew what the surfaces of the planets and their moons ought to look like. Many of his images look as though they could have been based on NASA photographs.

"SINCE THE BEGINNING OF TIME, MANKIND HAS CONSIDERED IT AS AN EXPRESSION OF ITS EARTHLY WEAKNESS AND INADEQUACY TO BE BOUND TO THE EARTH, TO BE UNABLE TO FREE ITSELF FROM THE MYSTERIOUS SHACKLES OF GRAVITY."

Hermann Noordung, *The Problems of Space Flying*, 1929

His portrayal of the lunar surface is especially remarkable. At a time when every other artist was still producing the stereotypical rough, saw-toothed mountain ranges that dated back to Nasmyth and Carpenter's work, Rudaux was depicting the rounded mountains and rolling landscapes found by the Apollo astronauts. Rudaux pointed out that anyone would have done the same had they merely looked, as he had done, at the limb of the moon against the night sky, where the outlines of the lunar mountains can be seen in profile. He also pictured Venus as an eroded, rocky dust bowl and Mars as flat and boulder-strewn, its sky occasionally tinted with pink dust clouds.

Interestingly, science-fiction magazines—the first of which was published in the late 1920s—were far ahead of more "respectable" journals in publishing astronomical art. (Indeed, they were far ahead of mainstream magazines in publishing anything at all serious concerning spaceflight. For example, the first English-language publication of Hermann Noordung's classic *The Problems of Space Flying* [July–August 1929] was in Hugo Gernsback's science-fiction pulp magazine *Science Wonder Stories*.) The artists who contributed some of the best astronomical work included Charles Schneeman and Hubert Rogers, who did the first depiction of a gravitational lens. By comparison, the paintings of solar system provided by Charles Bittinger for the July 1939 *National Geographic*, though

ABOVE: In 1910, George F. Morrell wondered what one might see if London were on Saturn. This painting, subtitled "The magnificent spectacle presented by the rings as seen from latitude 51," was the result. The original recently sold at Christie's for £2,185 ($3,522).

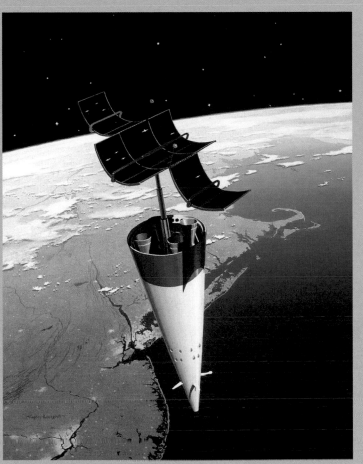

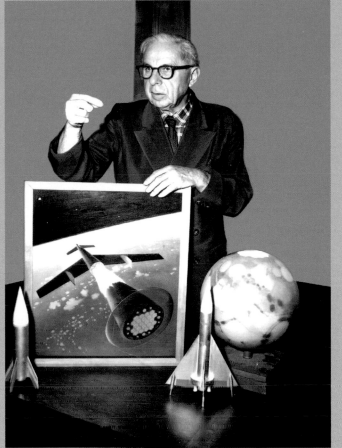

described as "combining a fine sense of color values and artistic composition with a painstaking effort to achieve scientific accuracy," are for the most part crude and amateurish compared with the best of science-fiction pulps or anything published by Rudaux.

SHOOTING STAR

But if Rudaux was astronomical art's grandfather, then its undisputed father was Chesley Bonestell (1888–1987). It is difficult to overstate Bonestell's influence and inspiration: his was exactly the right sort of art at exactly the right time. The best of his work appeared between the end of World War II and 1960, when the American public was on a postwar technology high. Spaceflight symbolized everything that the postwar world promised, and it appeared an imminent possibility. Magazines, books, television shows, and motion pictures featuring space travel became incredibly popular, and it seemed that Bonestell was contributing something to them all. So pervasive was his art that he shaped the very thinking of both layperson and scientist as to what future spacecraft would look like.

Bonestell's space art first appeared in print in *Life* in 1944: a series of paintings showing Saturn as it would appear as seen from its various moons. Nothing like these images had ever been seen before. Bonestell combined a highly polished technical skill with his experience as a Hollywood special-effects matte artist to create pictures that looked more like postcards than mere "artist's impressions." His paintings possessed an intense believability that was far more influential than any mere scientific facts they may have contained. That was the sole problem with Rudaux's work: accurate as his paintings were—and, ironically, they were often far more accurate than Bonestell's—they nevertheless looked like

"IT MIGHT...BE SUGGESTED THAT WITHOUT BONESTELL AND HIS EARLY SPACE-AGE ARTISTRY, THE NASA ERA MIGHT HAVE BEEN DELAYED FOR MANY YEARS, OR IT MIGHT NOT HAVE HAPPENED YET."
Joseph M. Chamberlain, Adler Planetarium

paintings. There was always a nagging doubt in a viewer's mind that perhaps Rudaux might just have made it all up. Bonestell managed to remove himself from the scene he was depicting, with the result that planets took on a sense of reality as never before.

These paintings and many others were collected in a best-selling book, *The Conquest of Space* (1949), with a text by German expatriate rocket expert Willy Ley. This was followed by countless magazine articles, books, and special-effects art—Bonestell created the space scenes for the films *Destination Moon* (1950), *When Worlds Collide* (1951), and *The War of the Worlds* (1953).

Although scores of space scientists trace their interest in astronomy and astronautics to these books and films, perhaps the work that was most directly influential upon the early development of the American space program was the series of articles published by *Collier's* magazine under the general supervision of Wernher von Braun.

Though Bonestell's art was known for years to space enthusiasts, wider tributes came only in his last years. He was honored with many one-man shows, including exhibitions at the Smithsonian Institution. A number of Bonestell originals are now in the collection of the National Air and Space Museum, and the Adler Planetarium, Chicago, now has its own "Bonestell Room." A few months before Bonestell died, an asteroid was named "Bonestell," much to his satisfaction.

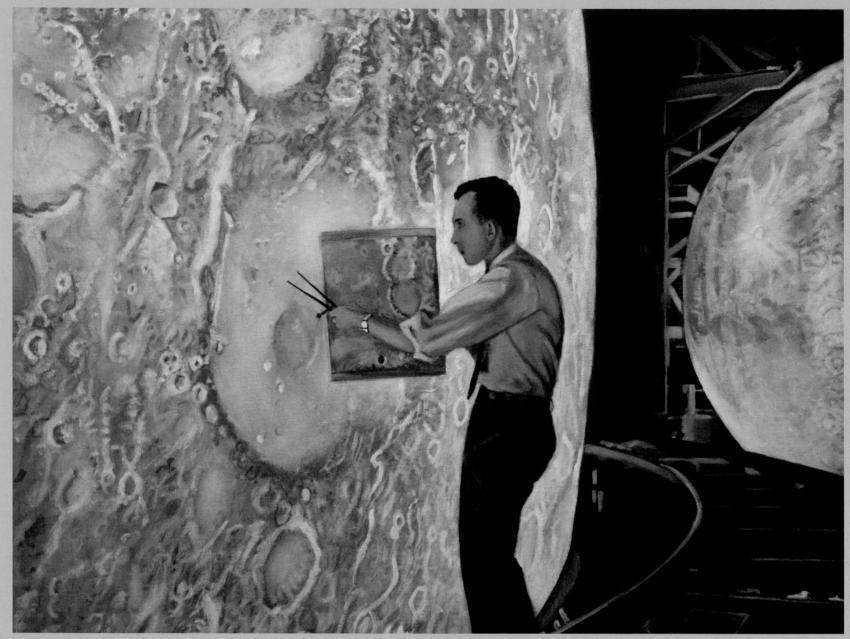

ENGINEERING SPACE

Another important artist who shaped both modern astronomical art and astronautics was the British engineer-artist Ralph Andrew Smith (1905–1959, see pages 90–91). Smith's work was almost exclusively connected with the British Interplanetary Society (BIS) and, until recently, collected in only one book, *The Exploration of the Moon* (1954). From the founding of the BIS in the late 1930s until his death in 1959, Smith used his engineering background to meticulously re-create the detailed space program developed by the BIS. Unlike Bonestell, Smith was an active participant in the design of the spacecrafts he illustrated, and he often insisted on first proving that his illustration was a real engineering possibility before starting his picture. In particular, he was co-designer (with Harry Ross) of the "Smith-Ross" space station, a seminal design in the history of the space station and an immediate predecessor of Wernher von Braun's giant rotating wheel concept. Also unlike Bonestell, Smith was relatively uninterested in astronomy, and his lunar and Martian landscapes serve only as backgrounds for his spacecrafts.

WHY SPACE ART?

Space artists seek to serve the same function as their artistic ancestors, the painters of the Hudson River School—namely, to inspire a sense of wonder about the universe. There is an educational side to this art form, but, in my opinion, delineating bald scientific facts is not the main purpose of space art—any more than Moran and Bierstadt were trying to teach their audiences geology. What space art ought to try to inspire in its viewers is not so much concepts of what other planets are like, but the belief that they are *real*. Believability is at least as important as accuracy, perhaps more so, for if no one believes that the scene represents some place that actually exists, then all the accuracy in the world is for naught.

Chesley Bonestell is a perfect example: much of his work was scientifically unsound at the time he created it—he was still indicating canals on Mars as late as the 1950s, to say nothing of natural bridges on Phobos and volcanoes on Jupiter. Nevertheless, so persuasive was his art that when *Lunar Orbiter*

ABOVE: *The Moon Builders—Lunar Orbit and Let-Down Approach Simulator* by contemporary artist Simon Kregar depicts the creation of a huge globe of the moon that was used to help train Apollo astronauts in lunar landings.

TOP & BOTTOM LEFT: Canadian Kara Szathmary is another scientist—in this case an astrophysicist and mathematician—who has found expression for his ideas in art. Rather than attempting to depict concepts of physics and math literally, he experiments "with interpreting quantum cosmology events using various collage materials and paint."

ABOVE RIGHT: Space-inspired art is increasingly finding its way into public spaces. This beautiful 24-foot-(seven-meter-)wide mobile, created by B. E. Johnson and Joy Alyssa Day and titled *Celestial Winds*, hangs in the atrium of the executive boardroom of Orbital Sciences in Dulles, Virginia.

and the Apollo astronauts returned photographs that showed that lunar mountains were not the precipitous peaks that Bonestell and his myriad impersonators had depicted, it truly seemed as though it were the moon's fault and not the artist's. Although Rudaux, one generation earlier, had been correct in more realistic but less dramatic renderings of the lunar surface—and for all the right reasons—would we have been so eager to visit the moon had we known, or admitted, that Rudaux was right and Bonestell was wrong?

The year 1970 saw the end of the isolated specialist in space art. The ever-increasing awareness and interest in space travel created a demand for space art that was met by equally increasing numbers of illustrators and artists—enough to form their own organization: the International Association of Astronomical Artists. They were inspired not only by commercial demand, but more importantly (for their artistic success) by the adventure of space exploration. The reality of space travel had much the same effect on astronomical art that the advent of photography had upon fine

art. Space artists suddenly found themselves free to explore and experiment. According to space artist Lynette Cook (see pages 70–71), photos sent back by space probes from the moon and planets and spectacular images from the Hubble Space Telescope "have been invaluable in providing real information about distant objects." For the first time, artists know what these worlds look like. "Not only the similarities," Cook explains, "shared by the planets and moons, but also the amazing diversity that exists among them."

The advent of space exploration enabled some artists to create space paintings of unprecedented accuracy, and it enabled others to abandon realism entirely, leaving them free to explore the impact of space on humanity in other ways. In their own ways they each strive to answer vital philosophical questions. What does it feel like to explore another world? What does the possibility of other life-forms mean to humankind? What shape will our future take, and where will it take us?

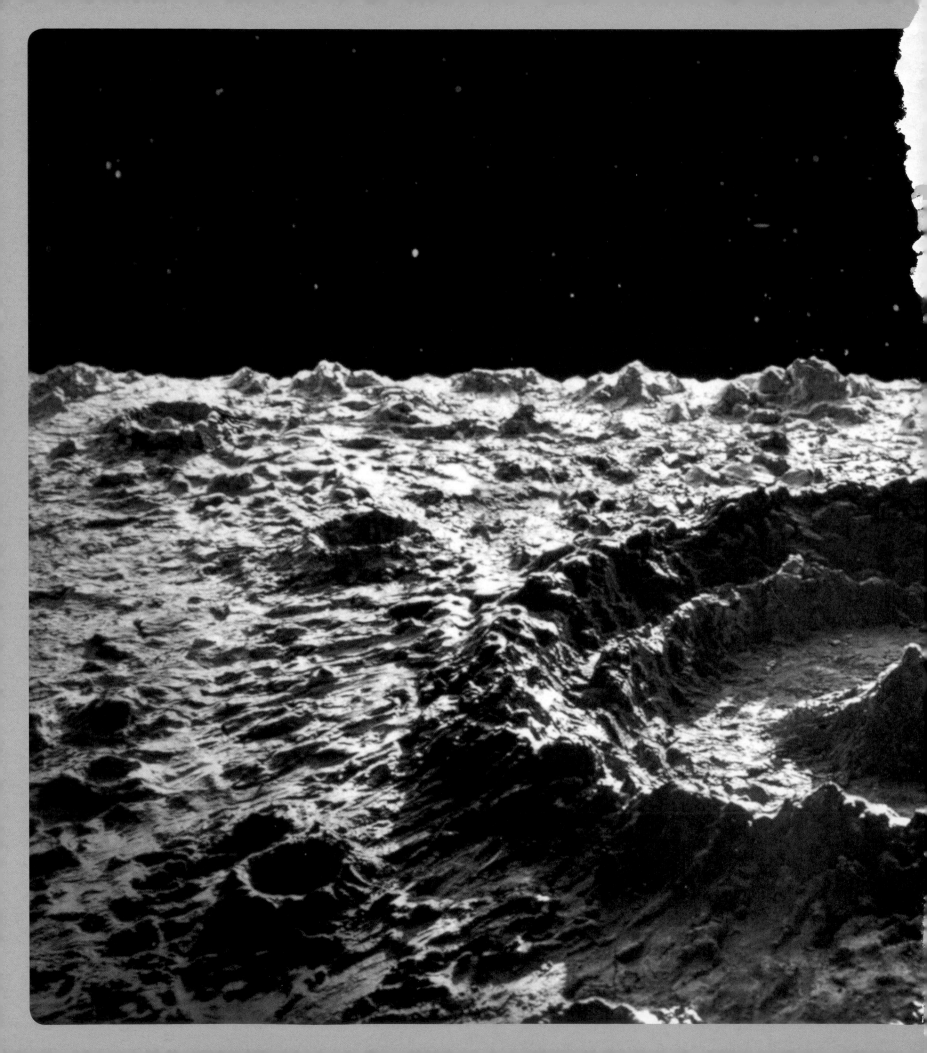

PLANETS & MOONS

PLANETS & MOONS:
SURVEYING OUR SOLAR SYSTEM

BEFORE THE PUBLICATION OF JULES VERNE'S *FROM THE EARTH TO THE MOON* (1865)
AND *AROUND THE MOON* (1869), LITERARY JOURNEYS TO THE MOON AND PLANETS
WERE ALMOST EXCLUSIVELY LIMITED TO ALLEGORY, FANTASY, OR SATIRE. TWO THINGS
WERE NEEDED TO CHANGE FANTASY INTO REALITY.

First, there needed to be solid, scientific knowledge about the actual conditions that existed beyond the earth's atmosphere and on the moon and other planets. Second, there needed to be a realistic means of leaving the earth.

Before the seventeenth century, little was known of the moon. It was certainly not thought of as a world in its own right. The stars, while some were brighter than others, were nevertheless thought to be at more or less the same distance from the earth—though just what that distance might be was a matter for debate. The planets were merely a special class of bright stars that wandered among the other "fixed" stars. Indeed, the word "planet" comes from the Greek word *planete*, meaning "wanderer." While today we use the word to mean any solid, spherical body circling a star, 500 years ago it meant one of the five bright stars that were not "fixed" in the heavens. The term "Planet Earth," so familiar to us today, would have been nonsensical.

NEW WORLDS
It was unthinkable to the ancients that those twinkling lights might be actual places that could be traveled to, and only the moon served as a destination in a rare handful of fantasies. Even then it was not regarded as something altogether physical, but rather a kind of ethereal never-never land. But in the year 1610, and almost literally overnight, Galileo Galilei (1564–1642) forever changed mankind's view of the universe. Turning a telescope to the night sky for the first time, the moon, he reported, "does not possess a smooth and polished surface, but one rough and uneven, and just like the face of the earth itself, is everywhere full of vast protuberances, deep chasms, and sinuosities." While many of the early Greek

philosophers had speculated that the moon might be like this, Galileo was the first to *know*: he had seen it with his own eyes.

Turning his telescope on the rest of the planets. Galileo discovered that they did not have the same appearance in his telescope as other stars. No matter what the magnification used, stars retained the appearance of points of light. But the planets were revealed as tiny disks with indistinct features. Jupiter, Galileo discovered, was a pale, golden globe with—astonishingly—four tiny worldlets circling it. Venus, he found, showed phases exactly like the moon. They were obviously other worlds like the moon and the earth.

The Catholic Church forced Galileo to recant his discoveries and related interpretations of them, but the damage had already been done. When human beings looked skyward they no longer saw abstract points of light. They saw the infinite possibilities of new worlds.

SPACE TRAVEL
The German astronomer Johannes Kepler (1571–1630) wrote his strange moon-voyage tale, *Somnium*, around the time that Galileo's discoveries first became known. It was the first science-fiction novel written by a scientist—or, for that matter, by anyone at all knowledgeable in science. And, important to us, it is perhaps the first example of an astronomical discovery influencing an art form. It is unfortunate that the novel was not illustrated, for if it had been, it might have provided the first true astronomical art.

As Galileo was discovering new worlds in the sky, so new worlds were being discovered here on earth. Scarcely more than a century earlier the continents of North and South America had been discovered quite by accident, lying unsuspected and

> "HOW VAST THOSE ORBS MUST BE, AND HOW INCONSIDERABLE THIS EARTH, THE THEATRE UPON WHICH ALL OUR MIGHTY DESIGNS, ALL OUR NAVIGATIONS, AND ALL OUR WARS ARE TRANSACTED, IS WHEN COMPARED TO THEM. A VERY FIT CONSIDERATION, AND MATTER OF REFLECTION, FOR THOSE KINGS AND PRINCES WHO SACRIFICE THE LIVES OF SO MANY PEOPLE, ONLY TO FLATTER THEIR AMBITION IN BEING MASTERS OF SOME PITIFUL CORNER OF THIS SMALL SPOT."
>
> Christiaan Huygens, *Cosmotheoros*, 1698

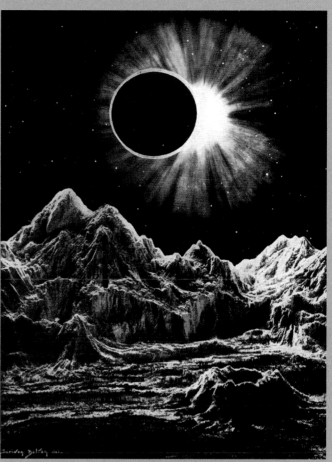

ABOVE LEFT: The March 1956 issue of the *Space Adventures* comic book was an adaptation of the George Pal film, *Destination Moon*. Published six years after the movie was released and containing no credit to Pal, and with the names of the characters changed, it was probably entirely unauthorized.

ABOVE RIGHT: This scene, set on the moon as the earth eclipses the sun, is one of the many extraordinary pictures created by Scriven Bolton in the first decades of the twentieth century. To create many of his illustrations, Bolton introduced the imaginative technique of combining painting with photos of meticulously constructed model landscapes.

unknown on the far side of the Atlantic Ocean. Soon, hundreds of ships and thousands of explorers, colonists, soldiers, priests, and adventurers had made the journey to these fertile, rich, and strange new lands. Now they learned that an Italian scientist had found that not only did our own earth harbor unsuspected worlds, but that the sky was full of them, too.

How frustrating it must have been! The new worlds of the Americas, which lay invisibly beyond the horizon and which existed for the vast majority of Europeans only in the form of traveler's tales and evocative if imaginative charts, nevertheless could be visited by anyone possessing the funds or courage. But now here were whole new *earths*—Venus, Mars, Jupiter, Saturn, and the moon—which could be seen by anyone and even mapped; whole new planets with unimaginable continents and riches… yet there was no way to touch them! They were like a mirage of an oasis in the middle of the desert, in plain sight yet tantalizingly out of reach.

Little wonder, then, that Galileo's discoveries could not be easily suppressed. They were followed by an unprecedented spate of space travel stories: *Somnium* (published in 1634), *The Man in the Moone* (1638), *A Voyage to the Moon* (1657), *A Voyage to the World of Cartesius* (1694), *Iter Lunare* (1703), *John Daniel* (1752), Voltaire's "*Micromegas*" (1752), and countless others. If it was not possible to reach these new worlds in the sky in reality, it would be done on the page.

Few of these books were illustrated, and, when they were, the artists demonstrated as much disregard for astronomy as did the authors. Nevertheless, they were representative of the rapidly increasing interest in voyaging into outer space and the possibilities of other worlds.

VISUAL RECORDS

By the nineteenth century, astronomers had made vast strides in their knowledge of the moon and planets—enough so that by the 1860s, artists were finally able to create realistic views of the surfaces of those worlds. And by the beginning of the twentieth century, there was now a handful of artists who had begun to specialize in illustrating alien landscapes. Artists such as Scriven Bolton, Lucien Rudaux, and Chesley Bonestell laid the groundwork for modern space art, but their depictions of the planets were only equal to the science of the time. So in these paintings we see Mars with canals and a blue sky; Jupiter with a solid, volcanic surface; and a moon with precipitous, craggy peaks. Yet such errant leaps of imagination did not detract from the importance of these artworks. First, they played a seminal role in educating and exciting the public about earth's sister worlds. There were countless scientists, engineers, and astronomers who got their initial inspiration from paintings by these artists. Second, for the modern observer, they provide an invaluable record of the state of astronomical knowledge at the time they were created.

Today's space artists are able to work with photographs and information gathered firsthand by space probes, orbiters, landers, and rovers—and in levels of detail that would have astonished the space artists of even half a century ago. Yet these artists fulfill the same functions as those of the nineteenth and early twentieth centuries. They instruct, they inspire, and they amaze—while at the same time creating a visual record, frozen in time, of what humans knew of the universe, and their aspirations for the future.

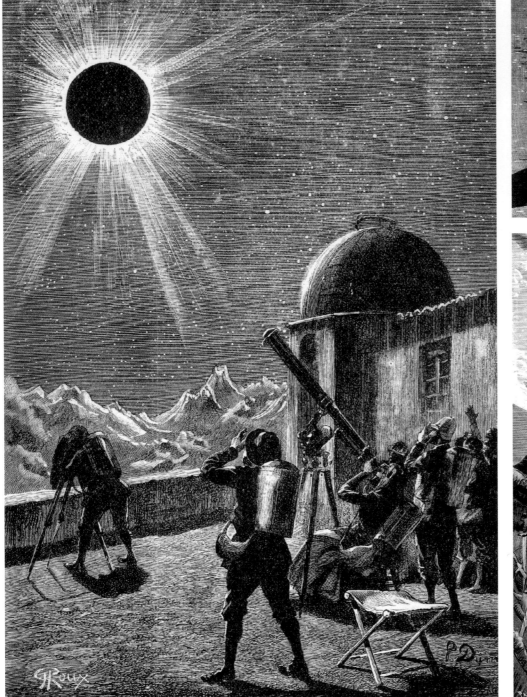

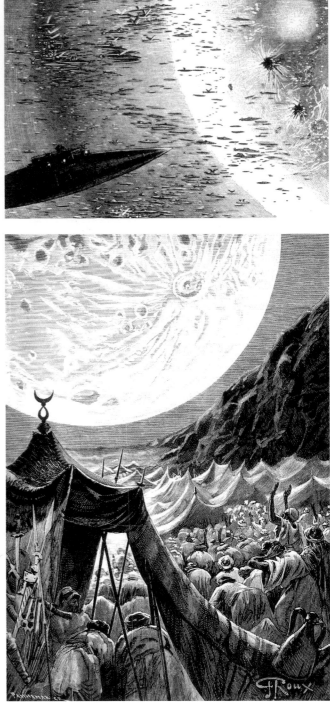

ABOVE LEFT: In this scene from 1887's *Conquest of the Moon*, French artist George Roux depicts a crew of lunar castaways observing an eclipse as the earth passes in front of the sun.

TOP RIGHT: A Mercurian spaceship approaches the sun in the midst of a fleet of similar spacecrafts in this illustration by British artist Paul Hardy for "Letters from the Planets" (1887–1893) by Rev. Wladislaw S. Lach-Szyrma.

BOTTOM RIGHT: Author André Laurie neatly sidestepped the need to figure out a method for traveling to the earth's satellite in his *Conquest of the Moon*. Instead of going to the moon, enormous electromagnets are used to draw the moon down to the earth… with catastrophic results.

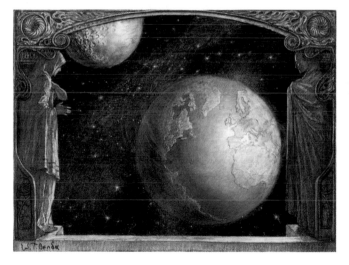

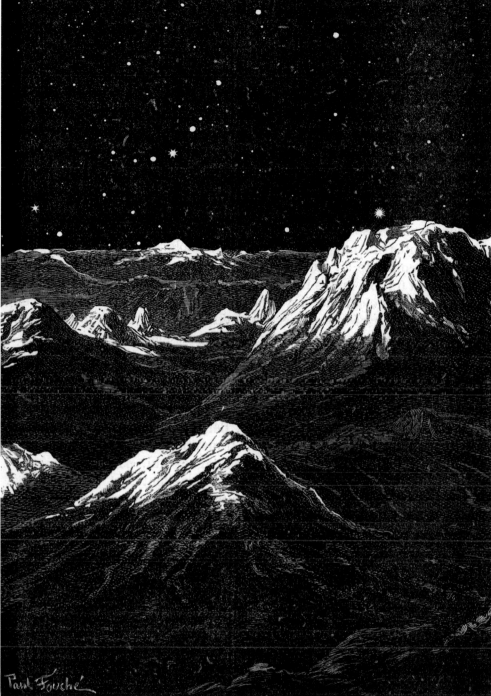

TOP LEFT: A volcanic eruption takes place on an upper latitude area on the moon a few billion years ago in this 2005 painting by American space artist Michael Carroll. The young moon is bathed in earthlight and the dull red glow of molten lava.

MIDDLE LEFT: The earth hovers above a typically craggy lunar landscape in this George Roux illustration from *The Conquest of the Moon* (1887). This was a "spot" illustration designed to fill in a space at the end of a chapter.

BOTTOM LEFT: In this 1918 charcoal rendering, *The Earth with the Milky Way and Moon*, Polish American artist W. T. Benda depicted two figures framing and contemplating the earth and moon with the Milky Way in the background. It was originally published to accompany the *Cosmopolitan* magazine article "The Future of the Earth," by Maurice Maeterlinck.

ABOVE RIGHT: This depiction of the lunar surface was created by Paul Fouché for Camille Flammarion's *Les terres du ciel* (1884). Featuring nearly 100 specially commissioned illustrations, it was the first book to be illustrated almost entirely with space art. Here, Fouché depicts a lunar landscape that is more realistic than the towering crags favored by most other artists at that time.

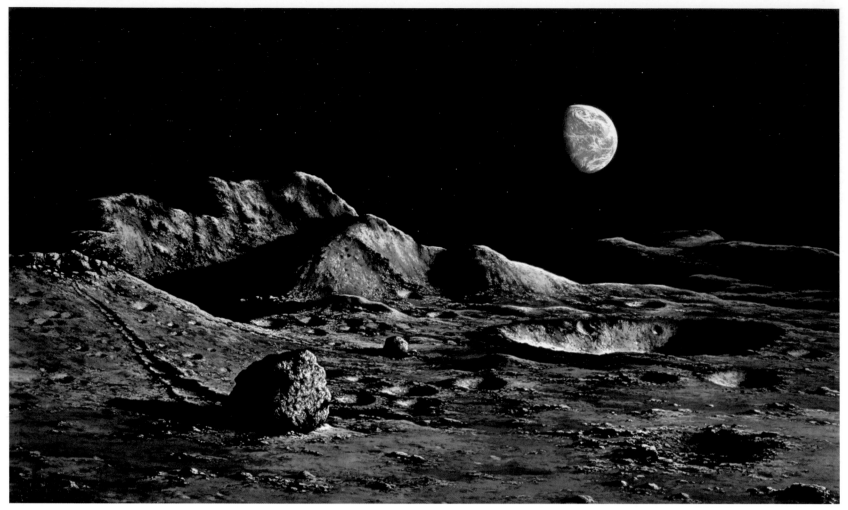

ABOVE: Czech-born Ludek Pesek was one of the most influential space artists of the latter half of the twentieth century, with work appearing in scores of magazines and books. In an image inspired by actual *Lunar Orbiter* photos, a moonquake in the lunar highlands has shaken loose a pair of boulders that have rolled down a slope.

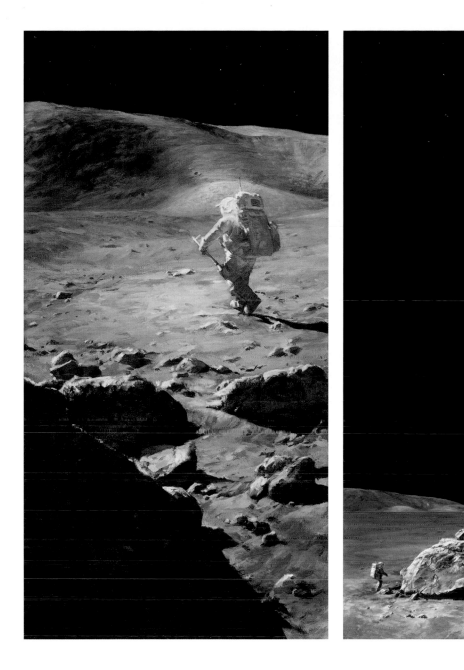

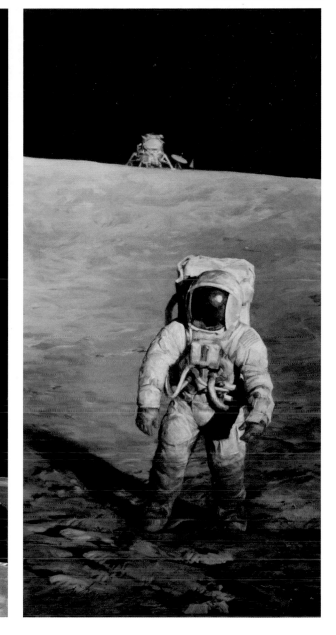

ABOVE LEFT: In *Moonwalk*, a painting by American artist Pam Lee, we see *Apollo 17* astronaut Harrison Schmitt, lunar "rake" in hand, as he strolls back to his distant lunar rover after exploring the ejecta surrounding the crater Camelot.

ABOVE MIDDLE: In *Big Sky Country*, Pam Lee again depicts *Apollo 17*'s Harrison Schmitt, this time as he explores a giant boulder the astronauts named "Split Rock" because it had been broken in two. The boulder has rolled down a mountainside, leaving a trail along the slope much like that depicted in the Ludek Pesek painting on page 22.

ABOVE RIGHT: *On the Ocean of Storms* is a portrait by Pam Lee of *Apollo 12* astronaut Alan Bean as he explores a crater near where the unmanned probe *Surveyor III* had landed two years earlier. The *Lunar Module* is on the horizon. Next to the lander is the large S-band antenna used to transmit television signals back to the earth.

ABOVE LEFT: This highly imaginative interpretation of the surface of the sun and its possible future explorers was created by R. T. Crane for *Men of Other Planets* (1951) by Kenneth Heuer, an otherwise sober discussion about life on other worlds.

ABOVE RIGHT: This iconic image of the surface of Mercury was painted by Chesley Bonestell for his classic 1949 book, *The Conquest of Space*. Illustrated with nearly 60 paintings, the book became an international best seller, largely because of the unprecedented realism and beauty of Bonestell's artwork.

OPPOSITE: Shortly after its formation, the surface of Mercury was still a volcanic, semi-molten landscape, as shown in this painting by Michael Carroll. Rising beyond the horizon is the luminous corona and glowing prominences of the sun.

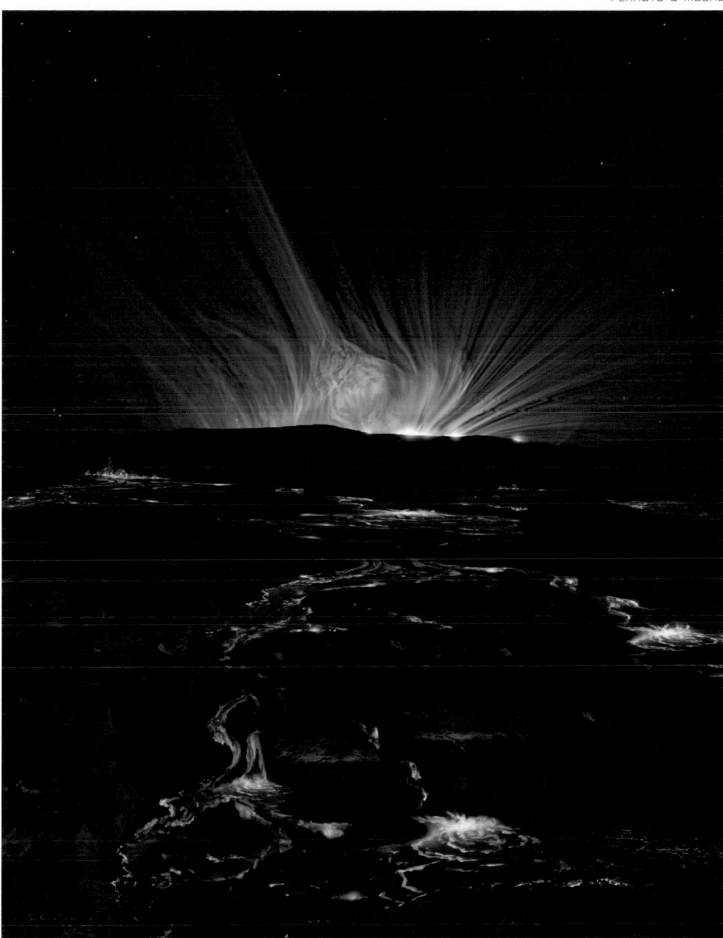

CHESLEY BONESTELL:
FATHER OF SPACE ART

ASTRONAUTICS OWES MUCH OF ITS EXISTENCE TO THE ARTS. LITERARY WORKS SUCH AS JULES VERNE'S NOVEL *FROM THE EARTH TO THE MOON* WERE DIRECTLY RESPONSIBLE FOR INSPIRING THE FOUNDERS OF MODERN SPACEFLIGHT. AND IN THE VISUAL ARTS, PAINTER, ILLUSTRATOR, AND DESIGNER CHESLEY BONESTELL (1888–1986) SHARED A VISION OF THE UNIVERSE IN WHICH SPACE TRAVEL WAS TRULY BELIEVABLE.

When Bonestell's space art was first published in the 1940s and early 1950s, most people associated spaceflight with comic books and pulp fiction. Bonestell, working with such great scientists as Wernher von Braun, depicted space travel with such vivid reality and scientific accuracy that it suddenly no longer seemed so fantastic. His artwork appeared when the United States was first taking an interest in astronautics, and his paintings went a long way toward encouraging both public and government support.

There are hundreds of artists working today whose first inspiration was nourished by Chesley Bonestell's sense of wonder, his craftsmanship, and his meticulous artistry. Yet his work affected scientists, artists, and authors alike. Science-fiction author Sir Arthur C. Clarke once said of Bonestell, "Chesley is the original Kilroy—he's been there ahead of them all. Neil Armstrong? Well, Tranquility Base was established over Bonestell's tracks and discarded squeezed-out paint tubes. The man not only moves across space, but also across time. He was present at our world's birth and has also set up his easel to paint its death…"

STAR OF HOLLYWOOD

Chesley Bonestell's life spanned almost as many careers as it did decades. Originally trained as an architect, he worked on iconic structures such as the Golden Gate Bridge and the Chrysler Building. But in 1938, aged 50, he began a new career in Hollywood. Using the skills he learned while working as an architectural renderer— techniques of perspective, light, and shade—Bonestell worked for RKO Pictures as a special-effects matte painter. One of the first films he worked on was Orson Welles's masterpiece *Citizen Kane* (1941), providing re-creations of turn-of-the-century New York and the moodily evocative scenes of Kane's mansion Xanadu. Over the next decade, Bonestell worked for several studios and on many movies now regarded as film classics: *How Green Was My Valley* (1941), *The Magnificent Ambersons* (1942), and *The Fountainhead* (1949). In many instances, the entire movie screen would be filled by one of Bonestell's paintings. He eventually became the highest-paid special effects artist in Hollywood.

In Bonestell's next career, he combined what he had learned as an architect and matte artist about camera angles, perspective, and painting with his lifelong interest in astronomy. In 1944 he created a series of paintings that showed the planet Saturn as seen from several of its satellites. These were immediately bought by *Life* magazine for its May 29, 1944, issue and published to a readership of 3 million. The paintings' realism and sense of wonder caused a sensation, especially among astronomers and science-fiction fans. Bonestell soon began collaborating with leading engineers and astronomers to illustrate the future progress of space exploration.

ABOVE: Chesley Bonestell (1888–1986) was probably the most influential of all space artists. His work inspired astronauts, astronomers, engineers, and scientists, to say nothing of an entire generation of astronomical artists.

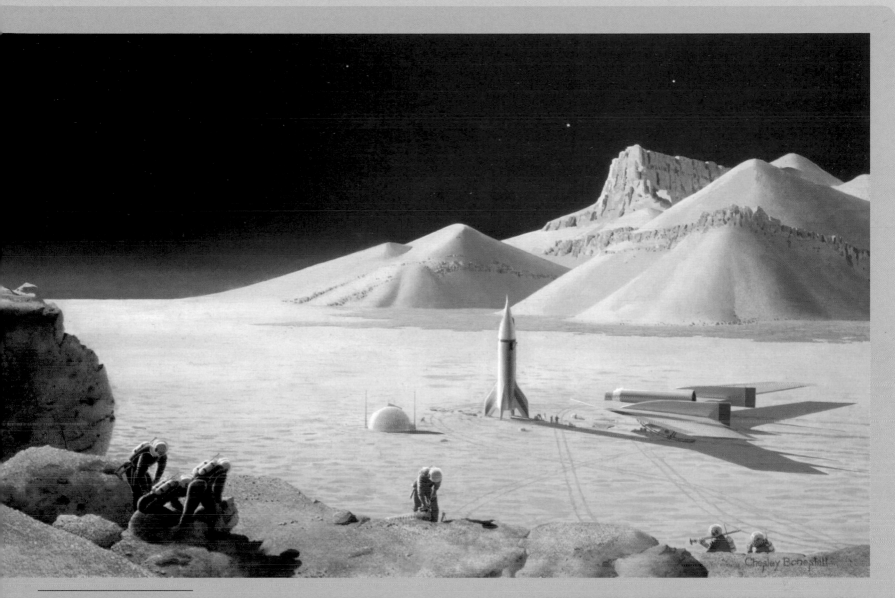

ABOVE: *The Exploration of Mars* (1956) contained 22 paintings by Chesley Bonestell, including this one, the similarly titled *Exploring Mars*. With text by Willy Ley and Wernher von Braun, the book outlined the first realistic plan for the exploration of the red planet.

VISIONS OF EXPLORATION

In 1952, Bonestell took part in the now-legendary *Collier's* symposium on spaceflight (see pages 116–119)—in half a dozen issues between 1952 and 1954, the magazine outlined a comprehensive and grandiose plan for the exploration of space, beginning with the launch of the first earth satellite and finishing with a manned mission to Mars. Bonestell not only provided photo-realistic illustrations of what these spacecrafts would look like, but he acted as a liaison between the scientists and his fellow illustrators, Fred Freeman and Rolf Klep. The *Collier's* publications eventually proved a major contribution in "selling" both the American public and Congress on the immediate potential of spaceflight.

Having established himself as a pioneer of astronomical art, in the 1950s Bonestell returned to Hollywood to collaborate on three science-fiction films for producer George Pal. Now Bonestell provided not only special effects artwork, but also expert technical advice on the science represented in *Destination Moon* (1950), *When Worlds Collide* (1951), and *The War of the Worlds* (1953).

ENDURING LEGACY

Since the mid-twentieth century, Bonestell's rank as "the dean of astronomical artists" remains unchallenged. His meticulous and

> "WE SHOULD BUILD A MUSEUM ESPECIALLY FOR BONESTELL'S WORKS— ON THE MOON—IN GRATITUDE FOR PROVIDING THE VISION THAT LIFTED OUR EYES STARWARD."
>
> Ben Bova

realistic renderings of planets have been published in more than a dozen books and hundreds of magazines, notably *The Conquest of Space* (1949) and *Beyond Jupiter: The Worlds of Tomorrow* (1972). Exhibitions of his paintings have been held all over the world. The first exhibition at the Smithsonian Institution's National Air and Space Museum devoted to a solo artist was dedicated to Bonestell and his work, and more than 20 original Bonestell paintings are in the permanent collection of the Adler Planetarium in Chicago. His contributions to art and science have been honored by many prestigious awards, from science fiction's Hugo Special Achievement Award to the British Interplanetary Society's Special Award and Medallion. Bonestell was also inducted into the International Space Hall of Fame and the Science Fiction Hall of Fame.

In perhaps the ultimate honor for an astronomical artist, just weeks before his death in 1986, Chesley Bonestell had an asteroid named for him. When astronomer Carl Sagan informed him of the honor, he remarked that it was only fitting that Bonestell should be given a world of his own, since he had given so many worlds to others.

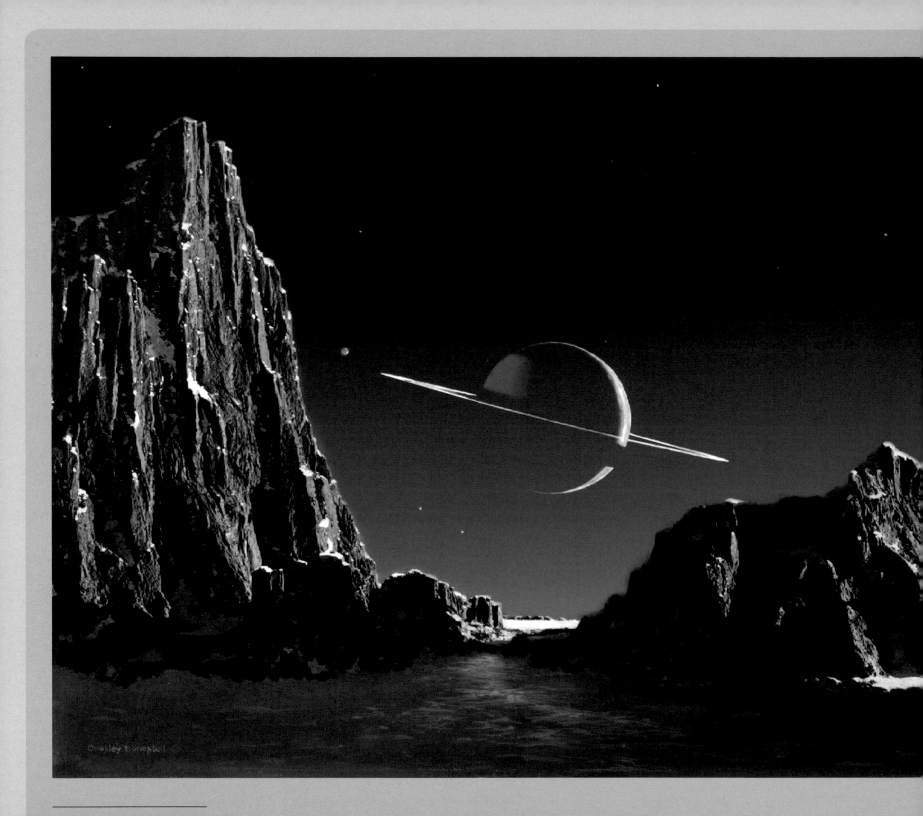

ABOVE: Bonestell's *Saturn as Seen from Titan* is probably the most recognizable and most reproduced space painting ever created. Originally published in *Life* magazine in 1944, it has been dubbed by space artist Kim Poor "the painting that launched a thousand careers." The subsequent discovery that Titan is in fact covered by a layer of opaque orange clouds has not diminished the painting's evocative power.

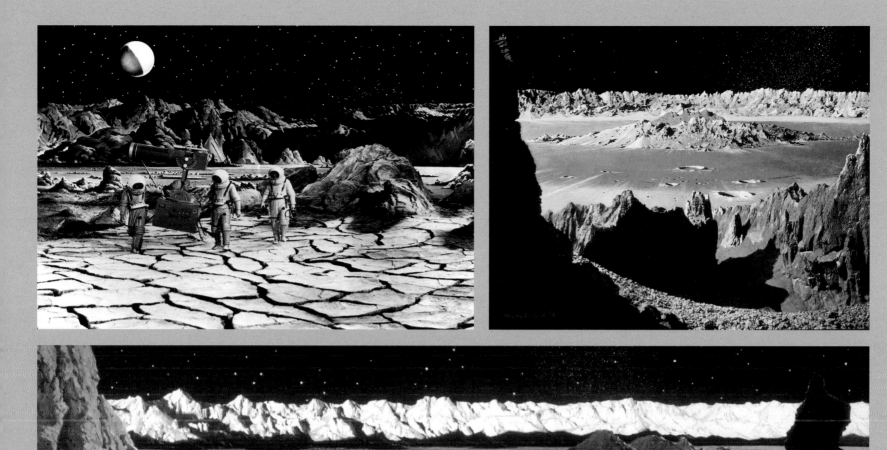

TOP LEFT: For the 1950 George Pal film *Destination Moon*, Bonestell created a 14-foot-(four-meter-)wide lunar panorama. This was translated by studio artists into the enormous cyclorama that filled the background of the lunar surface set.

TOP RIGHT: This view from the rim of the lunar crater Theophilus was originally published in *Life* magazine in 1946 and later in Chesley Bonestell's *The Conquest of Space*. It depicts a group of intrepid astronauts (barely visible on the peak at the far left) as they peer toward the far wall of the crater, 64 miles (103 kilometers) away.

BOTTOM: In this 1952 Bonestell painting created for the famed *Collier's* space series, a group of explorers descend the wall of a small crater in the Sinus Roris, one of the great lava plains on the moon. Only the distant crater wall is lit by direct sunlight—the rest of the scene is illuminated by greenish earthlight.

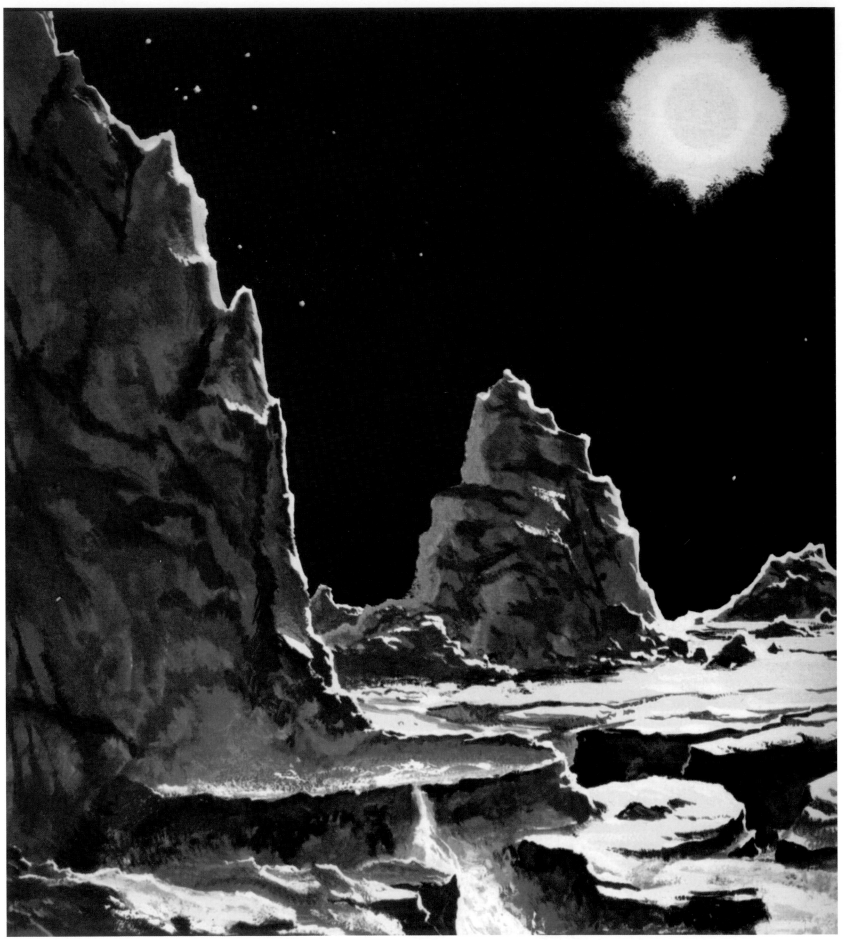

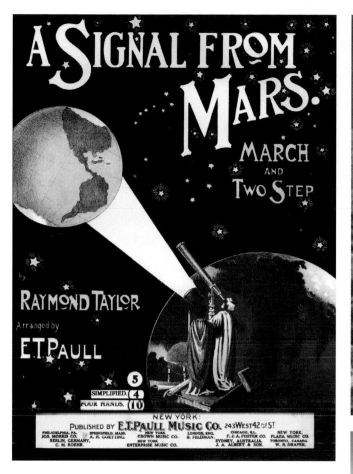

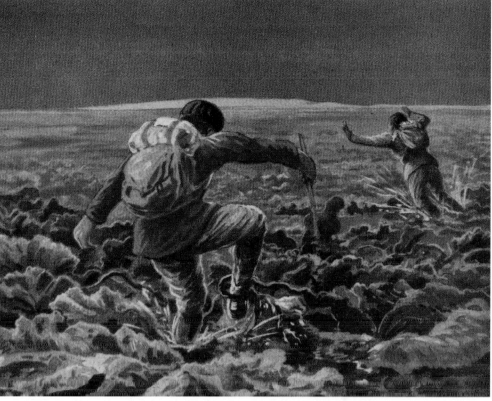

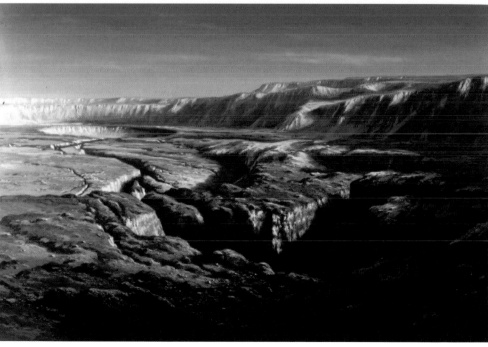

OPPOSITE: The furnace-like surface of Mercury was effectively illustrated by Anglo-American artist Jack Coggins in this striking watercolor painted for *The Big Book of Stars* (1955), a children's book about astronomy.

TOP LEFT: Beginning in 1895, the publication of Percival Lowell's theories about the nature of the "canals" on Mars and the possibility of intelligent life on the planet spawned an international frenzy of interest in the red planet. This resulted in everything from novels such as H. G. Wells's *War of the Worlds* to popular sheet music, such as this example from 1901.

TOP RIGHT: In the 1930s, Lucien Rudaux created this scene of a pair of hapless explorers slogging through the dense marshes that some astronomers thought might exist on Mars. The illustration was one of several illustrating different theories about conditions on the surface of the red planet.

BOTTOM RIGHT: A scene set on the rim of the giant Martian volcano, Olympus Mons, looking across the fissured floor of its 50-mile-(80-kilometer-)wide caldera. During the 1970s, artist Ludek Pesek specialized in painting Martian landscapes, creating in the process some of the best depictions of the planet by any artist.

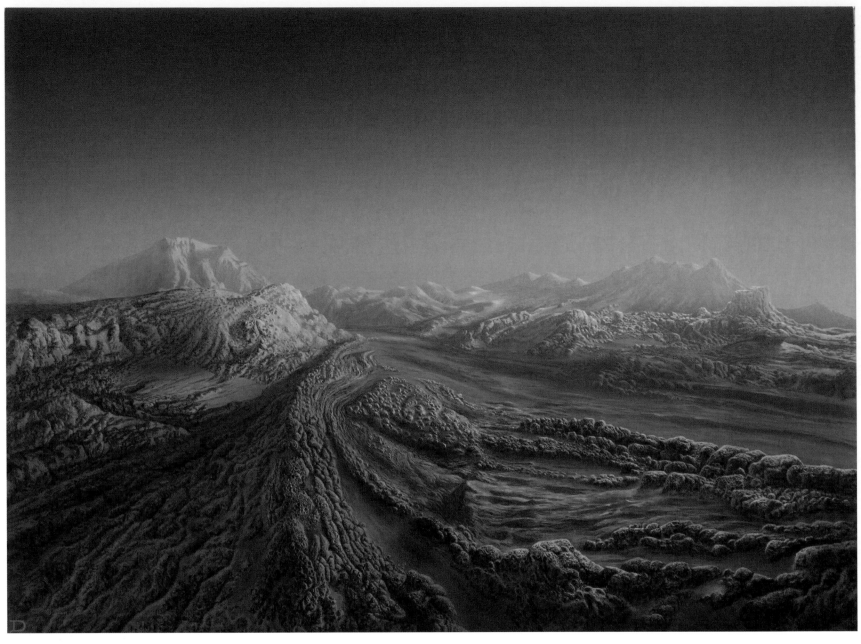

ABOVE: Many space artists have found inspiration in terrestrial counterparts to alien landscapes. Here, in a painting created in 1983, Don Dixon depicts a scene in Valles Kasei on Mars. The landscape was inspired by a gulley the artist once visited at Zabriskie Point, Death Valley, California.

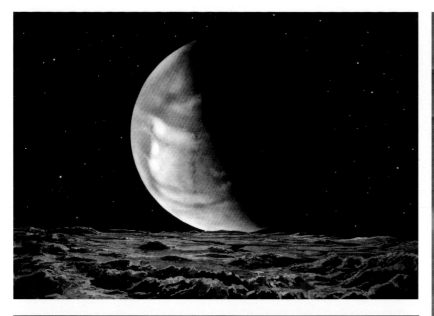

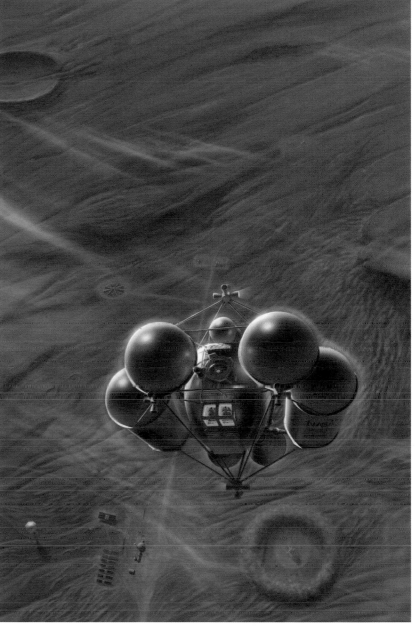

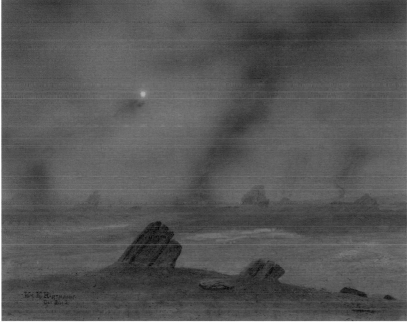

TOP LEFT: Here, Mars is seen from the surface of its satellite, Phobos. This gouache painting was created by seminal French space artist Lucien Rudaux for his book *Sur les autres mondes* (1937). A superb watcher with his own observatory, Rudaux's depictions of Mars were astonishingly accurate, even by today's standards.

BOTTOM LEFT: A dust storm on Mars is depicted in this 2012 painting by astronomer-artist William K. Hartmann. An acknowledged expert on the evolution of planetary surfaces, Hartmann's space art combines scientific accuracy with the skills of an accomplished painter.

ABOVE RIGHT: In this 1990 Pat Rawlings painting, we see the ascent stage of a two-stage Mars lander as it takes off for the yearlong return trip back to earth, following a projected two-year exploration of the surface of the red planet.

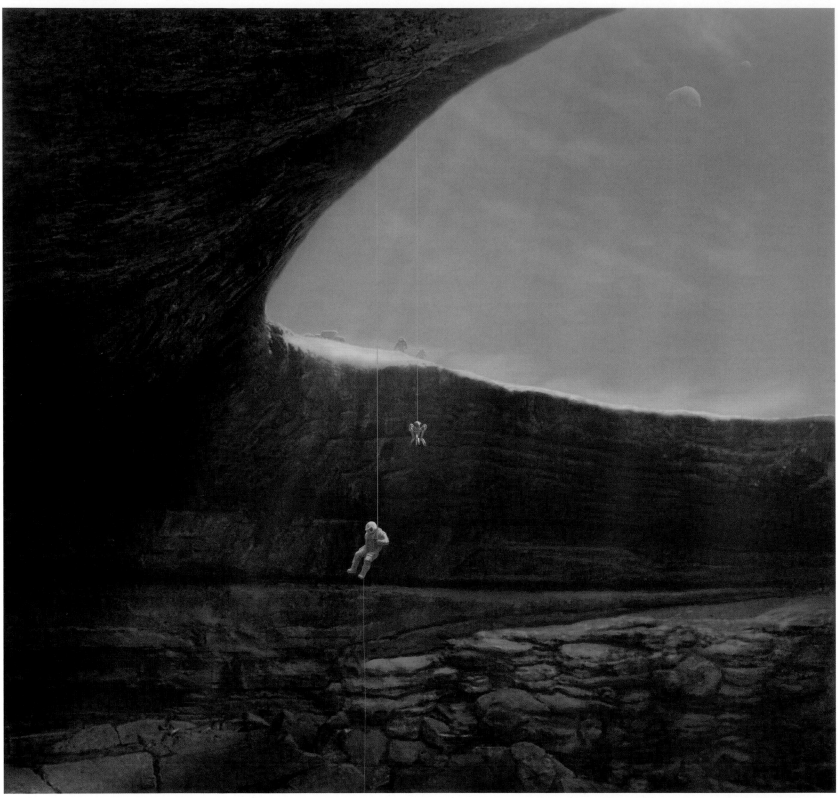

ABOVE: In *The Pit* by Pat Rawlings, we see a team of scientists descending into one of the mysterious circular openings in the Martian surface. These may lead to caverns or lava tubes in which habitats may be constructed, protected from solar radiation by the thick crust above.

OPPOSITE TOP: In *Mars Landing: Heading for the High Ground*, astronomer-artist Dan Durda created an image of what the future exploration of Mars might look like. Like many other space artists, Durda was inspired in his depiction of the Martian landscape by visits to California's Death Valley.

OPPOSITE BOTTOM: With this rendering, artist Ron Miller tried to create a Martian landscape with as many features typical of the planet as possible: dark, volcanic rocks; sandy, dune-covered desert; and swirling whirlwinds transporting dust into a yellow-orange sky, in which a distant sun glows.

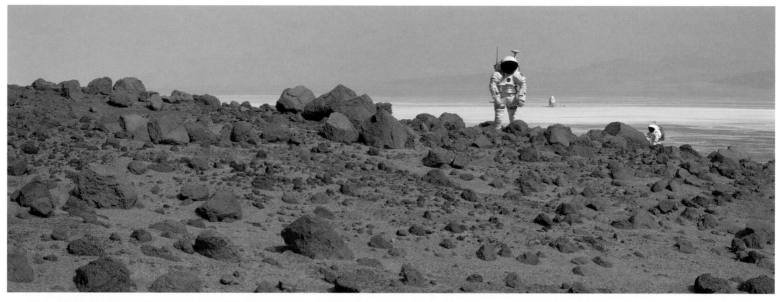

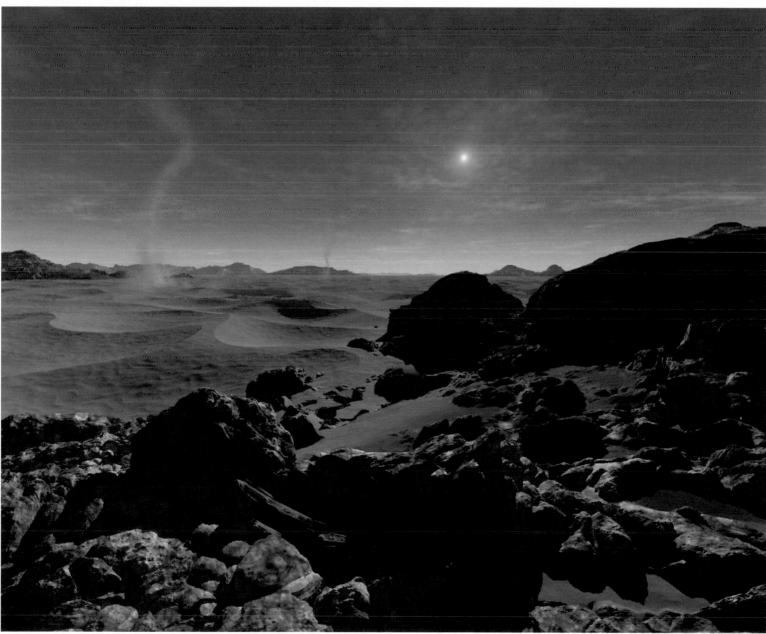

ASTRONAUT ARTISTS:
VISIONS FROM ZERO G

FOR ASTRONOMICAL ARTISTS AND APPRECIATORS OF SPACE ART, THE ULTIMATE DREAM
IS TO ORBIT THE EARTH OR WALK ON THE MOON—TO SEE AND EXPERIENCE FIRST-HAND
THE WONDERS THAT LIE BEYOND OUR PLANET'S ATMOSPHERE. OVER 500 PEOPLE HAVE
TRAVELED IN SPACE, BUT SO FAR ONLY THREE HAVE BEEN ARTISTS. THE FIRST WAS
COSMONAUT ALEXEI LEONOV.

RUSSIAN CLASSES

Born in 1934, Alexei Leonov graduated from a military flying school
and the Zhukovsky Air Force Engineering Academy. After serving
in the air force, he joined the Soviet team of cosmonauts in 1960,
shortly before Yuri Gagarin's historic flight. During a glittering
career he became the first human to walk in space, co-commanded
the joint US-USSR Apollo Soyuz Test Flight, and was head of
cosmonaut training at Star City. Always interested in drawing and
painting, Leonov also studied art at the Kharkov Higher School of
Pilots and eventually became a member of the Cosmic Group of the
USSR Artists Union, which represented artists who were interested
in astronautical and astronomical themes. He is unique among the
astronaut-artists in having taken colored pencils and paper into
space in order to create the first eyewitness sketches ever created
of the earth in space. Leonov's work has been exhibited in the USA,
Germany, France, and Russia. He is also the author of seven books,
many of them illustrated with his own paintings and drawings.

Another cosmonaut-artist is Vladimir Dzhanibekov. Born in 1942,
Dzhanibekov became a cosmonaut in 1970, making five flights as
spacecraft commander. During one of these missions he oversaw
the effort that saved the *Salyut 7* space station. To date, he is the
most experienced of the astronaut-artists, having spent a total of
146 days in space.

Dzhanibekov studied art at the V. Komarov Higher Air Force School
and, like Leonov, was a member of the Cosmic Group of the USSR
Artists Union. He has shown his work in exhibitions in the United
States, Russia, Saudi Arabia, and many other countries. While
Dzhanibekov considers space exploration to be his profession,
he says that in his artwork, "I try to show the philosophical side
of this not-always-easy work."

APOLLO ARTIST

The third astronaut-artist is American Alan Bean, who took art
classes at night while working as a test pilot for the US Navy in
1962. He became a member of the astronaut corps in 1963 and

was a member of the *Apollo 12* mission that made the second
manned landing on the moon in 1969. Bean flew into space again in
1973, when he spent 59 days aboard the *Skylab 2* space station. Too
busy during these years to pursue his art, he resumed his studies in
the 1970s. When he resigned from NASA in 1981, Bean took up painting
professionally, specializing in scenes of lunar exploration based
on his own experiences and observations. He also did extensive
research. Interviewing Neil Armstrong, Ed Mitchell, Gene Cernan,
and many others among his fellow Apollo astronauts, he tried to
find out how they perceived things such as color of lunar soil
and rocks. "When I talked with Neil Armstrong," says Bean,
"he remembered the moon as being a sort of brownish tan
downsun, a darker brown upsun, and a gray-brown cross-sun."

"WHEN WE TALK ABOUT ACTUAL OBSERVATIONS IN SPACE AND HOW AN
ARTIST MIGHT PORTRAY THESE SIGHTS, I PERSONALLY BELIEVE THERE'S
NO SINGLE ANSWER. EACH ARTIST DECIDES HOW CLOSE TO THE ACTUAL
SIGHT HE OR SHE FEELS THE ART SHOULD BE. I THINK THIS IS THE KEY
QUESTION IN ANY ART."
Alan Bean, *In the Stream of Stars*, 1990

From all of these notes, Bean created a chart showing the range
of color, shade, and texture impressions. Then, he says, "I had to
make a choice. Was I going to paint these paintings as an astronaut-
engineer-scientist would do it, literally following my chart, or was
I going to paint this adventurously, as an astronaut-artist would?"

Bean's solution was to create his paintings in such a way that a
viewer looking closely would see "all sorts of beautiful colors," but
from a distance would perceive astronauts in white space suits in a
gray landscape. "I would key [the colors of] the painting artistically,"
he explains, "yet I hoped that when I asked a viewer what color
the moon was, he'd decide it was gray." In this way, Bean hoped
to convey the complex impressions he and his fellow astronauts
had of the lunar surface. "It's a subtle thing. Above all I want my
paintings to suggest accuracy but be beautiful to look at."

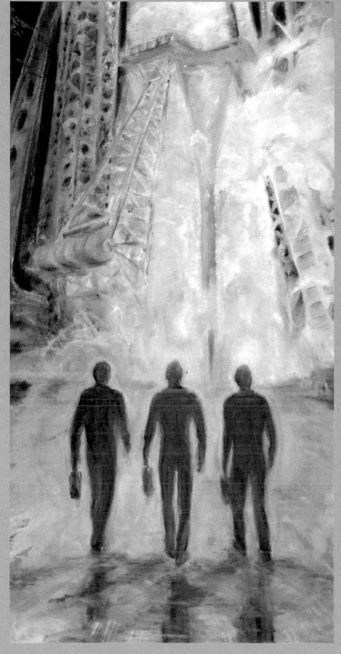

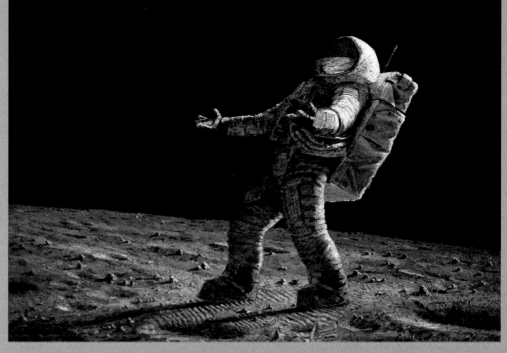

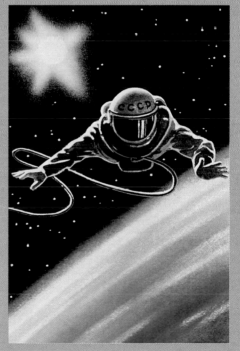

TOP LEFT: Russian cosmonaut Vladimir Dzhanibekov has made five flights into space, clocking a total of 145 days, 15 hours, and 56 minutes in orbit around the earth. He is also an accomplished artist. He explains this painting by saying, "The start of the cosmic trip is one of the most intense moments. They are the last minutes on the earth before a long flight."

BOTTOM MIDDLE: Although not himself a cosmonaut, Russian artist Andrei Sokolov collaborated closely with Soviet space explorers, to the extent of sending sketches such as this one into orbit with cosmonauts so they could be corrected and commented on by eyewitnesses. Sokolov then used their notes to create his finished paintings.

TOP RIGHT: "Is anyone out there?" asks the lunar explorer in this 2004 painting. This work is by American astronaut-artist Alan Bean, who walked on the moon as part of the *Apollo 12* team.

BOTTOM RIGHT: Alexei Leonov, the first human to walk in space, was also a very serious artist and illustrator. He was the first artist to take drawing materials into space in order to sketch what he saw.

ABOVE LEFT: For centuries, what lay beneath the clouds of Jupiter was as big a mystery to astronomers as it was to artists. Many scientists believed that Jupiter was a primitive planet much younger than the earth, and that its surface might be volcanic or ravaged by tremendous storms. This was a view shared by Motty, one of the artists who illustrated Camille Flammarion's *Les terres du ciel* (1884).

ABOVE RIGHT: This impression of Jupiter's mysterious landscape was created by R. T. Crane for *Men of Other Planets* (1951), written by Kenneth Heuer—a book the author described as a "guide-book to the planets, to planetary people and places."

OPPOSITE, TOP LEFT: Howard V. Brown (1878–1945) created this cover for *Astounding Science-Fiction* in 1938, illustrating Jupiter as seen from its moon Ganymede. Brown was a prolific illustrator for the pulps, whose science-fiction work often included convincing aliens and space scenes. The fact that the shadow on Jupiter is incorrect was an error that *Astounding Science-Fiction* readers were challenged to discover.

OPPOSITE, TOP RIGHT: A telescopic view of Jupiter drawn by astronomer J. Browning on the evening of January 31, 1870 (as published in *Other Worlds than Ours* [1870] by Richard Proctor). Before the perfection of astrophotography, astronomers needed to be skilled artists.

OPPOSITE BOTTOM: Australian digital artist Steven Hobbs created this striking image of Jupiter's Great Red Spot, a hurricane-like storm on Jupiter the size of earth that has been raging for at least 400 years. "Through my artwork," Hobbs says, "I present visually what for most people are just points of light in the sky."

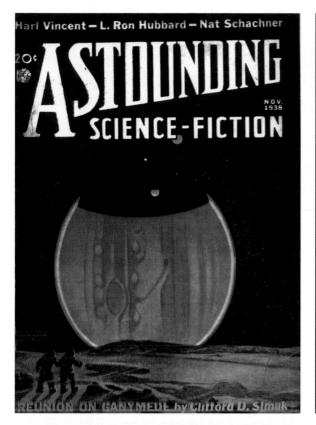

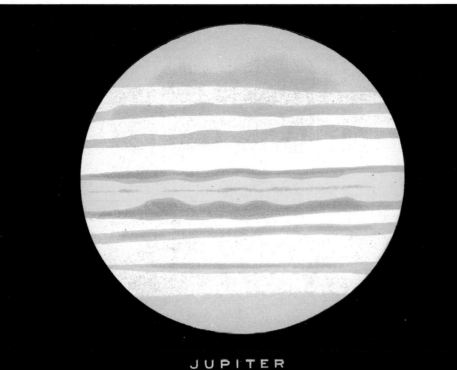

JUPITER
as seen on Jan.x 31st 1870 9.30 P.M. by J. Browning FRAS.

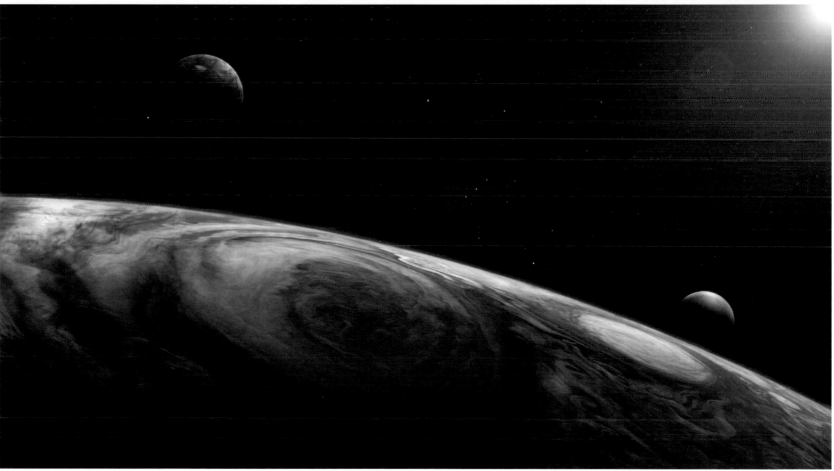

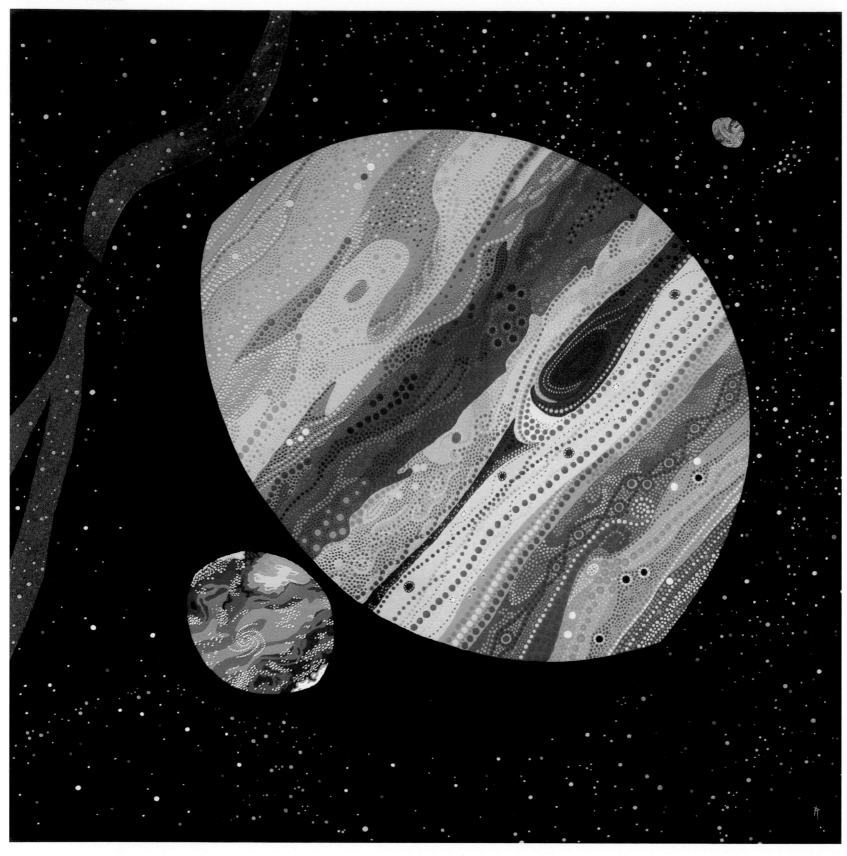

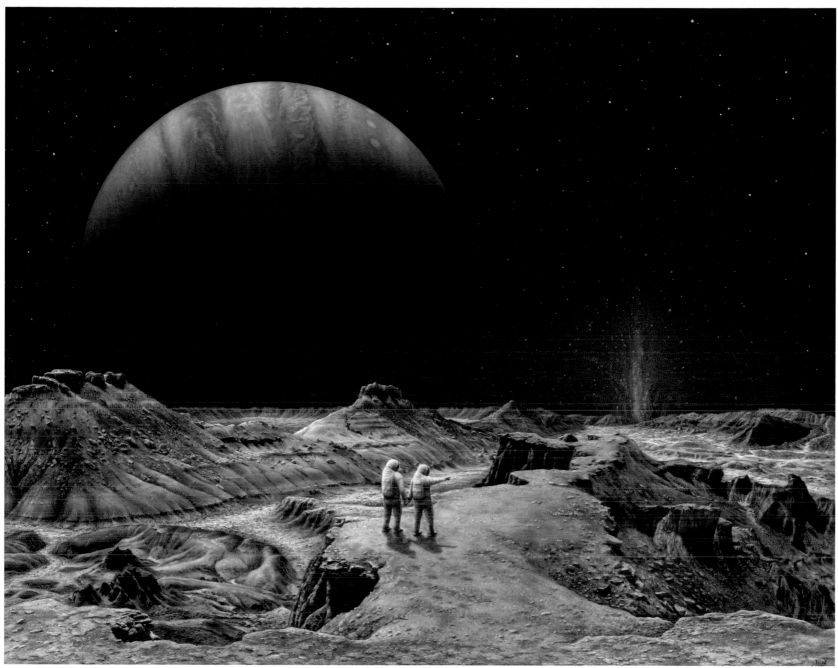

OPPOSITE: American artist Jon Ramer was inspired by a style of Australian aboriginal art called "dot art," a combination of simple lines and shapes with a mixture of dots in different colors. Here, in a work called *Living Moons*, Ramer shows an earthlike world in orbit around a Jupiter-like planet.

ABOVE: In *Shamshu Sojourn*, a painting created in 2011, Marilynn Flynn depicts a pair of astronauts exploring the Shamshu region of Jupiter's volcanic moon Io. The scene was inspired by a visit to the "Devil's Kitchen" area near Greybull, Wyoming, a geologic oddity that appeared as the alien planet Klendathu in the 1997 film *Starship Troopers* directed by Paul Verhoeven.

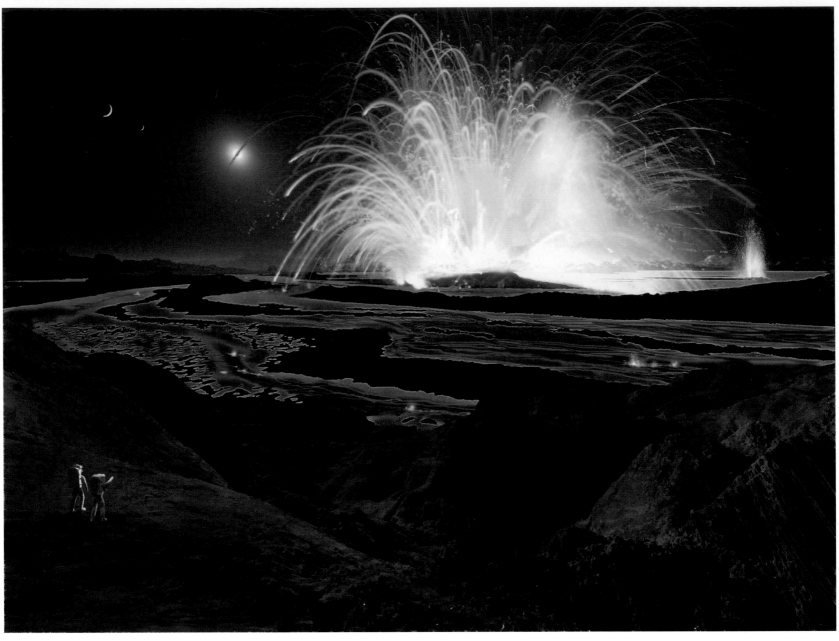

ABOVE: *Exploring Io* by Ron Miller focuses on one of the astonishing volcanic eruptions on Jupiter's moon Io. It is the most volcanically active body in the solar system. The most powerful eruptions can throw plumes of material nearly 200 miles (322 kilometers) above the surface.

OPPOSITE: Tohil Mons is a towering, 18,000-foot (5,486-meter) peak looming over the volcanic landscape of Io. Of all the different places in the solar system, artist Ron Miller especially enjoys creating scenes set on Io and Saturn's giant moon, Titan.

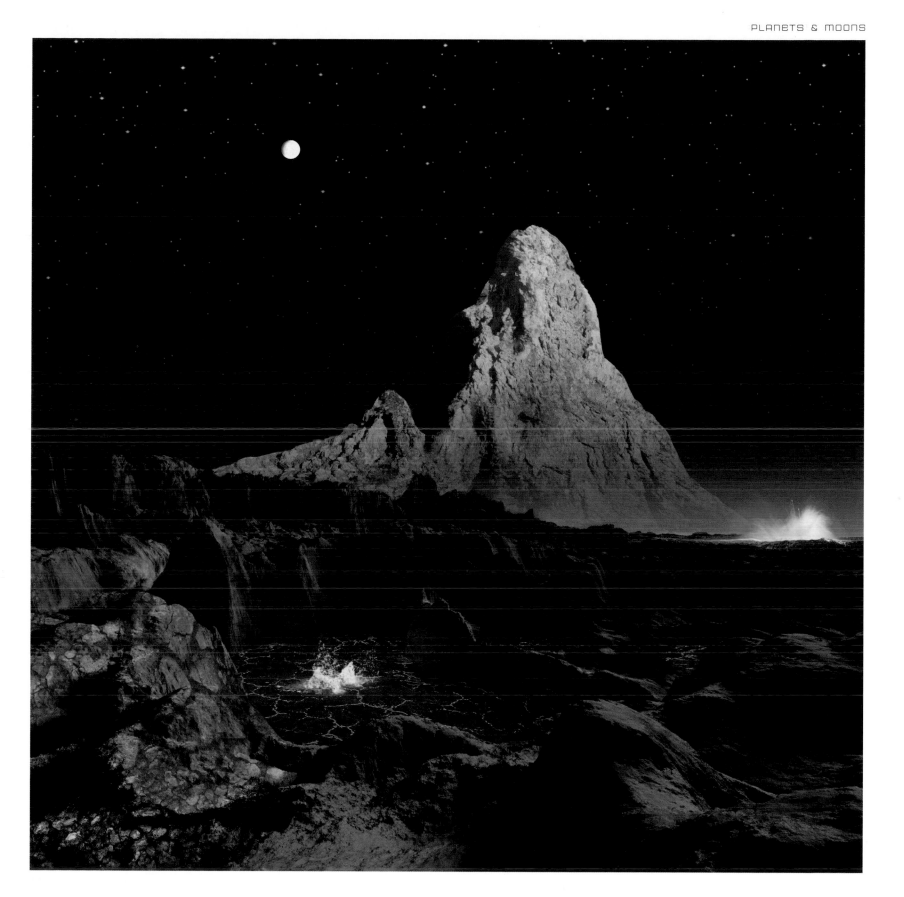

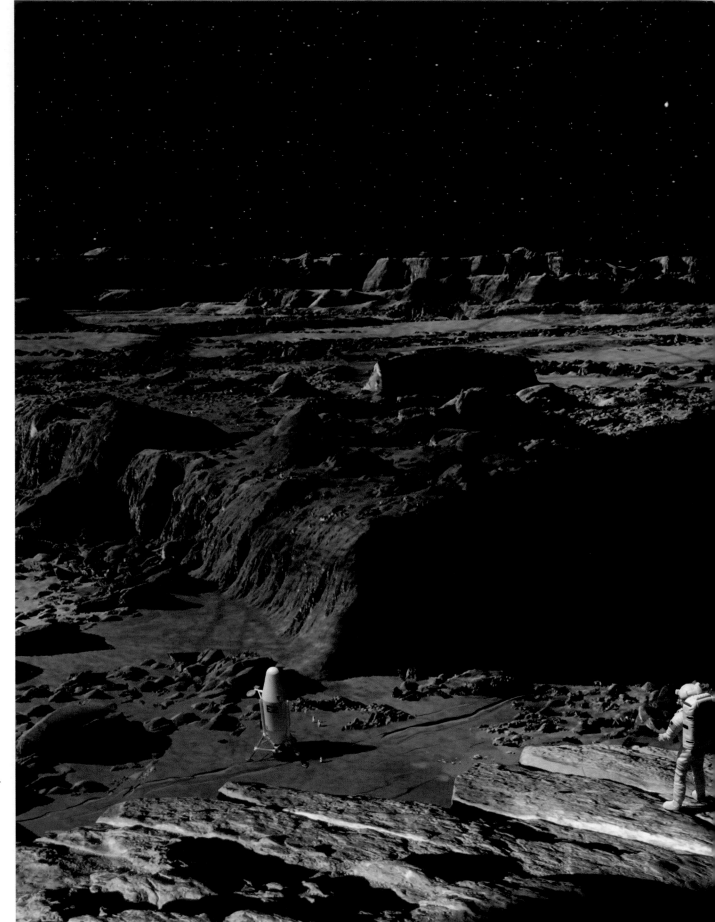

RIGHT: In *Exploring Europa,* Ron Miller tries to convey a sense of what it might feel like to stand on the surface of Jupiter's huge ice moon. Scientists suspect that deep beneath Europa's fractured crust may lie an enormous underground sea of warm water, making the moon a prime candidate in the search for life.

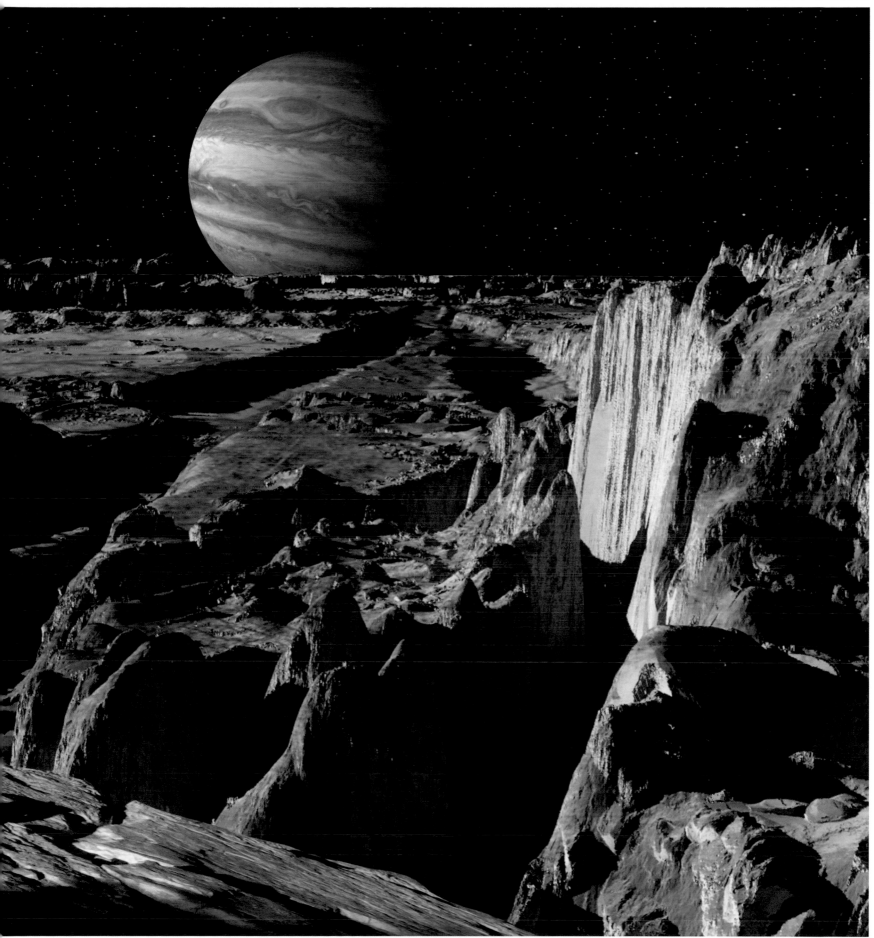

THE GREAT MOON HOAX:
LUNARIAN LIES

FIRST PUBLISHED IN THE *NEW YORK SUN* NEWSPAPER ON AUGUST 25, 1835, THE GREAT MOON HOAX DID NOT INVOLVE ACTUAL SPACE TRAVEL—BUT IT DID CREATE ENORMOUS EXCITEMENT ABOUT THE POSSIBILITY OF LIFE ON OTHER WORLDS. IT WOULD ALSO PROVE A MAJOR INFLUENCE ON THE GREAT AMERICAN WRITER EDGAR ALLAN POE (1809–1849).

SUPER-TELESCOPE

The hoax was a series of sensational articles created by reporter Richards Adams Locke, in which he told of the startling discoveries being made by the famed British astronomer Sir John Herschel at his observatory at the Cape of Good Hope, in South Africa. (Herschel was actually in South Africa at the time, albeit completely unaware of the sensation his "discoveries" were making.)

Through the use of a super-telescope built on entirely new principles, Herschel had supposedly found that there were not only living creatures on the moon, but that they were humanoid, fur-covered, bat-winged beings. Locke larded his serialized account with so much detail and scientific-sounding jargon that not only were his American readers absolutely convinced of the reality of his reports, but the news quickly spread to Europe, where it was translated and reprinted in French, German, and Italian, inspiring numerous artists to create prints and lithographs showing the imaginary discoveries in great detail—although some of this interest may perhaps have owed something to the reported presence of nude moon-maidens.

The *Sun* finally confessed the whole thing as a hoax on September 16. When Herschel finally arrived back home and learned how his name and reputation had been so freely used, he took it with great good grace and humor, remarking that his only regret was that he would never be able to live up to the fame.

ITALIAN INSPIRATION

The hoax became enormously popular in Europe, particularly in Italy. It was the inspiration for a large number of engravings and lithographs based on Locke's descriptions of the lunar landscape and its inhabitants, such as *Scoperte fatte nella Luna dal sig.r Herschell* (Lunar Discoveries Made by Signor Herschell), a suite of four lithos published anonymously in Naples; *Delle scoperte fatte*

"CERTAINLY THEY WERE LIKE HUMAN BEINGS, FOR THEIR WINGS HAD NOW DISAPPEARED, AND THEIR ATTITUDE IN WALKING WAS BOTH ERECT AND DIGNIFIED."
Richard Adams Locke, 1835

nella Luna dal Dottor Giovanni Herschell (Of the Lunar Discoveries Made by Dr. John Herschell), an engraving published in Naples; *Nuove cose e cose nuovissime nella Luna e sulla Terra* (New Things on the Moon and the Earth) by "Sir Causticolo Oestro"; *Delle scoperte fatte nella Luna dal signor Herschell* (Of the Lunar Discoveries Made by Signor John Herschell); *Scoperte fatte nella Luna dal Signor Herschell* (Lunar Discoveries Made by Signor Herschell) by Michele Clapié, Turin; and *Altre scoverte fatte nella Luna* (More Discoveries Made on the Moon).

HOT AIR

But there was at least one person with cause not to see the funny side of Locke's joke. Just two months before his lurid tales of nude moon-maidens had hit the newspaper stands, the *Southern Literary Messenger* had published its own hoax story of space travel: "Hans Phaall—A Tale," by Edgar Allan Poe. In Poe's account, Phaall traveled in a hot-air balloon to the moon, where he spent five years living among "lunarians." However, the satirical tone of the article meant that readers were quick to see through it, and the Great Moon Hoax would soon eclipse Poe's efforts.

Undeterred, in 1844 Poe wrote another series of "factual" articles—again in the *New York Sun*—describing how a European balloonist named Monck Mason had crossed the Atlantic Ocean in a hot-air balloon flight lasting three days. Like Locke's work before him, "The Balloon-Hoax" was a work of pure fiction—although a markedly less successful one, with the story's retraction following just two days later.

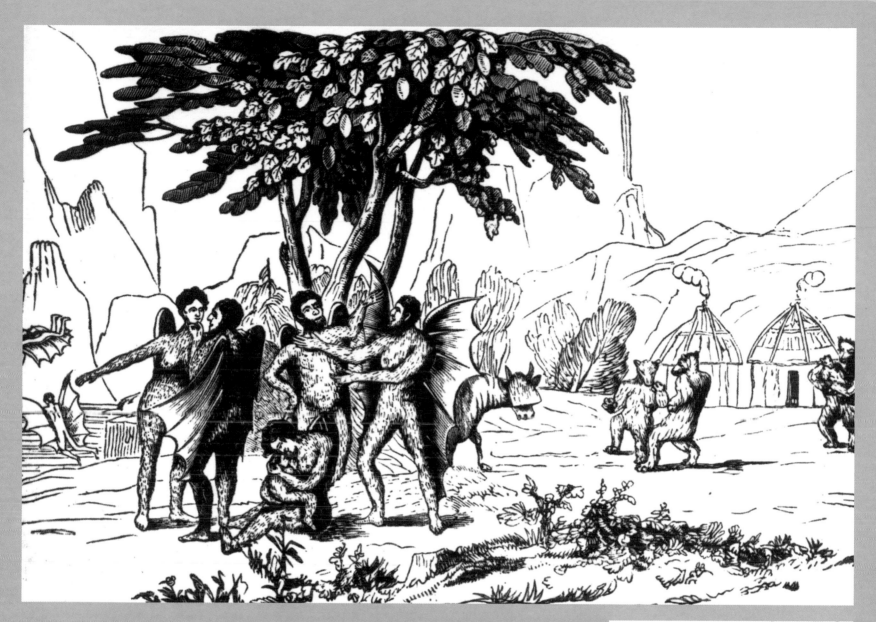

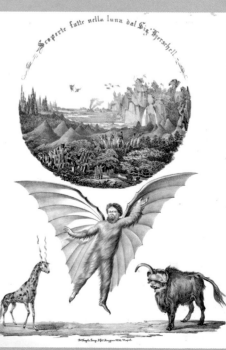

TOP: In 1835, reporter Richard Adams Locke hoaxed the entire world with his series of newspaper articles for the *New York Sun.* Locke described the discovery of winged humanoids on the moon known as Lunarians.

BOTTOM RIGHT: An illustration taken from an Italian edition of the *Moon Hoax,* published in 1836. It is really a kind of sequel to the original, in which missionaries travel to the moon by balloon to convert the Lunarians to Christianity.

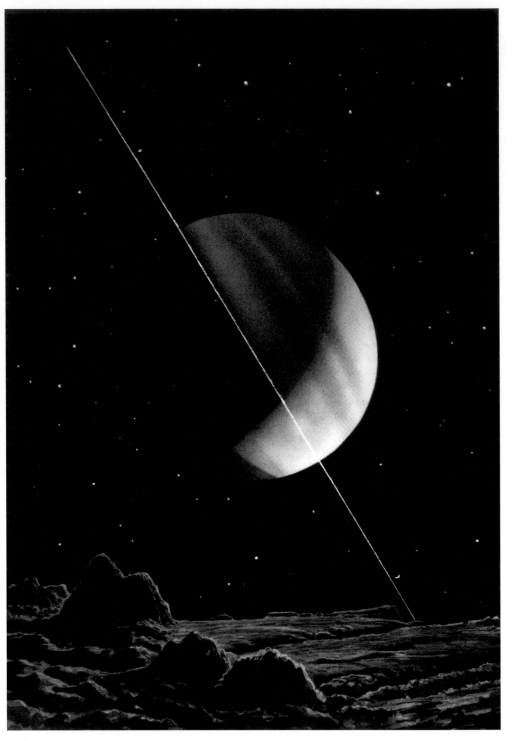

ABOVE LEFT: Artist Ken Fagg was one of the first to suggest that volcanism might exist somewhere in the solar system other than earth. The first active extraterrestrial volcano was not discovered until 1979. Fagg did a large number of excellent astronomy-themed covers for *If*, many of them wraparound.

ABOVE RIGHT: Lucien Rudaux painted this superb rendering of Saturn seen from its moon Rhea for his 1937 book, *Sur les autres mondes*. Although created nearly 80 years ago, it still holds up well even with the detailed knowledge we have since gathered about the planet.

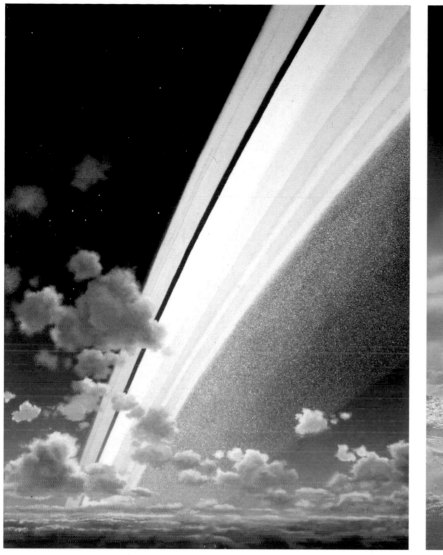

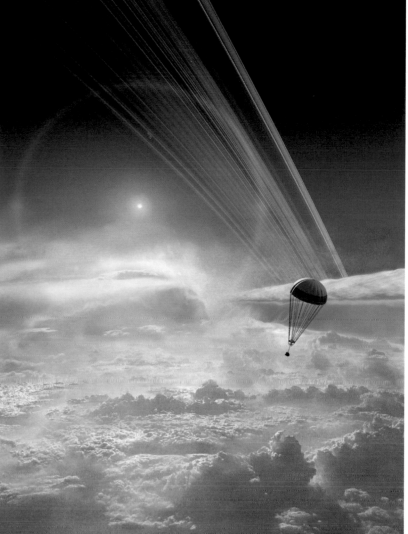

ABOVE LEFT: Chesley Bonestell created this ethereal image of the rings of Saturn in 1970, when he was 82 years old. The viewpoint is at about 20 degrees north latitude, the equivalent of Mexico City on the earth.

ABOVE RIGHT: The back rings of Saturn appear shadowy and ghostlike in this painting by veteran space artist Joe Bergeron. A probe from earth drifts in the foreground, still hundreds of miles above the distant clouds that lie below.

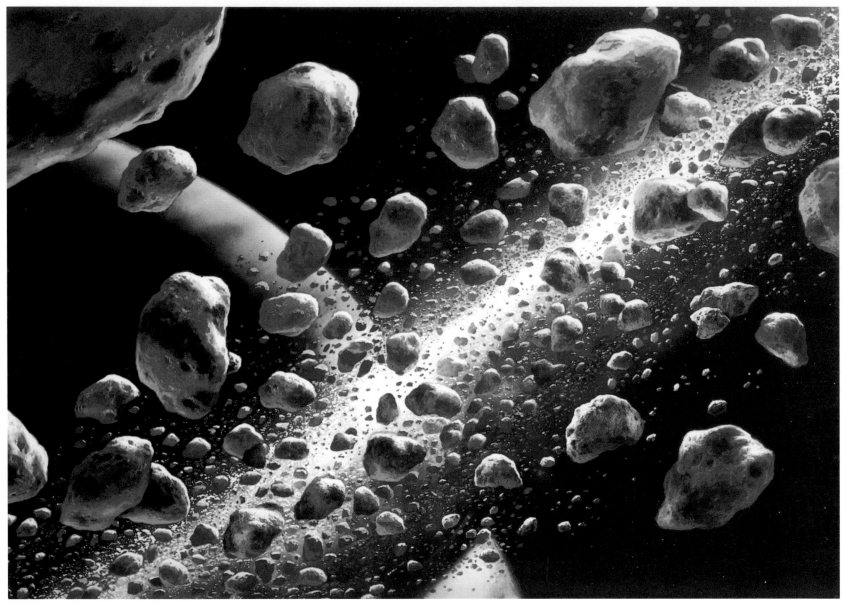

ABOVE: Ludek Pesek was one of the first space artists to wonder what the view might look like from within Saturn's rings. He created some of his first paintings on this subject as early as 1963. This is a more recent version, painted in the 1980s.

OPPOSITE: A weather probe hovers above a hurricane at the south pole of Saturn in this painting by Pat Rawlings. Although best known for his work in illustrating spacecrafts and other hardware, Rawlings has done some spectacular astronomical work over his long career.

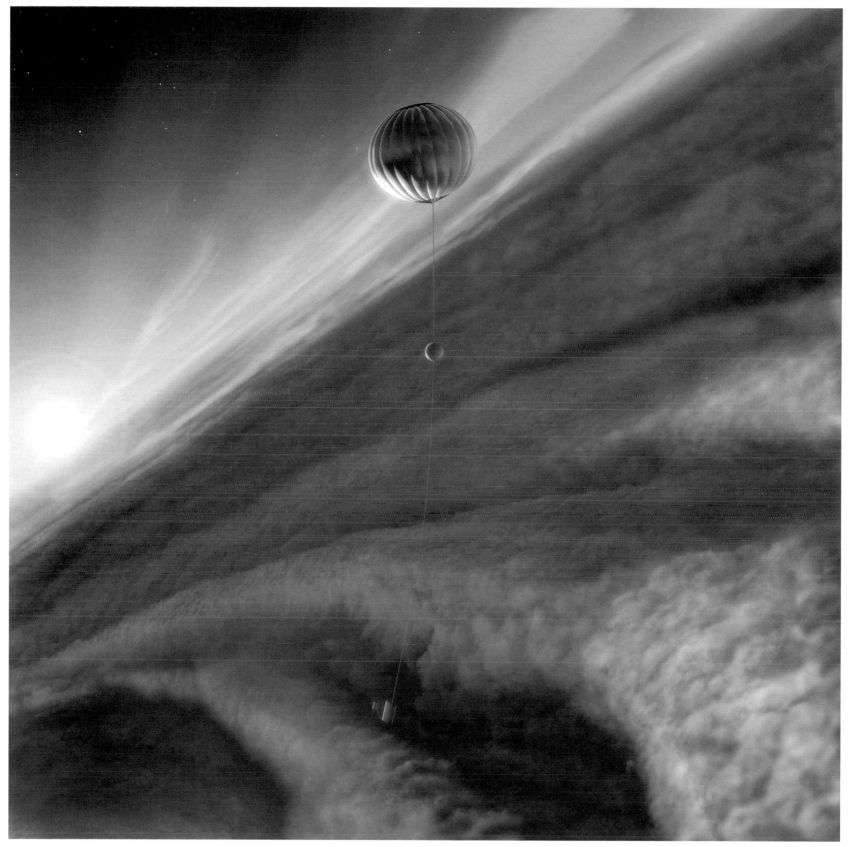

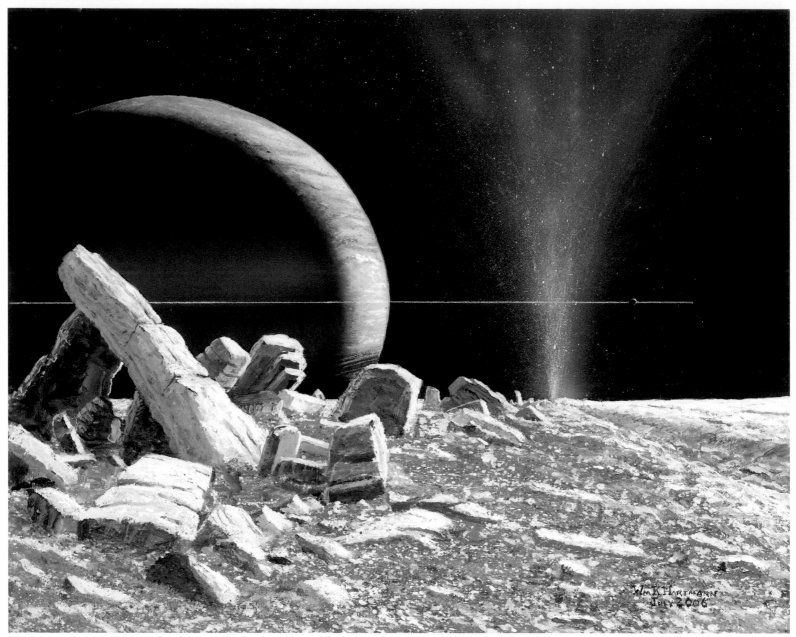

ABOVE: Not long after the discovery of geysers on Saturn's tiny moon Enceladus in 2005, space artists were imagining what they might look like seen close-up. One of the first was astronomer-artist William K. Hartmann, who created this impressionistic image in 2006.

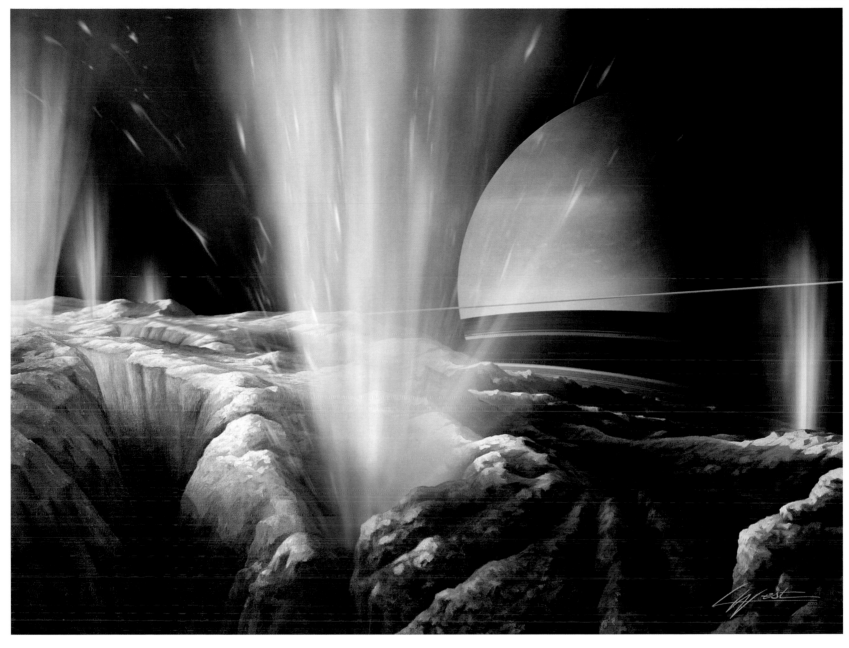

ABOVE: Artist Lucy West consulted with Dr. Carolyn Porco and astronomer Phil Plaitt in order to "better understand how to render the exciting dynamics" taking place on Enceladus. In this acrylic and digital rendering, she effectively illustrates the "enormous, effervescent jets of icy brine" that erupt into space for hundreds of miles.

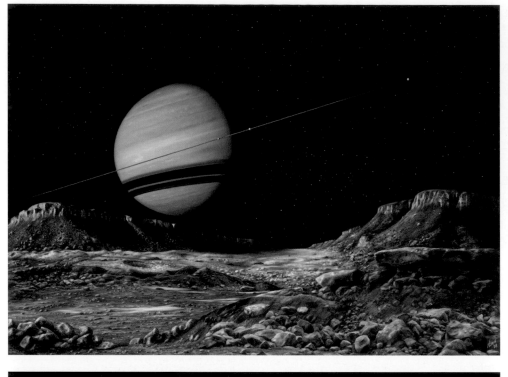

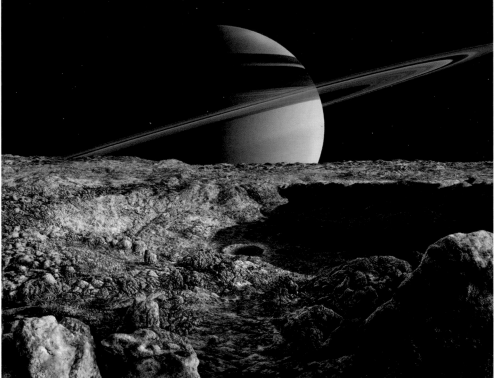

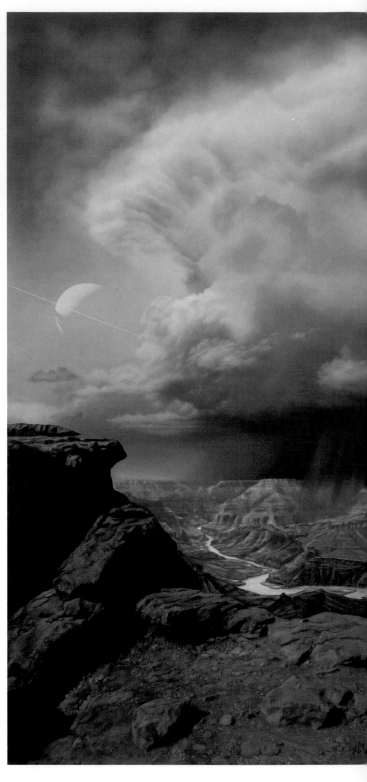

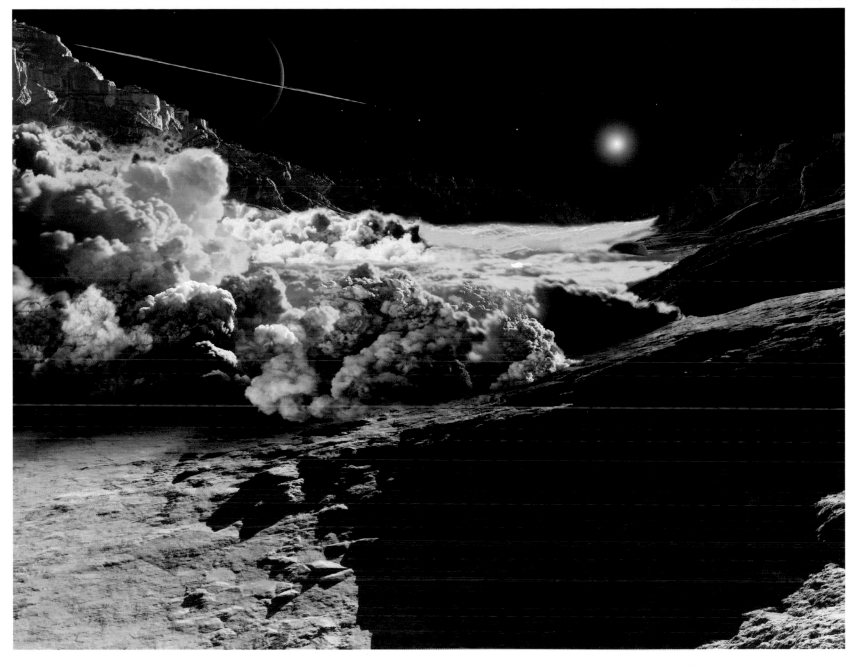

OPPOSITE, TOP LEFT: Saturn looms above the desolate landscape of its moon Rhea in this 2010 painting by Marilynn Flynn. She describes what we are seeing as a view "located in the southern hemisphere on the trailing edge of the moon…Enceladus and Mimas appear in front of [Saturn's] rings, and Titan is far off to the right on the other side… It is Summer in Saturn's southern hemisphere, and the northern hemisphere shows its characteristic blue Winter color."

OPPOSITE, BOTTOM LEFT: This digital artwork by Don Dixon shows Saturn dominating the sky of the battered little moon Mimas. The original art had been commissioned in 2007 by the Griffith Observatory in Los Angeles.

OPPOSITE RIGHT: In this digital composition we see distant cloudbursts of liquid methane raining into a canyon on Saturn's giant moon Titan, flooding a river that is carving a channel through layers of frozen ices and rock mixed with hydrocarbons. Artist Marilynn Flynn was inspired by a thunderstorm she witnessed over the Grand Canyon in Arizona.

ABOVE: An avalanche of ice comes roaring down a canyon on Saturn's tiny moon Iapetus, in this digital work by Ron Miller. When the rim wall of a crater collapses, it plunges more than five miles (eight kilometers) to the crater floor and surges over 20 miles (32 kilometers) across the landscape before finally coming to a stop.

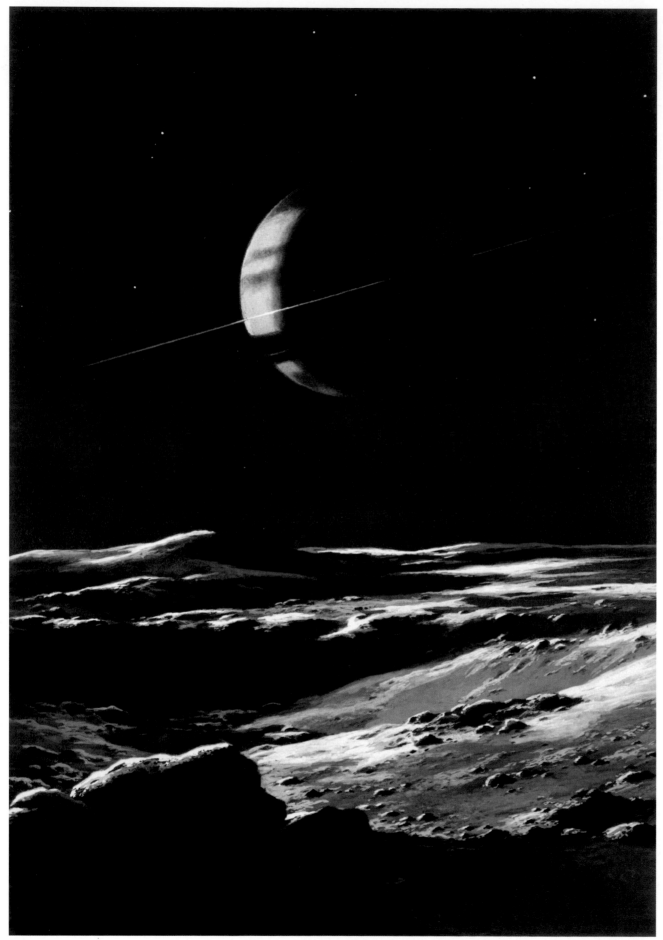

LEFT: A lyrical scene set on Saturn's giant moon, Titan, in this 1974 gouache painting by Ludek Pesek. It was created before the *Voyager* spacecraft discovered that Titan has an opaque orange cloud cover, making the possibility of ever seeing Saturn floating in a clear blue sky very remote.

OPPOSITE: In this digital artwork by Ron Miller, we stand by a methane stream on Titan just after a methane rainstorm has passed. Although it's highly unlikely that Saturn would ever be visible from the surface of Titan, the artist imagined a rare clearing in the perpetual cloud cover.

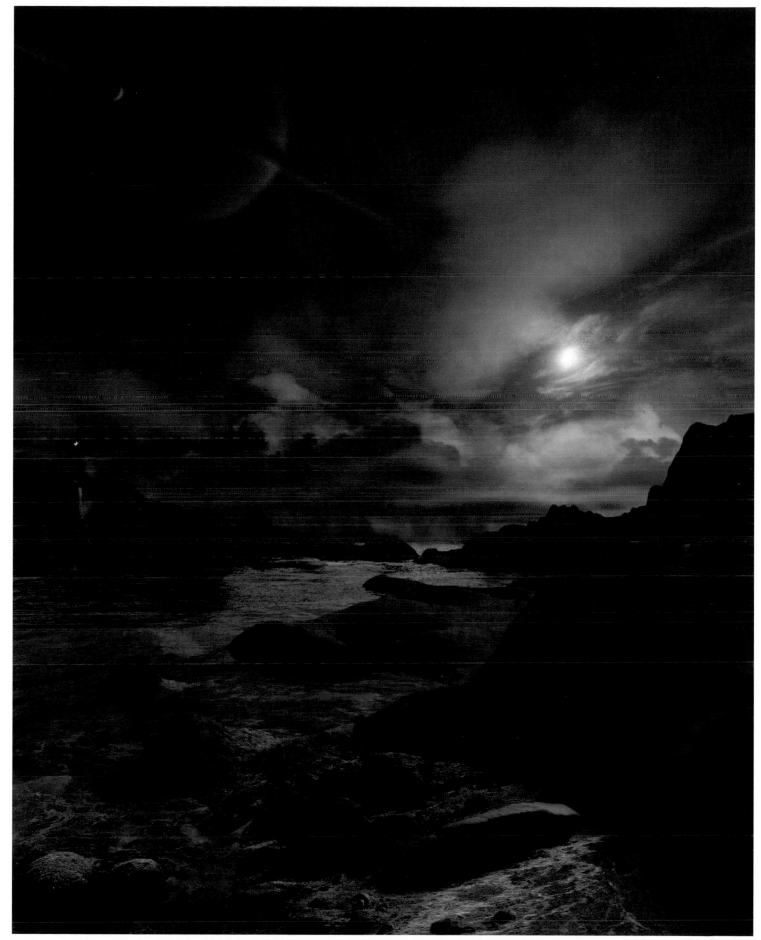

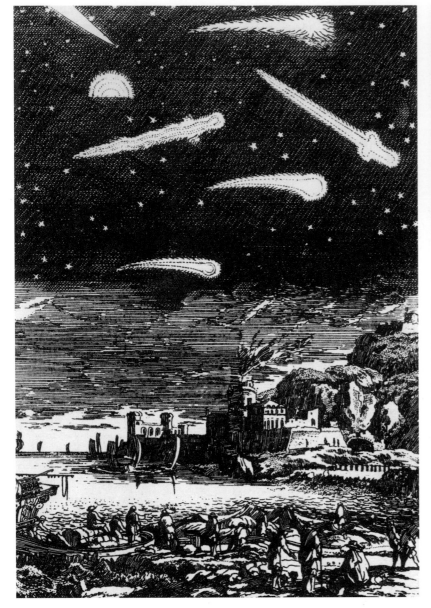

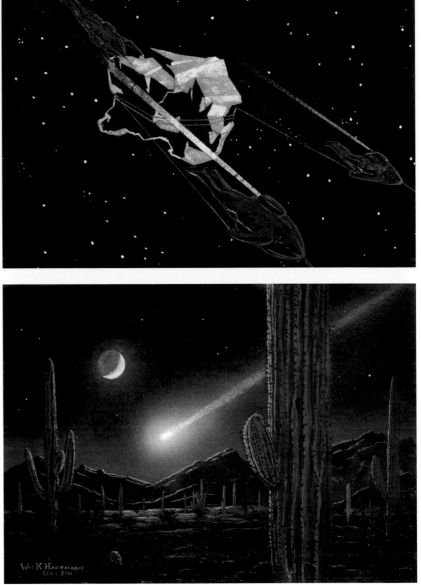

ABOVE LEFT: By depicting comets as having the shapes of swords, *Comet Types*, this engraving from Alain Mallet's *Description de l'univers* (1683), illustrates the once-common superstition that comets are portents of evil events.

TOP RIGHT: Asteroid miners are bringing home the goods in this striking example of Soviet-era space art by Andrei Sokolov. An impressively prolific artist, his work spanned decades and showcased markedly different artistic styles, ranging from abstraction to hard scientific realism.

BOTTOM RIGHT: A fireball lights up the night sky over an Arizona desert in this painting by astronomer-artist William K. Hartmann. Fireballs are simply unusually large meteors that can flame across the sky for several minutes instead of disappearing in a brief flash like most "shooting stars." A nice touch by the artist is the indication of earthlight illuminating the dark side of the moon.

OPPOSITE: In Michael C. Turner's *Cosmic Titans*, the artist offers us a dramatic view from within an active nebula. As a new star forms within the clouds of dust and gas, colliding dust, rocks, and asteroids begin the process of planetary formation.

02

stars & galaxies

STARS & GALAXIES:
IN THE LIGHT OF OTHER SUNS

ON A CLEAR NIGHT, FAR FROM CITY LIGHTS, IT IS POSSIBLE TO SEE AS MANY AS 2,000 STARS IN THE SKY, DUSTING THE NIGHT LIKE A SCATTERING OF DIAMONDS ON BLACK VELVET. MODERN LIGHT POLLUTION MAY MAKE THIS AN INCREASINGLY RARE PROSPECT, BUT IT WAS A FAMILIAR ONE IN THE ANCIENT WORLD, ABOVE THE DARK STREETS OF BABYLON, THE FARMS OF EGYPT, AND THE PLAINS OF PERSIA.

The stars provided more than just a pretty view—their movement in the sky measured the passing seasons of the year, while their positions provided a crucial navigational tool. In ancient Polynesia, for example, the ability to navigate accurately between tiny islands separated by hundreds of miles of trackless ocean was a matter of life or death.

Most ancient peoples viewed the stars as points of shining light affixed to a dome that arched over the earth, like lamps in a vaulted ceiling. They were all considered to be about the same distance from earth, even if some were larger and brighter than others. Although early astronomers could not determine exactly what the stars were, or even how far away they were, they were very good at observing them and measuring their positions. The Greek scholar Eratosthenes (c. 276–192 BC) created a catalog of the positions of 675 of the brightest stars, while Hipparchus (c. 146–127 BC) logged 850 stars from his observatory on the island of Rhodes. With the fall of Western science during the Middle Ages, the advance of astronomical knowledge was taken up by the Arab world, with the result that to this day many stars bear Arabic names, such as Betelgeuse, Aldebaran, Algol, Mizar, and Deneb.

THE MILKY WAY

When the Italian scientist Galileo Galilei (1564–1642) pointed his newly invented telescope at the Milky Way in 1609, he observed that it was nothing but "a mass of innumerable stars planted together in clusters." Later, the British astronomer Sir William Herschel (1738–1822) theorized that the Milky Way we see from earth is in reality a broad, flat cluster of stars, shaped something like a lens—thicker in the center than at the edges. We see this cluster, he said, as a band of stars arching through the sky because we are seeing it edge-on. Still, no one knew for certain how far away the stars were.

In 1838, German astronomer Friedrich Wilhelm Bessel (1784–1846) made the first measurement of the distance to a star. Using a method called parallax measurement, he determined that a star called 61 Cygni was 10.9 light-years from earth. A light-year is the distance light travels in one year. Since light moves at the speed of 186,000 miles per second (299,330 kilometers per second), in one year it travels some 6 trillion miles (9 trillion kilometers)! Such incredible distances explained why the stars appeared to be nothing more than points of light. Even Alpha Centauri, the star nearest to earth, was calculated by Scottish astronomer Thomas Henderson (1798–1844) to be 4.3 light-years away—some 277,420 times more distant than the sun.

"ACROSS THE SEA OF SPACE, THE STARS ARE OTHER SUNS."
Carl Sagan

The great spaces that lie between the stars are not empty. They are filled with dust and gas—mostly hydrogen. There are places where this dust and gas accumulates in great clouds, called nebulae. Many of these clouds glow in beautiful colors. Some glow from the radiation of the stars within or near them, while other clouds are visible only as dark silhouettes against the stars and glowing nebulae in the background.

All of the stars we can see in the sky are part of the Milky Way galaxy, a vast collection of 200 to 400 billion stars, swirling together like cream stirred into a cup of hot coffee. If we were able to see all of the Milky Way at once from some vast distance beyond it, the galaxy would resemble a fried egg—a bulbous center surrounded by a thick, flat disk. The disk, we would see, is composed of graceful, ghostly arms that spiral out from the central bulge like a pinwheel. Buried deep within one of those spiral arms, about two-thirds of the way from the central bulge, is the sun and its solar system. Like every other star in the Milky Way, it orbits around the center of the galaxy, taking about 250 million years to make a single trip. In galactic years, then, earth is only about 16 years old.

The Milky Way galaxy and its satellites are members of a much larger neighborhood of galaxies known as the Local Group.

SCUTUM SOBIESKY AND SERPENS.

This has more than 30 members, including the Milky Way. The galaxies that form the Local Group are not isolated, but locked together by their mutual gravitation. For example, the nearby Andromeda galaxy is so large that it can be seen with the naked eye from earth, and has been known to astronomers for more than a thousand years.

More than 300 years ago, philosophers and scientists suggested that the existence of our solar system implied that there might be other ones. Nowadays, it is almost impossible to imagine that our system of planets is unique. The real question is: How many other solar systems might there be?

PLANET HUNTERS

Evidence and logic had long indicated that there *should* be planets around other stars. Still, there had never been an unambiguous observation of one, and at the end of the 1980s astronomers were still searching. In 1983 the star Beta Pictoris had been discovered to have a thin disk of dust surrounding it. Scientists considered such a disk the by-product of planetary formation, so it seemed likely that Beta Pictoris might have planets orbiting it. But if it did, they were undetectable. Their existence might just be wishful thinking.

Using Doppler shift measurements, it was shown that some stars have at least one object orbiting them, but in most cases these objects are very large—many times the size of Jupiter (the largest planet in our solar system, which is 318 times the mass of earth). It has to follow that these are not true planets but instead are brown dwarfs—objects much bigger than planets but not quite large enough for their gravity to ignite the nuclear fires and form stars. Although the planet hunters had not yet found real planets, the search showed that they were on the right track and that their techniques worked.

In 1990, astronomer Alex Wolszczan made an astonishing discovery while studying pulsars, neutron stars that emit electromagnetic radiation. He found that one pulsar—PSR

1257+12—had something odd about its pulse. Sometimes the pulse came a fraction of a second late, while at other times it came a fraction of a second early. Theoretically, this was impossible… unless the pulsar had planets orbiting it. If planets were circulating the pulsar, their gravity would pull it first toward earth and then away. This could affect the timing of the pulses.

Wolszczan believed that there were two planets orbiting PSR 1257+12. One was about three times the mass of earth and took about 98 days to circle the pulsar, and the other was about 3.5 times the size of earth and orbited in just over 66 days. Both planets were roughly the same distance from the pulsar that Mercury is from the sun. There was also the possibility of the existence of at least two other planets.

GOLDILOCKS ZONE

It was an exciting discovery—the first real evidence of planets around a star other than the sun. Such worlds would be terribly harsh, though, with little chance of life existing on them. Pulsars are powerful emitters of x-rays, and the intense radiation would be deadly. So astronomers kept looking, hoping to discover a planet around a star similar to our own sun. Two scientists, Michel Mayor and Didier Queloz, began searching for the telltale wobble in stars indicating the possibility of planets. In 1995, after examining 150 stars, they found a planet orbiting the star 51 Pegasi. The planet is much bigger than earth, but still only about half the mass of Jupiter. Most importantly, it is far too small to be a brown dwarf. But it does orbit very close to its sun, at about only 4.3 million miles (7 million kilometers)—so close that the new planet's "year" is only four days long and its surface probably red-hot.

Since that historic discovery, scientists have improved their instruments and refined their techniques. Today, more than 1,000 extrasolar planets have been discovered—with dozens nearly the size of our own planet and orbiting their stars in the "Goldilocks zone," where life might conceivably flourish.

ABOVE LEFT: This engraving by Andreas Cellarius was created in 1660 as one plate in *The Celestial Atlas, or The Harmony of the Universe*. The observer at the eyepiece of the telescope is using a protractor and plumb bob to measure the height of a star above the horizon, allowing him to correctly position it on the chart he is creating.

ABOVE RIGHT: An illustration from Thomas Wright's *An Original Theory or New Hypothesis of the Universe* (1750). Wright was one of the first to recognize the true nature of the Milky Way, explaining that it was in reality "an optical effect due to our immersion in what locally approximates to a flat layer of stars."

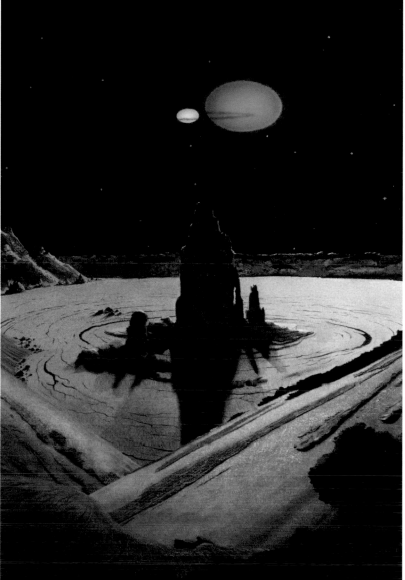

ABOVE LEFT: Chesley Bonestell created this painting of the binary star Beta Lyrae in 1964 to illustrate his book, *Beyond the Solar System*. Seen here from a hypothetical planet, the two stars are so close to one another that they have become distorted into egg shapes. They orbit each other so fast that a spiral of glowing gas is spun off into space.

ABOVE RIGHT: Another double star system, RW Persei, was depicted by Chesley Bonestell, this time for the Time-Life book, *The World We Live In* (1955). Note the care Bonestell took with the multicolored shadows cast by the stars: the blue star casting an orange shadow, the orange star a blue one. Lucien Rudaux was the first space artist to depict this sort of effect, but Bonestell took it to a new level of realism.

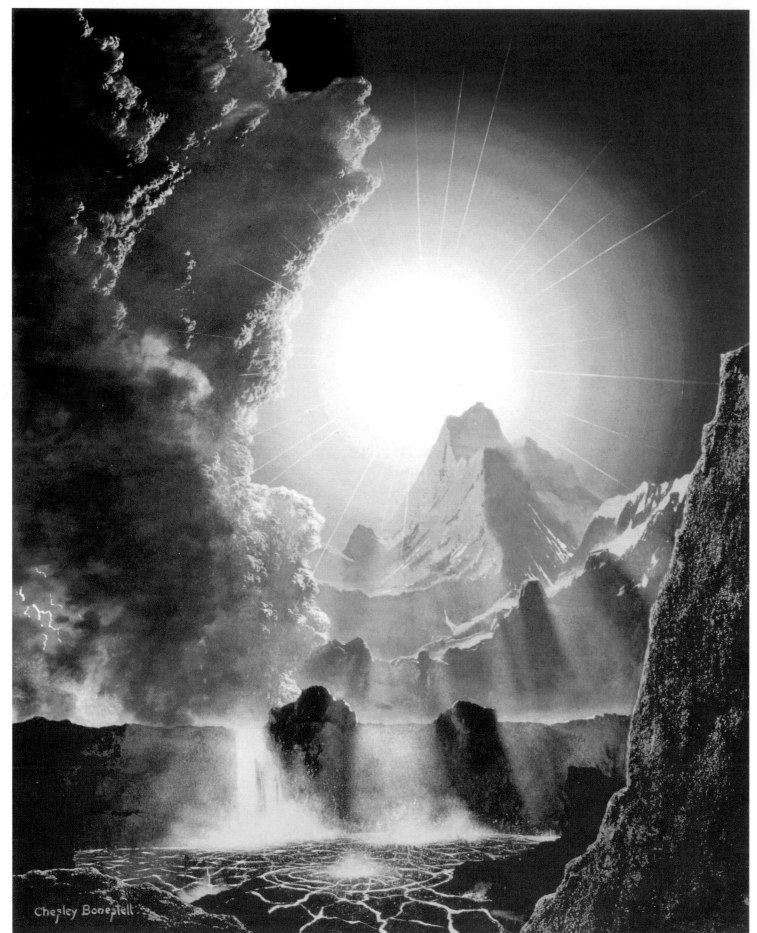

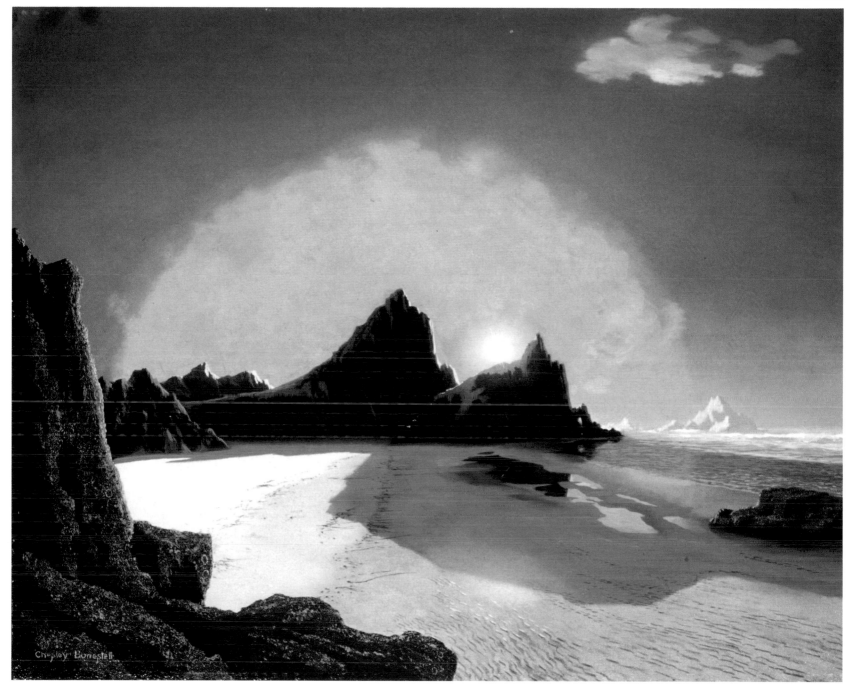

OPPOSITE: In this Chesley Bonestell painting from *Beyond the Solar System*, the intense radiation from a nova has begun to melt the red-hot mountains of an ill-fated, earthlike planet. The world's seas have long since evaporated and much of its atmosphere has been blown into space.

ABOVE: Chesley Bonestell created this painting for *Astounding Science-Fiction* in 1948. It depicts the double star Mira Ceti as seen from a hypothetical planet 450 million miles (724 million kilometers) away. Bonestell had the details of the painting checked by astronomers Alfred Joy and Robert Richardson of the Mount Wilson and Mount Palomar Observatories.

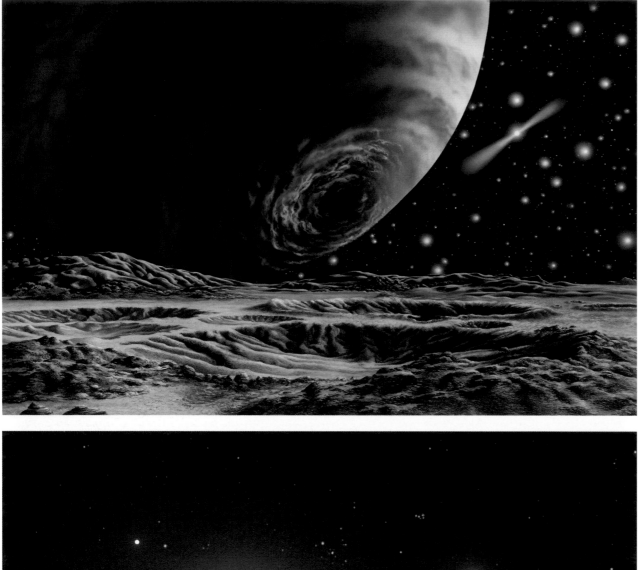

TOP LEFT: Here, artist Lynette Cook illustrates a scene on the moon of a Jupiter-like planet. In the distance is the pulsar at the center of the planetary system. The intense radiation from the pulsar is causing the spectacular auroral display around the pole of the giant planet.

BOTTOM LEFT: Here Dr. Dirk Terrell shows us a view from the upper atmosphere of Kepler 64, a gas giant orbiting within a system of four stars. An astrophysicist by profession, Dr. Terrell was among those who actually discovered Kepler 64, giving him the unique experience of painting a world he had helped to locate.

OPPOSITE: Here Lynette Cook imagines the future exploration of HD168443c, a giant Jupiter-like planet orbiting a sunlike star. Like Jupiter, this planet probably has no solid surface on which a spacecraft could land, so the only way to explore it would be to drift among its towering clouds.

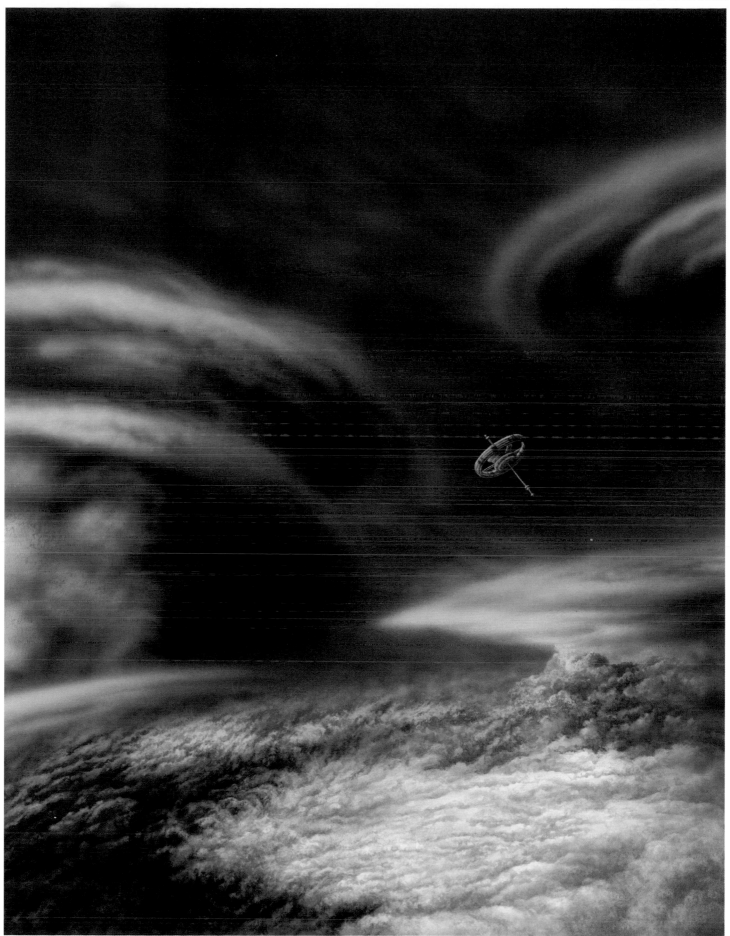

LYNETTE COOK:
DISTANT WORLDS

"FROM AN EARLY AGE," EXPLAINS AWARD-WINNING SPACE ARTIST LYNETTE COOK, "MY TWO MAIN INTERESTS WERE ART AND NATURE. MY SPECIAL INTEREST IN ASTRONOMY, HOWEVER, WAS SOMETHING OF A 'MELTING POT'..."

There was no single event or person that triggered Cook's interest in astronomy, but on family camping trips she, like so many, would gaze up at the night sky and admire how dazzling the stars were when seen far from city lights. These experiences, paired with science-fiction books and the awesome impact of the original *Star Wars* series, paved the way for one of the leading astronomical artists.

Cook pursued her early interest in nature and science, majoring in both biology and drawing & painting at the Mississippi University for Women. She continued her education at the California College of the Arts, where she specialized in scientific illustration and graduated with a Master of Fine Arts. Having interned at the California Academy of Sciences in San Francisco, Cook took on a job as a staff artist and photographer for the Morrison Planetarium—a position she held for 16 years. "This was my introduction to space art," she says.

EXOPLANET EXPERTISE

In the field of astronomical art, Cook is probably best known for her depictions of extrasolar planets—or exoplanets. "My work in this subject began in 1995," she recalls, "following the announcement of the first confirmed extrasolar planet orbiting a sunlike star, 51 Pegasi b." Many of Cook's paintings accompanied the press releases announcing the discovery of these worlds. Her extrasolar depictions have appeared internationally in books, periodicals, television, and film, such as *Astronomy*, BBC Television, The Discovery Channel, Japan Public Television, The Learning Channel, PBS, *Science et Vie*, *Science News*, *Sky & Telescope*, *Time*, and *US News & World Report*.

Lynette is especially proud of the work she did for the book *Infinite Worlds: An Illustrated Voyage to Planets Beyond Our Sun* (2005), coauthored with Ray Villard, which featured nearly 70 of her paintings. She has also illustrated a children's book on the subjects of extrasolar planets and life in space, titled *Faraway Worlds*.

GENDER GAP

Lynette Cook is one of the handful of women specializing in space art, and she is not surprised at this. "Traditionally," she explains, "women in the sciences are the minority gender. Thus, it probably is no surprise that women in space art also are fewer than men." Has she ever felt her gender to be an impediment? Though she says she has had no direct experience of gender bias, she adds, "There have been times that I felt I needed to be more 'like men' to be noticed and appreciated in astronomy. Thankfully, I have not experienced this when amongst my fellow space artists, but I certainly have when outside our small circle."

Her method of working is similar to many other "hard science" space artists. "I consult with astronomers," she explains, "science editors, and art directors to discuss what these alien places might look like and decide how best to represent the subject matter. I then create a work of art based on the known data. I sometimes incorporate scientifically plausible elements such as moons and planetary rings as well."

"SPACE IS MYSTERIOUS, VAST, AND SEEMINGLY NEVER-ENDING. LIKE MANY OTHER PEOPLE, I SEE THE STARS SHINING BRIGHTLY AFTER THE SUN HAS SET AND WONDER WHAT IS OUT THERE."
Lynette Cook

But why so much focus on exoplanets and the possibility of life in the universe specifically? "Because," she says, "it is my way of wondering about and exploring in a tangible way the questions of human existence and our place within the cosmos. These areas of research are also at the cutting edge of discovery. Thus, my involvement helps me to feel that I am making a unique and important contribution to science and science education. This said, I've had fun with other subjects as well, such as black holes, Dyson spheres, string theory, dark matter, and more."

DIGITAL REVOLUTION

As a traditionally trained artist, Cook originally used a mixed-media technique of gouache, colored pencil, and acrylic airbrush paint in creating her paintings. However, she says, "in keeping with the times, and to accommodate short deadlines and frequent last-minute changes, my science illustration now is created digitally."

But for Cook, the use of the computer is to do with necessity rather than choice. "While marveling at the magic of the computer," she says, "being velcroed to a monitor for long periods causes me to yearn for tangible pigment and ground. As a result, I have picked up the paintbrush again and walk the paths of scientific illustrator and fine artist simultaneously."

ABOVE: Lynette Cook is one of the most talented of the modern space artists. Her work is respected by both scientists and her fellow artists. Not only does she depict other worlds with precise scientific accuracy, but at the same time she explores the effect of astronomical discoveries on the history and psychology of humankind.

ABOVE LEFT: *Growing Planets* is one of a series of surrealistic paintings by Lynette Cook that bring to mind the work of René Magritte. Here she not only plays upon the evolutionary process by which our solar system was created—she indulges in a nice pun as well.

TOP RIGHT: *HD209458 Station* depicts a far-future research station hovering in the upper cloud decks of a super-Jovian exoplanet. It is a hostile world blasted by intense storms, and orbiting so close to its star that the planet is heated to more than 1800°F (982°C).

BOTTOM RIGHT: Here Lynette Cook shows us the disk surrounding the star Beta Pictoris as a nursery where new planets are being born amid the gas and dust. It is like looking into the distant past of our own solar system, not long after the birth of the sun, when the earth and its sister planets were first forming.

© 2013 Matthew Stricker

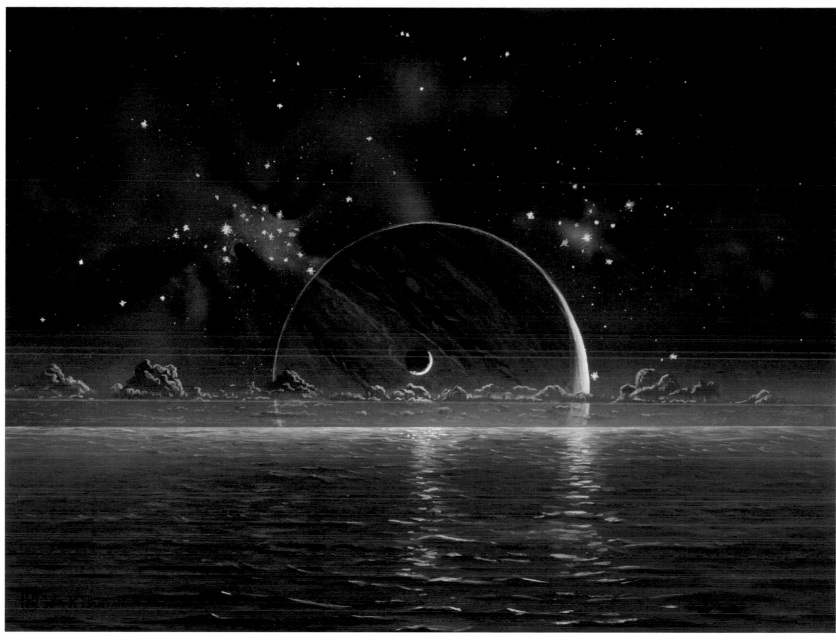

OPPOSITE: Matthew Stricker's rendering of the exoplanet HD 168443c shows it as it might look as seen from an icy moon. The planet itself is a massive object many times larger than Jupiter. It may in fact be one of the strange almost-stars known as "brown dwarfs."

ABOVE: Astronomer-artist William K. Hartmann is best known for his depictions of the planets of our solar system. In this painting, however, he ranges further afield, depicting the water-covered moon of a hypothetical, Jupiter-like exoplanet.

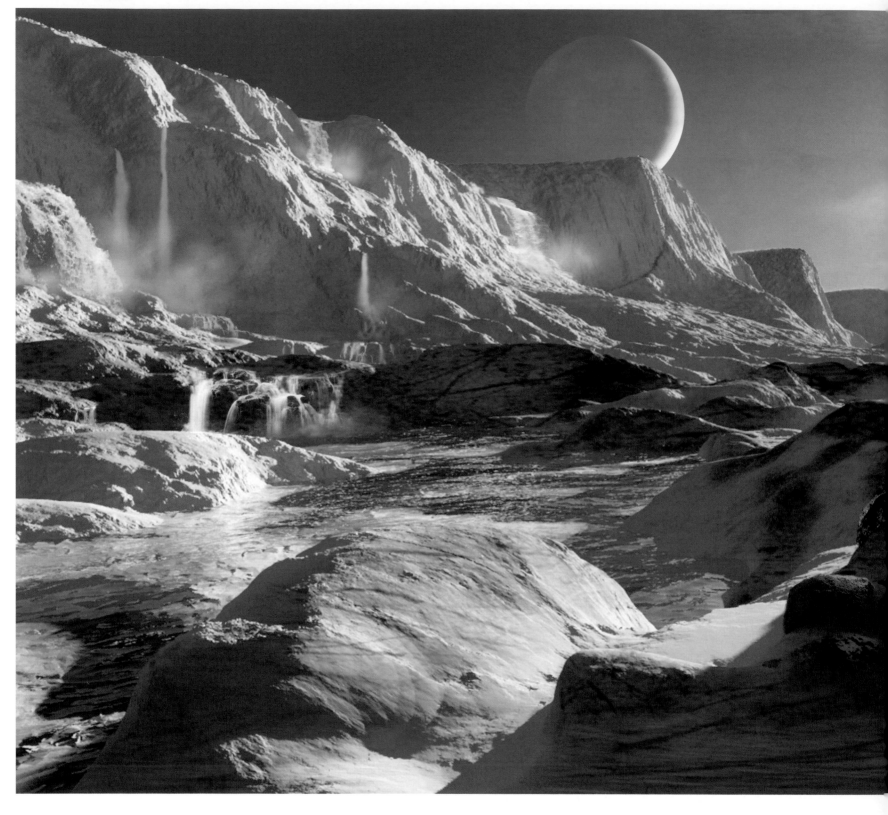

ABOVE: For this digital composition, Ron Miller has chosen a partially hypothetical subject. Beta Hydri is a highly luminous star that may have at least one giant planet. Here the artist presents a scene set on an icy moon of the planet, which can be seen hovering in the sky above the glaciers. Since the star may be in the early stages of expanding into a red giant, the increased output of heat is shown thawing the surface of the frozen moon.

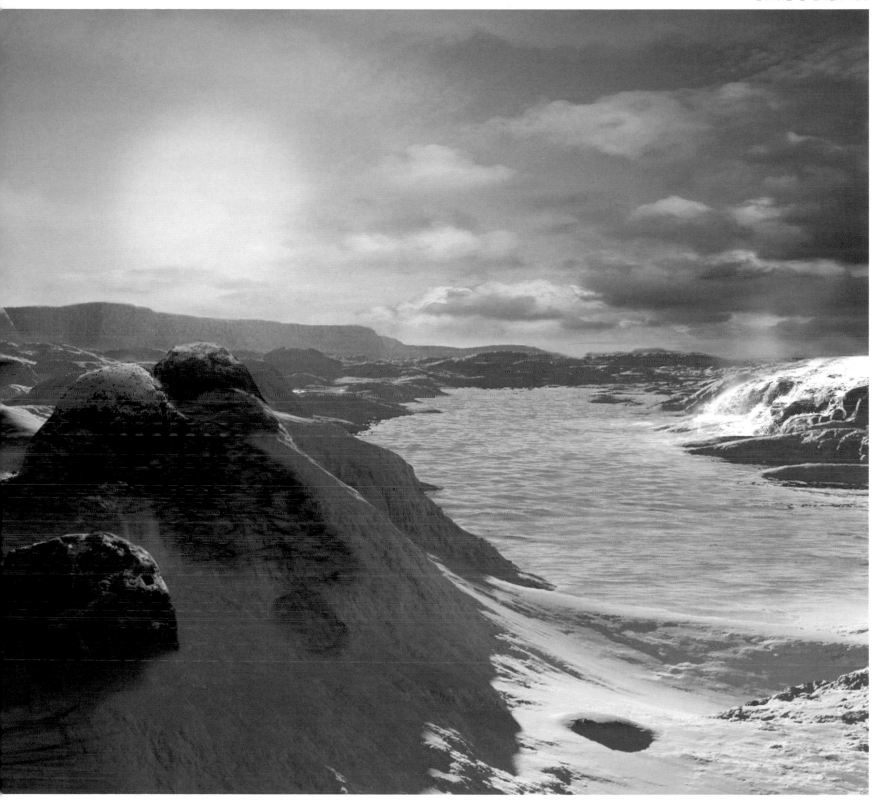

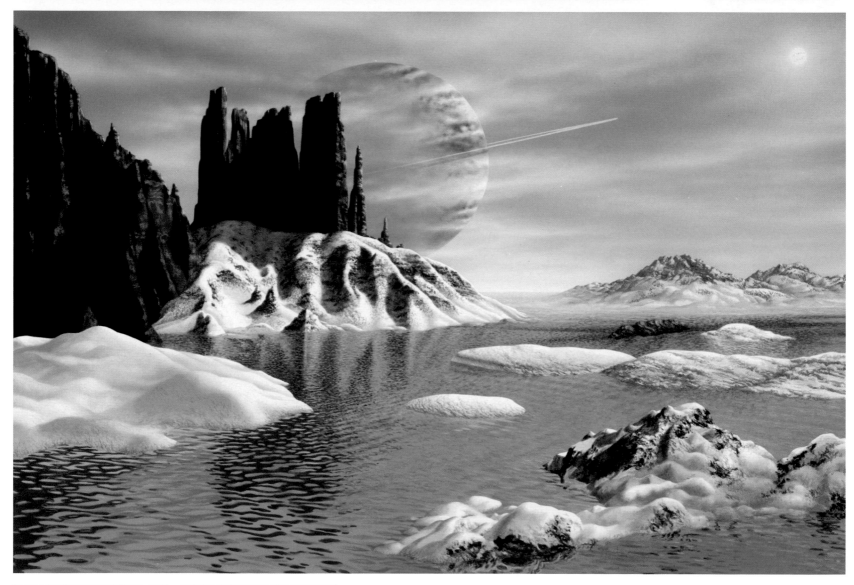

TOP: Dirk Terrell's *The Calm Before the Storm* illustrates a scene on an earthlike planet orbiting in a triple star system. Terrell is an astrophysicist with the Southwest Research Institute in Boulder, Colorado, whose work often deals with multiple star systems and extrasolar planets.

BOTTOM: Lynette Cook places us on a frigid moon of HD222582 b, an exoplanet with a highly eccentric orbit around its star that draws it as near as Mercury is to the sun, and then takes it farther away than Mars. This results in alternating periods of intense heat and bitter cold.

ABOVE: Tau Ceti e is an earthlike world almost twice the size of our planet. It orbits in the "Goldilocks zone" of its star, where temperatures would be conducive to liquid water and possibly life. In this work, artist Ron Miller imagines the Tau Ceti system to be a young one, so the sky is filled with comets, the leftover material from the formation of the planets.

THE SWIRLIES' COSMOS:
SPIRITUALITY IN SPACE

IN THE FIELD OF SPACE ART, THERE IS MORE TO DEPICTING THE UNIVERSE THAN PAINTING REALISTIC LANDSCAPES OF MOONS AND PLANETS. THERE IS ALSO THE EFFECT THESE PLACES HAVE ON THE HUMAN MIND AND PSYCHE.

It is one thing, for instance, to show what the Valles Marineris canyon system on Mars looks like, but it is an entirely different problem to try to illustrate the emotional or philosophical reaction to seeing such a place. Space artists who have embraced this approach see themselves—and humanity—as part of the universe around them, rather than mere spectators. Their goal is to try to express something of this relationship.

OPPOSING VIEWS

Some space artists exploring these more abstract realms make use of romantic images—the human figure is more likely to appear in their art—while others use the symbols of mythology and religion. Unlike "rock and ball" space art, a term used to describe the meticulously detailed space artists of the Chesley Bonestell school of realism, there may be outright abstractionism. This approach has provided Rock and Ball artists with their own term for the symbolists: they are the "swirly" painters.

The "Swirlies" approach the cosmos as philosophers, expressing ideas of humanity's relationship with the planets and stars. These artists try to record a more personal experience than a literal documentation of reality—to go beyond the realistic to evoke a sense of the philosophical, romantic, emotional, and spiritual aspects of the universe. "The artist," wrote Russian space artist Andrei Sokolov, "has a human response to the environment, in particular to that part of it which we have explored or transformed with our own minds and hands."

In order to share these impalpable concepts, the Swirlies employ every technique available. Through the use of color, shapes, textures, and symbols, they hope their viewers will experience the moods, ideas, and emotions generated by this contemplation of the universe. Or, perhaps, to convey some of the sensuality of the universe: not only what it looks like, but what it feels like. "The artist," writes Togrul Narimanbekov, "is part and parcel of nature… Artistic integrity is inherent in space. Scientists may not have yet seen it, but that only means that they should look for it."

LOST IN SPACE

Unlike the traditional space artists, whose view of the universe is almost universally positive and optimistic, the Swirlies are as likely to depict the darker side of space exploration as they are a sense of wonder.

"IN OUTER SPACE, MAN MUST ACQUIRE NEW WAYS OF THINKING, NEW VISION, NEW SENSATION, AND, IN MANY WAYS, NEW PSYCHOLOGY."
Andrei Sokolov

A powerful painting by the late Russian painter Josef Minsky depicts a lone cosmonaut sitting on a bench, his space helmet next to him, evidently lost in contemplation as he waits to be called to board his spacecraft. Is he thinking that space exploration is no longer romantic, but simply another tiring and everyday job that must be done? Or is he like cosmonaut Valery Ryumin, who felt "that I am leaving the planet forever. And there is no power that could bring me back"? One thing is for sure: as long as humankind continues to explore the furthest reaches of the universe, expanding the breadth of our collected knowledge, then space artists such as Minksy will continue to pose searching philosophical questions.

OPPOSITE TOP: In *Origins*, artist Lucy West explores the beginnings of life. "Since humanity first stepped out of the African savannas," she explains, "we have searched to understand our place and purpose in our world and universe." In this painting, shadowy figures march across a bridge from the sun to the earth—an evocative reminder that human DNA, and thus all human life itself, is essentially recycled star-stuff.

OPPOSITE BOTTOM: Ludek Pesek, one of the seminal space artists of the hard-science school, was equally interested in the intellectual, philosophical, and spiritual impact of the universe. He created a large number of paintings in which he explored these themes, such as this quietly evocative image of a cathedral that appears to have formed naturally in the midst of a lunar crater.

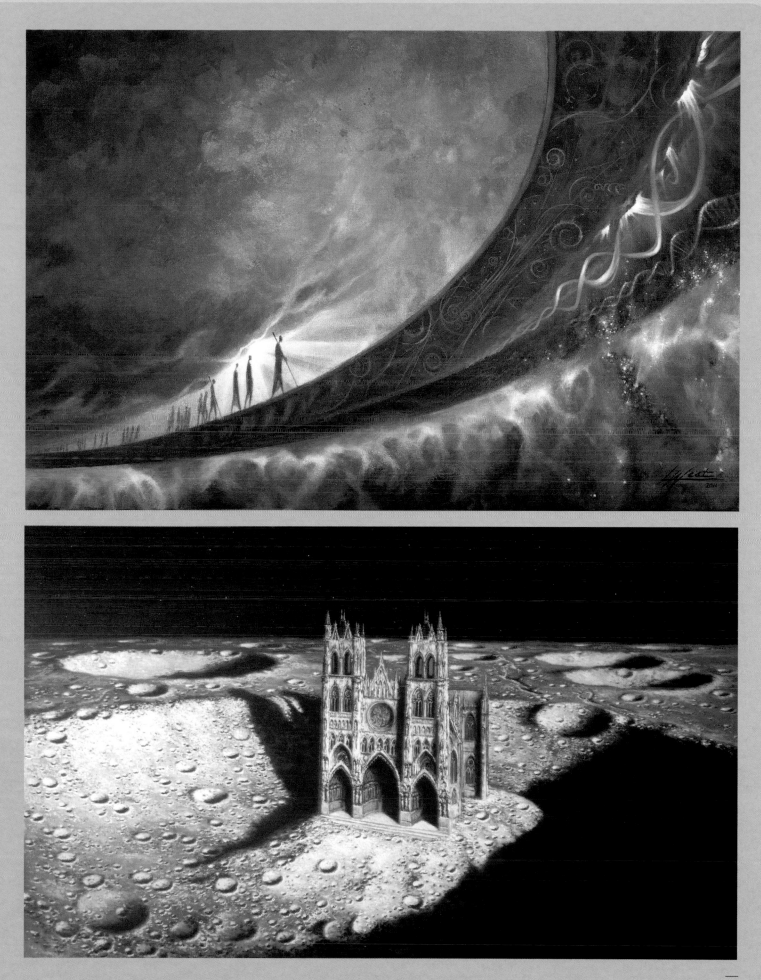

ABOVE LEFT: *Model Worlds* was one of 12 illustrations by Lynette Cook produced for the paperback version of Dava Sobel's *The Planets*. Juxtaposing the author's childhood diorama of the solar system with subsequently discovered planet and moons on the wallpaper and a potential earthlike planet in the window, Cook brings together past, present, and future.

TOP RIGHT: Mark Garlick's *Origins* is a subtle reminder not only of the genesis of the earth in an ancient, vast cloud of cosmic dust and gas, but of its fragility as well as its connection with life.

BOTTOM RIGHT: Like many Russian space artists, Josef Minsky (1947–1994) focuses on the human experience of space exploration. In *Oh God, How Tired I Am*, he deglamorizes space travel in a moody painting of a weary cosmonaut—suggesting that for some, space exploration is no longer romantic but simply part of the job.

TOP LEFT: In *Naomi's Galaxy*, artist Matthew Stricker transforms a spiral galaxy into swirls of energy, the repeated, pulsing waves making the viewer almost aware of the *sound* of the galaxy as it ponderously spins its way through the universe.

BOTTOM LEFT: Self-taught artist and poet Gennady Golobkov (1935–1978) epitomized the Russian preoccupation with exploring the psychological and philosophical impact of space exploration. But where many of his fellow Soviet artists depicted brave cosmonauts triumphing over the universe, Golobkov more often depicted humans living in relative harmony with the cosmos.

TOP RIGHT: British artist Chris Williams uses traditional materials such as wood to convey abstract ideas and concepts about the universe in the form of three-dimensional sculptures. *Orrery*, in which the orbits of the planets are represented by graceful ellipses, is on display at the Herschel Museum of Astronomy in Bath.

BOTTOM RIGHT: In *Star Absorption*, Chris Williams symbolizes first the distortion in space-time created by a super-massive object like a black hole and, secondly, an unhappy star being inexorably drawn to its doom.

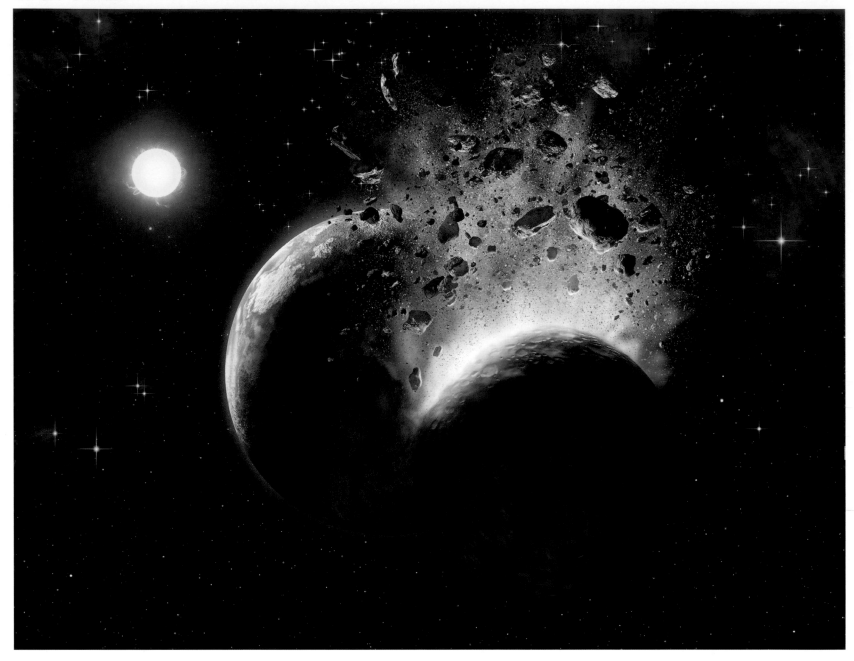

ABOVE: In *Planet Collision in the Pleiades*, Lynette Cook depicts what may be an all-too-common event in the universe. A large amount of dust found orbiting the star HD 23514 in the Pleiades star cluster may well be the result of the disastrous collision of two earth-sized planets.

OPPOSITE TOP: COROT 7b is an exoplanet one and a half times the size of earth that orbits its star 23 times closer than Mercury orbits the sun. The result is that the surface of the planet is heated to nearly 9000°F (4982°C). As shown here by artist Ron Miller, the planet's surface is a sea of molten rock.

OPPOSITE, BOTTOM LEFT: Kepler 70b and 70c were once a single giant gas planet orbiting barely half a million miles (800,000 kilometers) above the surface of their star. At some point the planet was ripped in two by powerful tidal forces, so now there are two planets orbiting at the same distance from the star. This titanic event is illustrated by Ron Miller.

OPPOSITE, BOTTOM RIGHT: Here, artist Ron Miller depicts the star system nearest our own. It is a triple system consisting of the sunlike Alpha Centauri B, which we see rising above a planet, and its near-twin Alpha Centauri B, the bright star to the upper right. The third star in the system, Proxima Centauri, is not visible.

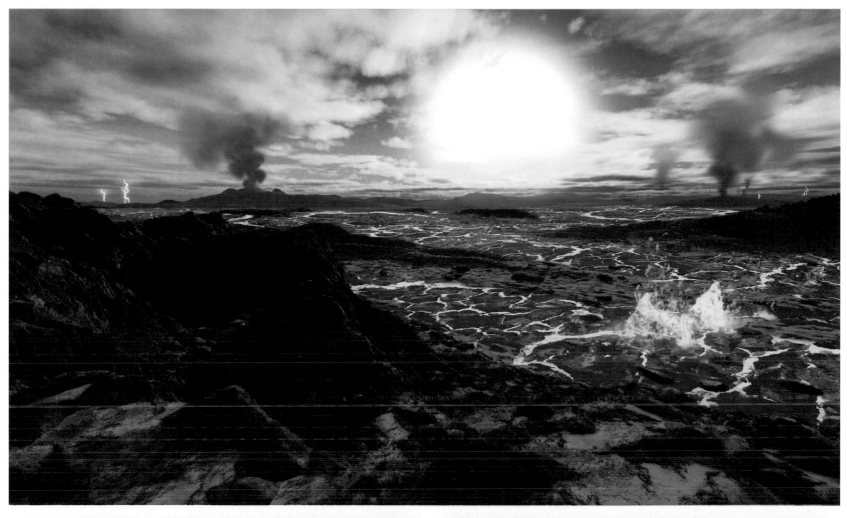

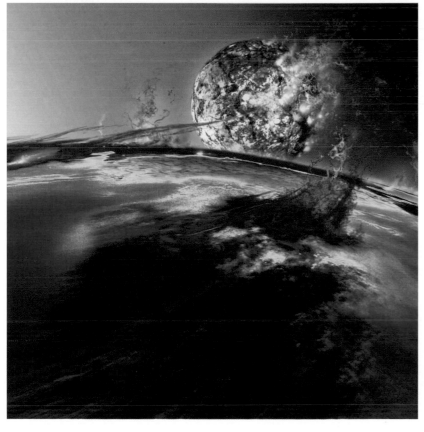

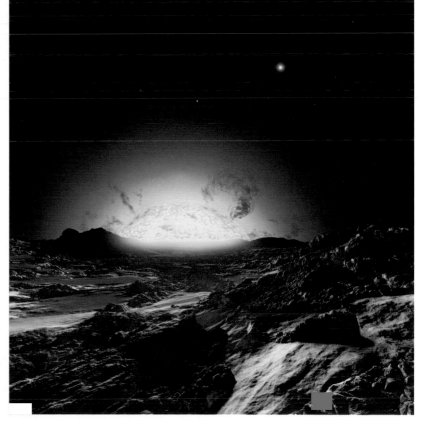

PREVIOUS SPREAD: Upsilon Andromedae b is a super-Jupiter orbiting so close to its star that the side of the planet facing it is heated to a temperature of as high as 3000°F (1649°C). The side facing away from the star, however, is as cold as -380°F (-229°C). The temperature difference is the cause of the tremendous storms that rage across the planet, as seen in this work by Ron Miller.

ABOVE: PSR 1257+12 is a pulsar that has four planets orbiting it. The first three, shown in this painting by Lynette Cook, were the first confirmed exoplanets ever to be discovered. The radiation from the distant pulsar sweeps over the foreground planet like the beam from a lighthouse, energizing its atmosphere and causing spectacular auroral displays.

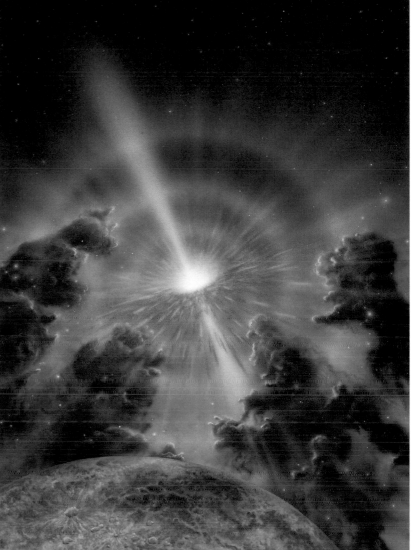

ABOVE LEFT: Quasars are highly energetic galaxies that are among the most luminous objects in the universe. In this painting by Lynette Cook, the core of one of these active galaxies emits jets of hot gas at nearly the speed of light.

ABOVE RIGHT: Here artist Lynette Cook depicts a gamma ray burst. Scientists are unsure what causes these tremendous bursts of energy, but it is possible that one could have been responsible for one of the major extinctions of life to have occurred on earth.

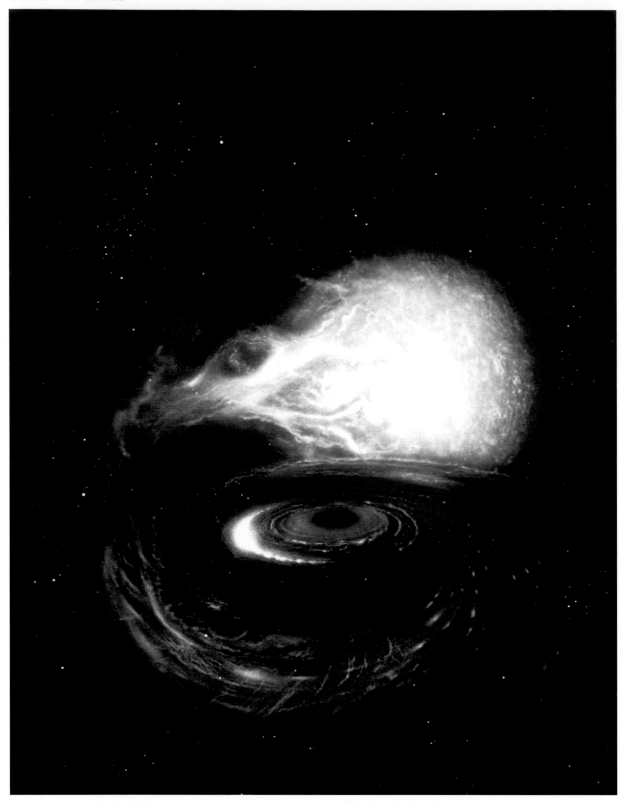

ABOVE: The star in this dramatic Don Dixon painting is doomed, its matter swirling into the vicious whirlpool of energy surrounding a voracious black hole that will eventually devour the star entirely.

OPPOSITE: This artwork by Ron Miller illustrates one scientist's conception of what might be seen within the event horizon of a massive black hole, such as the one that exists at the center of our galaxy. To ensure an accurate depiction, Miller worked from a computer-generated re-creation of the black hole provided to him by the scientist.

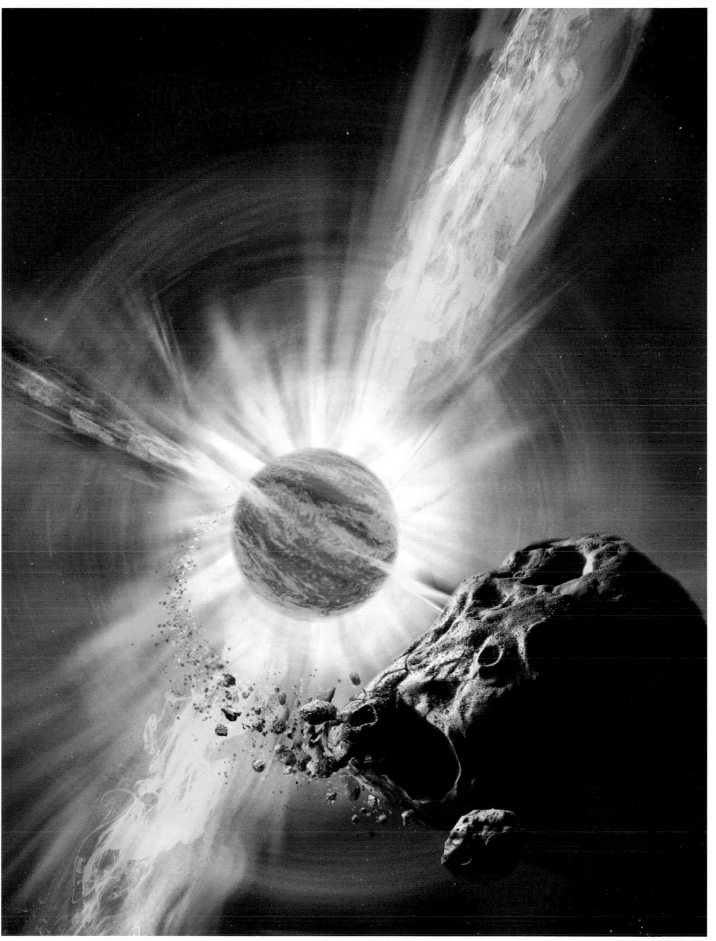

British interplanetary society

IN 1939, THE BRITISH INTERPLANETARY SOCIETY (BIS) CONCLUDED A TWO-YEAR STUDY OF A MANNED MOON LANDING. IT WAS THE FIRST TIME IN HISTORY THAT A GROUP OF ENGINEERS AND SCIENTISTS HAD EVER SAT DOWN AND DESIGNED A REALISTIC MANNED SPACECRAFT. THE RESULT WAS A SPACESHIP OF A RADICAL NEW DESIGN, COMPLETELY DIFFERENT THAN ANYTHING PREVIOUSLY SUGGESTED.

Although the Apollo lunar landing program would not take place for another quarter of a century, the BIS scheme turned out to be uncannily similar. A key member of the group was an engineer-artist named R. A. Smith (1905–1959)—a man who, like Chesley Bonestell, became one of the few space artists who helped create the future they painted.

THE ENGINEER-ARTIST

Ralph Andrew Smith's renderings of spacecrafts were the result of long hours spent calculating engineering details; he was always reluctant to produce a drawing that depicted an unreasonable possibility. Unlike Chesley Bonestell, however, Smith rarely painted an astronautical scene unless specifically requested to, and of his 100 space drawings and paintings, almost all were created on commission.

Smith was a member of BIS from its inception in 1933. He became its organizing secretary and chief designer, as well as a member of the Council, Technical Committee, and Experimental Committee. It was Smith who laid the solid engineering foundation for the BIS moonship.

LUNAR LANDER

The BIS lunar lander was to be a gumdrop-shaped vehicle bearing a very strong resemblance to the *Apollo Lunar Excursion Module*. It was 11 feet tall (3.4 meters) and 13 ½ feet (4.1 meters) in diameter. The remainder of the 105-foot (32-meter) ship consisted of clusters of solid fuel rockets. A ceramic dome protected the plastic shell of the cabin during takeoff and the cabin contained three form-fitting couches, a catwalk around the perimeter (parallel to the rotational axis), as well as four windows looking forward, 12 around the circumference, and six in the floor, in addition to "coelostats" that provided a steady view of the heavens while the cabin rotated. A young member of the society named Arthur C. Clarke contributed to its design.

Provisions for the crew's well-being were considered. Enough food for 20 days would be carried, as well as air and water. A repair kit and medicine chest would be included—with "a little alcohol which might be raided to celebrate the lunar landing." To save weight, there would be only one cup, plate, knife, fork, and spoon to be shared among the three astronauts. All power for cooking and

lighting would be provided by storage batteries. Clothing was to be made of a fabric with a high silk content, including a tight-fitting elastic garment for the purpose of controlling blood pressure. Instruments included almanacs, mathematical tables, balsa-encased pencils and rice paper, range finders, telescopes, sextants, chronometers, and motion picture and still cameras. A deck of playing cards provided the only entertainment.

> "MANY OF [SMITH'S] PICTURES WERE NOT COMMENCED UNTIL HE HAD SPENT A LONG WHILE PROVING BY CALCULATION THAT WHAT HE WOULD DRAW WAS A REASONABLE ENGINEERING POSSIBILITY."
> Bob Parkinson, *Interplanetary*, 2008

For the lunar landing, special shock-absorbing legs would extend from the base of the crew module. On the craft's eventual return to the earth, a parachute would provide the final descent. These plans mirrored the exact reality of the Apollo missions 30 years later—although admittedly the rocket and lunar lander were considerably updated after World War II to take advantage of postwar technologies. The most obvious result of these advances was the conversion of the booster to a single atomic-powered stage.

ORBITAL BASE

Smith also collaborated with fellow BIS member Harry Ross on a design for an "orbital base," a space station inspired by the 1928 proposal of Hermann Noordung. The BIS station consisted of three main parts: the "bowl," which was the 200-foot (61-meter) mirror of the solar power generator; the "bun," which was the manned section; and the "arm," which carried the communications antennae. In addition to living quarters and laboratories for the crew of 24, the station had a mess room, kitchen, surgery, recreation room, library, and two bathrooms.

Smith and Ross gave considerable thought to the details of constructing and provisioning the station, which was to be assembled from materials lifted into orbit by means of cargo-carrying spaceships. A similar process would be used to assemble the spacecraft for a manned flight to the moon. For this, Harry Ross and R. A. Smith described an orbital rendezvous technique that was utilized by NASA's Apollo program 20 years later.

ABOVE: R. A. Smith was the leading British space artist from the 1930s through the early 1950s. Indelibly associated with the British Interplanetary Society, he was not only responsible for the consistent look of the BIS spacecrafts, he was instrumental in their design.

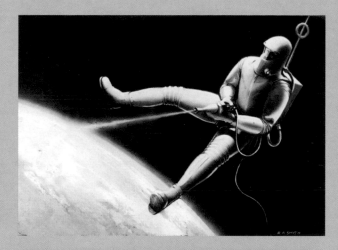

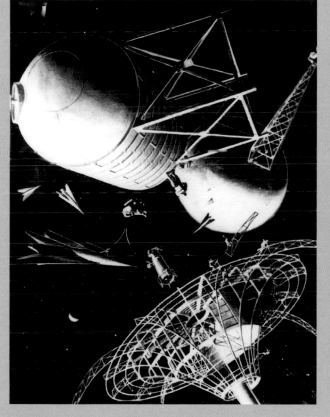

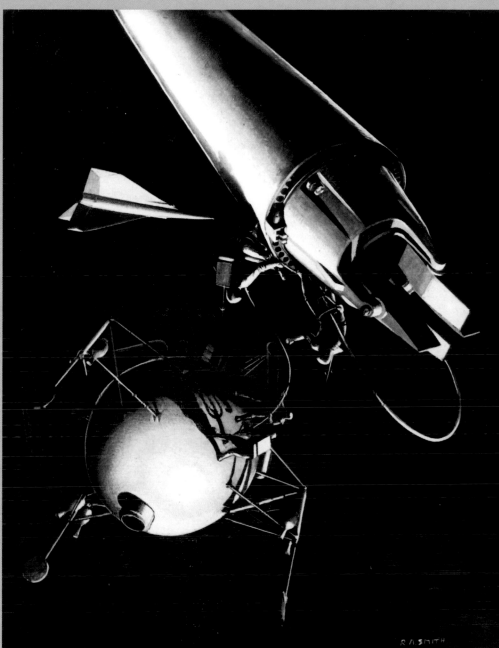

TOP LEFT: No details were left out of the grand scheme proposed by the BIS for the exploration of space. Even the design of the space suits required by the crews working in orbit or on the moon was carefully worked out. R. A. Smith shows here one of the BIS astronauts navigating with a portable rocket unit.

BOTTOM LEFT: One of the great accomplishments of the BIS was its carefully designed, incremental space program. It was one of the first organizations to develop a detailed design for a practical space station, here shown under construction in an illustration by R. A. Smith.

ABOVE RIGHT: One of the necessary steps in the BIS space program was the landing of a robotic probe on the moon in advance of a manned landing. Here R. A. Smith shows the probe being fueled from a tanker while a manned shuttle craft waits in the background.

ABOVE: Lynette Cook shows us our own galaxy, the Milky Way. From its center billow bubbles of hot gas. The Sagittarius dwarf galaxy streams around the Milky Way as the gravity of the larger galaxy pulls it apart. In the lower left are the two Magellanic Clouds.

OPPOSITE TOP: In *The Brush Strokes of Star Birth*, artist Lucy West depicts a nebula known as Sharpless 2-106, a star-forming region that stretches nearly two light-years across. In the middle is a newly born star, radiating so intensely that it has heated the surrounding gases to 18,000°F (9982°C), causing them to glow like brilliant auroras.

OPPOSITE BOTTOM: Matthew Stricker takes us to the very edge of reality in *Event Horizon*—that point of no return surrounding a black hole, beyond which the very laws of physics break down.

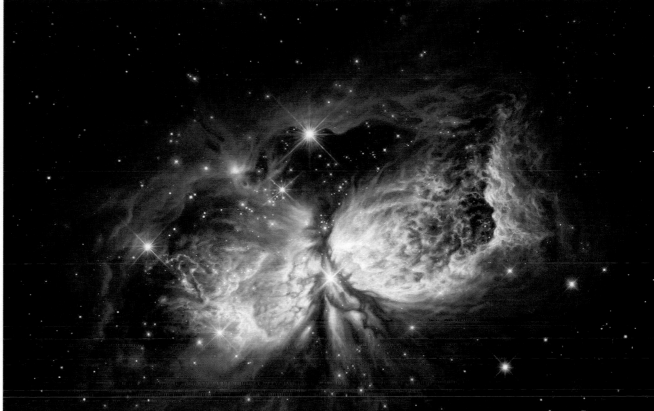

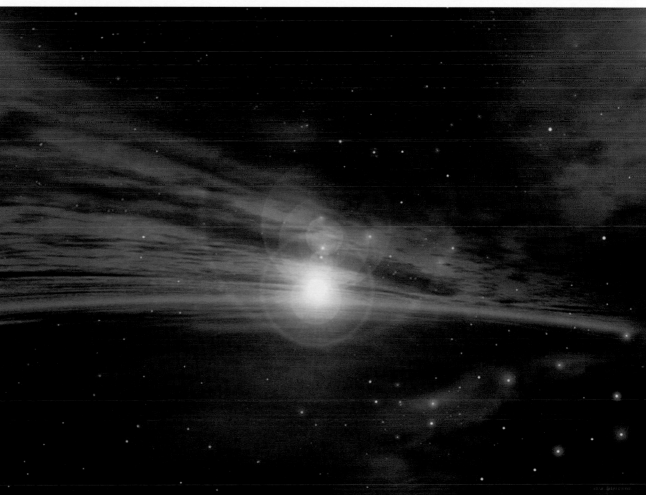

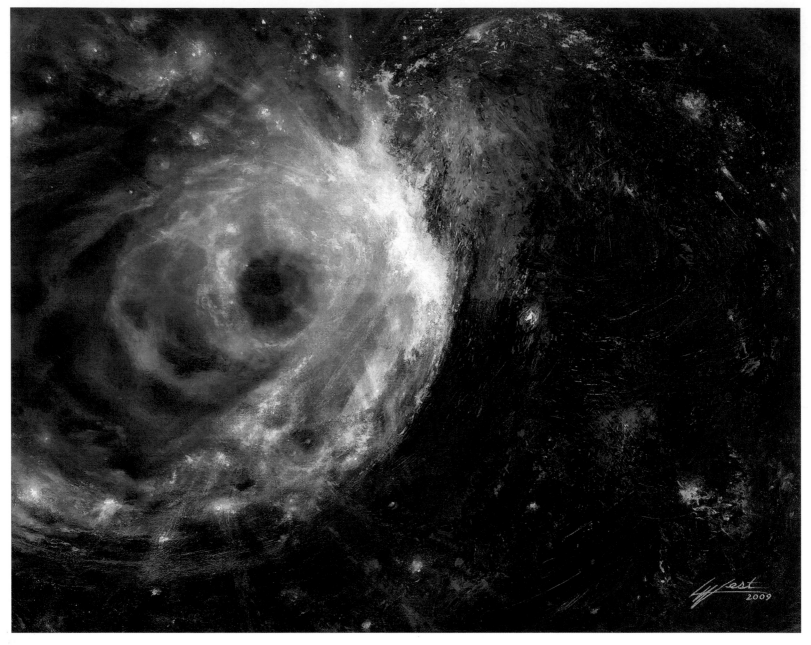

ABOVE: "*Shines the Nameless,*"
according to artist Lucy West, depicts
"compelling light tunnels through the
fabric of space and time, generating
a vibrant wave of cosmic creations."
It gracefully shows how such great
nebulae are in fact nurseries, where
stars are born as shock waves from
the explosions of dying stars.

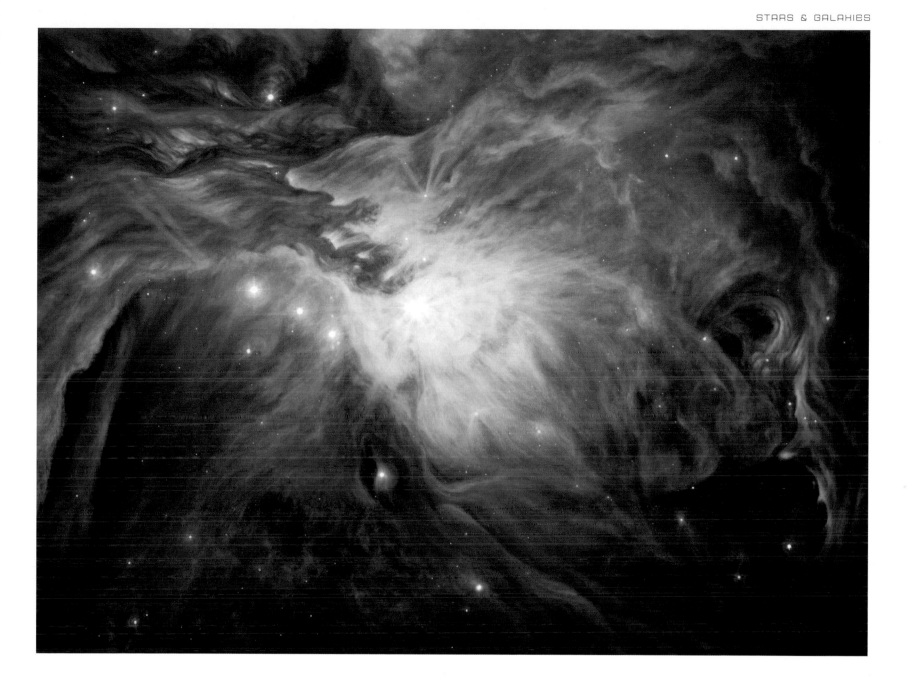

ABOVE: Lucy West was inspired by M42, the Great Nebula in Orion, one of the most beautiful sights in the night sky. Although the Great Nebula is easily visible through even a small telescope, it took the Hubble Space Telescope to reveal its full grandeur.

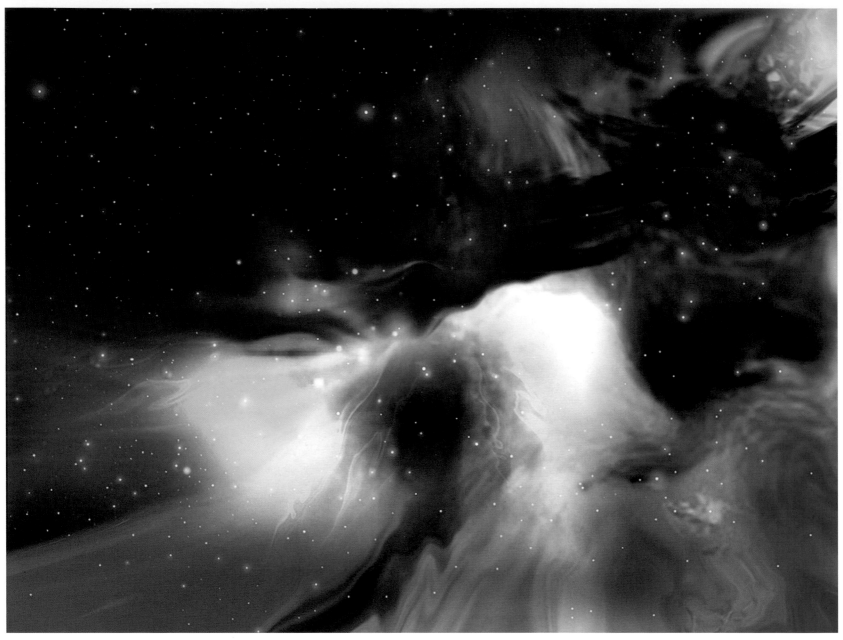

ABOVE: In *Sun-Nebula*, Matthew Stricker has created his impression of one of the great star-birthing nebula, similar to the Great Nebula in Orion. Here, the artist has imparted a sense of movement and vitality, communicating a feeling of this stellar creativity.

OPPOSITE: Artist Robin Hart employed various techniques to simulate the appearance of the Great Spiral Whirlpool Galaxy in fabric. Having created a design pattern of squares for background light and dark gases, she then used colored threads and appliqués to portray glowing gases and stars.

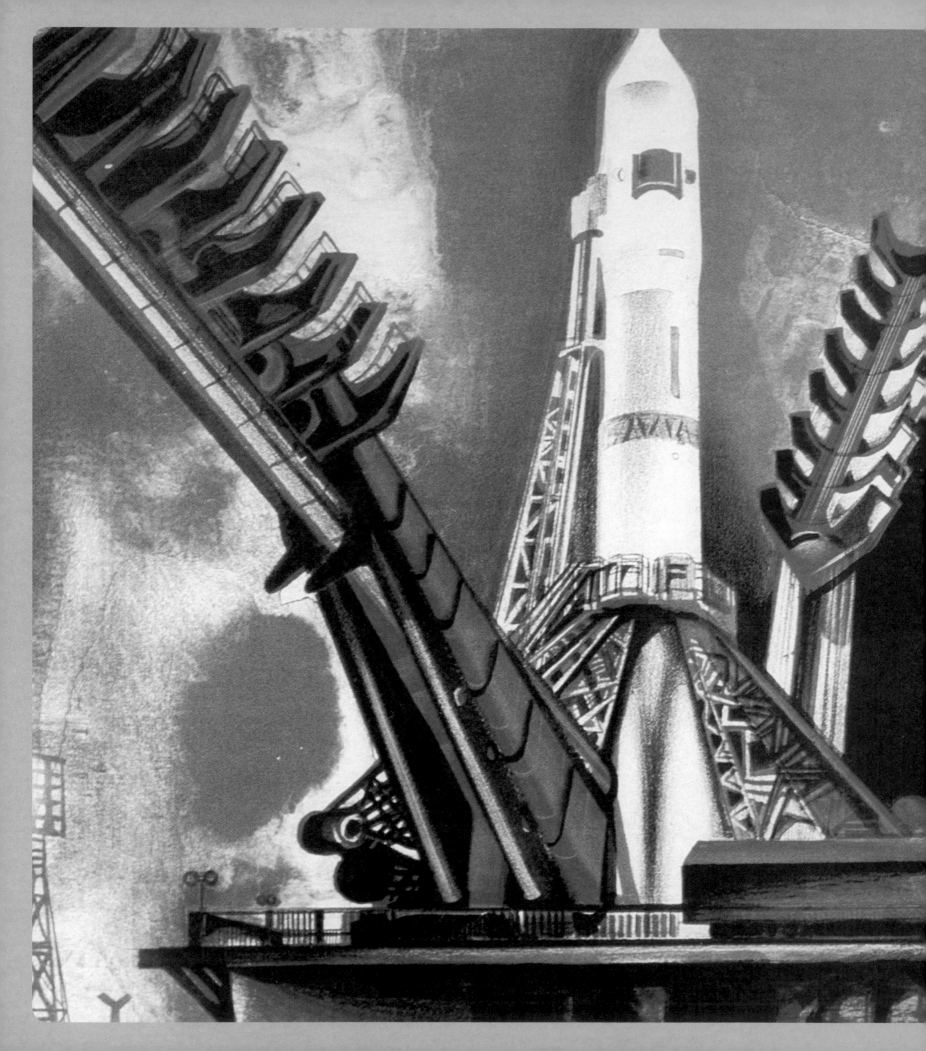

SPACESHIPS
& SPACE STATIONS

SPACESHIPS & SPACE STATIONS:
FROM EARTH TO ORBIT

FOR A MODERN INVENTION SYNONYMOUS WITH CUTTING-EDGE TECHNOLOGY, THE SPACESHIP HAS A SURPRISINGLY LONG PEDIGREE, ONE THAT GOES BACK MORE THAN 200 YEARS. FOR CENTURIES PEOPLE HAVE DREAMED OF TRAVELING TO THE MOON AND THE OTHER WORLDS IN OUR SOLAR SYSTEM.

For a long while, man's ambition to leave earth had to remain dreams: there was no realistic way to make such journeys, so authors fell back on fantasy and magic. But in 1783, an amazing new invention brought these dreams one step closer to reality: a hot-air balloon, the brainchild of pioneering brothers Joseph-Michel and Jacques-Étienne Montgolfier. For the first time in history a human being could rise higher into the sky than the distance they could jump. And it had been accomplished not by magic or occult means, but by the use of a man-made machine, a device of science. If it were possible for a human being to lift himself half a mile (805 meters) from the surface of the earth, then surely a flight to the moon was merely a matter of scale?

As the nineteenth century progressed, popular literature reflected the growing belief that science and engineering could make the impossible possible. Inspired by advances in technology and exploration, Edgar Allan Poe introduced scientific verisimilitude into his stories. His novelette *The Unparalleled Adventure of One Hans Pfaall* (1835), in spite of its satirical comic overtones, was packed with realistic and well-researched details—so much so that his description of a high-altitude balloon flight sounds like one of the stratosphere balloon flights of the 1930s and 1950s. Poe was the first author since Johannes Kepler to take the scientific basis of a fictional story seriously, and consequently was a major influence on Jules Verne. The hardcore realism of Verne's classic space novels—*From the Earth to the Moon* and *Around the Moon*—influenced the development of astronautics more than any other author of fiction. The founding pioneers of spaceflight—such as Hermann Oberth, Konstantin Tsiolkovsky, and others—all admitted to owing their introduction to spaceflight to Jules Verne.

EARLY EXPERIMENTS
In the first decades of the twentieth century, the problem of spaceflight gradually evolved away from the purely speculative and theoretical, to be replaced by a more developmental approach. It was far simpler, cheaper, and safer to experiment with small-scale rockets than with full-size spaceships; it was realized very early on that the exploration of space would be a fabulously expensive and difficult proposition.

In 1903, the great Russian theoretician Konstantin Tsiolkovsky published the first of his spacecraft designs. It employed liquid fuel and gyroscopic stabilization, and in outward appearance his spaceship laid the groundwork for the modern spaceship to come. Twenty years later Hermann Oberth published his seminal *Die Rakete zu den Planetenräumen* (The Rocket in Planetary Space), one of the theoretical cornerstones of modern spaceflight. In it he first proposed his "Model E," an enormous manned rocket that finally settled the outward form of the classic spaceship: a bullet-shaped hull standing erect on the tips of four fins. Oberth's spaceship formed the basis for the design of the spaceship *Friede* in Fritz Lang's 1929 motion picture *Frau im Mond* (Woman in the Moon), the first realistic spaceship in movie history.

During the 1920s and 1930s, three highly influential organizations were formed: the Verein für Raumschiffarht (or VfR, the German Society for Spaceship Travel), the American Interplanetary Society (later the American Rocket Society) and the British Interplanetary Society (BIS, the only one of the three to exist in more or less its original form today). The VfR launched the first European liquid fuel rockets and in 1939 the BIS published the results of the first-ever detailed scientific and engineering study for a manned lunar rocket and lander. Later, ex-members of the ARS formed the private companies that produced wartime rockets and JATO (Jet-Assisted Take Off) units for the United States military and, later, the propulsion systems for the first American rocket-propelled aircraft.

Meanwhile, amid all these technological developments, the legacy of the Montgolfier brothers survived. High-altitude balloonists were taking their "spaceships" to the limits of the earth's atmosphere (by the mid-1930s altitudes of 12 miles [19 kilometers] or more were being reached), and rocket-powered gliders and aircrafts were being built and piloted by Germans and Russians.

ROCKET POWER
When the first successful launch of the V2 took place in 1942, General Walter Dornberger saw the rocket soar to an altitude of 53 miles (85 kilometers). "Do you realize what we accomplished today?" he exclaimed. "Today the spaceship was born!" With the reality of the V2 and the practicality of manned rocket aircraft demonstrated, space travel was transported into the immediately foreseeable future.

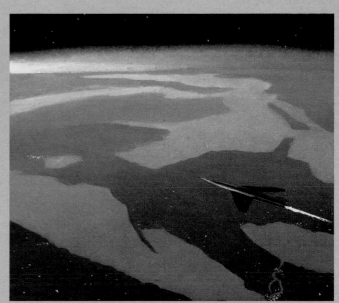

It is both difficult to imagine and to underestimate the influence of the V2. It was far larger than any other rocket ever built and it flew faster, higher, and farther. And it looked great, helping it to take hold of the public imagination. More than just a rocket, it was a potential spaceship: the popular science writer and expatriate German rocket experimenter Willy Ley pointed out that the ton of explosives the V2 carried could easily be replaced by a pilot and life-support equipment.

Science-fiction moviemakers were not slow to pick up on the public's burgeoning interest in space travel. George Pal's *Destination Moon* (1950) was a big-budget epic about the first rocket trip to the moon. Told with documentary-style realism, it was the first serious film about spaceflight since *Frau im Mond*. There were a handful of other space-inspired movies during that decade, but a peak was reached with the *Collier's* magazine-inspired spacecraft in George Pal's *Conquest of Space* (1955). The graceful toroidal space station, a delta-winged ferry rocket, space taxis, and the elegant Mars glider are all brought to the screen in color and with extraordinary realism.

All of the great spaceships that took humans to the moon, the *Space Shuttle*, and the spaceships that may take us to the planets and stars are all direct descendants of these early dreams and designs. Today's rockets have gotten bigger and more sophisticated, but they all share the same genes as Jules Verne's projectile and the V2.

SPACE STATIONS

The notion of actually *living* in space on an artificial satellite has a history that parallels but does not quite duplicate that of the spaceship. The idea might be attributed to Jonathan Swift. In *Gulliver's Travels* (1726) he described the flying island of Laputa. Where earlier writers would have resorted to magic or occultism, Swift, already under the early influence of a renaissance in science and technology, had his 4.5-mile-(7.2-kilometer)-diameter circular island kept aloft by "magnetic levitation."

However, while Laputa hovered permanently above the earth's surface, it wasn't a true space station. That idea wasn't invented for another 150 years. In "The Brick Moon" (1869), American clergyman and author Edward Everett Hale became the first to

describe an artificial earth satellite. Hale not only foresaw the space station, but its use as an aid to navigation, geodetics, mapping, reconnaissance, communications, sea surveillance, bioscience, meteorology, human habitation, and orbital rendezvous.

The first serious attempt at designing a realistic space station was made by Hermann Potočnik (writing as Hermann Noordung). In 1929, he described an orbiting laboratory that anticipated almost every detail of today's space stations. When his design appeared for the first time in English, it was accompanied by a painting by the ubiquitous Frank R. Paul—the first time a space station had ever been depicted in a color illustration.

Noordung's design was adapted and improved a decade later by the British Interplanetary Society, and illustrated by their own R. A. Smith—an engineer-artist who also contributed to the final design (see pages 90–91). This space station ultimately led to one of the most beautiful, if not iconic, of all space station designs: the great wheel of Wernher von Braun. Taking the ideas of Noordung and the BIS to an entirely different level of scale, von Braun's rotating, 200-foot-(61-meter)-diameter station would have been home to 100 men and women, orbiting 1,075 miles (1,730 kilometers) above the earth. Von Braun's concept was the direct inspiration for the giant double-wheeled station featured in *2001: A Space Odyssey* (1968), directed by Stanley Kubrick.

By the 1960s, NASA and the aerospace industry had begun taking the idea of a space station seriously and dozens of plans were proposed. The first real space station to orbit the earth was the Russian *Salyut 1*, launched in 1971. This was soon followed by the American *Skylab*, the Russian *Mir*, and, ultimately, the International Space Station.

Today, there are few plans for space stations as science labs. The next great era in space stations will more likely be in tourism, as space travel becomes ever more commercialized. Civilian tourists have already spent time at the International Space Station while *SpaceShipOne*, the prototype for the first commercial, passenger-carrying spacecraft, was test-flown in 2004.

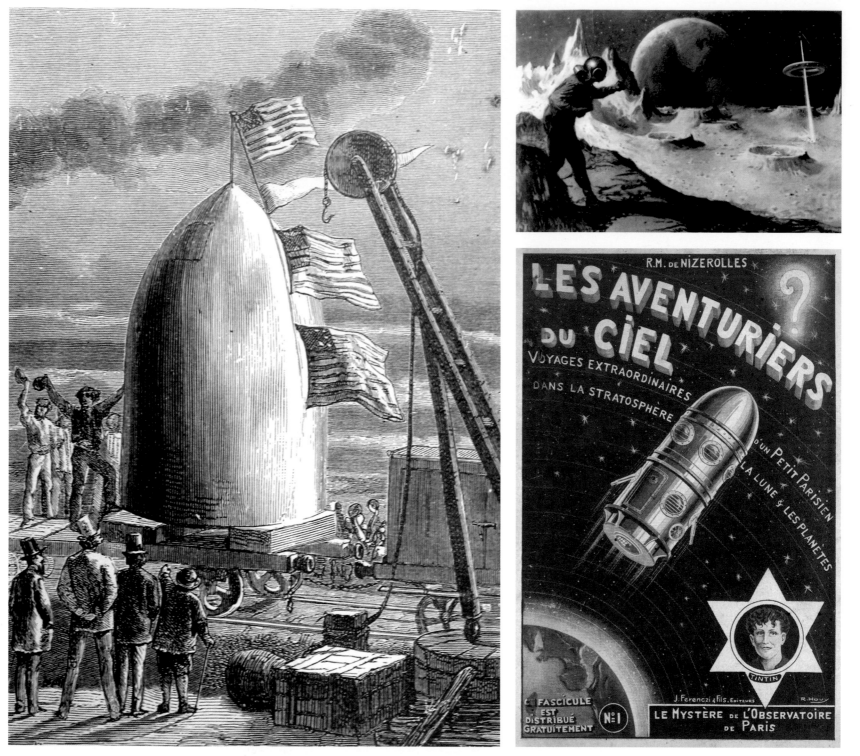

ABOVE LEFT: Henri de Montaut's illustration of Jules Verne's lunar projectile underscores the many uncanny resemblances the story has to the Apollo program of the 1960s. Not only is the projectile nearly the same size as the *Apollo Command Module*, it is made of aluminum and was launched from Florida, not far from Cape Canaveral.

TOP RIGHT: An illustration by George Gibbs for *The Moon-Maker*, a novel written in 1915 about a nuclear-powered spacecraft sent on a mission to intercept an earthbound asteroid. Here we see the heroine, Rhoda Gibbs, making a frantic dash for the spaceship *Flying Ring* before her oxygen runs out.

BOTTOM RIGHT: Marcel Priollet, writing as René Marcel Nizerolles, wrote a long series of pulp magazines about the adventures of a young Parisian named Tintin (no relation to the more famous Hergé character). These included a voyage to the stratosphere, moon, and planets in a story stretching across 108 booklets.

TOP LEFT: The onset of the 1950s saw the publication of hundreds of popular books about space travel, in large part aimed at younger readers. The *Authentic Book of Space*, published in England, was one of these. It boasted not only thrilling fictional space adventures but factual articles written by noted authorities and celebrated writers such as Arthur C. Clarke, Forrest J. Ackerman, and William F. Temple.

BOTTOM LEFT: *The Girl in the Moon* also known as *Woman in the Moon* (1929) was the first feature-length space movie to pay attention to scientific accuracy. Director Fritz Lang even went to the length of having rocket expert Hermann Oberth design the spaceship for the film. The screenplay, written by Lang's wife Thea von Harbou, was quickly novelized and published in several international editions.

ABOVE RIGHT: Since R. A. Smith usually worked in black and white, artist Leslie Carr re-created many of his paintings in color. In this illustration from 1954, we see a future launch site somewhere on the equator, with a manned shuttle rocket in the foreground and two robot tankers.

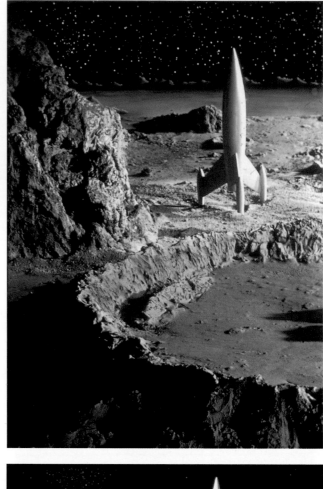

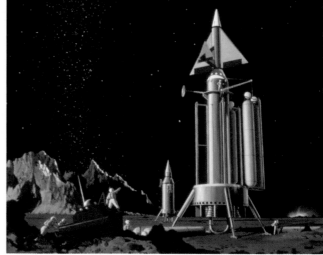

TOP & BOTTOM LEFT: In the early 1980s, Dutch artist Frans Roetman was inspired by automobile parts to create these whimsical etchings of a lunar rover and a space probe, which resemble the surrealistic, anthropomorphic machines of Boris Artzybasheff.

TOP RIGHT: Morris Scott Dollens (1920–1994) was one of the most prolific of all the space artists, though he was rarely published professionally. In the early 1960s, he created a series of elaborate three-dimensional tableaux to help promote his documentary film *Dream of the Stars*, which unfortunately was never produced.

BOTTOM RIGHT: This lunar lander was designed and illustrated by Chesley Bonestell for *Man and the Moon*, a 1961 book written by astronomer Robert Richardson. Many of the paintings in this book were also used as preproduction art for the 1959–1960 American TV series, *Men in Space*.

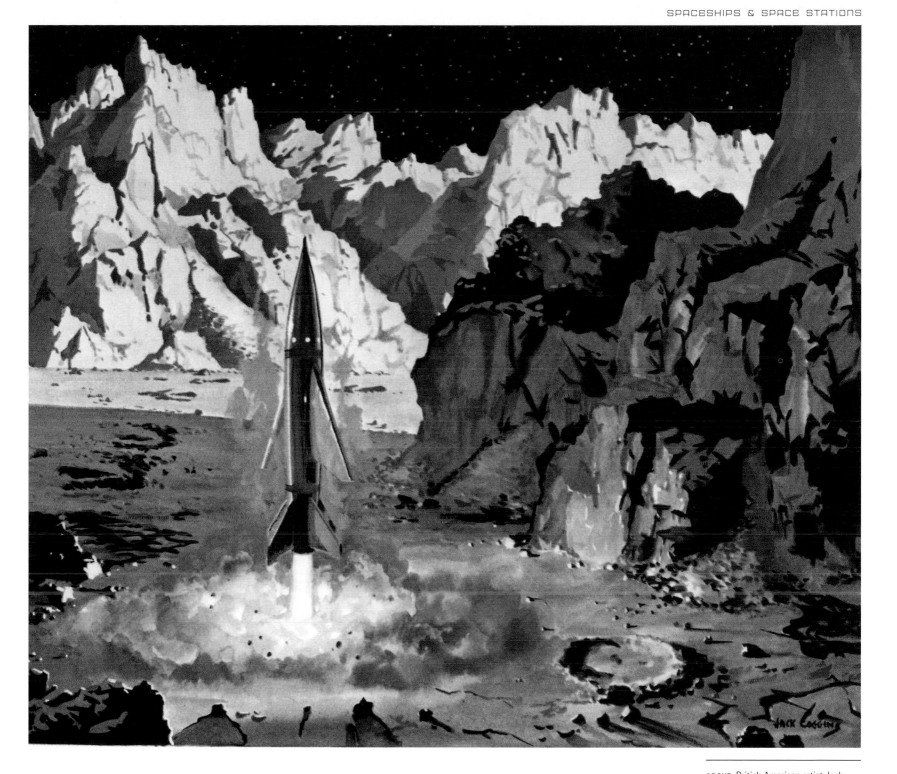

ABOVE: British American artist Jack Coggins was one of the major figures in space art during the 1950s. His boldly rendered watercolors brought a sense of everyday reality to the spacecrafts he illustrated. Of the books he illustrated, two—*By Space Ship to the Moon* and *Rockets, Jets, Guided Missiles and Spaceships*—are considered classics. The painting above now hangs in the National Air and Space Museum in Washington, DC.

RIGHT: Created by illustrator Frank Hampson, *Dan Dare* was an immensely popular British comic strip whose hero was the chief pilot of the Interplanet Space Fleet. First published in *Eagle* magazine on April 14, 1950, it ran throughout the 1950s and 1960s and sporadically up to the present time.

PAT RAWLINGS:
PICTURING OUR FUTURE

PAT RAWLINGS HAS BEEN DOCUMENTING THE FUTURE OF SPACE EXPLORATION FOR MORE THAN 30 YEARS. HIS PAINTINGS DEPICTING HUMAN AND ROBOTIC EXPLORATION PROVIDE A CHRONOLOGY OF THE PLANS, HOPES, AND DESIRES OF THE PLANET'S BEST SPACE VISIONARIES, RANGING FROM ROBOTIC PLANETARY MISSIONS TO THE HUMAN EXPLORATION OF MARS AND BEYOND.

Rawlings's paintings have appeared in hundreds of magazines, books, television programs, and films in both in the United States and abroad, as well as every NASA research center. He has recently created several large-format murals for commercial and government clients. The themes range from technically accurate space art to imaginative literary themes for public libraries.

EARLY INSPIRATIONS

"I have been creating space art since 1978," Rawlings says, "when I was recruited to work on *New Earths*, a book about terraforming by space expert Jim Oberg." His interest in space began even earlier, however, when he read the scientific adventures of teenage inventor Tom Swift. From there Rawlings graduated to the hard science fiction of writers like Robert Heinlein. Like many other space artists, he was fascinated by the work of Chesley Bonestell in books such as the classic *The Conquest of Space* (1949). "I was inspired by other science fiction and space artists, such as Bob McCall, Kelly Freas, Frank Frazetta, and Syd Mead, as well as more traditional artists like Maxfield Parrish and Norman Rockwell. To say nothing," Rawlings adds, "of many of my fellow IAAA artists!"

At the beginning of his career, Rawlings painted with traditional media. "I used acrylics with the occasional oil painting. I used to use mostly airbrush application of the paint with a little traditional brushwork. I gradually transitioned to mainly brushwork with only a bit of airbrush." Rawlings was one of the first major space artists to begin working with a computer. "About 20 years ago I began a transition to digital art," he explains, "and now I use a combination of digital stylus painting, 3D modeling, and photography to create very realistic scenes."

> "I MOST ENJOY PAINTINGS OF HUMAN SPACE EXPLORATION. IT ENABLES THE VIEWER TO BE A VICARIOUS EXPLORER."
> Pat Rawlings

ROMANCE AND DRAMA

To ensure scientific and technical accuracy in his compositions, Rawlings consults closely with astronauts and experts in spacecraft design, mission design, mission operations, planetary geology, meteorology, and other related fields. The resulting photorealistic images give the viewer a sense of "being there."

Like many of his colleagues, Rawlings has mixed feelings about the photographs being sent back to earth by probes and rovers. "They have certainly impacted the textures and situations that I depict. And they have also proven that it is pretty hard to take an ugly picture of things in space. But I think photography has tended to make space art more naturalistic and less romantic. I think space artists need to work hard to maintain the romance and drama of space."

Rawlings certainly has not lost the sense of wonder that space inspires. "It makes where we are seem so insignificant. Inspiring, too, is the thought of pushing beyond the boundaries where humans have been or what we have seen."

Despite a long and successful career, Rawlings still harbors unfulfilled ambitions. "I would like to do a graphic novel," he says. "I did a short comic book for NASA and thoroughly enjoyed the process of writing, drawing, inking, coloring, and lettering the work. I had hundreds of comics as a kid!"

ABOVE: Pat Rawlings's illustrations of space hardware are among the most recognizable and respected in the world. In a career spanning over 30 years, Rawlings has presented the world with a credible, consistent view of the future exploration of the moon, Mars, and the solar system.

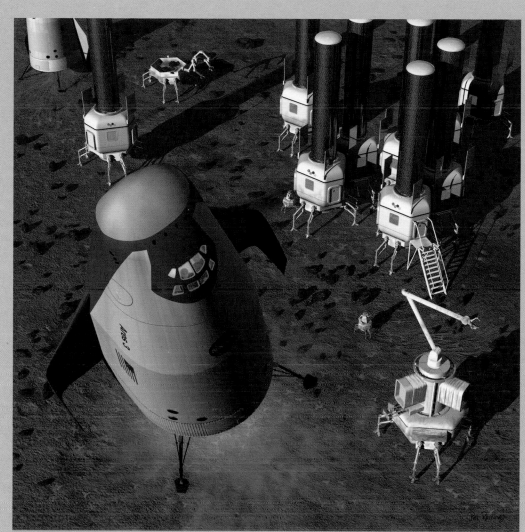

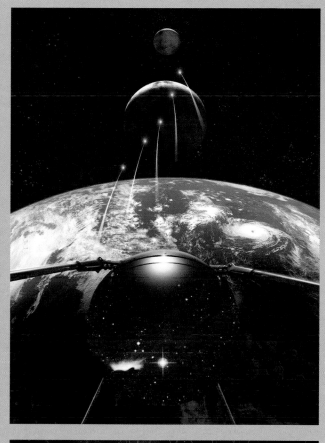

TOP LEFT: Here, Pat Rawlings illustrates the idea of automatic "hab-bots" that might be sent to Mars ahead of human explorers. These would consist of systems that would enable the individual mobile habitat modules to interlock, creating a ready-made, fully functional habitation awaiting the eventual arrival of the astronauts.

BOTTOM LEFT: The space elevator is one of the most exciting concepts of the past few decades. The idea is that a geosynchronous satellite—which remains always above one point on the earth's surface—could be linked to the earth by a permanent cable. Electrically propelled cars could travel up and down this cable, transporting people and material into space at very low cost.

BOTTOM MIDDLE: *Inn Space* depicts an orbital hotel with attached entertainment, office, and research facilities. Artist Rawlings says that space "might be the next great travel destination of the new millennium."

TOP RIGHT: Created in 2007 to celebrate the 50th anniversary of the launch of *Sputnik*, this painting symbolizes the Russian satellite—the first to ever orbit the earth—as a link in the human exploration of the solar system and universe.

BOTTOM RIGHT: One of the dangers facing future interplanetary explorers is solar radiation. One way to combat this would be to surround the spacecraft with an electromagnetic shield. Here Rawlings shows such a ship with its donut-shaped crew's quarters surrounded by a ring-shaped, super-conducting electromagnet.

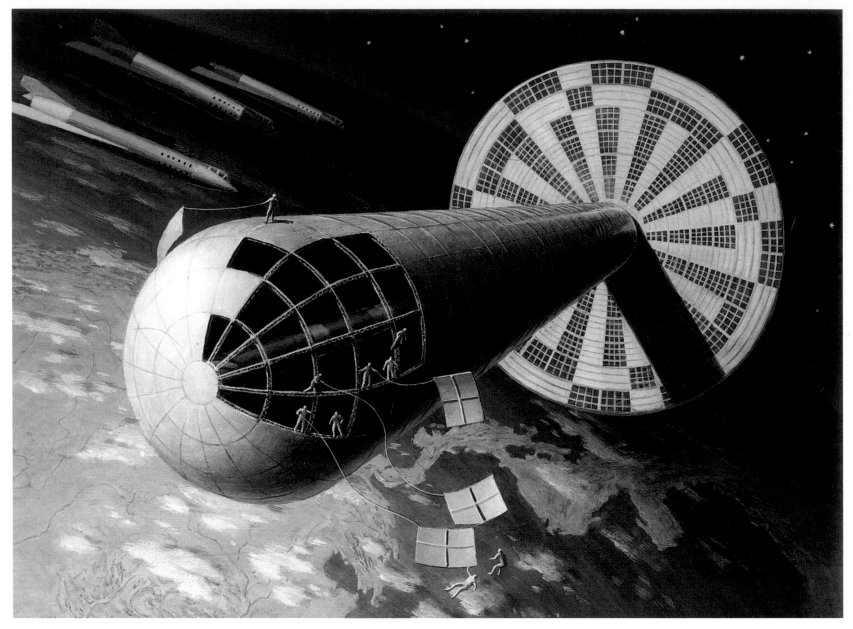

ABOVE: In the 1950s, aerospace engineer Darrell Romick devised an elaborate plan for the future exploration of space. The ultimate goal was the creation of an enormous orbiting space colony that would be inhabited by 20,000 individuals. Artist Ray Pioch illustrated most of the steps of Romick's scheme. Here he shows us the nearly completed colony.

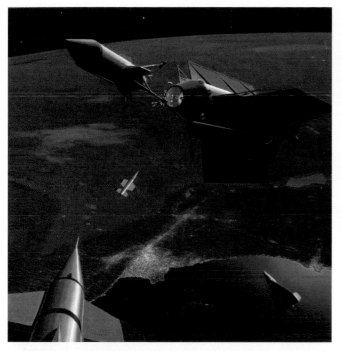

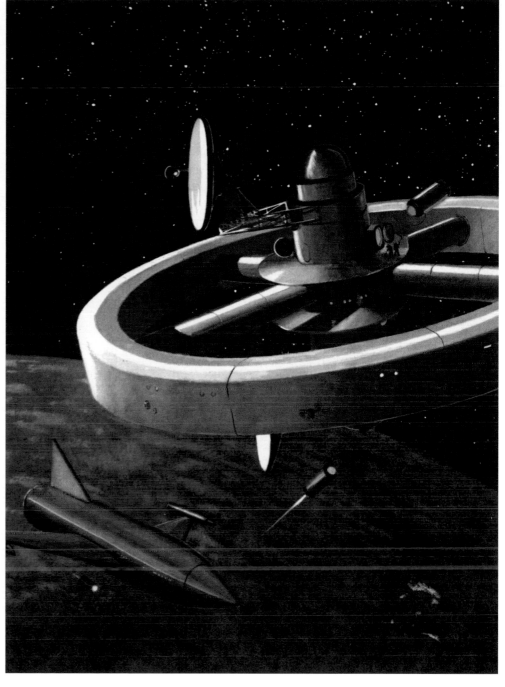

TOP LEFT: Chesley Bonestell illustrated the assembly of a future ion-propelled spaceship in this painting he created for his book *Mars* (1964). The orbiting spacecrafts are 200 miles (322 kilometers) above the Pacific Ocean, with Los Angeles and San Diego visible below.

BOTTOM LEFT: A Mars-bound spacecraft takes off from its Florida launch site. Its upper stage will eventually receive an ion-propelled booster for the next leg of its journey to Mars.

ABOVE RIGHT: For his book *By Spaceship to the Moon* (1953), artist Jack Coggins envisioned two different types of space stations. One was a zero-G design not dissimilar to the *Skylab* space station that orbited the earth from 1973 to 1979 (see page 112). The alternate was a wheel-shaped space station that rotated to provide artificial gravity for its crew.

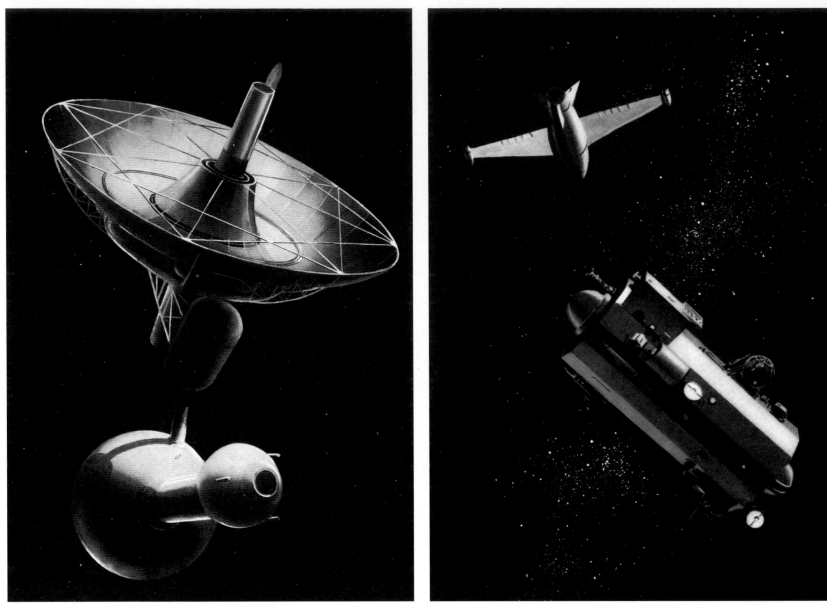

ABOVE LEFT: In 1948, the British Interplanetary Society presented its design for a manned space station closely based on Hermann Noordung's 1928 proposal (see page 10). It was developed by H. E. Ross and artist R. A. Smith, who created this image of the space station. Note the dumbbell-shaped, nuclear interplanetary spaceship preparing for its journey to Mars and the outer planets.

ABOVE RIGHT: If weightlessness didn't prove to be a physiological problem for astronauts, there would be no need for a space station to rotate in order to create artificial gravity. Jack Coggins was one of the first artists to depict such a space station in his book, *By Spaceship to the Moon* (1953). On one side of the station, the moon lander from page 10 is visible, still under construction.

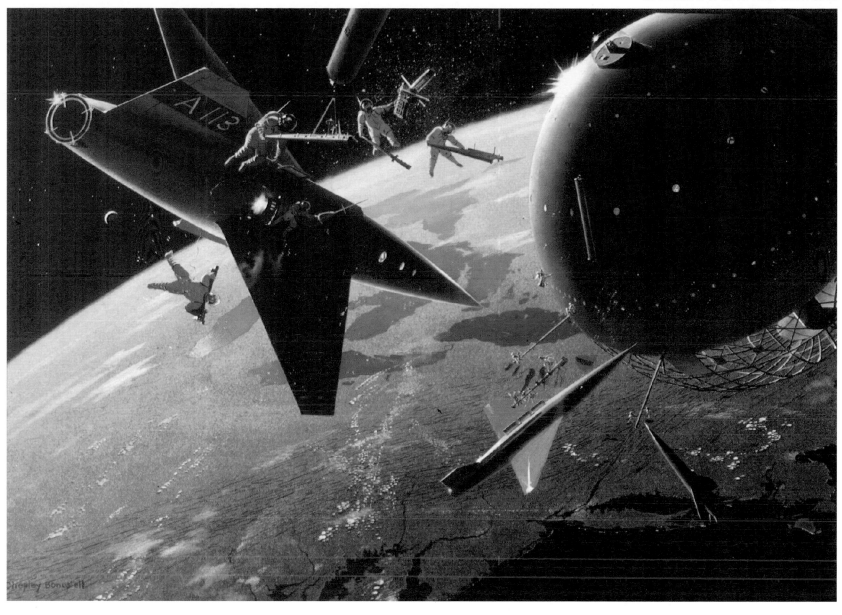

ABOVE: This dramatic painting of a spherical space station under construction was created by Chesley Bonestell in 1949 for the *Sunday Mirror* magazine. Always meticulous about such things, Bonestell was careful to make the landmarks on the earth below—here, the East Coast of the United States—as accurate as possible.

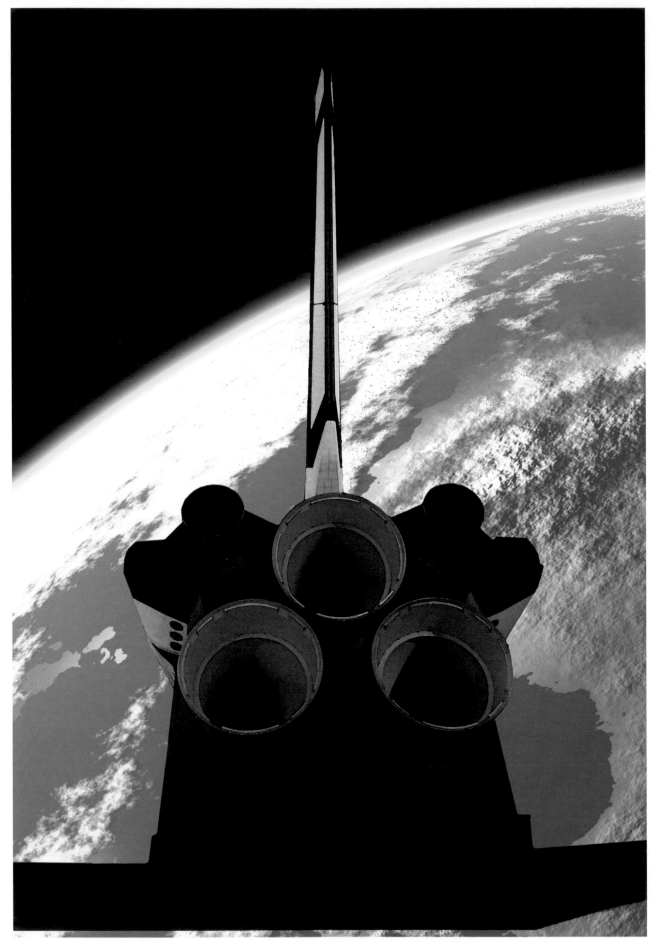

LEFT: In this dramatic painting by Julie Rodriguez Jones, we see a space shuttle on its way to a rendezvous with the International Space Station. One of the great challenges of the space artist is to create compelling imagery from the workhorse technology and engineering of space exploration.

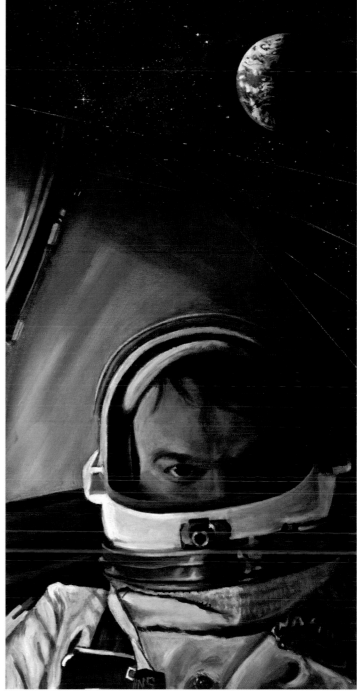

ABOVE LEFT: Michelle Rouch turns the splashdown of an *Apollo Command Module* into a near-abstract design. A fine artist with a master's degree in engineering, Rouch has not just a special appreciation of the technology of space flight, but also the ability to depict it with skill and imagination.

ABOVE RIGHT: In this portrait of astronaut Mike Collins during his *Gemini X* flight, artist Simon Kregar effectively conveys both the wonder and excitement of space travel, and also the great emotional and physical cost it entails.

COLLIER'S COMPENDIUM:
"MAN WILL CONQUER SPACE SOON!"

DURING THE 1940S AND 1950S, *COLLIER'S* WAS THE FOURTH MOST POPULAR MAGAZINE IN THE UNITED STATES—RIVALED ONLY BY *LIFE, LOOK,* AND *THE SATURDAY EVENING POST.* IN 1952 IT SPONSORED A UNIQUE GATHERING OF THE WORLD'S GREATEST SPACE EXPERTS WHO, IN A SERIES OF ILLUSTRATED ARTICLES, OUTLINED ONE OF THE FIRST COMPREHENSIVE SCENARIOS FOR THE EXPLORATION OF SPACE. ITS FIRST ISSUE WAS CONFIDENTLY TITLED "MAN WILL CONQUER SPACE SOON!"

DREAM TEAM

Concerned about the potential military use of space, the editors of *Collier's* decided to investigate the feasibility of space travel in the near future. To this end editor Gordon Manning organized a symposium on space travel, assembling a dream team consisting of Wernher von Braun, then technical director of the Army Ordinance Guided Missile Development Group; Fred L. Whipple, chairman of astronomy at Harvard University; Joseph Kaplan, professor of physics at University of California–Los Angeles; Heinz Haber, of the US Air Force Department of Space Medicine; and Willy Ley, an authority on space travel and rocketry who served as general adviser (and was also the only professional writer among the group). The symposium was placed under the general direction of *Collier's* associate editor Cornelius Ryan.

To translate the hardware concepts of von Braun and Ley into visual form, Ryan commissioned artists Chesley Bonestell (see pages 26–29), Fred Freeman, and Rolf Klep. Their work resulted in setting the standard for what the public—and other artists— expected spacecrafts to look like for the next two decades.

The results of the symposium were published in a series of articles that ran from March 22, 1952, through April 30, 1954. According to the experts, the United States could have an artificial satellite in orbit by 1963, a 50-man expedition to the moon by 1964, and a manned mission to Mars soon afterward. The first two parts of the program were expected to cost a mere $4 billion.

THE CRITICS' CIRCLE

The *Collier's* scenarios prompted mixed reactions from readers, both civilian and official. The magazine's letter columns were filled with generally enthusiastic responses. Others chose to comment upon the series's overoptimism and lack of allowance for testing and experimentation. Wernher von Braun's colleagues made the most thoughtful critiques, for the most past singling out either the grandiose nature of the project or its overt military overtones.

"WHAT YOU WILL READ HERE IS NOT SCIENCE FICTION. IT IS SERIOUS FACT."
Collier's magazine, March 22, 1952

Then, *Time* magazine devoted a cover story to a less-than-salutary synopsis of von Braun's ideas. The magazine admonished an "oversold public…[which] happily mixing fact and fiction, apparently believes that spaceflight is just around the corner." One of von Braun's bitterest critics exclaimed, "Look at this von Braun! He is the man who lost the war for Hitler… von Braun has always wanted to be the Columbus of space. He is thinking of spaceflight when he sold the V2 to Hitler. He says so himself. He is still thinking of spaceflight, not weapons…"

ENDURING APPEAL

But if initial reaction was mixed, over time the series proved to be greatly influential. It was collected together in three books: *Across the Space Frontier* (1953), *Conquest of the Moon* (1953), and *The Exploration of Mars* (1956). They are all now highly prized collectibles, as are the magazines themselves.

In 1969, after the success of the *Apollo 8* circumnavigation of the moon, Cornelius Ryan wrote to von Braun, reminding him of the *Collier's* articles: "My mind went back to 15 years ago and the days when newspapers and magazines are calling me 'Blast Off Ryan' (and even more derogatory names) because of the *Collier's* space series. I guess a little ground is broken then. I know it is for me and so I can tell you how I felt when I saw *your* rocket and *your* design streaking skywards culminating for you what surely must have been a lifetime of hoping and finally fulfillment." Dr. von Braun replied: "None of us have ever forgotten the impetus to space that you helped to provide 'back when'… You wouldn't believe how many people still remember 'our' *Collier's* series. Time and again complete strangers tell me that those articles really opened their eyes to these new possibilities 'out there.'"

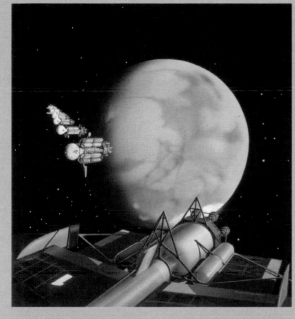

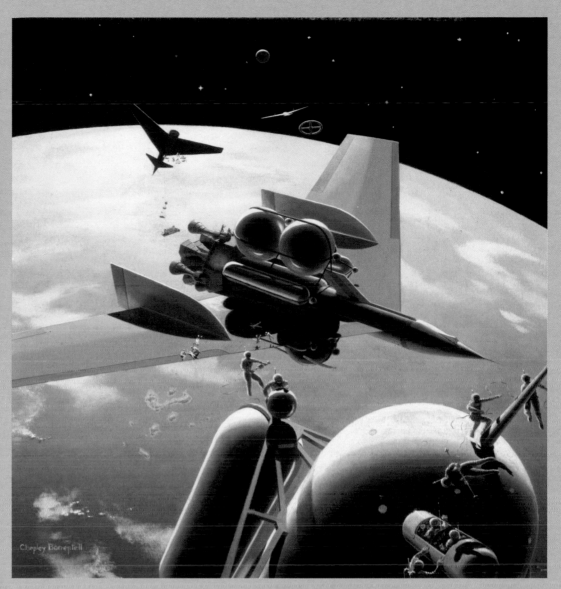

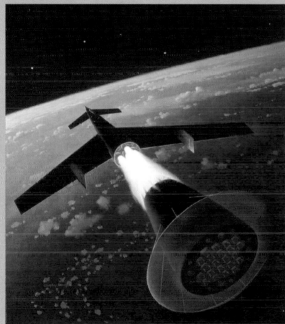

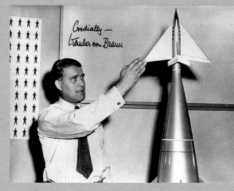

TOP LEFT: Never one to think small, Wernher von Braun's plan for the exploration of Mars entailed an entire fleet of manned orbiters and landers. Here, in a painting that appeared on the cover of the April 30, 1954, edition of *Collier's*, Chesley Bonestell shows the Mars-bound spacecraft as they near the red planet.

BOTTOM LEFT: The second step in the *Collier's* space program was the development of a manned space shuttle. In this painting for the March 22, 1952, cover of the magazine, Bonestell shows the winged shuttle separating from the second-stage booster. Von Braun pointed out that he received complaints from his fellow rocket scientists about the painting: a good engineer would never allow his engines to become red-hot!

BOTTOM MIDDLE: Wernher von Braun poses beside a large model of the three-stage ferry rocket he designed for the *Collier's* space series. One of the most telling features of the series was that no future technologies or materials were assumed: the entire program could be accomplished with off-the-shelf engineering available in the 1950s.

TOP RIGHT: The assembly of the Mars fleet in earth orbit. This Bonestell painting was created for the book version of the *Collier's* Mars issue, *The Exploration of Mars* (1956), in which the Mars expedition differed substantially from how it was described in the magazine series.

BOTTOM RIGHT: The team responsible for writing and illustrating the *Collier's* magazine series. From left to right: artist Rolf Klep, Willy Ley, Heinz Haber, Wernher von Braun, Fred L. Whipple, and Chesley Bonestell. Not shown are Joseph Kaplan, Oscar Schachter, and artist Fred Freeman.

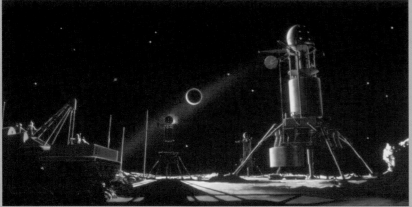

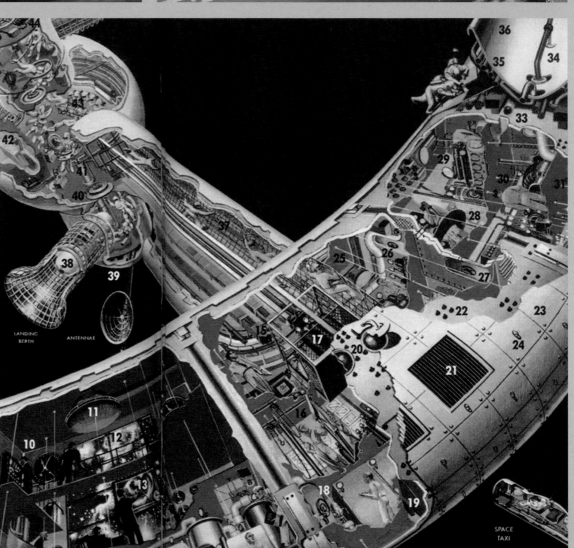

SECTIONAL VIEW OF THE SPACE STATION

(Reading around from left to right, then through to center)

1. Communications section
2. Meteorological unit
3. Sleeping quarters
4. Earth observation, general
5. Earth observation, detail views televised from observatory
6. Oxygen helmet for possible emergencies
7. Computer
8. Telescope control
9. Photographic darkroom
10. Screen control
11. Air conditioning
12. Celestial observation, main (photographic) projector screen
13. Magnifier
14. Water-recovery plant
15. Weight control
16. Loading area
17. Elevator cage
18. Emergency oxygen helmet
19. Fuel tanks; air duct below tanks
20. View ports
21. Temperature regulator
22. Inner wall, with studs that hold meteor bumper
23. Meteor bumper (thin sheet metal)
24. Hook-on rings for personnel in space suits
25. Floor supports
26. Pump room
27. Airtight door between sections of Space Station
28. Air control
29. Air-conditioning unit
30. Power room
31. Air-testing laboratory
32. Air-conditioning ducts
33. Power cables and water pipes inside meteor-bumper wall
34. Mercury boiler
35. Cooling pipes for mercury, in shade of solar mirror
36. Solar mirror which focuses sun's rays on mercury boiler
37. Landing net, paralleling elevator shaft, for use of personnel
38. Space taxi in its landing berth
39. Turret to which landing berth for space taxi is attached; turret stationary when in use
40. Air lock
41. Supply tube
42. Cargo hatch
43. Space suits
44. Turret motor, to keep turret stationary while space taxi lands

TOP LEFT: Chesley Bonestell created this elegant scene of the von Braun lunar landers, one of which is blocking the sun so we are able to see the distant earth, its backlit atmosphere glowing in a luminous ring of light.

TOP RIGHT: One of the most iconic and reproduced space paintings ever created is Chesley Bonestell's depiction of the classic von Braun space station and winged space shuttle as they pass over Central America, 1,075 miles (1,730 kilometers) below.

BOTTOM: This detailed cutaway view of the von Braun space station was created by Fred Freeman. Its design was enormously influential—both among space scientists and with other artists. For decades, versions of it appeared in everything from pulp magazines to motion pictures.

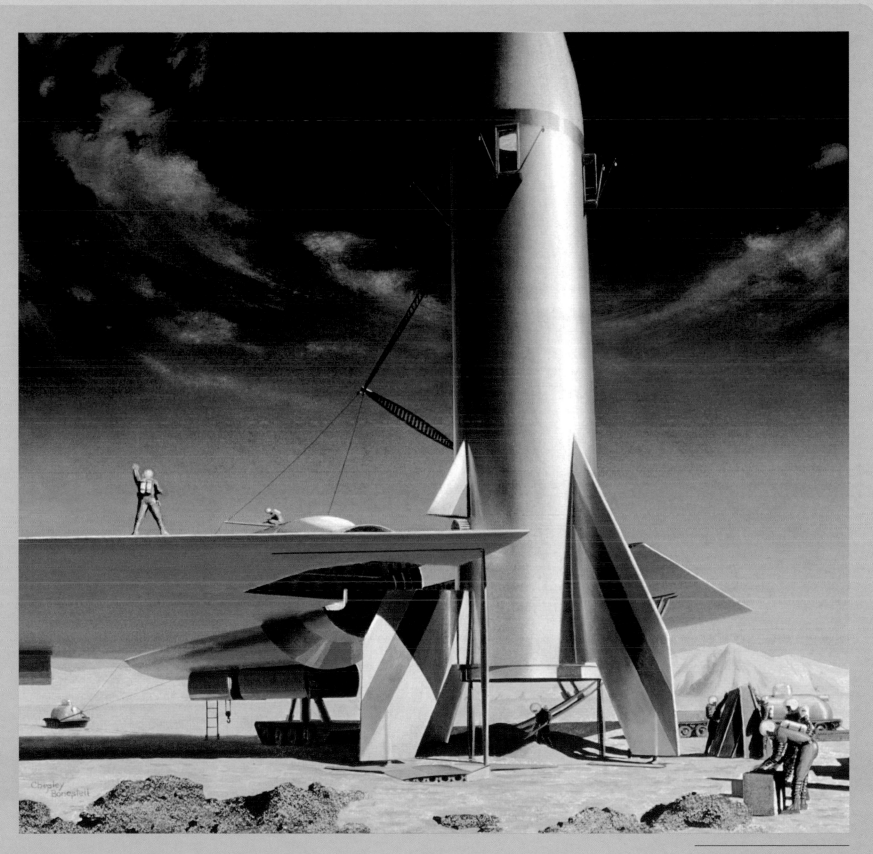

ABOVE: Painted by Chesley Bonestell for *The Exploration of Mars* (1956), this illustration depicts the expedition's astronauts just as they have completed disconnecting the return rocket from the giant wing used to land on Mars.

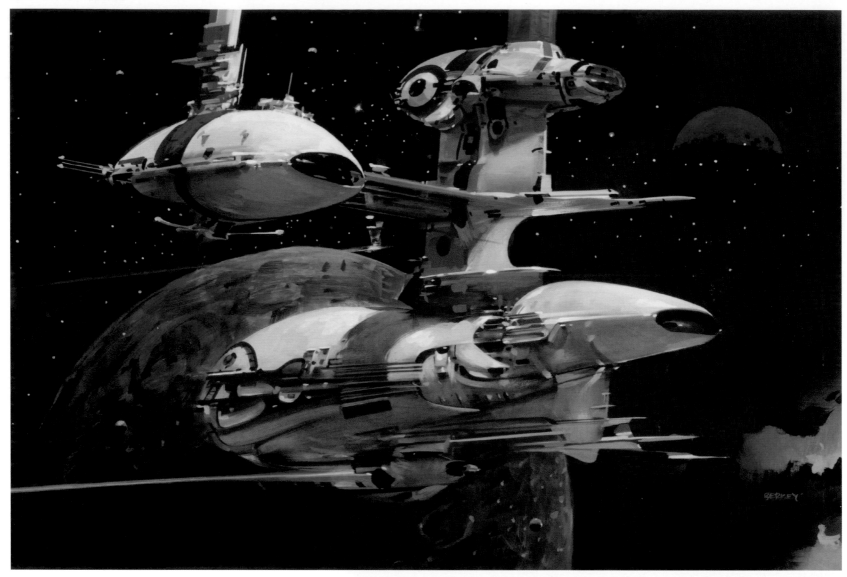

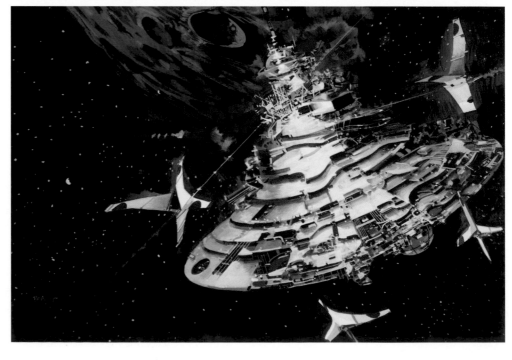

TOP: John Berkey (1932–2008) was one of the most influential of the "hardware" artists. His distinctive style—painterly, yet detailed, and always filled with vigor and drama— was an inspiration to scores of science-fiction illustrators.

BOTTOM RIGHT: A prolific artist who created thousands of illustrations in every genre over the course of his career, John Berkey is probably associated most with science fiction. He got his start in this field in the 1960s when he was commissioned to create portraits of NASA Apollo astronauts.

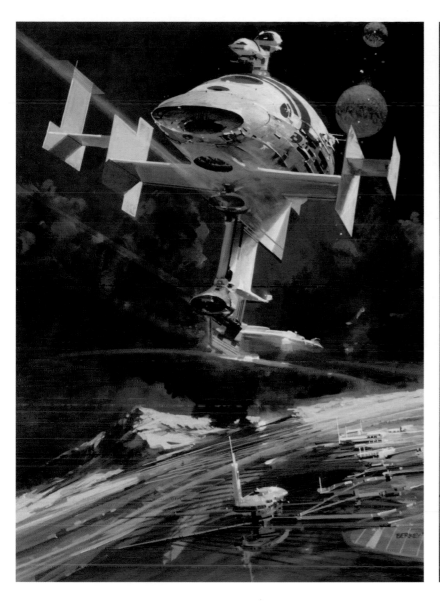

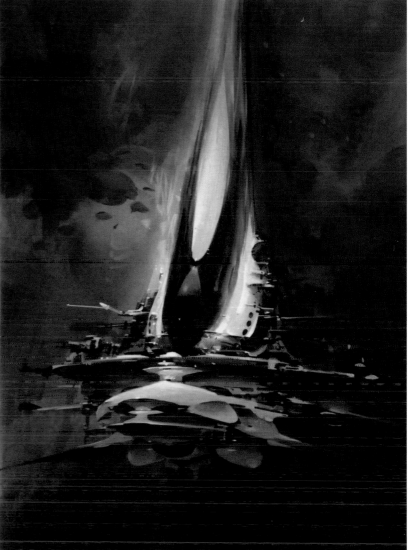

ABOVE LEFT: After creating the covers for Ballantine Books' *STAR* series in the 1970s, John Berkey's work was in great demand for science-fiction book covers. This painting, *End of the Run*, is typical of the work he did. Berkey was eventually inducted into the Society of Illustrators' Hall of Fame, where he was called the most influential and innovative futurist artist of his time.

ABOVE RIGHT: *Feather Ship* is a perfect example of the elegance Berkey brought to his spacecrafts. A consummate professional, he took on whatever an assignment called upon him to do, whether that was book and magazine covers, movie posters, or postage stamps.

FOLLOWING SPREAD: In *City on the Eastern Sea*, artist Pat Rawlings gives us a glimpse into the far future of space exploration and colonization as we hover over a sprawling lunar city, with a vast orbiting space station looming in the foreground.

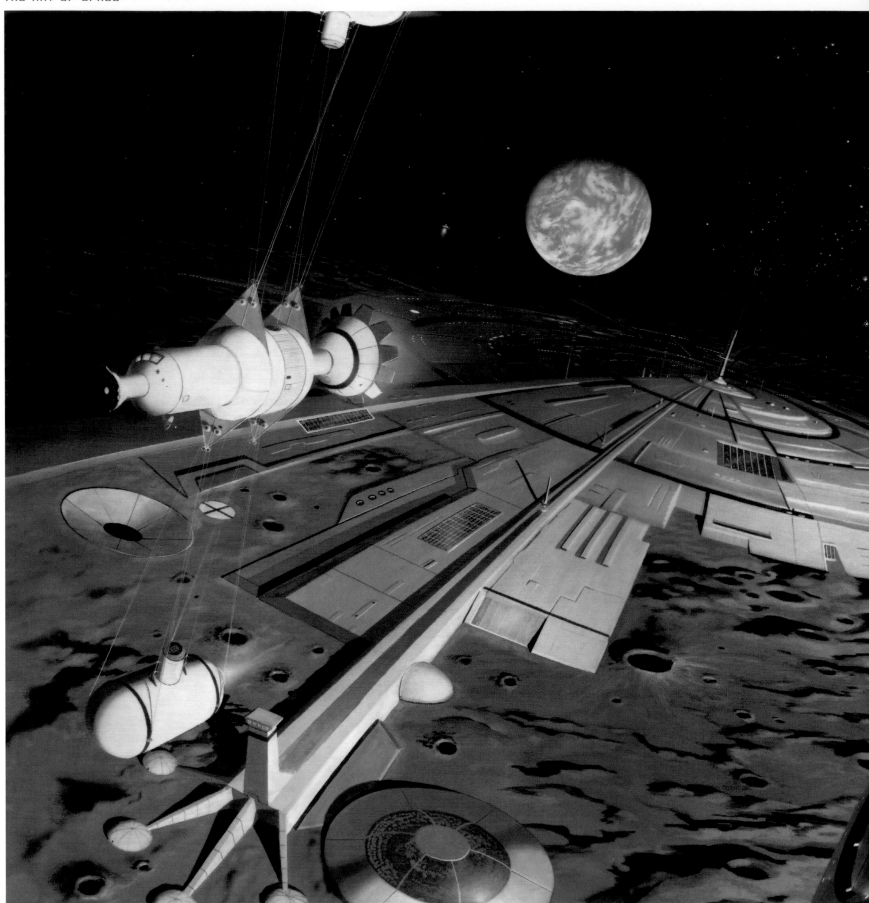

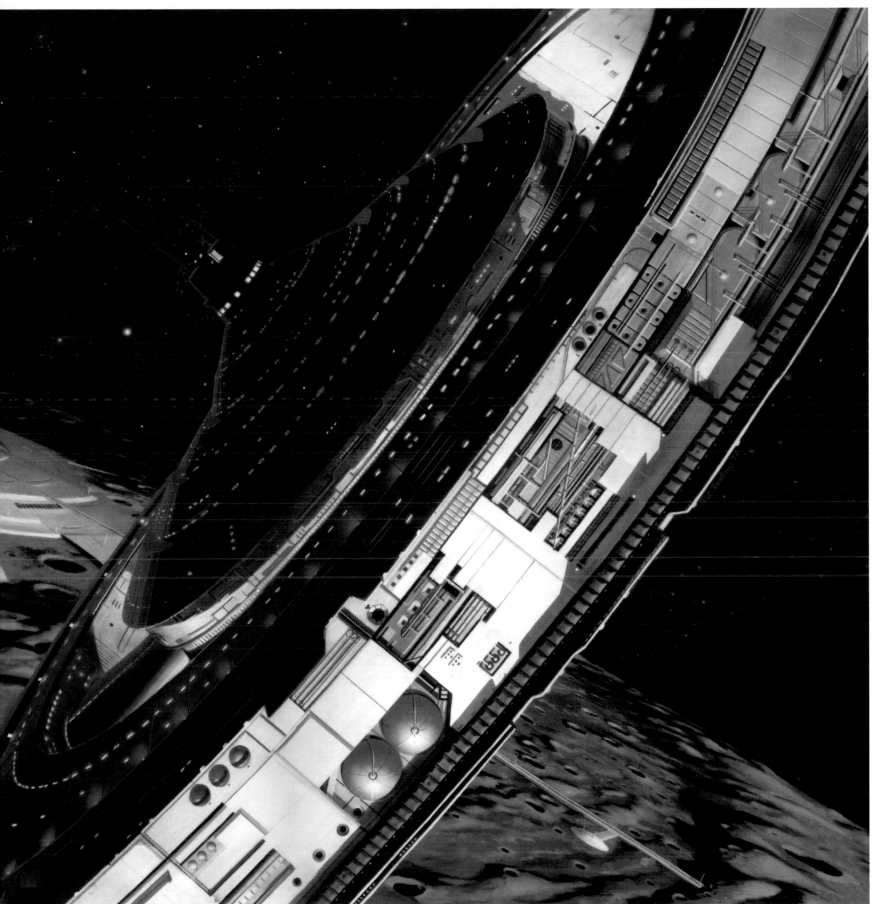

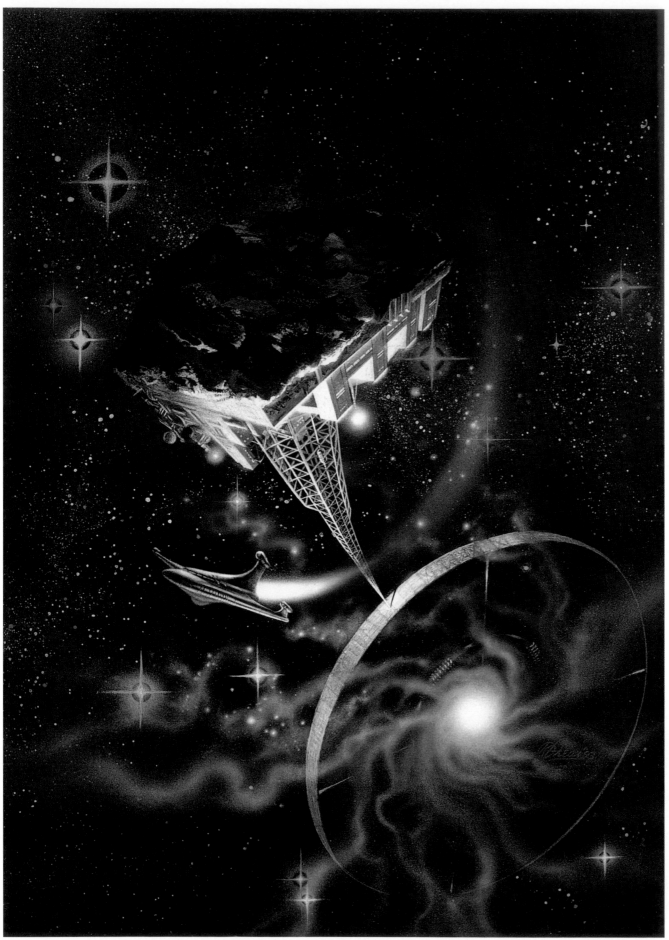

LEFT: With a career spanning more than 50 years, Kelly Freas (1922–2005) was one of the most beloved—and prolific—science-fiction illustrators. He created this painting depicting a future research station orbiting a black hole for *Amazing Stories* in 1993. The station's headquarters are on a tethered asteroid, keeping its crew at a safe distance.

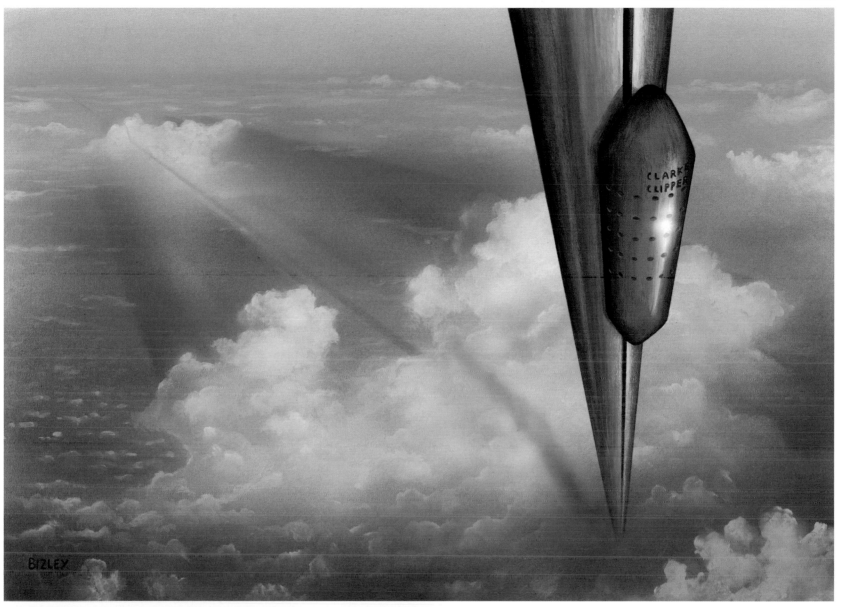

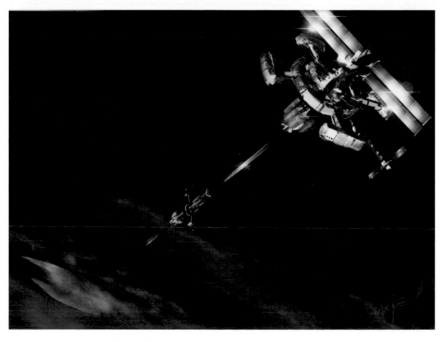

LEFT: Here Christopher Doll illustrates the far end of a space elevator: a huge space station whose geosynchronous orbit keeps it hovering perpetually over the same spot on the earth. Doll is also a skilled model-maker whose detailed miniature spacecrafts have won numerous awards.

ABOVE: Artist Richard Bizley created this dramatic and evocative image of one of space technology's most extravagant and appealing ideas: the space elevator. The concept is deceptively simple: an immensely strong cable attaches a satellite to a point in the earth below. Elevators can then run up and down this cable, carrying passengers and cargo to and from orbit.

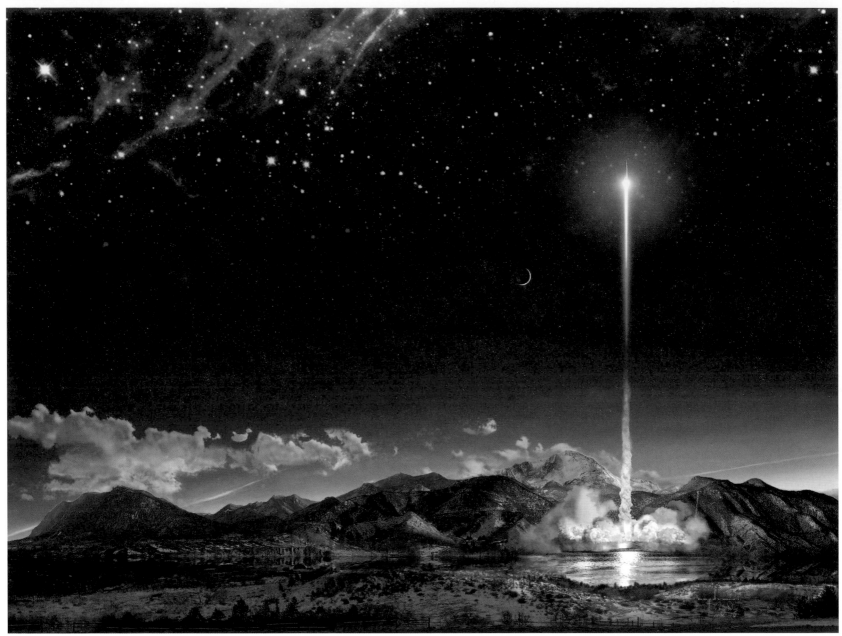

ABOVE: As artist B. E. Johnson points out in the subtitle to this painting, *Rocky Mountain High*, a spacecraft launched from the American Rocky Mountains is already a mile (1.6 kilometers) closer to space than one launched from Kennedy Space Center in Florida.

ABOVE LEFT: In the wistful *It's a Rocket*, Croatian digital artist Nikola Subic captures the childlike sense of wonder that a rocket can evoke in even the most jaded engineer or scientist. The image is a favorite of Subic's admirers, one of whom said that the picture "seems to be a poster: 'Off to the moon…be back soon!'"

TOP RIGHT: Kelly Freas was commissioned by the *Skylab* astronauts to create their official mission patch. Inspired by what he learned of the space station and its goals, Freas also created this evocative painting, which was issued as a limited-edition print to celebrate the launch in 1973.

BOTTOM RIGHT: As part of its now-abandoned Constellation program, NASA developed the Orion Crew Exploration Vehicle (CEV), shown here by artist Aldo Spadoni. The CEV would have been an essential part of this ambitious program for the human exploration of near space and the planets.

"HYMN TO THE SOVIET REPUBLIC":
SOVKINO POSTER DESIGN

POSTERS WERE A POWERFUL ART FORM IN THE SOVIET UNION. THEY FIRST APPEARED DURING THE GREAT OCTOBER REVOLUTION, WHERE THEIR POWERFUL GRAPHICS AND INFLAMMATORY SLOGANS CARRIED THE COMMUNIST MESSAGE TO THE MASSES. THE LEADER OF THE COMMUNIST PARTY, VLADIMIR LENIN, WAS A FIRM BELIEVER IN THE POWER OF ART TO TRANSFORM AS WELL AS COMMUNICATE.

Following the end of World War II, Soviet poster art changed from encouraging revolution to themes of loyalty and productivity at home, and the presentation of Soviet Russia as a force for peace and international friendship to the world at large. Along with past masters of poster art such as Viktor Govorkov (1906–1974), new and upcoming artists brought more modern sensibilities to poster design. But perhaps because the tradition of Russian art was so strong in the Soviet Union, or because the regime's insular nature kept its artists from being overly influenced by Western trends in the graphic arts, Soviet posters—however modern their subject matter—kept at least one foot firmly rooted in the past. The result was posters that were compelling and powerfully designed, but vaguely retro at the same time.

AT THE MOVIES

At the same time the Soviet movie industry was achieving success at home and internationally, advertising its films with eye-catching posters. Artists employed the same techniques for their posters as were being used in the films: unusual lighting, distorted angles, intersecting planes, and bold, abstracted shapes. Movie poster artists also found they had a little more freedom than their political poster comrades. Where a propaganda poster may be expected to have a lifetime of a few months or even years, a movie poster was infinitely more ephemeral. Printed on cheap paper (and sometimes on the backs of outdated posters), they were expected to be seen for only a few days.

The posters themselves were produced in-house by the film studios, who maintained special art departments just for this purpose. The finished art had to be approved by the advertising department of Sovkino. This was managed by Ya. Ruklevksy, who had assembled a team of extraordinary young talents, such as Georgy and Vladimir Stenberg (who signed their work "2 Stenberg 2" during the 1920s), Grigory Borysov, Leonid Voronov, and many others. Almost all were graduates of the Soviet state-run art school. During the period preceding World War II, the Stenbergs alone created more than 300 different movie posters, sometimes producing two different posters for the same film.

"WHETHER ON EARTH OR IN SPACE, I AM A RUSSIAN CITIZEN. YOU CANNOT ESCAPE FROM THE WORLD, EVEN WHEN YOU ARE IN ORBIT."
Grenady Pedlako, Cosmonaut, *Colors 45*, September 2001

Russia had already a long tradition of producing first-class science-fiction films. *Aelita* (1924) was one of the earliest feature-length films to depict an interplanetary voyage. Based on a novel by Alexei Tolstoy, it combined adventure with post-revolution propaganda. This was soon followed by a series of big-budget sound films, one of which, *Cosmic Voyage* (1932), boasted the collaboration of the pioneering spaceflight expert Konstantin Tsiolkovsky. This film was made on the order of the Communist Youth Union (Komsomol) to encourage student interest in astronautics. The posters for this film—like other posters of that era—were dramatic in their depiction of Soviet aspirations and ambitions.

Postwar films included movies like *The Heavens Call* (1959), a special effects–laden epic that took viewers to the moon, Mars, and the asteroids. The film's state-of-the-art effects were later cannibalized by American B-movie producer Roger Corman for his low-budget *Battle Beyond the Sun* (1963), something he also did to another classic Soviet space film, *Planet of Storms* (1962), which was transformed almost unrecognizably into two films, *Voyage to the Prehistoric Planet* (1965) and *Voyage to the Planet of Prehistoric Women* (1968).

HEROES OF THE COSMOS

The transition from fictional space travel to the actual space age in the mid-1950s provided a new impetus for Soviet poster artists. They now focused not just on the technological triumphs of the Soviet system, but the heroism and idealism of the cosmonauts who were exploring space and the men and women who put them there. Dramatic posters and epic monuments to space heroes such as Yuri Gagarin and Gherman Titov appeared across the country. But as much as these posters were a celebration of scientific achievement and individual courage, slogans such as "Socialism is our launching pad!" and "Science and Communism are inseparable" provided a firm and constant reminder of the political regime underpinning them.

TOP LEFT: Although not a Soviet poster, this design for a Swedish poster advertising the classic 1929 German science-fiction film *Woman in the Moon* is very much in the same style, having the same modernist roots as the posters created by the Soviet designers.

BOTTOM LEFT: "Our Triumph in Space—An Anthem to the Soviet Republics!" proclaims this striking poster that, although created in the 1960s, proudly displays its prewar modernist roots.

ABOVE RIGHT: "Be proud of the Soviet people—by going to the stars you opened the way to the earth!" Like many others of its kind, this poster aimed to remind the Russian people of the triumphs their nation had made in space, and to foster a sense of pride and patriotism.

TOP: A poster advertising the Soviet science-fiction film *Cosmic Voyage* (1936). The movie was created under the auspices of the Communist Union of Youth, who hoped it would inspire interest in space travel and rocketry among Soviet students. To ensure accuracy, director Vasili Zhuravlov enlisted the services of Konstantin Tsiolkovksy, one of the founders of modern spaceflight.

BOTTOM LEFT: *Dream Meeting* was a 1963 Soviet film based on Olesya Berdnik's novel, *Heart of the Universe*. The story is about an alien spacecraft that crashes on Mars's moon Phobos, leading to a spaceship being sent from the earth to rescue its crew.

BOTTOM RIGHT: *Aelita* was a feature-length film released in 1924. Based on a novel by Alexei Tolstoy, it is a thinly disguised retelling of the Soviet revolution as an adventure set on Mars. While the actual journey to the red planet is all but glossed over, the real interest in the film lies in its innovative set and costume design.

RIGHT: "To the Stars!" proclaims this poster. The artwork dates from the late 1950s or early 1960s, when the configuration of Soviet launch vehicles was still top secret. The winged rocket towering behind the figure was one of the "official" versions of the Vostok rocket—which, of course, didn't resemble the actual rocket in the slightest.

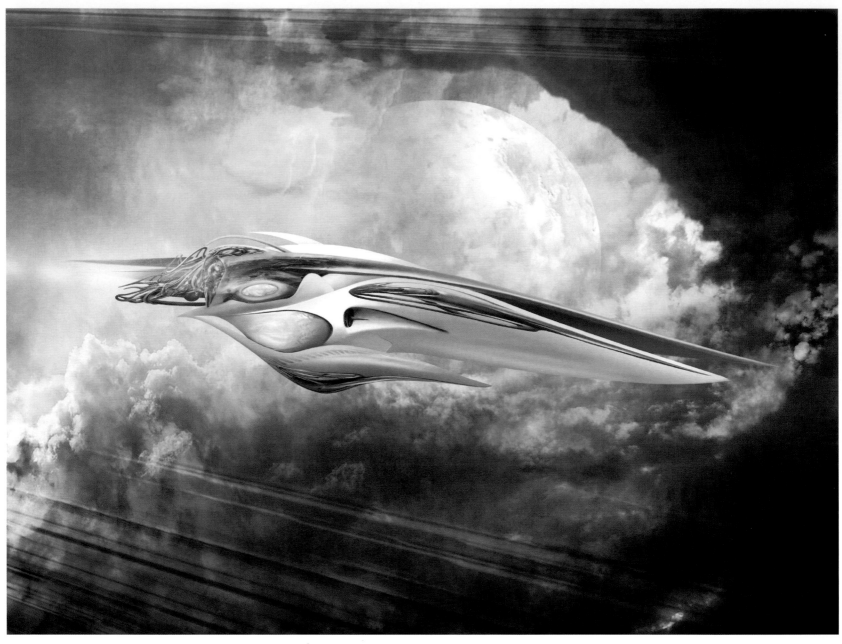

ABOVE: Welsh artist Jim Burns is among the most prolific and well respected of modern science-fiction illustrators. In *Tachyonic*, he presents us with a faster-than-light starship of extraordinary grace—and completely believable alienness. Like many of his colleagues in the UK, Burns was influenced as a youngster by the British comic strip *Dan Dare*.

OPPOSITE TOP: A Bussard ramjet, as illustrated by Ron Miller. A powerful magnetic field is used as a kind of enormous "scoop," sweeping interstellar gases into the ramjet engine of the asteroid-sized spacecraft. Able to accelerate as long as fuel is available, the spaceship will ultimately be able to achieve enormous velocities.

OPPOSITE BOTTOM: This typically organic-looking spacecraft was created by Jim Burns as the cover art for Peter F. Hamilton's novel *Judas Unchained*. "The notion," says Burns, "that many of my paintings provide pleasure to people in ways beyond their original commissioned purpose is immensely gratifying."

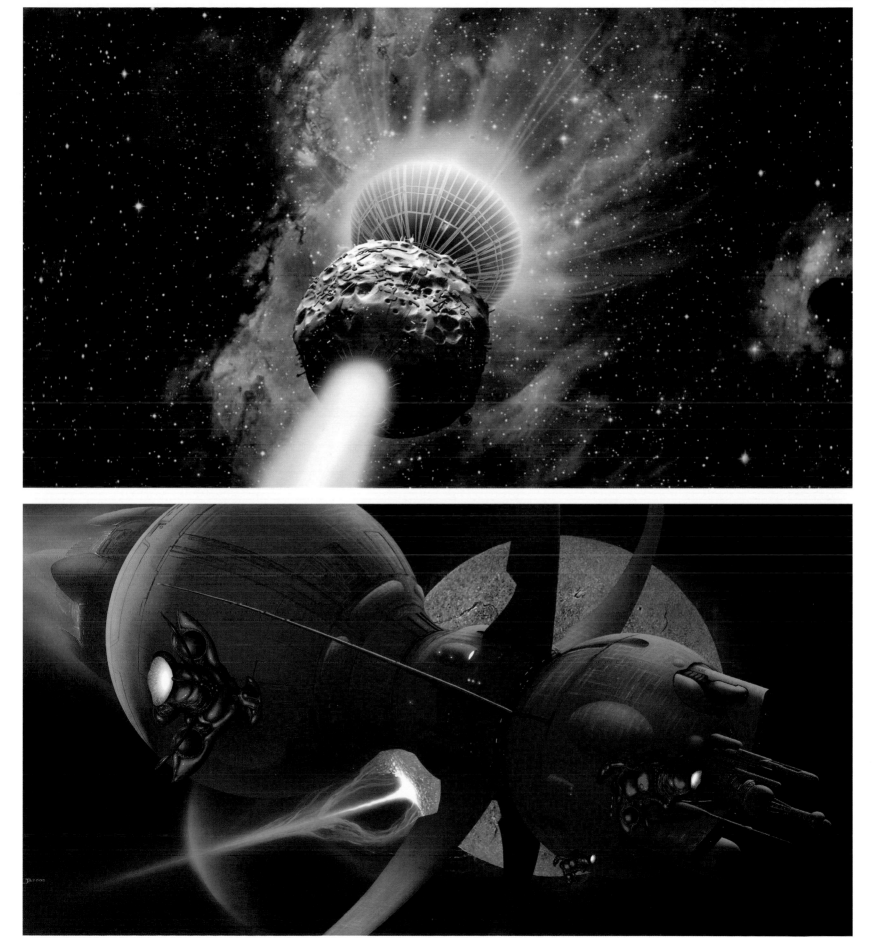

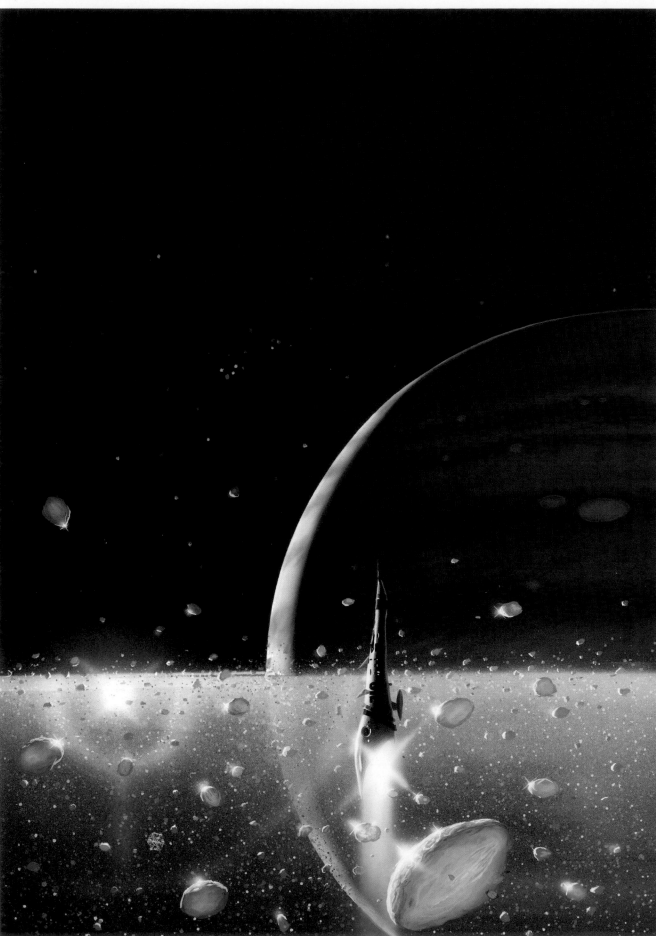

LEFT: Originally created as the cover for an Isaac Asimov novel, this painting by British artist Peter Elson (1947–1998) shows a spaceship running the gauntlet of Saturn's rings, where countless billions of tumbling icebergs threaten disaster at any moment.

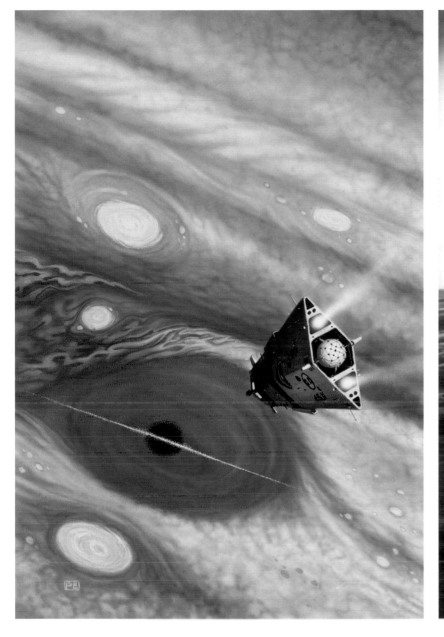

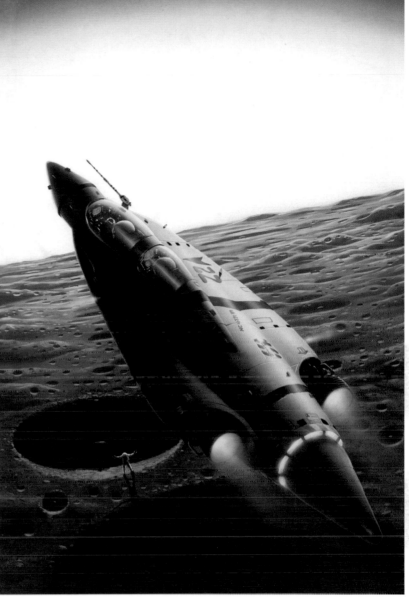

ABOVE LEFT: Like many of the paintings in this book, Peter Elson's *Divergence* was originally commissioned as a book cover, in this case for a 1991 novel by Charles Sheffield. Here we see a spaceship plummeting toward a shimmering black hole, the Great Red Spot of Jupiter glowering in the background.

ABOVE RIGHT: A great many of Peter Elson's space paintings were based on a good knowledge of real astronomy. In *The Big Sun of Mercury*, we see a two-man spacecraft rocketing over the barren, crater-pocked surface of Mercury, the planet closest to the sun.

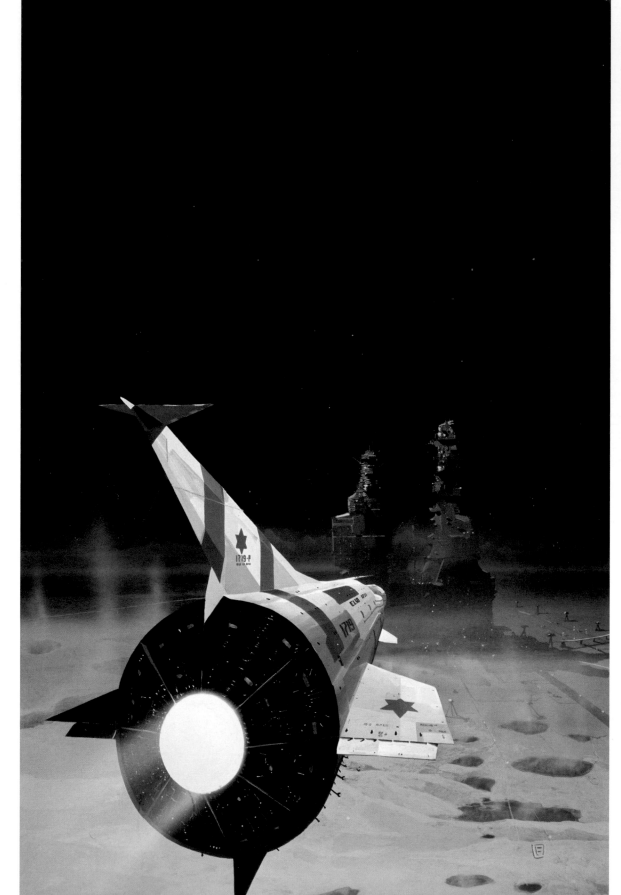

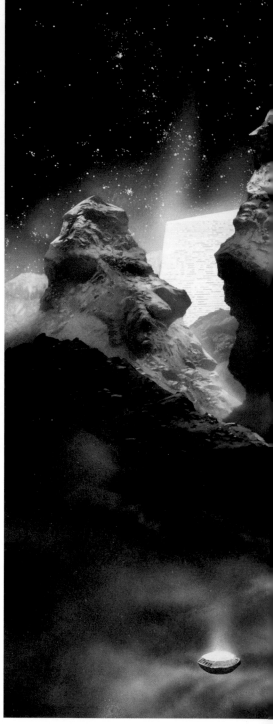

LEFT: The name of British illustrator Chris Foss has become almost synonymous with stylish, imaginatively designed spacecrafts that are uniquely his own. A typical example is in this painting, originally created in 1974 for *Slan*, a science-fiction novel by A. E. van Vogt.

ABOVE: Since many of the paintings in this book were created to illustrate books written by others, this example is a rarity. It is an illustration that artist Chris Foss painted for a novel he wrote himself, *Diary of a Spaceperson*, chronicling the adventures of a future female astronaut as she travels from galaxy to galaxy.

ABOVE: Polish concept artist Maciej Wojtala introduces *Spaceship Wreckyard* by saying that he "wanted to visualize the idea of an environment covered with old spaceship wrecks, being absorbed by nature and decaying for many years." The work harkens back to the genre paintings of the nineteenth century, where every element of a painting contributed to the story it told.

SPACE COLONIES & CITIES

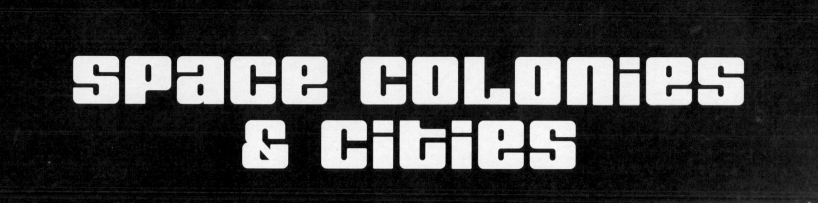

SPACE COLONIES & CITIES:
HOMES AWAY FROM HOME

THE IDEA OF COLONIES OF HUMANS ON OTHER WORLDS IS NOT A VERY NEW ONE. AFTER ALL, THERE REALLY IS NO FUNDAMENTAL DIFFERENCE BETWEEN COLONIZING A REGION OF THE EARTH AND COLONIZING ANOTHER PLANET... AND PEOPLE HAVE BEEN CREATING COLONIES ON EARTH FOR MILLENNIA. IT'S JUST A MATTER OF TECHNICAL DIFFICULTY.

No one even suspected that there might be other worlds until the year 1610, when Galileo Galilei first turned a telescope toward the night sky. Until that moment, the planets were considered only a special class of star that moved among the other stars, and the moon a disk made of some sublimely luminous celestial substance. They weren't regarded as worlds like the earth. What Galileo discovered changed all that. Venus, Mars, Jupiter, Saturn, and the moon, he discovered, were worlds in their own right. The moon had mountains and valleys just like the earth's.

At the same time that Galileo and others were discovering new worlds in the sky, other explorers were discovering worlds on the other side of the Atlantic Ocean. During this "Age of Exploration," explorers and colonists made the journey to explore these fertile, rich, and strange lands. Now it was revealed that not only were there new lands on earth, but the sky was full of them too. If the new lands on earth could be visited and colonized, why couldn't those in the heavens? The problem, of course, was how to go about *getting* to these new worlds. Anyone could jump on a ship and travel to the Americas or the Indies—but how to get to the moon?

Most early fictional visitors to the moon and planets were more or less tourists, who came only to observe, have whatever adventures they might find, and (with any luck) return home. While scores of authors rushed to describe what it might be like to visit the moon and planets, few if any thought about staying there to live.

It wasn't until after the turn of the twentieth century that anyone turned his or her mind to the creation of permanent settlements on other worlds. One of the earliest was a novel by William Dixon Bell titled, appropriately enough, *The Moon Colony* (1937). The author described the construction of a populated base on the moon and introduced his readers to the crucial concept of "terraforming"— the process of converting a planet's atmosphere and environment to make it suitable for human habitation.

MANNED SATELLITES

Creating a habitable environment on another planet is one thing, however. Creating a habitable environment in space itself— effectively creating a planet from scratch—is another matter entirely.

Placing a satellite into earth orbit is not a particularly difficult thing to do. And if a satellite is large enough, human beings can live in it. This was first done by the Russians in 1971, in the form of space station *Salyut 1*, albeit on a relatively small scale. Eventually, space agencies from the United States, Russia, Europe, Japan, and Canada came together to build the International Space Station. Launched on October 31, 2000, this monster satellite weighed nearly 1 million pounds (450,000 kilograms) and was capable of sustaining a crew of six. But the time any space station crew spends in orbit is always temporary. The occupants go, do their jobs, and return to the earth. The idea that people might live in space as permanent residents is an entirely different idea, and one that requires an entirely different scale of thinking.

"EARTH IS THE CRADLE OF MANKIND, BUT MANKIND CANNOT LIVE IN A CRADLE FOREVER."
Konstantin Tsiolkovksy, 1911

It's also a relatively recent idea. While one might point to the earth-orbiting satellite in Edward Everett Hale's short story "The Brick Moon" (1869) as a space colony, since its residents lived on it permanently, they were there by accident. The Brick Moon was not *intended* to be a space colony. Likewise, the little colony of castaways in Jules Verne's *Off on a Comet!* (1877) accidentally found themselves aboard an asteroid as it careened through the solar system. Contending with low gravity and the frigid conditions of deep space, Verne's band of unwilling colonists faced many of the hardships that real interplanetary colonists may someday have to deal with. André Laurie's remarkable *Conquest of the Moon* (1889) also dealt with involuntary space colonists, as an entire mountain torn from the earth by a super-magnet lands on the moon, carrying an observatory and all its inhabitants with it.

In 1896, German author Kurd Lasswitz's *On Two Planets* described an artificial self-contained world. Unlike the Brick Moon, Lasswitz's space station was deliberately built to be inhabited. In

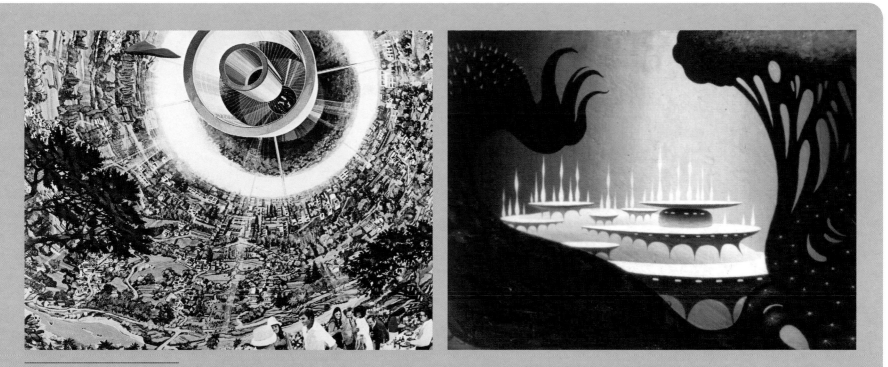

ABOVE LEFT: In the late 1970s, NASA undertook a long study on the feasibility of orbital space colonies. This resulted in the publication of a detailed report: *Space Settlements—A Design Study* (1977). Among the numerous illustrations that Rick Guidice provided was this scene, which transported the ideal American suburbia into outer space.

ABOVE RIGHT: Here the idea of a future colony or city on another world is seen through the sensibilities of a Soviet painter named Fagyev. Myth, legend, and fairy tales are a strong current running through Russian culture, and we can see their influence in this dreamlike interpretation.

this case it was a huge ring built by Martians that hovered 3,800 miles (6,115 kilometers) above the earth's North Pole. It was at this same time that the first serious attempt was made to describe an orbiting space station in realistic term. In 1895, the pioneer Russian spaceflight theorist Konstantin Tsiolkovsky used the form of a short story (titled "Visions of Earth and Sky") to outline his basic idea. Eight years later he expanded his description of a space station to include rotation for artificial gravity, the use of solar energy for power, and even a greenhouse with a closed ecological system to provide the inhabitants with food and oxygen. In doing this, he laid the groundwork for every space colony concept that followed.

It's more or less here that the history of space stations and that of space colonies really diverges. While most scientists and engineers focused on the more immediate problems of practical manned satellites, a handful harbored more grandiose, long-term visions. For instance, Arthur C. Clarke, in *A Fall of Moondust* (1961), was one of the first to suggest placing large, permanent space stations at the Lagrangian points: areas of gravitational stability that would allow the stations to maintain a fixed position relative to both the earth and the moon. This was an idea that was picked up in spectacular fashion a decade later by the American physicist Gerard O'Neill.

DRY DOCKS

Yet by this stage the first detailed design for an orbital station and true space colony had arguably already been created, by Goodyear engineer Darrell Romick in the 1950s. Romick's colony consisted of a huge, zero-gravity cylindrical "dry dock" over 1,500 feet (457 meters) long and 1,000 feet (305 meters) in diameter. At one end would be a 1,500-foot (457-meter) rotating disc inhabited by 20,000 people. Artificial gravity would be created by the rotation. The distance around the perimeter of the giant wheel would be nearly a mile. In fact, the wheel would be so large that people inside wouldn't be able to detect any curvature in the floors.

The colony's 82 floors would contain apartments, stores, churches, schools, gymnasiums, and theaters as well as its own

TV stations and newspapers. Power would be derived from the 12 acres (4.9 hectares) of solar panels (an incredibly ambitious concept considering the mere half acre of solar panels that currently adorn the International Space Station).

Romick believed that people would eventually want to travel into space not only as tourists but as emigrants. "The station," he claimed, would be "capable of providing safe, comfortable living accommodations similar to those on the ground for thousands of inhabitants, as well as affording them recreational facilities and cultural experiences not available on earth. The view from the living-room window would be sensational…" For the station's more active inhabitants, Romick's design provided for quarter-gravity and zero-gravity gymnasiums, "which would be most interesting and stimulating."

MOBILE HOME

Conceptually, a space ark is a close relative of the space colony—except it is not limited to orbiting a planet, and can move from place to place like a spaceship. First suggested in 1918 by the American physicist Robert Goddard, the space ark offered a way for the human race to travel to distant stars. Entire generations would live out their lives aboard a vast spacecraft, their descendants finally arriving at the destination star.

Following the publication of Robert A. Heinlein's *Universe* (1941), the space ark ultimately became a staple of science fiction. But this is one idea that will require huge technological advances before science fiction becomes science fact. In 1952, Leslie Shepherd of the British Interplanetary Society examined the space ark from an engineer's viewpoint. He believed that such a mobile colony would have to be "a veritable Noah's Ark." In order to colonize another world, many animals other than humans would need to live on board, to say nothing of plants. "Life," Shepherd said, "would go on in the vehicle in a closed cycle, it would be a completely self-contained world." This necessitated a spacecraft of enormous proportions—literally an artificial planet weighing a million tons or more. "Even this," Shepherd concluded, "would be pitifully small."

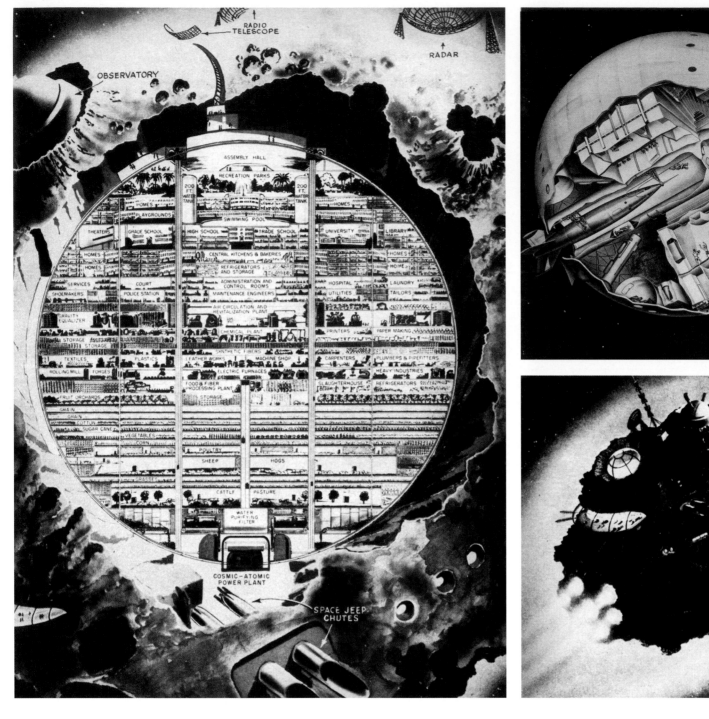

ABOVE LEFT: Legendary science-fiction illustrator Frank R. Paul created this cutaway view of an interstellar space ark built out of a hollowed-out asteroid. Favoring his artistic imagination over scientific fact, Paul powered his ship with a "cosmic-atomic power plant" and provided his crew with imaginary gravity.

TOP RIGHT: Although James Cutter was working at about the same time as Frank R. Paul, he was considerably more accurate when he created this cutaway view of a future space station in 1950. His spherical habitat is given a spin to create artificial gravity while shuttle rockets enter and exit along the spin axis.

BOTTOM RIGHT: Frank R. Paul's interstellar asteroid-ship is seen here in full flight between worlds. While Paul's spacecraft was entirely the product of his fertile imagination, the notion of turning an asteroid into a huge space-traveling colony has been given serious consideration by scientists.

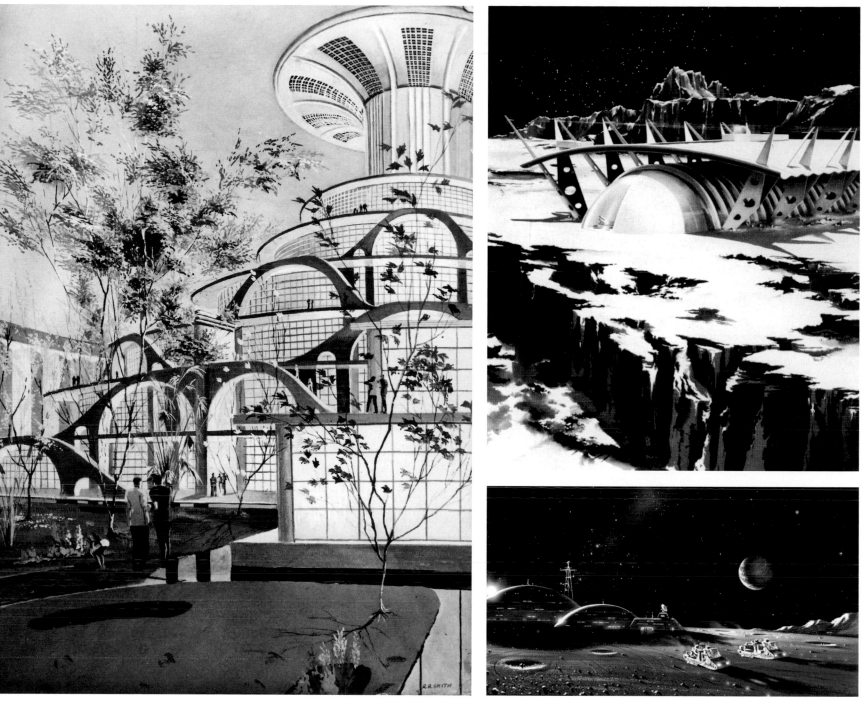

ABOVE LEFT: R. A. Smith designed the interior of this future lunar habitat for the 1954 book, *The Exploration of the Moon*. Moving clouds and sunsets are projected on the inside surface of the dome to help stave off homesickness for its thousands of inhabitants. The low gravity of the moon allows architects the freedom to perform experiments in design that would be impossible on earth.

TOP RIGHT: In 1959, artist Fred Wolff illustrated a lunar habitat designed by the Wonder Building Corporation of America—a company that specialized in self-supporting arched structures. Covered by a meteor shield, the building was 340 feet (104 meters) long, 160 feet (49 meters) wide, and 65 feet (20 meters) high. It contained living quarters, laboratories, and an observatory in the dome in front.

BOTTOM RIGHT: A domed lunar city is depicted in this painting by David A. Hardy, a British artist who has enjoyed perhaps the longest career of any living space artist since his work was first published in 1952. This was originally created as a preproduction painting for a proposed film version of Arthur C. Clarke's novel *A Fall of Moondust*.

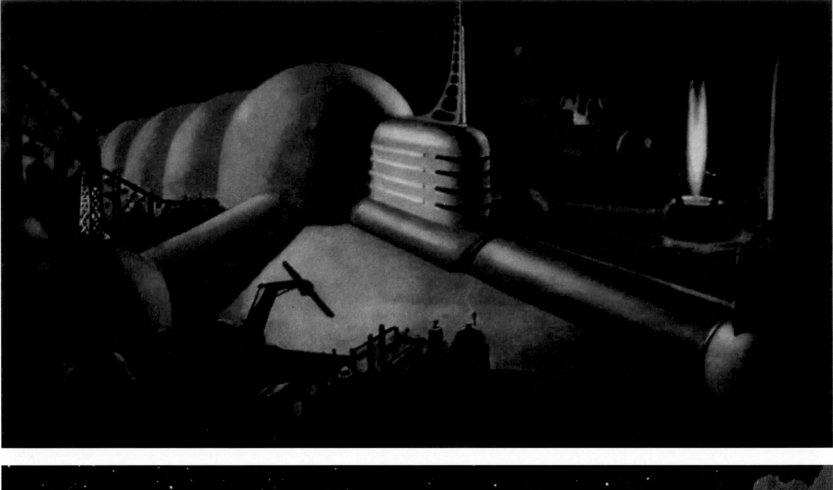

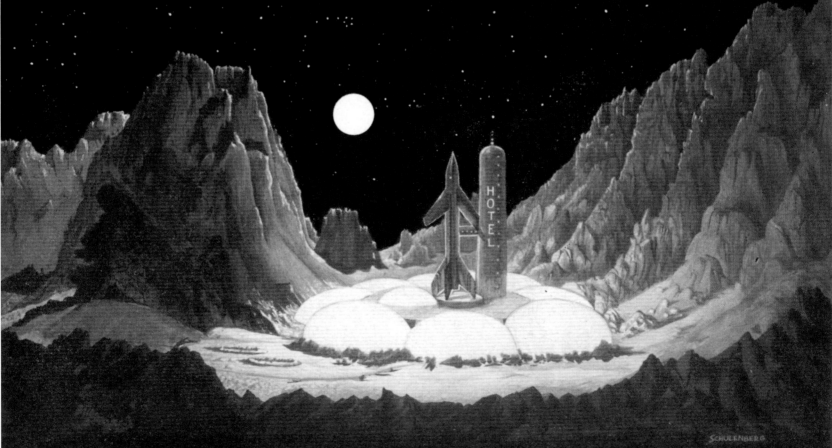

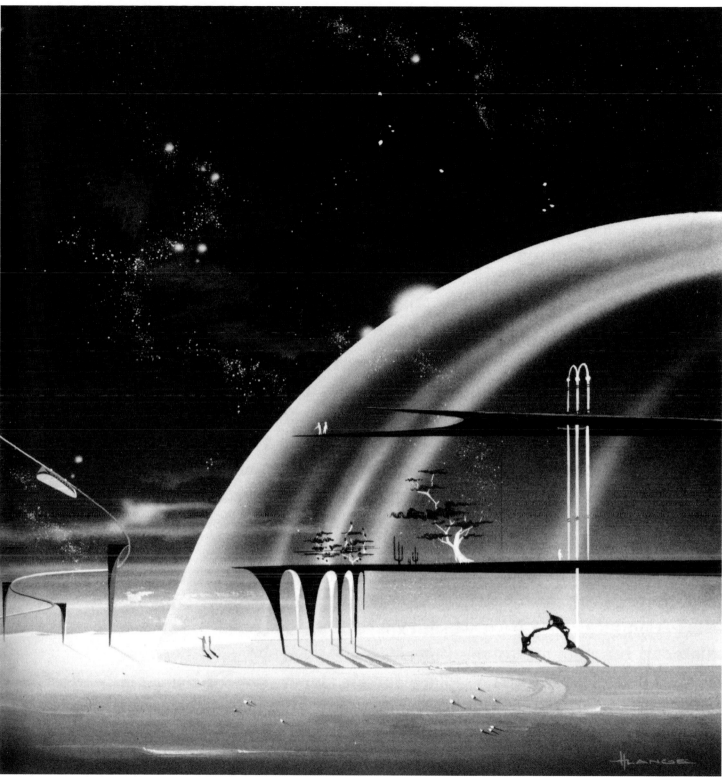

OPPOSITE TOP: Alexander Leydenfrost (1888–1961) was a Hungarian-born American illustrator who specialized in futuristic industrial design. Here is an illustration he created for a 1946 issue of *Collier's* magazine depicting a future lunar base, written by rocketry expert G. Edward Pendray.

OPPOSITE BOTTOM: This 1959 illustration by Robert Schulenberg for an advertisement in *Space Journal* magazine is an imaginative but not entirely unrealistic depiction of a future lunar colony. What sets this apart from most other concepts of the time is the assumption that space tourism would become so important that it would eventually demand amenities such as hotels. Not too surprising in this case, since the ad was for Holiday Inn of Huntsville, Alabama—America's "Rocket City."

ABOVE: Illustrator Hans Kurt "Harry" Lange (1930–2008) was a German-born American artist who specialized in aerospace subjects. He was one of the principal designers for the motion picture *2001: A Space Odyssey*. While heading the future projects section at NASA, he illustrated a number of popular books about spaceflight, often with a distinctly surrealistic touch.

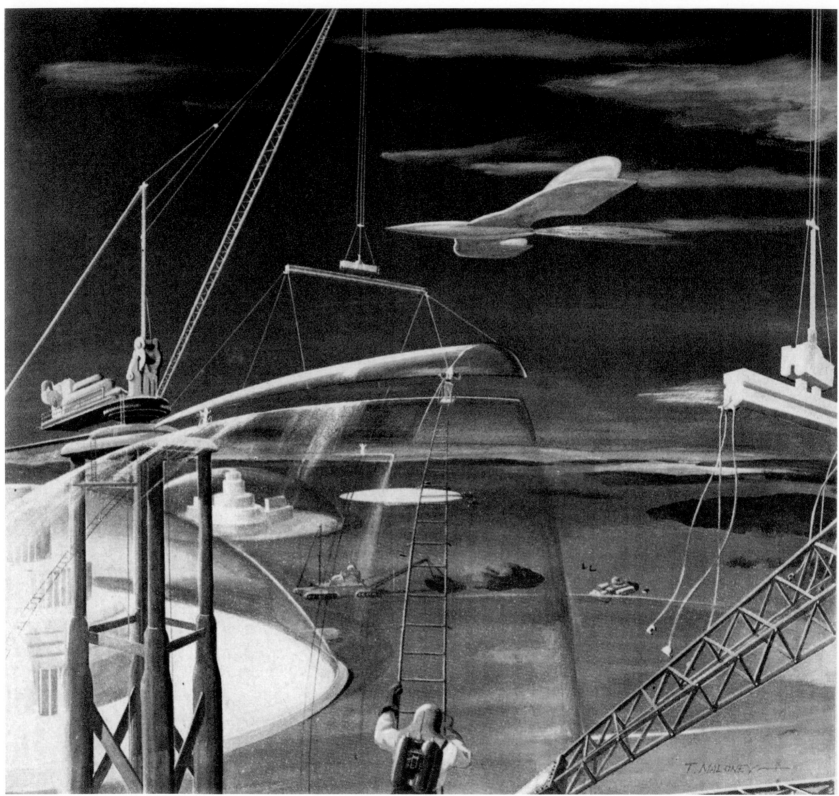

ABOVE: Terry Maloney (1917–2008) was a British writer and illustrator who produced popular books about astronomy such as *Other Worlds in Space* (1957). He was also among the team of artists who contributed to the *Dan Dare* series. Here, Maloney illustrates a future Martian colony under construction.

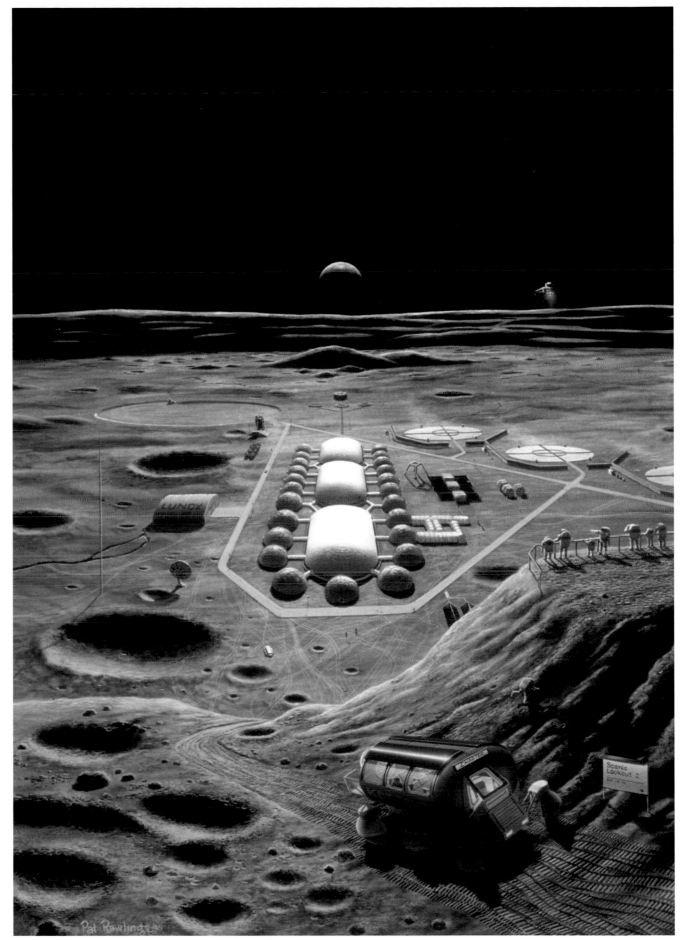

RIGHT: In this 1990 painting, Pat Rawlings gives us a realistic idea of what "Moonville," a future lunar base "thirty years from now" might look like. Moonville not only supports scientists and explorers but an active tourist trade as well.

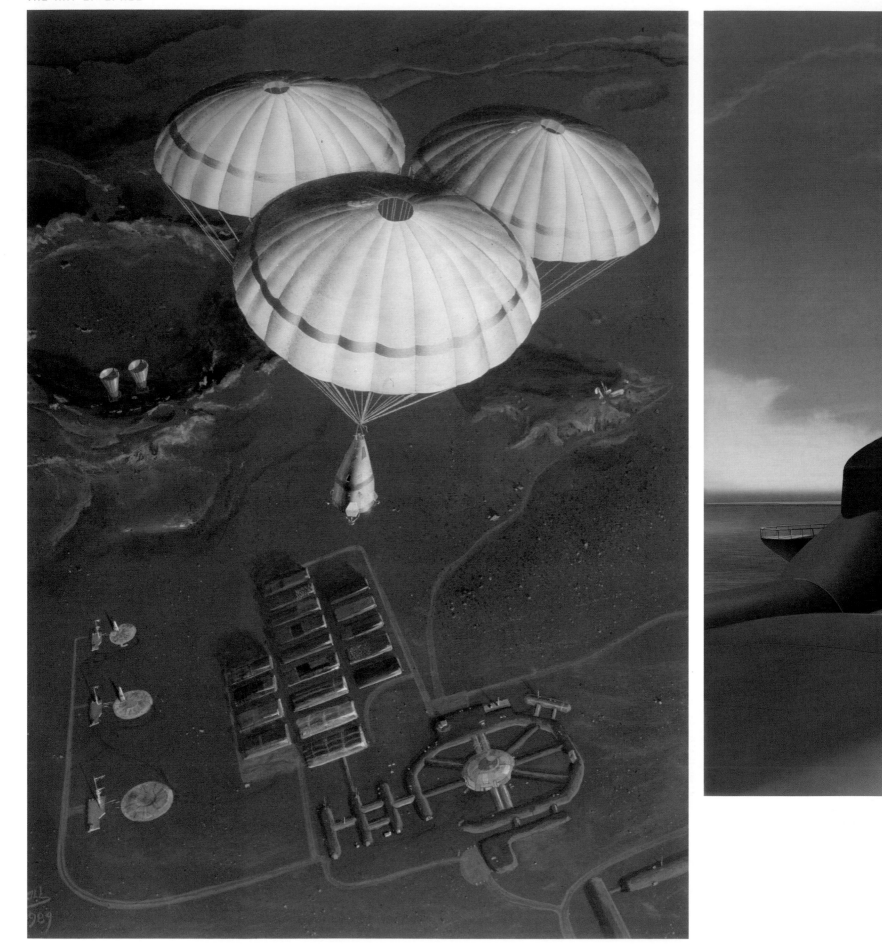

OPPOSITE: Michael Carroll's *Final Descent* shows us a lander's-eye view of the last leg of the long journey from the earth to Mars. The Mars base is a thriving colony of earthlings who have established habitats buried under mounds of Martian soil and banks of greenhouses producing food. The small, cone-shaped objects in the distant crater are the cooling towers for the nuclear power plant

ABOVE: In *Ground Floor*, Pat Rawlings focuses on the earth end of a future space elevator, located on the equator. Made of threads stronger than diamonds, the cable continues to a distance of more than 22,000 miles (35,405 kilometers), where a satellite remains hovering over a fixed point on the earth below—geostationary earth orbit (GEO). The elevator vehicle, traveling at a speed of up to 1,200 miles (1,931 kilometers) an hour, reaches the GEO station 10 hours later.

DON DAVIS:
FROM PAINTBRUSH TO PC

FEW SPACE ARTISTS CAN SAY THAT THEIR ENTIRE CAREER HAS BEEN DEVOTED TO SPACE ART FROM THE VERY BEGINNING. THE RARE EXCEPTION IS VETERAN SPACE ARTIST DON DAVIS, WHO SAYS THAT HE HAS BEEN "INTERESTED IN SPACE-RELATED THINGS EVER SINCE *SPUTNIK 1* WAS ANNOUNCED TO OUR KINDERGARTEN CLASS."

Like many of his fellow space artists, Davis was also inspired by the work of Chesley Bonestell, and tried his hand at astronomical painting while still in elementary school. He still has a watercolor of a space scene he painted at the age of 12.

SCHOOL OF ROCK

While still in high school, Davis went to work for the US Geological Survey (USGS), in their branch of Astrogeologic Studies. Geologist Don Wilhelms took one look at a painting of the moon that Davis had brought along, and he was hired on the spot. One of his first tasks was to create a series of paintings showing the early history of the moon.

Davis's work for the USGS led to his first commissioned and published piece of art, which appeared in *California Living* magazine. It was also around this time that a local exhibition of Chesley Bonestell paintings enabled Davis to finally see original Bonestell works up close, and to learn some of the techniques the artist had used.

Working for the USGS had real advantages for Davis as his "own efforts in space painting began to incorporate knowledge of the surfaces of the Moon and Mars practically as it was being gathered."

Davis joined the staff of the Hansen Planetarium in 1987, providing art for its shows and publications. Hansen began selling its astronomical presentations to smaller planetariums, becoming influential in breathing new life into the medium. Davis was twice artistic director of entire planetarium productions, "where my activities included participation in preparation of scripts, art, and even designing an effects projector." He eventually left the planetarium to work on the PBS shows *Infinite Voyage* and *Space Age*, doing special visual effects.

DIVIDING OPINION

According to Davis, "Among the most widely distributed of my paintings for NASA are a series of depictions of the interiors of giant space colonies of various designs." Many of these artworks were created under the personal direction of famed space habitat popularizer Gerard O'Neill. Davis's works quickly became iconic images of the future colonization of space and are still being reprinted nearly 40 years later.

Davis's space colony illustrations have been both celebrated and criticized. *Co-Evolution Quarterly* editor Stewart Brand declared that one of Davis's paintings "has inspired more belief and roused more ire than any other artifact associated with Space Colonies so far… Either way, it makes people jump."

"AT THE US GEOLOGICAL SURVEY I WAS TO LEARN OF THE FORCES WHICH SHAPE THE LANDSCAPES OF OTHER WORLDS. EVEN IN EARTHLY SCENES, THE GEOLOGISTS LIKED TO POINT OUT WHAT LOOKED NATURAL AND WHAT DIDN'T, AND WHAT MADE THE SCENERY LOOK LIKE IT DID."
Don Davis

Yet one thing is unarguable: Davis's meticulous style and almost obsessive attention to detail and scientific accuracy have served as both a model and an inspiration for scores of other space artists—novices and veteran illustrators alike.

BRUSH WITH FAME

Until the end of the 1970s, all of Davis's paintings were done in oils, using techniques suggested by Bonestell. But after using an airbrush extensively while working on Carl Sagan's TV series *Cosmos* (for which he received an Emmy for his visual effects work), he added it to his permanent set of tools. Davis's work with Sagan also resulted in his work appearing in several of Sagan's books, including the cover of the Pulitzer Prize–winning *The Dragons Of Eden* (1977).

Since then, Davis's work has appeared in venues as diverse as magazines, books, rock music albums, planetarium shows, and museum exhibitions. Most recently, he has been working in motion picture and video special effects. "Now I create art and animations for various television shows and video projections in [software program] Planetaria on my desktop," says Davis. "The machines get faster and I keep piling on the work to slow them back down!"

ABOVE: Don Davis is one of the grand masters of modern space art. Equally adept at depicting both extraterrestrial landscapes and space hardware, he has always set the bar high when it comes to meticulous attention to detail.

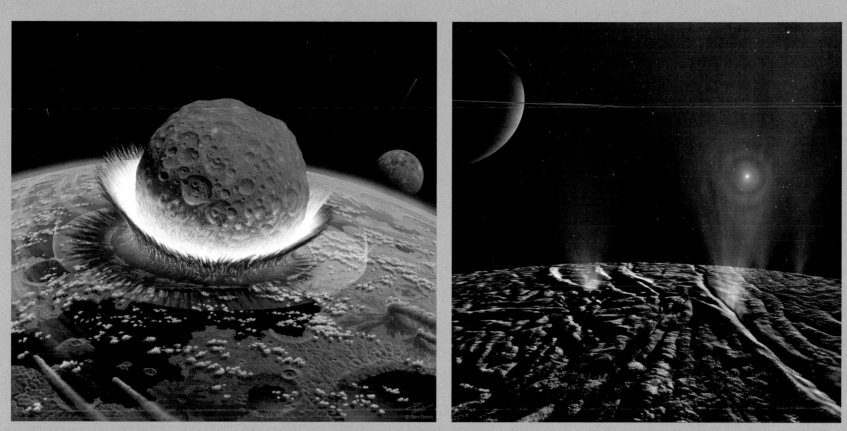

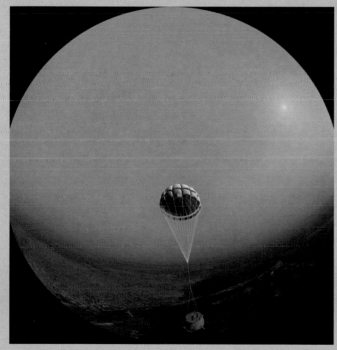

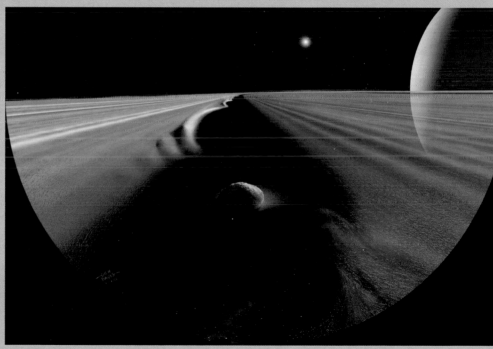

TOP LEFT: Davis has almost made a specialty of depicting asteroid impacts with the earth and other planets. Some of these are among the most reproduced space paintings ever created. Here, he depicts the moment of impact as an enormous asteroid collides catastrophically with the early earth.

BOTTOM LEFT: This fish-eye lens view of the touchdown of the *Huygens* lander on Saturn's giant moon Titan is a typical Davis tour de force. Creating this painting required making certain that every detail on the surface photographed by the lander was in the correct position, as well as also working out the correct distortion caused by the imaginary lens.

TOP RIGHT: The cryogeysers of Enceladus have been one of the most popular subjects for space artists ever since their discovery in 2005. Evidence for large masses of liquid water beneath the surface, the geysers make Enceladus a prime target for future exploration. A nice touch, typical of Davis's attention to detail, is the corona surrounding the sun—an effect created by the tiny ice crystals in the plume.

BOTTOM RIGHT: Daphnis is a tiny moon—barely five miles (eight kilometers) wide—that orbits within a narrow gap in Saturn's rings. As it orbits, its gravity affects the ring material on either side, in much the same way that the wake of a speedboat racing down a river can affect objects along either shore.

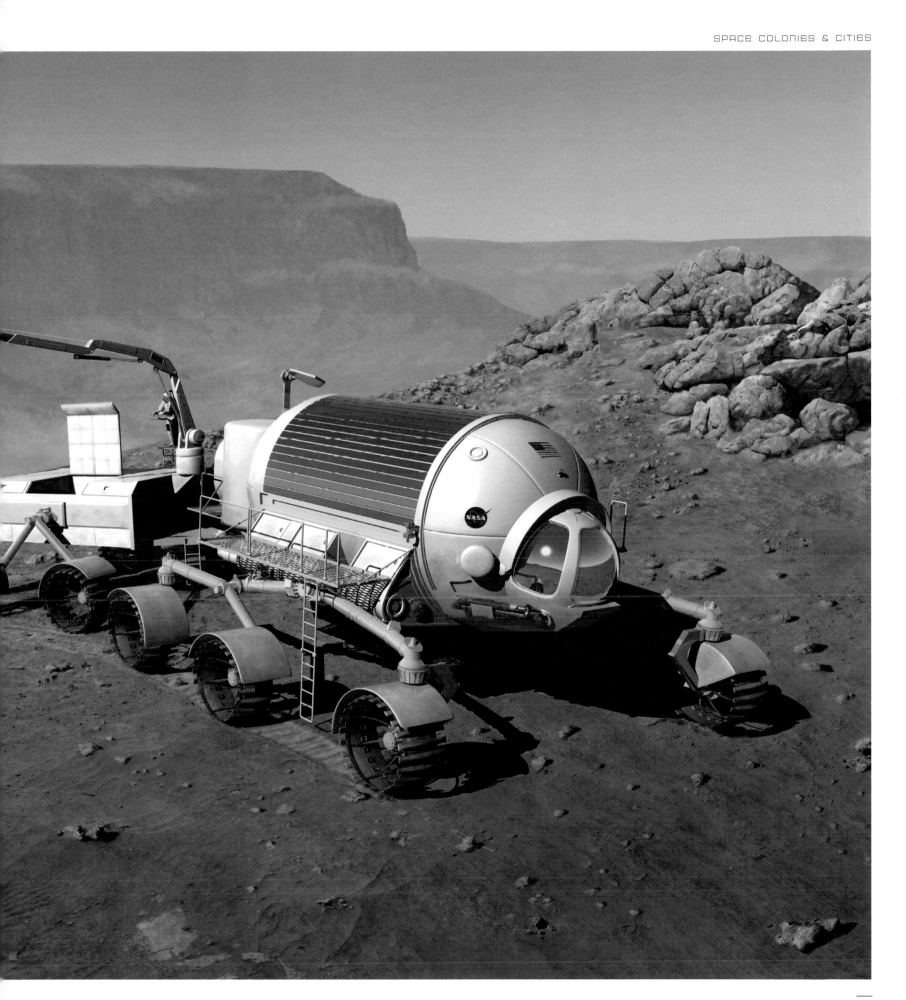

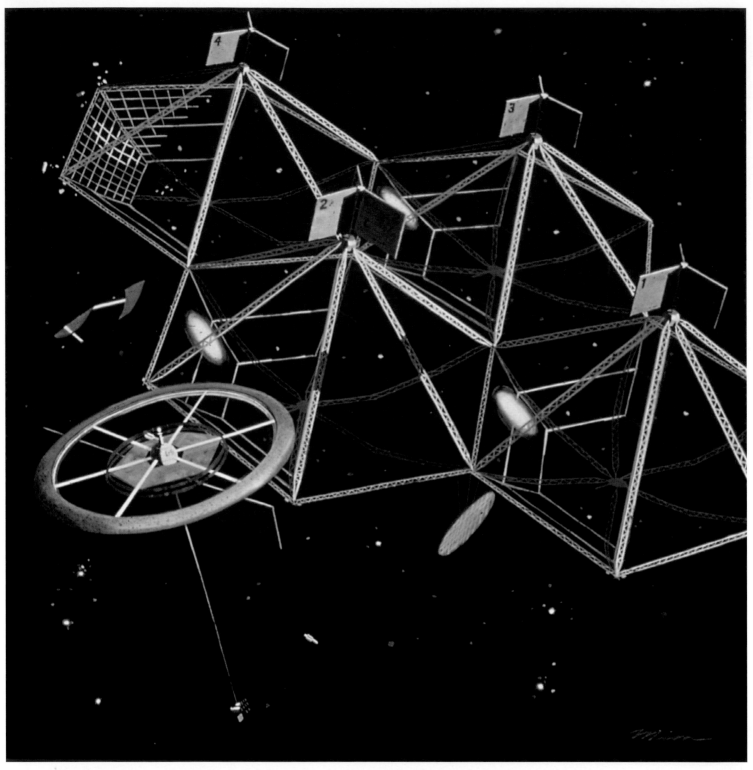

PREVIOUS SPREAD: This anonymous illustration commissioned by NASA depicts the latest thinking about future human exploration of Mars. The vehicles are rolling laboratories and habitats, capable of sustaining astronauts for days at a time as they roam the Martian landscape. The umbrellalike device provides solar-generated power while communication with the main base is achieved via an orbiting satellite link.

ABOVE: A space colony is dwarfed by a gigantic solar power generator in this 1976 Pierre Mion painting. More than six miles (10 kilometers) wide, it will eventually be towed to a geosynchronous orbit where it will generate power that will be beamed to earth as microwave energy, to be received by giant ground-based antennae and converted into electricity.

OPPOSITE: John Olson (1922–2001) was a prolific illustrator of aerospace subjects. As principal engineer in concept and design for Boeing and later as a consultant for both Boeing and NASA, he helped develop numerous future space projects. One of these was this proposal for a manned Mars lander. In 1985, he was honored with a one-man show of his work at the National Air and Space Museum in Washington, DC.

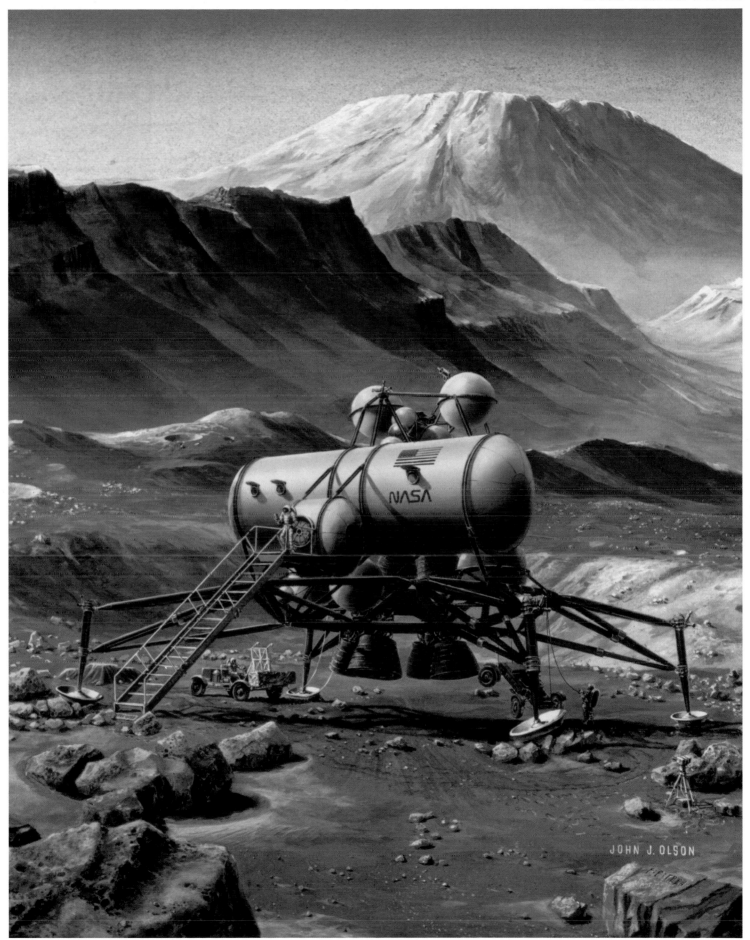

JOHN J. OLSON

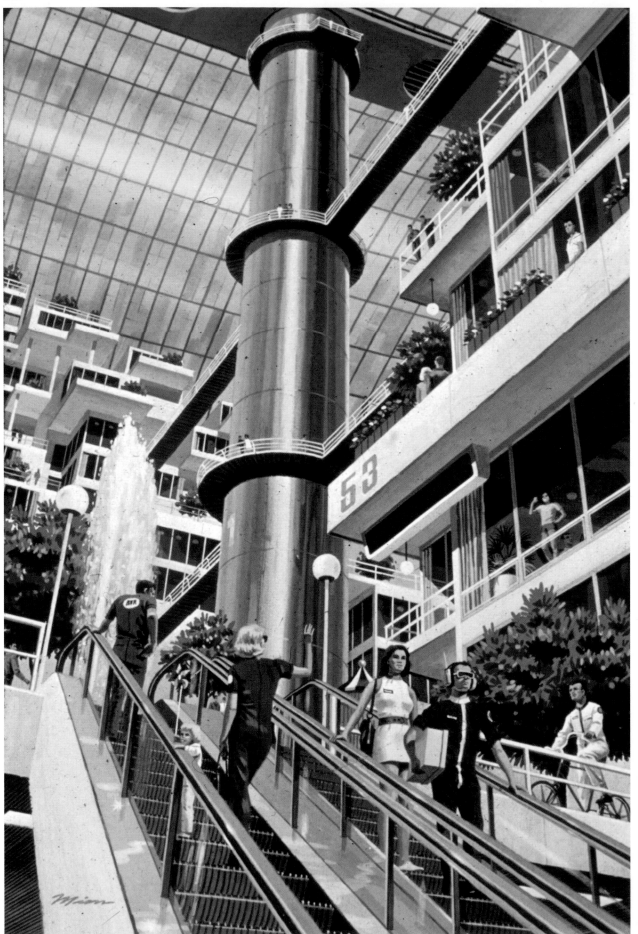

LEFT: In illustrating *Main Street, Hometown, Cosmos*, artist Pierre Mion depicts a typical day in the life of space colony inhabitants. Modular habitats are relieved by the presence of fountains and fruit trees, while climate and sunlight can be adjusted to suit.

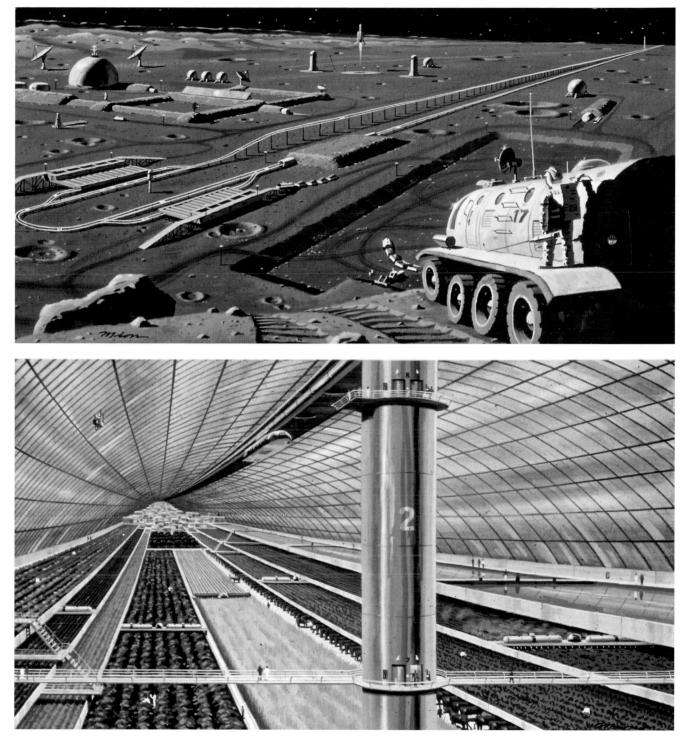

TOP: Pierre Mion's vision of a future lunar colony includes habitats buried under thick blankets of soil to protect the inhabitants from deadly solar radiation. The long track extending toward the horizon are the rails of an electromagnetic accelerator, which is used to launch unmanned cargo—such as raw ore mined on the moon— toward the earth.

BOTTOM: In another Pierre Mion view of space colony life, he shows us one of the "farms," where crops are grown and livestock raised on staggered "shelves" under the vast, glass-paned roof. A monorail connects the residential areas while elevators in the vertical spokes of the wheel transport passengers to and from the low-gravity central hub.

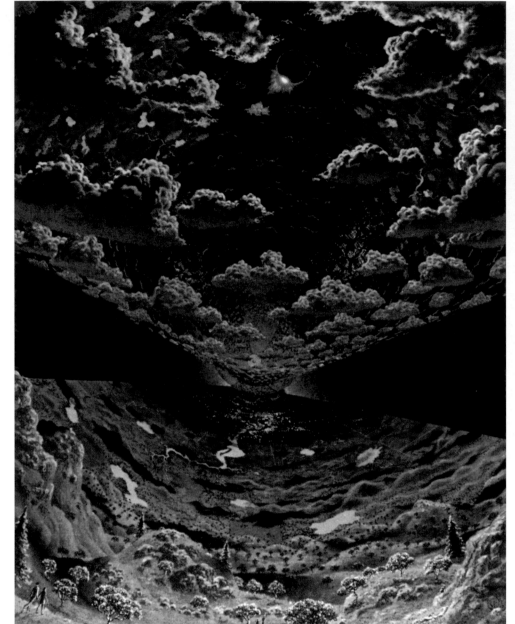

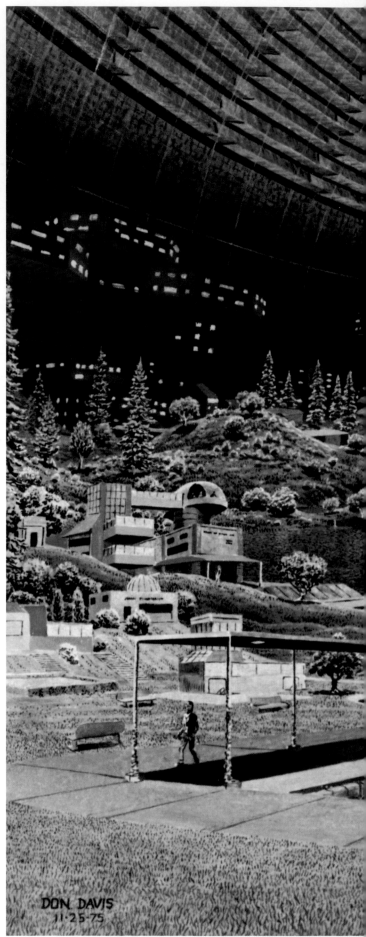

ABOVE: In the heyday of interest in orbital space colonies during the late 1970s, artist Don Davis was the go-to man for artwork. Here he shows us the interior of a Gerard O'Neill space habitat: an enormous cylinder with petallike mirrors reflecting sunlight into the interior.

RIGHT: In this 1975 painting, Don Davis illustrates what the interior of a toroidal—donut-shaped—space colony might looks like, one similar to that depicted by Pierre Mion on page 159. As the habitat spins on its axis, artificial gravity is created for the hundreds of thousands of people living on board.

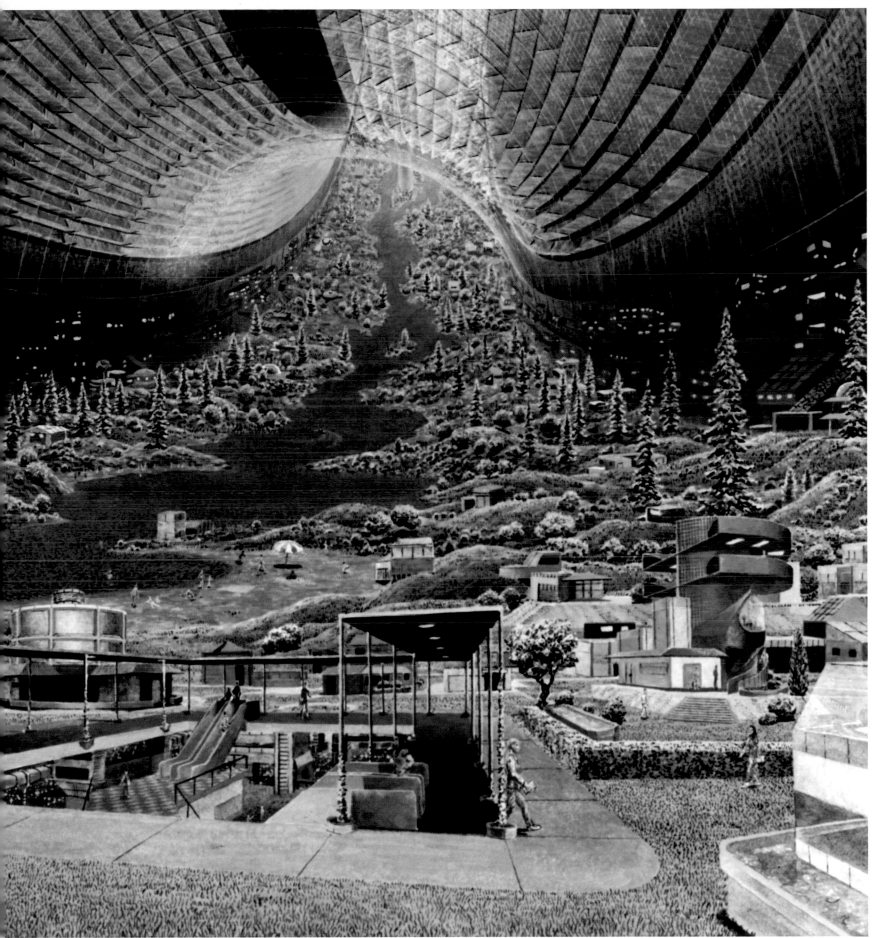

EXO-PATS:
LIVING IN SPACE

THE IDEA OF SPACE STATIONS HAS BEEN AROUND FOR 150 YEARS. BUT ON THE WHOLE, THESE WERE NEVER INTENDED TO BE PERMANENT HABITATIONS. INSTEAD, CREWS WOULD COME AND GO, MUCH AS THEY DO ON THE INTERNATIONAL SPACE STATION OR *MIR*. THE NOTION OF PEOPLE LIVING PERMANENTLY IN SPACE HAS ONLY RECENTLY CAPTURED OUR IMAGINATIONS.

It's true that science fiction invented the concept of the generation starship, or space ark—wherein only the distant descendants of the original passengers and crew would arrive at the final destination. But these were still just spaceships, and while generation after generation of humans may be born, live, and die on board, there was still an ultimate end to their journey.

ARTIFICIAL WORLDS

Colonizing the planets themselves is a staple of science fiction and an idea that is no less popular with scientists and futurists. Plans for permanent settlements on the moon and Mars are always on the drawing board. Any such plan faces two serious problems, however. One is that the available space is severely limited. Although there is plenty of real estate in the solar system, very little of it—perhaps only a few times the surface area of the earth—is remotely suitable for human habitation. At best, a world like Mars would have to be terraformed in order to make it genuinely livable, a process that would require vast technologies, energy, and time. The second problem with colonizing an existing planet or moon is that any spaceship entering or leaving its atmosphere has to fight against that world's gravity well using up inconceivable amounts of expensive and hard-to-get fuel in the process.

Might, then, it make more sense to build a world entirely from scratch, avoiding the problems and pitfalls of a natural planet? Gravity might present a problem to spaceships but it can be very convenient for human beings. However, on board a large craft such as a space station, gravity can be simulated with a mere gentle rotation of the ship—and this gravity would be limited to the interior. Any spacecraft outside the station would be unaffected. They could come and go freely, without worrying about climbing their way out of gravity wells.

O'NEILL'S ISLANDS

American aeronautical engineer Darrell Romick was probably the first to seriously conceive of a large-scale space habitat. In the 1950s he worked out an elaborate plan that would have 10,000 people living in space. The idea really caught on with the public, however, with the colossal space colonies developed by Princeton physicist Gerard O'Neill (1927–1992).

First popularized in his 1976 book *The High Frontier*, O'Neill proposed three different types of habitat, all to be constructed from raw materials gathered from asteroids or launched from the moon.

The first (Island 1) was to be an enormous rotating sphere 1,500 feet (457 meters) in diameter. Ten thousand people would be able to live in this and donut-shaped greenhouses would contain farms, providing food and oxygen for the space colonists. The second proposal, Island 2, would resemble a vast bicycle wheel 1.2 miles (1.8 kilometers) across with its 10,000 inhabitants living inside the 427-foot-(130-meter-)wide "tube." The third and largest of the habitats, Island 3, would be a pair of connected cylinders each 5 miles (8 kilometers) in diameter and 20 miles (32 kilometers) long. The total land area inside the two cylinders would be about 500 square miles (1,300 square kilometers). Each cylinder would rotate on its long axis in order to create artificial gravity. Several million people would live in Island 3 in a self-contained, self-sustaining environment that would not only feature individual homes, but parks and farmland.

"A LARGE, INHABITED SATELLITE TERMINAL CAN CERTAINLY BE CONSTRUCTED—A GLISTENING 'CITY IN THE SKY'... AND IT CAN BE A VISIBLE SYMBOL AS IT GROWS OF THE GREAT PROMISE OF NEW SERVICE, NEW KNOWLEDGE, INSPIRATION, AND ACCOMPLISHMENT FOR ALL MANKIND. ITS POTENTIAL SEEMS UNLIMITED—A STEPPING-STONE TO THE MOON, TO THE PLANETS, AND BEYOND."
Darrell Romick, *Manned Earth-Satellite Terminal Evolving from Earth-to-Orbit Ferry Rockets* (METEOR), 1956

As ambitious as these plans were, NASA took O'Neill's ideas seriously and in the 1970s, their Ames Research Center undertook three studies on space habitats—concluding that such designs would have real advantages. The physically disabled, for instance, might establish a zero-gravity habitat that would make wheelchairs and walkers unnecessary. Escape-proof penal colonies could be created. Political factions, religions, and cults could create their own colonies where they could live according to their own views without interference.

SPACE RACE

While the first space colonists would probably be trained specialists, the habitats would eventually house ordinary people. Eventually, NASA expects, most people in space settlements will be born there. In fact, the population of the habitats might one day exceed that of the earth—with perhaps as many as 10 trillion people living in orbiting colonies. The combined living space of such a situation might exceed that of the earth by hundreds.

OPPOSITE, ABOVE LEFT: British artist T. E. Branton created this illustration for *The Giant Book of Amazing Stories* (1952). It was one of a spate of books for children about astronomy and spaceflight that flooded bookshelves during the 1950s and early 1960s, a reflection of the vast public excitement about the dawn of the space age. The pair of astronauts appear to be exploring Saturn's moon Titan, in a landscape likely inspired by Chesley Bonestell's classic painting (see page 28).

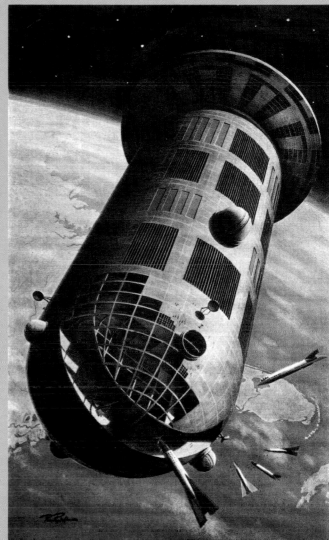

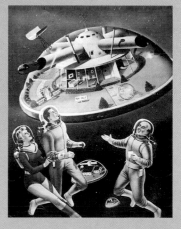

BOTTOM MIDDLE: Frank R. Paul did the cover painting of *Astropol*, the space station that figures prominently in Otto Willi Gail's 1930 story, "The Stone from the Moon," published in *Science Wonder Quarterly*. Gail was one of the most popular science-fiction authors in Germany during the early decades of the twentieth century and, like many other German science-fiction authors, closely followed the work of Hermann Oberth and Max Valier.

TOP RIGHT: In the late 1950s, Goodyear engineer Darrell Romick devised a complex plan for the systematic exploration of space. A central part of this was the construction of a vast space habitat that would house tens of thousands of people (see page 110). Romick's was the first detailed proposal for the kind of orbiting space colony popularized by O'Neill in the 1970s.

BOTTOM RIGHT: *Outer Space Real Estate* is a tongue-in-cheek look by artist Alex Schomburg at what might become a reality in the near future. It appeared on the December 1953 cover of *Science Fiction Adventures* magazine.

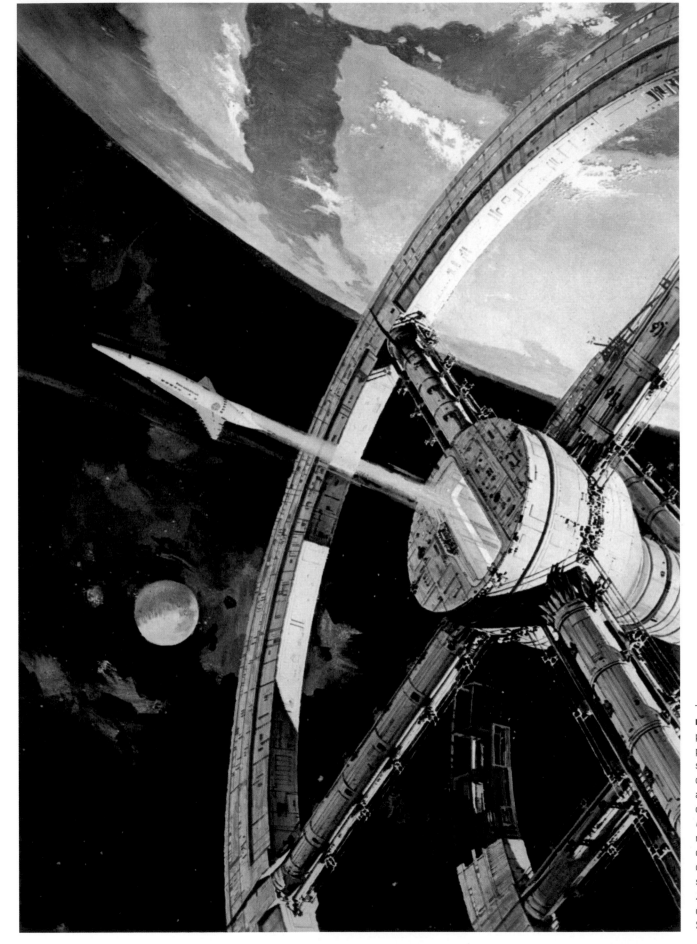

LEFT: Robert McCall (1919–2010) was probably one of the twentieth century's premier illustrators of spacecrafts and space exploration. He was the natural choice when it came time to select an artist to create the posters for the classic motion picture *2001: A Space Odyssey* (1968). In this, probably the most iconic of the images, McCall depicts one of the *Orion* space shuttles departing the giant, double-wheeled space station. McCall's paintings for *2001* now reside in the permanent collection of the National Air and Space Museum in Washington, DC.

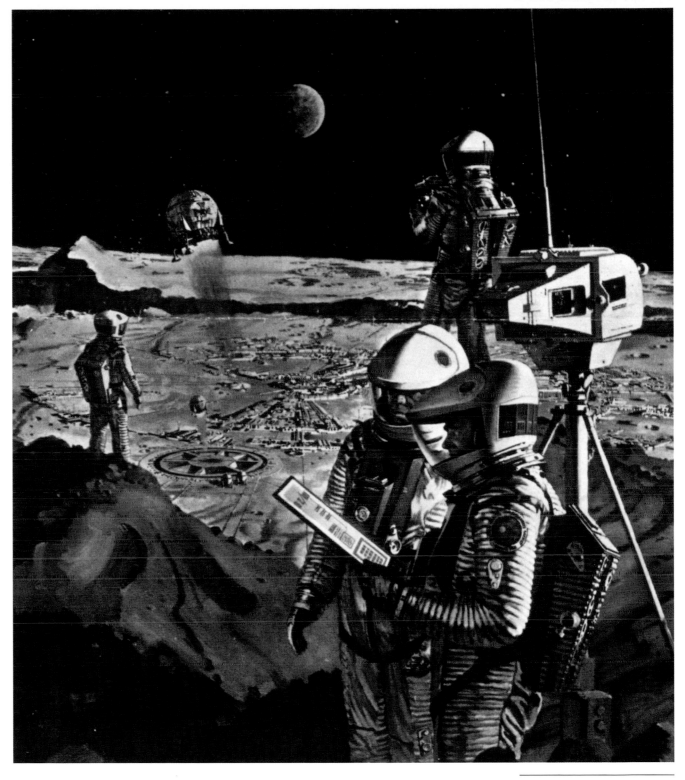

ABOVE: Two of a quartet of astronauts on a surveying party look out over the distant lunar settlement that has been built in the crater Clavius. Director Stanley Kubrick's obsessive attention to scientific accuracy in the film *2001: A Space Odyssey* made Robert McCall —who had decades of experience depicting military and astronautical subjects—the ideal poster artist.

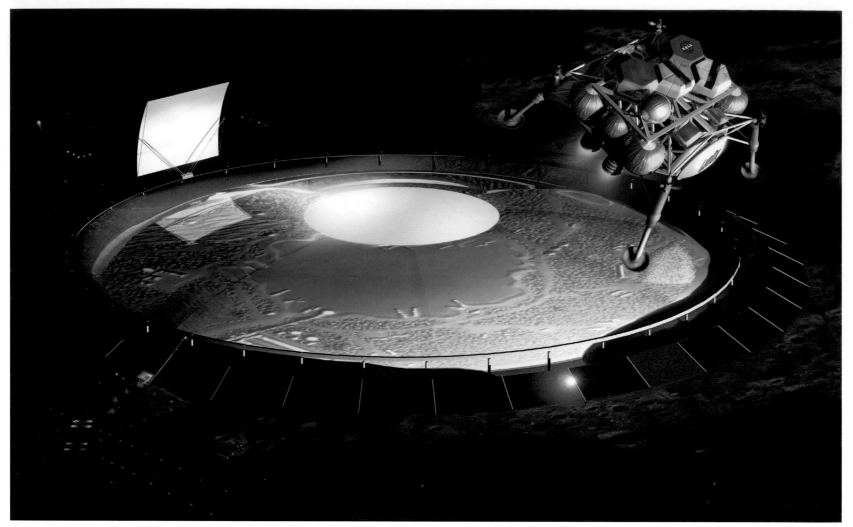

ABOVE: In *Bottom Land*, Pat Rawlings illustrates a vast, domed, solar-powered colony at the lunar south pole. It's known that water ice exists in large quantities at the lunar poles, a resource that would be of immense benefit to any future habitat.

OPPOSITE TOP: If future Olympic games were to be held on the moon, athletes could take advantage of the gravity being only one-sixth of that on earth. Pat Rawlings imagines the potential results—pole-vaulters clear 90 feet (27 meters) and human-powered flight is an exciting new addition to the competition.

OPPOSITE, BOTTOM LEFT: British artist Leslie Carr (1891–1961) created this stunning illustration of a future lunar city in the early 1950s. Best known for his dramatic paintings of ships and locomotives, he often collaborated with R. A. Smith in bringing the latter's black-and-white paintings to life as color renderings.

OPPOSITE, BOTTOM RIGHT: Rick Guidice created this almost abstract rendering of a Gerard O'Neill space colony for the NASA report *Space Settlements—A Design Study* (1977), for which he did a large number of equally striking paintings.

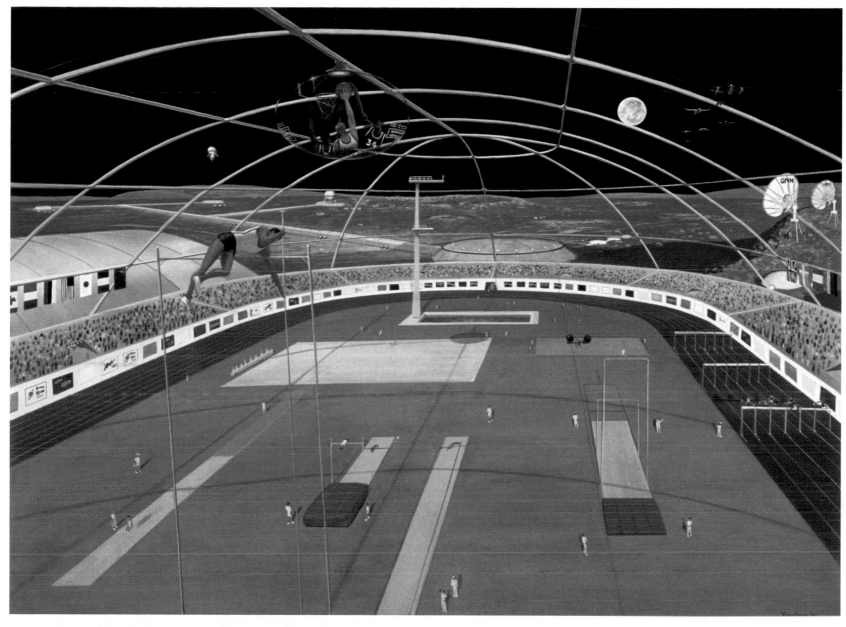

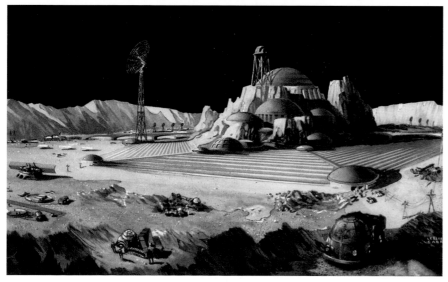

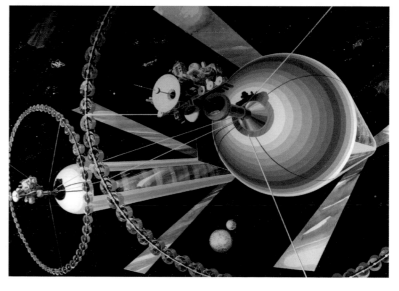

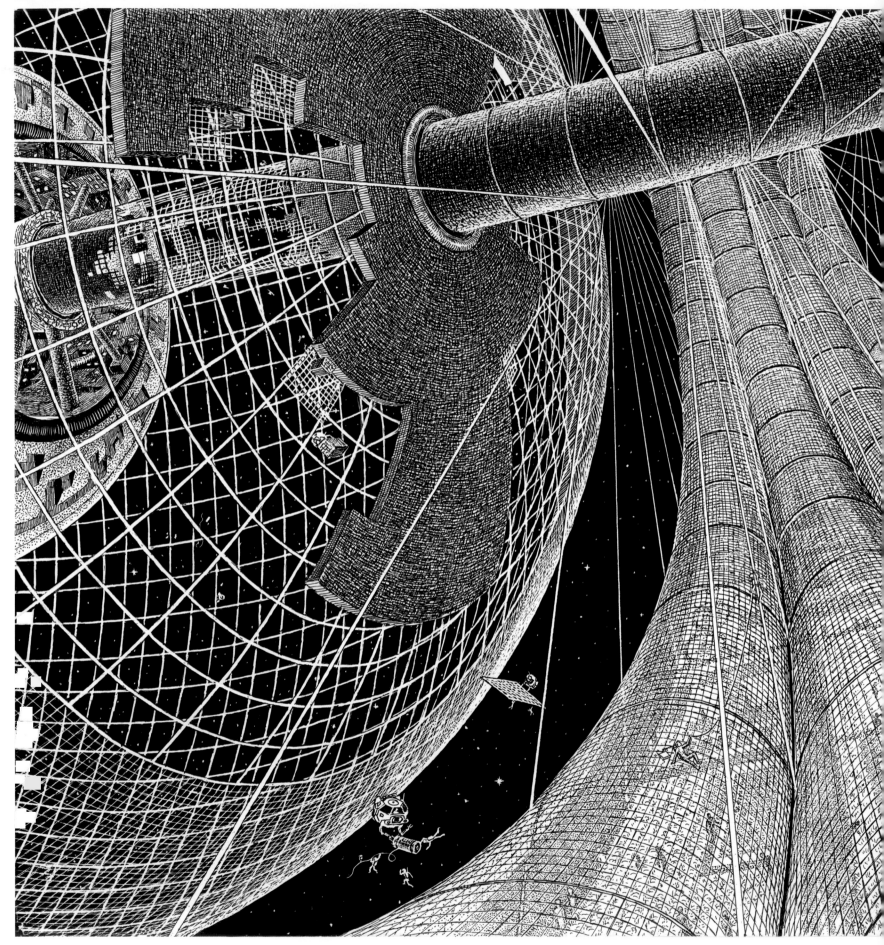

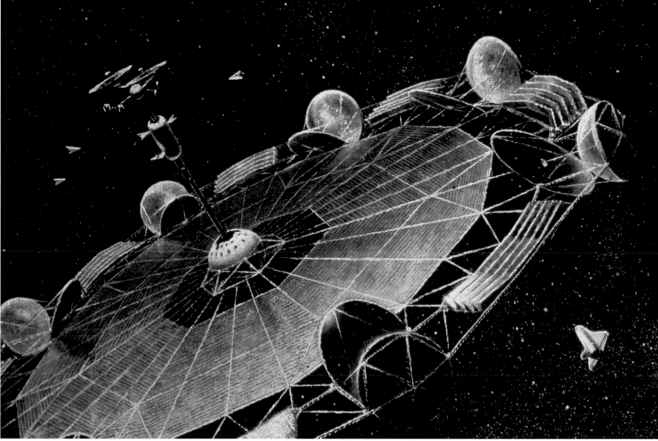

LEFT: This pen-and-ink and scratchboard illustration of a future Bernal sphere space colony under construction is a tour de force by virtuoso space artist Don Davis, who manages to create a spectacularly powerful abstract design while at the same time paying rigorous attention to detail.

ABOVE: A Soviet-era version of a future orbiting space colony probably painted by the great Russian space artist Andrei Sokolov in the 1970s. Mirrors reflect sunlight into the dome-shaped greenhouses while power is generated by a vast spread of solar cells.

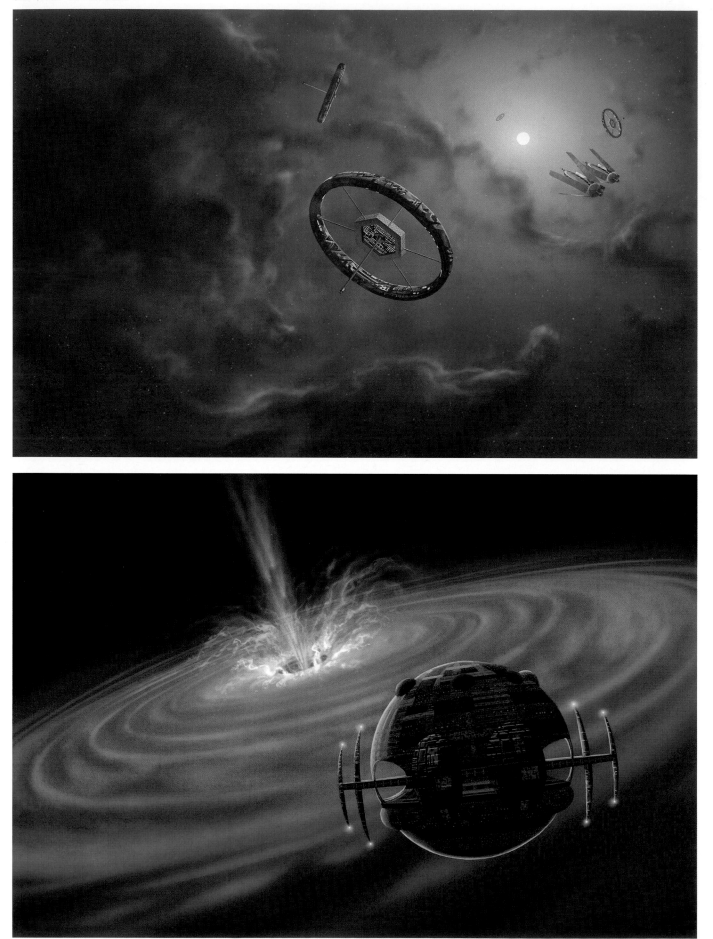

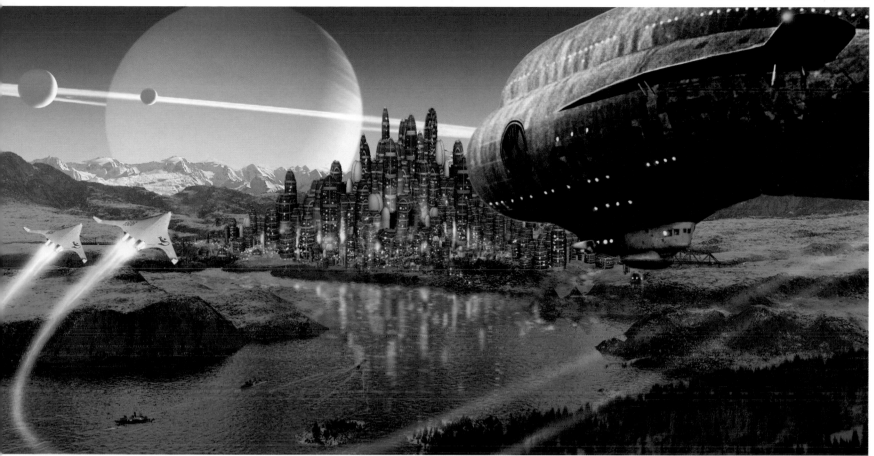

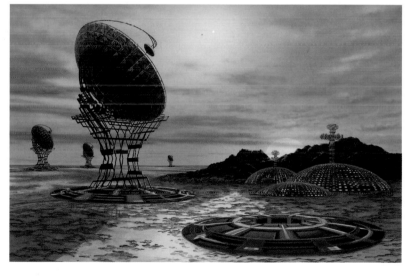

OPPOSITE TOP: This dreamlike painting by Lynette Cook depicts a colony of space habitats orbiting close to a white dwarf star (upper right). She has imagined that intelligent life-forms have migrated away from their dying planet to be nearer the white dwarf, in order to ensure that they receive enough energy to survive.

OPPOSITE BOTTOM: In this 2005 painting, Lynette Cook has imagined a bizarre scenario: a space habitat so large that it is literally an artificial planet, set in orbit around the seething cauldron of a black hole.

TOP: Ron Miller originally created this painting as the cover for *Coyote Destiny*, part of a series of novels by Alan Steele. At this point in the story, the colonists of the earth-sized moon Coyote have created large, populous cities, but still depend on relatively low-tech transportation, such as the dirigible shown here.

BOTTOM LEFT: *Canyon City* by scientist-artist Dan Durda depicts the night-lights of a city on a distant exoplanet. A city inhabited by aliens or human colonists? It's impossible to say.

BOTTOM RIGHT: SETI—the search for extraterrestrial intelligence—can work both ways. Here, Lynette Cook imagines a scientific outpost on a planet orbiting a double star system. The intelligent life-forms on this world are using giant antennae to patiently search the galaxy for signs of other intelligent life.

ROCKETS, RAY GUNS, AND ROGERS:
SPACE CRAZE TOYS

LONG BEFORE THE GENERAL PUBLIC, LET ALONE SCIENTISTS AND ENGINEERS, TOOK SPACE TRAVEL SERIOUSLY, KIDS WERE PLAYING WITH SPACESHIPS. TALES OF SWASHBUCKLING, INTERGALACTIC ADVENTURERS COULD BE FOUND IN SCIENCE-FICTION COMICS, RADIO PLAYS, AND FILMS—MAKING THEIR WAY FROM FAR-OFF GALAXIES TO CHILDREN'S PLAYROOMS.

The first Buck Rogers toys appeared in 1933. Rogers had made his debut five years earlier in "Armageddon 2419," a sci-fi adventure published in *Amazing Stories*. This soon spawned a newspaper comic strip and a weekly radio show, which in turn spawned a seemingly endless catalog of toys. In the decade before World War II, these models eventually numbered in the hundreds. Among them were Buck Rogers chemistry sets, fireworks, telescopes, model kits, costumes, wristwatches, ray guns, and lead-casting sets that would probably never be allowed on the market today. A year after the first Buck Rogers toys appeared, his archrival, Flash Gordon, debuted. Although Flash generated fewer toys than Buck, they are no less prized today.

A GOLDEN AGE

Following the end of World War II, the realization that space travel was an imminent possibility created a Golden Age of science-fiction toys in the 1950s and 1960s. The reality of the fabulous V2 rocket, a seemingly endless stream of articles in popular magazines by experts such as Wernher von Braun and Willy Ley, the success of movies like *Destination Moon* (1950), the immensely successful *Collier's* magazine series, a series of television documentaries about the future of space travel produced by Walt Disney… all of these things contributed to what amounted to mass hysteria on the subject of space travel. Needless to say, toy manufacturers were not slow to take advantage of this.

Between the end of the war and the beginning of the Apollo program, thousands of space-related toys crowded on to the market—everything from space helmets and ray guns to games and model rockets. Many of these were spin-offs of the children's science-fiction TV programs that were crowding the airwaves: *Space Patrol, Rocky Jones, Captain Video*, and *Tom Corbett*. These shows generated almost as many products as Buck Rogers and Flash Gordon had 20 years earlier.

Most of these toys made no more attempt at realistically depicting space travel and spacecrafts than did their predecessors in the 1930s, but there were a few manufacturers who made an effort to reflect what was going on in real time. They were influenced by events such as the launch of *Sputnik*, the Mercury and Apollo programs, and futuristic plans being published by reputable scientists and aerospace companies. Especially notable were a number of manufacturers of plastic model kits who consulted with experts such as von Braun, Ley, Elwynn Angle, and Krafft Ehricke. Some of these went so far as to include booklets detailing with scrupulous accuracy every aspect of the imaginary spaceship's mission.

"WE CARRY CHILDHOOD IN US TILL THE LAST MOMENT OF OUR LIVES"
Harlan Ellison, *Blast Off!*, 2001

When public interest in space travel wound down after the 1970s, demand for space toys slumped. It was left to Hollywood to take up the slack. Where toy stores were once filled with toys inspired by moon rockets, space stations, and interplanetary probes, children now played with spaceships from *2001: A Space Odyssey* (1968), *Star Wars* (1977), and *Star Trek* (1979). Real spaceships fared less well: the *Space Shuttle*, the last actual spacecraft to inspire a large number of toys, had already lost much of its play appeal long before its last flight in 2011.

TOYS OF THE FUTURE

Will there be a resurgence of space-inspired toys in the future equal to that of the 1950s and 1960s? Probably only if something occurs that genuinely sparks the public imagination in the way the early years of spaceflight did. The success of the recent Mars rovers, which proved surprisingly popular with both children and adults, came very close to doing this.

Whatever the inspiration for fresh space toys may be, it will have to be something new—some great adventure no one has achieved before. Just as flight was an international fad during the 1920s and 1930s, but lost its glamour once air travel became commonplace, so too did spaceflight lose much of its excitement once astronauts began traveling into space routinely. What will rekindle a new Golden Age of space toys? A mission to Mars? Time alone will tell.

ABOVE: Trailing the word "Mir" (peace) in its wake, a model of the Soviet satellite *Sputnik* zooms over the base of a music box playing the "Sputnik March." The national pride that Russians felt from their accomplishments in space is evidenced by the fact that this souvenir was still being manufactured and sold 30 years later.

ABOVE: In the two decades following World War II, in the heyday of the space fever that swept the world, there were few consumer products that did not feel its effects. From tin toys mass-produced by the tens of thousands in Japan (top right), to American automobiles (bottom right), the themes of rockets and space travel were everywhere. The Oldsmobile Rocket 88 (which referred to the engine, not the car itself) was produced under that name from 1949 to 1960. The button (upper left) was a souvenir of the 1939 New York World's Fair, where visitors to the Chrysler Motors "World of Tomorrow" exhibition witnessed the simulated launch of a rocket to the moon. In the center are two brands of Russian cigarettes— "Cosmos" and "Sputnik"—along with an American-made, rocket-shaped cigarette lighter.

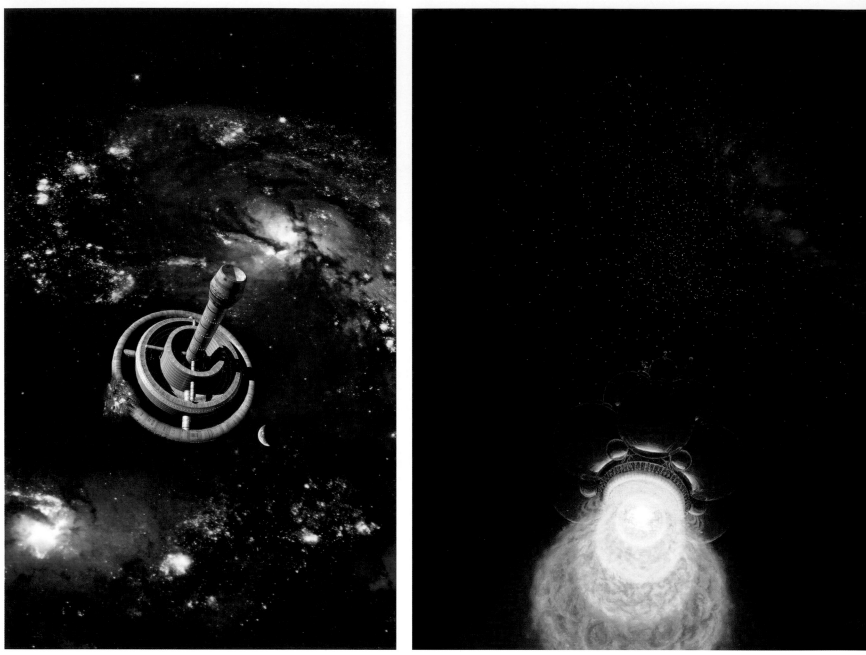

ABOVE LEFT: Don Dixon illustrated the "Chandeliers"—huge space habitats that provided humanity's last refuge before its destruction by an alien civilization—for the cover of *Great Sky River*, a 2005 novel by Gregory Benford.

ABOVE RIGHT: Don Davis shows us the launch of the fusion-powered *Daedulus* starship, a project proposed by the British Interplanetary Society in 1973–1978. Capable of achieving 12 percent of the speed of light—22,320 miles (35,921 kilometers) per second —it could reach the nearest star system in 50 years.

OPPOSITE: Artist Aldo Spadoni's painting of a future orbiting space city was created in 1996. The giant habitat consists of rotating rings stacked like the layers of a cake, each home to thousands of individuals.

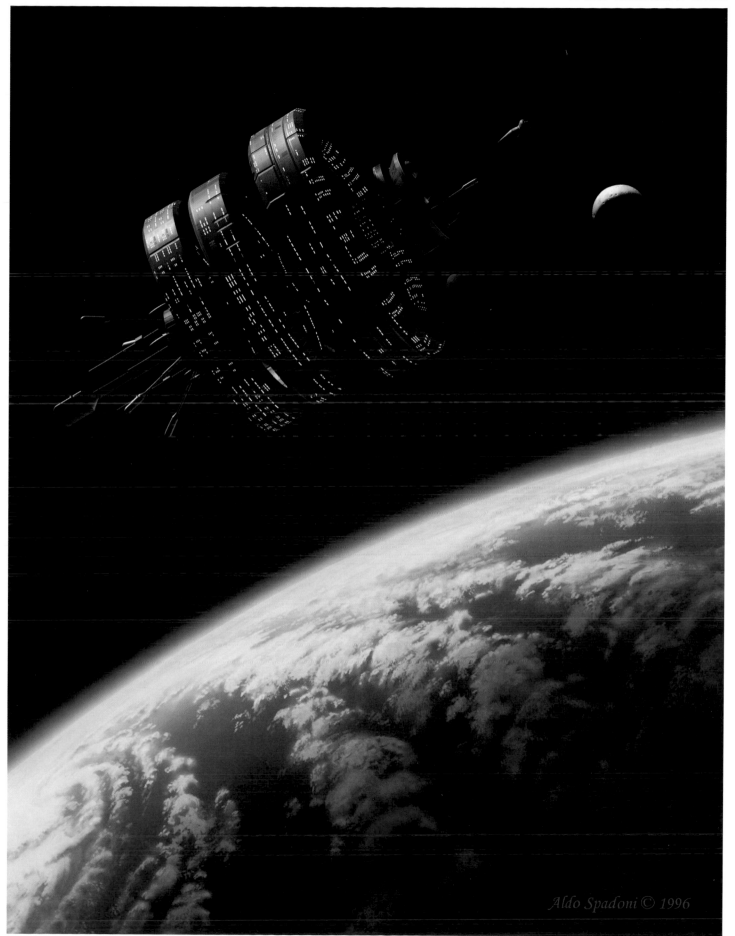

Aldo Spadoni © 1996

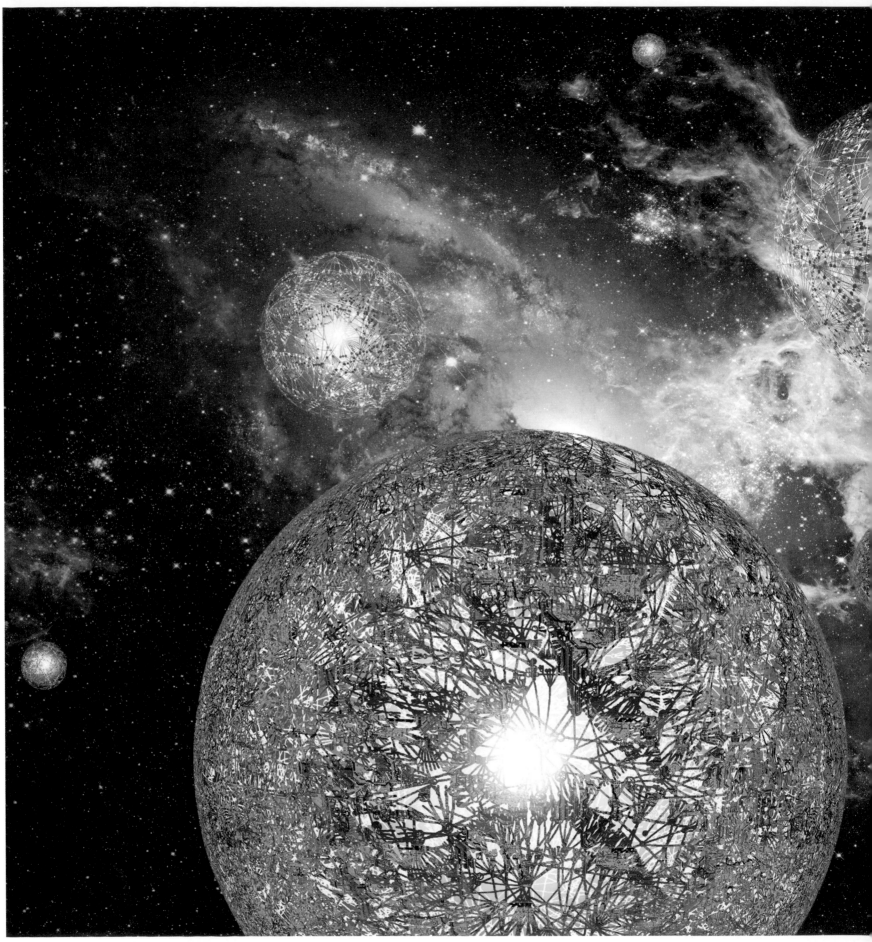

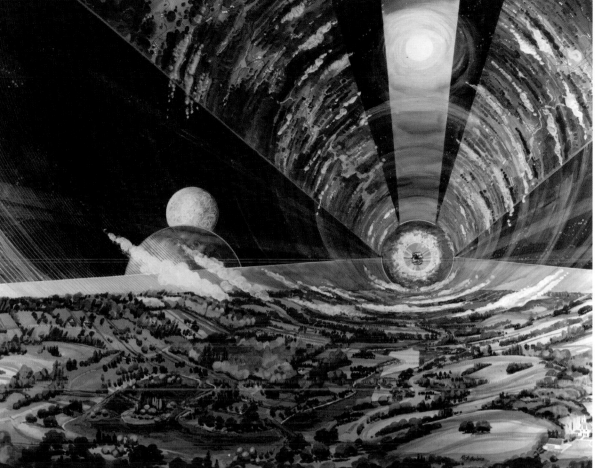

LEFT: In the 1950s, physicist and futurist Freeman Dyson realized that any sufficiently advanced civilization would eventually require *all* the energy produced by the star its planet orbits. The only way to do this would be to surround the star completely with energy-collectors. Artist Ron Miller has chosen to depict these "Dyson Spheres" in an entirely speculative and probably completely imaginary manner.

ABOVE: Another view inside a Gerard O'Neill–type space colony painted by Rick Guidice in the 1970s for NASA's studies of the feasibility of future orbiting habitats.

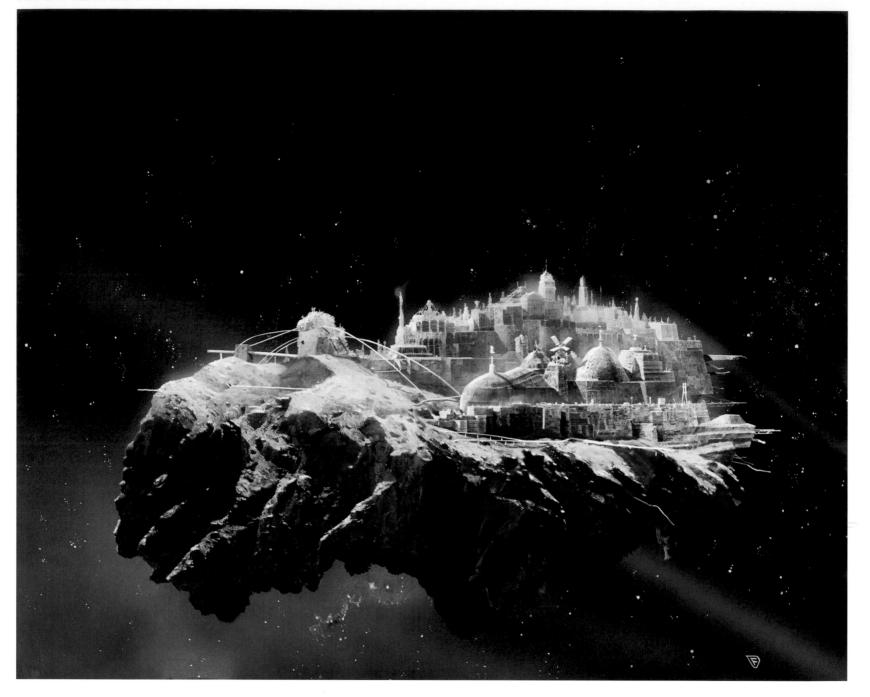

ABOVE: Chris Foss's illustration for the classic James Blish novel *Cities in Flight* becomes an evocative, dreamlike symbol for the future presence of humankind in the universe.

OPPOSITE TOP: Harking back to the hollowed-out asteroids of Frank R. Paul and James Cutter (see page 144), David Hardy takes the idea to a new level. Instead of just providing a habitat, the asteroid is an interstellar spacecraft. Here we see it, light-years from home, having finally arrived at a distant, earthlike world.

OPPOSITE BOTTOM: This stylish lunar city was created in 1960 for *Space Journal* magazine by an artist credited only as Kumagai. While scarcely pretending to be realistic, the illustration reflects not only the design sensibilities of the period, but also an exuberant confidence in the future of space exploration.

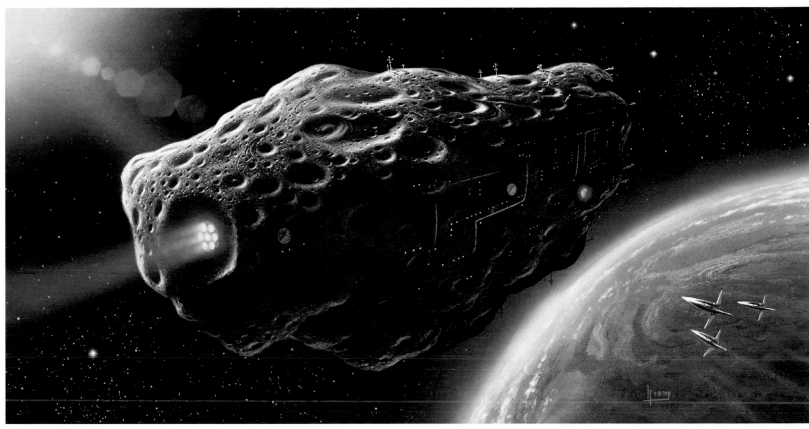

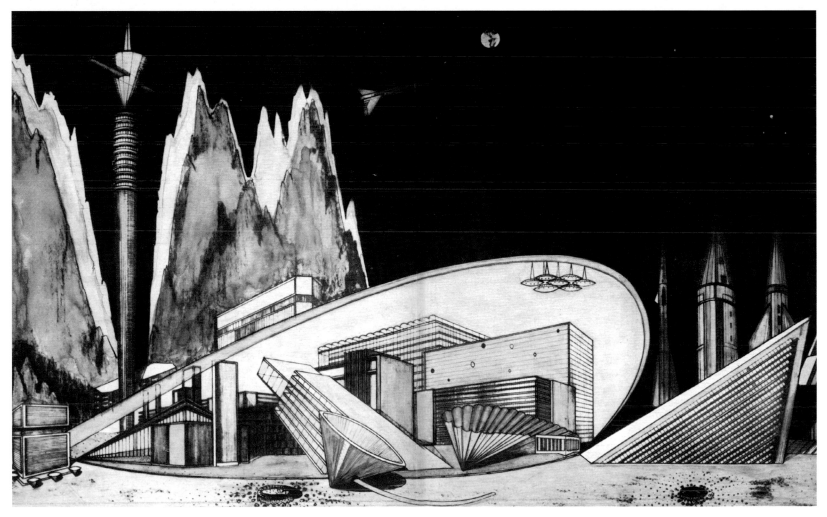

05

ALiENS

ALIENS:
LIFE AS WE DON'T KNOW IT

AFTER GALILEO GALILEI'S DISCOVERY THAT THE EARTH WAS NOT ALONE, THAT IT SHARED THE UNIVERSE WITH OTHER WORLDS, IT WAS NATURAL FOR PEOPLE TO WONDER: GIVEN THAT THE EARTH TEEMS WITH LIFE, MIGHT LIFE NOT EXIST ON THESE WORLDS TOO?

A seventeenth-century French mathematician named Bernard de Fontenelle posed exactly that question in his book *Entretiens sur la pluralité des mondes* (Discourses on the Plurality of Worlds, 1689). In fact, he not only asked the question, he attempted to answer it.

De Fontenelle realized three things: First, that the planets were worlds very much like our own. Second, that conditions on these worlds, however, would probably be very different. (For instance, Mercury must be very hot because it is so close to the sun.) Third, that life on the planets would have to reflect these conditions. But de Fontenelle lacked specific knowledge about the solar system. He knew, for example, that Mars was farther away from the sun than the earth… but he didn't know how far. All he had to work with were the approximate sizes of the planets, and what he could estimate of their surface temperatures based on their relative distances from the sun. He didn't let this stop him, however. The inhabitants of Mercury, he declared, were exuberant, excitable, and quick-tempered. The people of Venus were incorrigible flirts, those of Jupiter were great philosophers, and the denizens of Saturn were phlegmatic couch potatoes who, because of the frigid climate of their planet, preferred to sit in one place for their entire lives.

ALIEN CONCEPTS

Almost 200 years later, de Fontenelle's countryman Camille Flammarion—the great French astronomer, mystic, and science popularizer—put forward his own argument for extraterrestrial life. In his *Real and Imaginary Worlds* (1865), Flammarion expressed his belief that not only were the planets inhabited, but that its beings were repositories for human souls after their bodies' death on earth. This mix of mysticism and theology with speculation about extraterrestrial life persisted throughout the nineteenth century in such books as W. S. Lach-Szyrma's *Aleriel* (1886), John Jacob Astor's *A Journey in Other Worlds* (1894), James Cowan's *Daybreak* (1896), and William Arkwright's *Utanim* (1912).

The idea that there might in fact be life on the other planets—specifically Mars—was given a shot in the arm by a wealthy amateur astronomer named Percival Lowell (1855–1916). He wrote several books claiming that Mars was teeming with life. Very few

astronomers took Lowell's ideas seriously, but the public embraced them enthusiastically. A kind of "Mars fever" swept across the world. Everything from novels and magazine articles to plays and fairground rides reinforced the belief that there might be life on Mars.

Hundreds of authors were inspired by Lowell's vision of Mars, including Edgar Rice Burroughs, who wrote fabulous adventures about Barsoom, a Lowellian Mars inhabited by giant, four-armed, green warriors and beautiful red princesses. Perhaps the most prominent author who was impressed by Lowell's theory was H. G. Wells, who was inspired to write the classic science-fiction novel *The War of the Worlds* (1898). For the first time aliens were depicted as being truly *alien*. Wells's cold-blooded, octopoid Martians were like nothing ever encountered before in literature. Moreover, unlike the benevolent, humanoid aliens found in earlier stories, these creatures were patently evil, with nothing else on their minds but the systematic extinction of human life on the earth.

The American science-fiction author Stanley Weinbaum took the idea of nonhuman aliens even further. In his classic short story "A Martian Odyssey" (1934), he described extraterrestrials who were not only alien in appearance they also *thought* like aliens. Weinbaum was the first to suggest that an alien might be so different that meaningful communication could be impossible.

E.T. EQUATION

But although science fiction's conception of extraterrestrial life was evolving, science showed little interest in the possibility of life on other worlds. With the possible exception of Mars, astronomers had pretty much ruled out any expectation of finding life on the other planets in the solar system. Mercury was thought to keep one side perpetually facing the sun, leaving one-half of the planet dark and frigid and the other hot enough to melt lead. Jupiter, Saturn, Uranus, and Neptune were cold and covered in poisonous gases. Venus was the only mystery: no one knew for sure what lay beneath its opaque blanket of clouds. A steaming prehistoric jungle or a barren desert? Astronomers could only guess. So while there was always speculation about life in the universe, it was treated more as an intellectual exercise than serious science. Meanwhile,

"TWO POSSIBILITIES EXIST: EITHER WE ARE ALONE IN THE UNIVERSE OR WE ARE NOT. BOTH ARE EQUALLY TERRIFYING."
Arthur C. Clarke

the 1950s saw the rise of the flying saucer craze and if aliens weren't swarming all over our planet, they certainly conquered movies, television, and comic books. It was and is a craze that shows no signs of abating nearly 70 years later.

With the rise of the flying saucer craze in America in the 1950s, the subject of aliens gradually became a part of the UFO cult and fringe science, with the result that some scientists became more reluctant than ever to discuss the possibility of extraterrestrial life. However that was to change in 1961, when astronomer Frank Drake developed the famous "Drake Equation," wherein N is the number of civilizations in our galaxy with which radio communication might be possible:

$$N = R^* \cdot f_p \cdot n_e \cdot f_l \cdot f_i \cdot f_c \cdot L$$

The idea of the equation was to allow astronomers to make a reasonable estimate on the possible number of inhabited planets in the galaxy. It became the first real tool scientists had for determining the possibility of the existence of alien civilizations. With even the most conservative numbers plugged in, the equation resulted in astounding numbers. Thousands, perhaps even millions of technologically advanced civilizations may exist in our galaxy. Part of Drake's equation required that such civilizations be capable of broadcasting in the electromagnetic spectrum (radio, for instance). This led a number of scientists to wonder if such radio emissions might be detectable. Radio telescopes are perfect for this sort of work since they already search for electromagnetic emissions from the stars. Astronomers began to devote time to listening for signals that might bear signs of being artificial. The search for extraterrestrial intelligence (SETI) had begun.

Drake's work eventually led to the foundation of the SETI Institute in 1985. Since then, it has grown into an organization employing more than 120 scientists. Initially using borrowed time on existing radio telescopes, it now works not only with radio observatories all over the world but also with its own instruments—such as the large Allen Telescope Array in California—specifically dedicated to the search for life.

MAN IN THE MOON

The search for life in the universe was given another boost with the discovery that many of the worlds in our solar system aren't as hostile to life as once thought. Although Mercury and Venus are still considered too hot to support life, while the outer planets—Uranus, Neptune, and Pluto—are too cold, scientists have taken another look at Mars, Jupiter, and Saturn. Data from the recent Mars rover missions have conclusively proven that Mars was once a warmer, wetter world, with everything life would have needed to evolve. Whether this occurred—and whether any form of life may still remain on the planet—are questions still to be answered.

The brilliant orange, red, and yellow colors of Jupiter's clouds are due entirely to the presence of organic molecules. While these compounds are not classed as living material, they do form the basic building blocks of life. The visible surface of Jupiter's clouds is much too cold to support life and deep beneath them conditions are even more hostile. But somewhere in between, temperatures and pressures would be conducive to the evolution of life. Whale-sized balloons swimming through the towering clouds of Jupiter, perhaps?

The planets are not the only bodies that could potentially support alien life. Deep beneath the thick, icy shells of Jupiter's moon Europa lies a vast ocean of warm water. With an abundance of organic materials to work with and plenty of energy to power evolution, what life-forms might exist in those lightless depths? Astronomers are sufficiently convinced of its existence to the extent that serious work has gone into planning a robotic mission to Europa, which will drill through the ice in the search for life.

Should Europa prove barren, perhaps one of Saturn's moons may bear fruit. Its giant moon Titan has a dense atmosphere rich in organic compounds and a surface literally buried beneath them, while Enceladus may also have a hidden ocean of liquid water. As things stand today, too much of our solar system remains unexplored for the prospect of alien life to be completely discounted.

ABOVE LEFT: For most of the nineteenth century—until H. G. Wells published *The War of the Worlds*—most extraterrestrials were depicted by writers and artists as being more or less human… although usually more physically and mentally advanced than the humans of earth. In some cases, they are almost literally angelic, like the Martians encountered by the heroes of Fenton Ash's *A Trip to Mars* (1909).

TOP RIGHT: One of the cards in a collection called *A Trip to the Moon Before 1900*, published in France in the 1890s, depicts an encounter with a caterpillar-like "Lunarian." Written and illustrated by A. DeVille d'Avray, the set of cards details the adventures of a balloonist who travels to the moon and meets a bewildering assortment of alien creatures.

BOTTOM RIGHT: The Great Moon Hoax of 1835 was influential in exciting the general public about the possibility of life on other worlds. Presented as a series of true news reports, the announcement of the discovery of living creatures on the moon took the world by storm. Even once the hoax had been revealed, the story was copied and reprinted internationally.

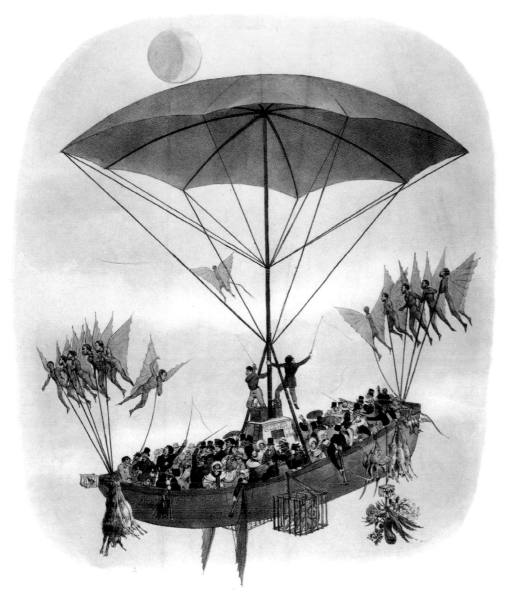

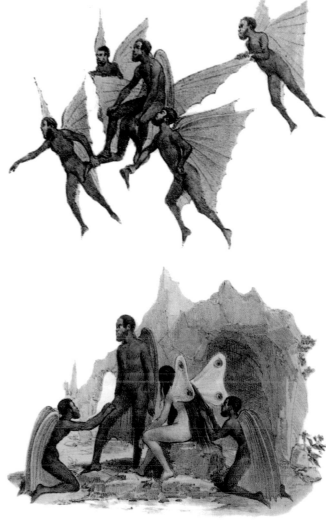

ABOVE: These illustrations were created for an Italian version of the Great Moon Hoax, *Altre scoverte fatte nella luna dal Sigr. Herschel*, published in 1836 by Leopoldo Galluzzo. This version has missionaries traveling to the moon by balloon to convert the Lunarians to Christianity—possibly a response to the horrified reaction in certain quarters to images of naked Lunarian women.

ABOVE LEFT: Among the 108 installments of Marcel Priollet's pulp series *Les Aventuriers du Ciel* (1935), his hero visited numerous worlds in our solar system, some of which were inhabited by fearsome creatures such as these.

TOP RIGHT: In George Griffith's classic science-fiction tale, *A Honeymoon in Space* (1900), artist Stanley Wood depicted this titanic battle between two monstrous inhabitants of Saturn's oceans. As every science-fiction story about the solar system has done, Griffith's tale reflects the state of astronomy at the time he was writing. As a result, we see a tropical Venus, a volcanic Jupiter, and Saturn covered with a worldwide ocean.

BOTTOM RIGHT: Harry Lange illustrated this hypothetical interstellar space probe, "Project Star," for the Winter 1959 issue of *Space Journal* magazine. Lange was a prolific illustrator of aerospace subjects and eventually became one of the art directors for *2001: A Space Odyssey*.

ABOVE LEFT: Robert A. Graef depicted this epic clash between monsters inhabiting an exoplanet for *Distant Worlds* (1932), a novel by Friedrich Mader that takes its young readers on a voyage through the solar system and to the stars beyond.

TOP RIGHT: A trio of earth children befriend a lost alien in *Snoggle* (1971), a novel by J. B. Priestly that anticipated Steven Spielberg's classic film, *ET*. The book was illustrated by Barbara Flynn.

BOTTOM RIGHT: Dan Beard illustrated this exciting scene set on Saturn for John Jacob Astor's *A Journey in Other Worlds* (1894). Although Astor's Saturn wasn't covered by a global ocean like George Griffith's, it was similarly shown as a prehistoric world inhabited by dinosaur-like monsters.

ABOVE: Pulp magazines and, later, comic books have always had a fondness for aliens—and the more bizarre and the more frightening the alien, the better. Aliens eventually became so commonplace and so stereotyped that they came to be referred to as simply "BEMs"— shorthand for "Bug-Eyed Monsters." For the first four or five decades of pulp publishing, it was rare to see an artist depict an alien as something other than vaguely humanoid. Probably feeding on the xenophobia behind such racist concepts as "the yellow peril," aliens were usually presented as odd-looking humans possessing distinctly human motives and desires… and the more evil these were, the better. Even the most nonhuman of aliens, however, always seemed to find human women fascinatingly attractive. Although there were occasional exceptions, there were no illustrators working in the pulp era who specialized in the depiction of alien species—though some, such as Edd Cartier (see pages 210–213), created extremely convincing extraterrestrials that seemed genuinely *alien*. Authors, of course, had long since abandoned the old humanoid aliens of the nineteenth century and, beginning with H. G. Wells and, later, Stanley Weinbaum's seminal stories, such as "A Martian Odyssey" and "The Lotus Eaters," were writing about truly *alien* aliens: beings that were not only nonhuman in appearance, but possessed nonhuman motives, nonhuman emotions, and nonhuman ways of thinking. Eventually, as both science fiction and its readers grew more sophisticated, it was no longer possible, let alone acceptable, for artists to depict aliens as being little more than humans with funny-colored skin and extra arms.

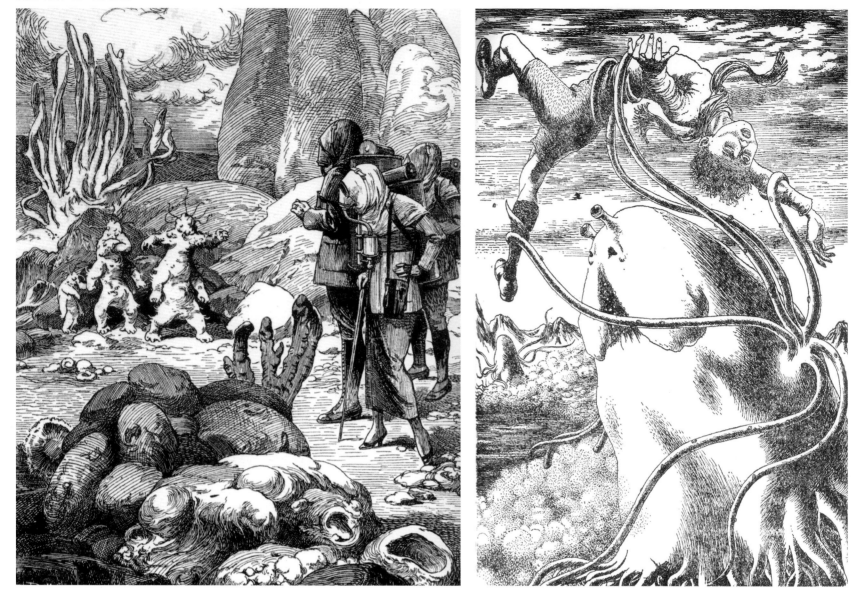

ABOVE LEFT: A trio of tuber-like aliens confront explorers from the earth in this illustration by Raffin from Henri de Graffigny's 1925 novel, *Voyage de cinq Américains dans les planètes*.

ABOVE RIGHT: John Keir Cross's *The Angry Planet* (1945) featured numerous beautiful pen-and-ink illustrations by Robin Jacques. The story describes how two boys and a girl accompany an eccentric scientist and a writer on their journey to the planet Mars. They have many incredible adventures, including an encounter with an army of horrific fungus-animals.

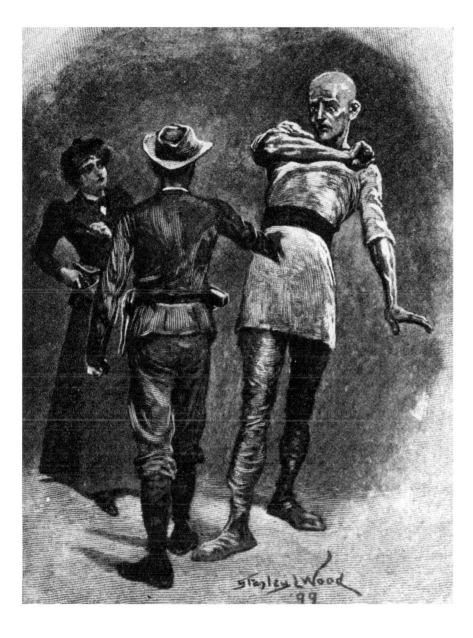

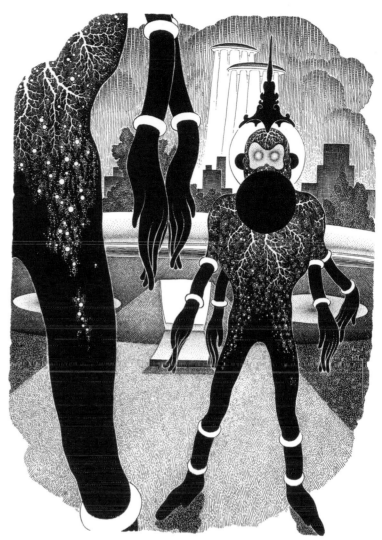

ABOVE LEFT: This illustration by Stanley Wood for George Griffith's *Honeymoon in Space* (1900) depicts the newlywed couple confronting a giant Martian as he recoils from the touch of a human hand. Ignoring the example of H. G. Wells's Martian octopoids which had appeared a year or two earlier, Griffith's aliens are all still distinctly human.

ABOVE RIGHT: Virgil Finlay (1914–1971), one of the grand masters of science-fiction illustration, gave us this impression of alien visitors to earth in his lavishly illustrated *The Complete Book of Space Travel* (1956). Coming as it did in the midst of the heyday of the UFO frenzy, the book was compelled to devote a chapter or two to the question of life on other worlds.

WAYNE BARLOWE:
AUDUBON OF ALIENS

EVERY SCIENCE-FICTION ARTIST HAS DEPICTED AN ALIEN AT SOME POINT IN HIS OR HER CAREER, BUT FEW HAVE MADE A CAREER OF CREATING EXTRATERRESTRIALS—AND NONE HAVE BEEN SO INTIMATELY ASSOCIATED WITH THE SUBJECT AS WAYNE BARLOWE.

UNNATURAL HISTORY

Barlowe, the John James Audubon of extraterrestrial life, came by his interest in alien life-forms naturally. His parents were both noted natural history artists. "I watched them work and had an undeniable fondness for biology. My dad bought me my first science-fiction paperback—Edgar Rice Burroughs's *A Princess of Mars*—and that set the wheels in motion." Barlowe's first professionally published work was a collaboration with his parents in illustrating the *Instant Nature Guide to Insects* (1979).

This grounding in natural history would prove invaluable when Barlowe turned his attention to more exotic creatures. "Over the years I read [science fiction] voraciously," he says, "and arrived at the conclusion that most aliens were not very original." The result of this thinking was his first solo book, the classic *Barlowe's Guide to Extraterrestrials* (1979), in which he illustrated 150 of the greatest alien creatures in science fiction, taken from the works of authors ranging from Arthur C. Clarke, Robert Heinlein, and David Niven to Frank Herbert, H. P. Lovecraft, and Isaac Asimov. In addition to providing a portrait of each being, Barlowe included details about its anatomy, history, and habits. "I personally gravitated towards the more outré depictions," he explains, "The work of Stanislaw Lem is a good example. His aliens were nearly always enigmatic and almost abstract. I love that—that's what I really think beings 'Out There' would be like."

Among the artists he feels most inspired his interest in aliens, Barlowe includes the great Czech paleontological artist Zdeněk Burian, as well as Edd Cartier. "I remember loving Cartier's aliens that he did for *Travelers of Space* back in the '50s. Those drawings were probably the biggest influence on me as a young kid."

Barlowe's second book, the acclaimed *Expedition* (1990), chronicled the natural history of an alien world, as seen by the members of a scientific exploration party. This was followed by several more illustrated books, including the retrospective *Alien Life of Wayne Barlowe* (1995).

"TO ME, THERE HAS TO BE A PLAUSIBILITY OF FORM AND FUNCTION— THE BIOLOGY OF AN ALIEN HAS TO SEEM LIKE IT TRULY EVOLVED."
Wayne Barlowe

ALIEN STARS

In the meantime, Barlowe provided hundreds of illustrations for science-fiction book covers as well as magazines such as *Life* and *Time*, and television and motion pictures. In 2004, the Discovery Channel presented a two-hour documentary based on Barlowe's book *Expedition*.

In recent years, Barlowe has contributed heavily to motion pictures and television. He created the principal aliens and their home world for TNT's movie *Babylon 5: Thirdspace* (1998) as well as creature designs for *Galaxy Quest* (1999), *Titan A. E.* (2000), *Blade II* (2002), *Hellboy* (2004), *The Day the Earth Stood Still* (2008), *Avatar* (2009), *John Carter* (2012), *The Hobbit: An Unexpected Journey* (2012), *Pacific Rim* (2013), and two of the Harry Potter films. While not a great fan of Hollywood's historically unimaginative approach to aliens, there are some creations he feels were outstanding. "[H. R.] Giger's gorgeous and brilliant *Alien*," Barlowe says, "stands out as a perfect paradigm shift that was never really built upon in the minds of Hollywood. It was merely copied in various diluted and less creative ways. [John] Carpenter's *The Thing* is marvelous in its various horrific iterations and I liked very much the depiction of the aliens in *District 9* and *Monsters*."

Today, Barlowe continues to illustrate as well as work on new film projects, including one based on his own screenplay. "The dream is to write and develop properties that are imaginative and well-realized and compelling to audiences," he says. "And, to give voice and image to my concepts in the fullest possible way."

ABOVE: Wayne Barlowe is a renowned and respected illustrator and author who has created more than 300 book and magazine covers, as well as designs for films such as *Avatar* and *John Carter*. He has also written a novel, a screenplay, and a number of book collections of his art.

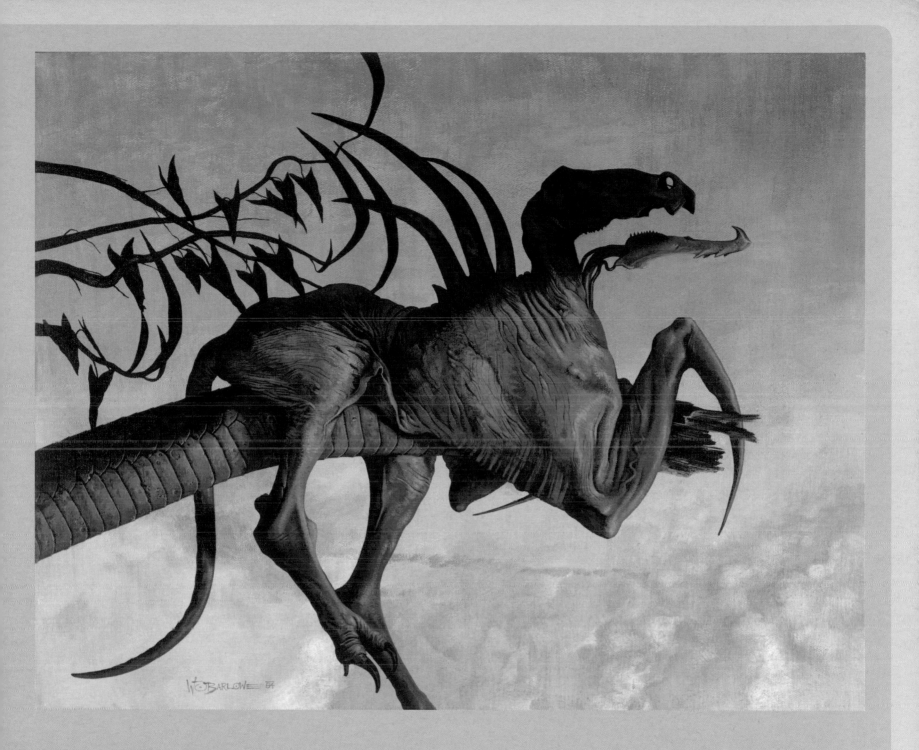

ABOVE: Barlowe's Daggerwrist is one member of the menagerie of creatures that inhabit the artist's imaginary planet, Darwin. Living exclusively in the dwindling pocket-forests of the planet, these social, arborial creatures— Barlowe tells us—have "piton-like forelimbs, gliding membranes and powerful ricochetal hind-limbs" that make them "perfectly adapted for life in the tree-tops."

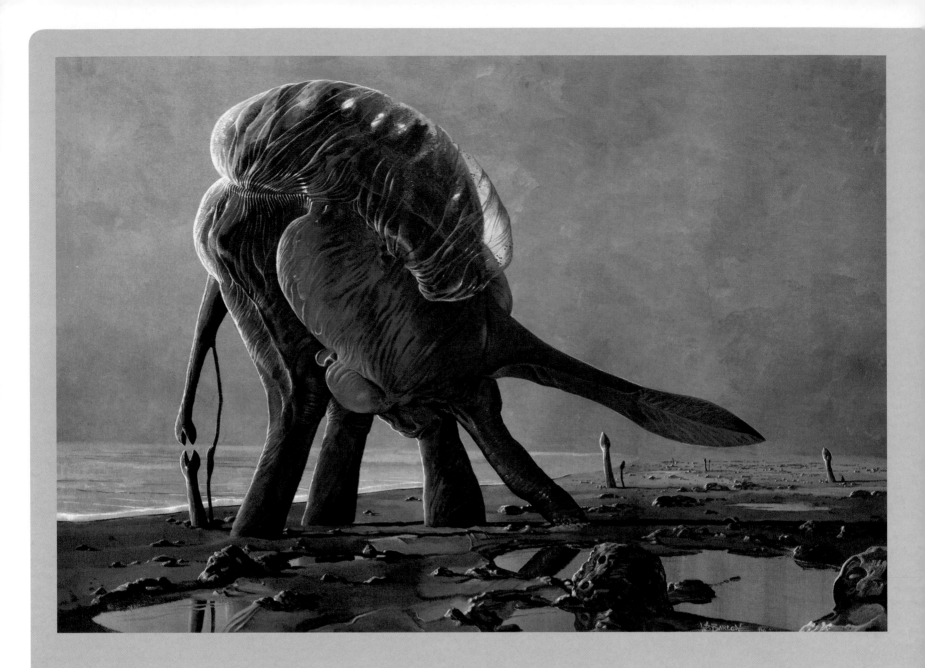

ABOVE: Another inhabitant of Wayne Barlowe's imaginary planet, Darwin IV. The Sac-back roams the desolate shores of the Amoebic Sea, plodding with its awkward, three-legged gait from one group of buried females to the next.

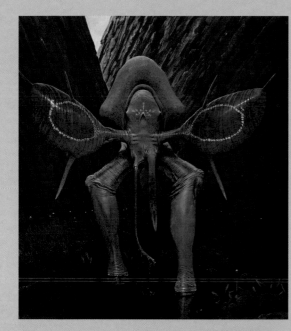

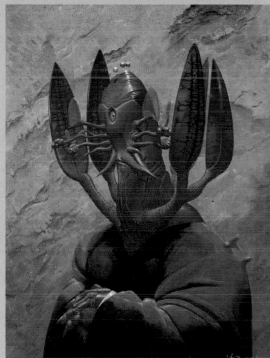

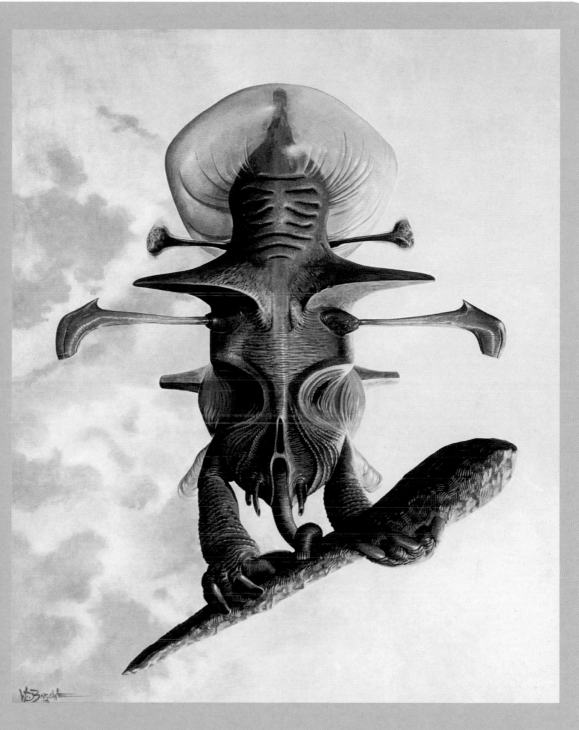

TOP LEFT: The Bladderhorn is an herbivore living in the mountains of Wayne Barlowe's Darwin IV, where it wanders among the passes and high plains.

BOTTOM LEFT: This contemplative creature was featured on the cover of *The Alien Life of Wayne Barlowe* (1995), a collection of 100 paintings and drawings by the artist.

ABOVE RIGHT: An Eosapien is one of the more dangerous inhabitants of Darwin. They are the most advanced life-form on Darwin IV, possessing the intelligence of such early humans as *Homo habilis*. They float in mid-air by using two bags filled with methane gas and can create and use primitive weapons.

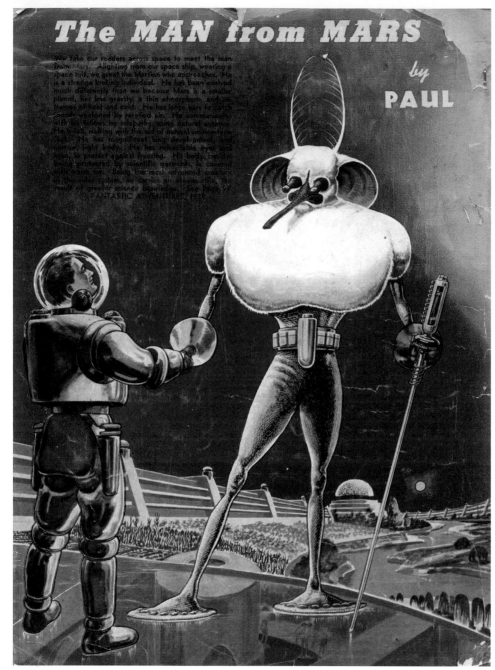

The MAN from MARS

by PAUL

We take our readers across space to meet the man from Mars. Alighting from our space ship, wearing a space suit, we greet the Martian who approaches. He is a strange looking individual. He has been evolved much differently than we because Mars is a smaller planet, has less gravity, a thin atmosphere, and extremes of heat and cold. He has large ears to catch sounds weakened by rarefied air. He communicates with his fellow by telepathy using natural antenna. Flesh left, making with the aid of natural suction-type discs. He has magnificent lung development, a narrow, light body. He has retractable eyes and nose, to protect against freezing. His body, being protected by scientific garments is cleansed with warm air. Being the most advanced creature in the solar system, he carries an atomic rifle, the latest of present science knowledge. See Page 97.

© FANTASTIC ADVENTURES, 1939.

KEY TO BACK COVER ILLUSTRATION

A Erectable natural telepathic antenna for extra sensory communication.

B Enormous shell shaped ear to catch sound waves in Mars' rarefied atmosphere.

C Retractable eyes and nose for protection against freezing in extreme cold.

D Huge lung development, to provide sufficient oxygen for a large body.

E Heavy, closely knit white fur, to protect the frail body against extreme cold.

F Atomic weapon, utilizing advanced atomic science of the power in the atom.

G Synthetic water and food pellets to provide nourishment on the desert.

H Scientifically constructed clothing, impervious to cold, electrically warmed.

I Disc shaped feet, equipped with natural suction cups and valve openings.

J Protective glassite helmet, since Mars' air is too thin for Earthmen.

K Amplifiers to pick up sound vibrations in the thin atmosphere inaudible to us.

L Oxygen purifier, to cleanse our air supply, and remove carbon dioxide.

M Oxygen tank to supplement meagre supply present in Martian atmosphere.

N Repulsion hand rockets, to aid in moving about on shipboard or in space.

O Heavy, air-tight, insulated suit, to protect against both cold and empty space.

TOP & BOTTOM LEFT: Frank R. Paul created this Martian in 1939 for the back cover of *Fantastic Adventures* magazine. He tried to make as realistic an alien as he could, given the knowledge at the time of the conditions on Mars, as he explains in the text within the artwork as well as in the accompanying diagram. This led him to make allowances for the red planet's lighter gravity, thin atmosphere, and freezing temperatures.

ABOVE RIGHT: This Martian, eerily reminiscent of the reported occupants of modern UFOs, appeared in Henri de Parville's 1865 novel, *Un Habitant de la Planète Mars*, in which the fossilized body of a Martian is discovered embedded in a meteorite. Today, many scientists believe that fossilized, single-cell organisms may have been found in a meteor that came from Mars.

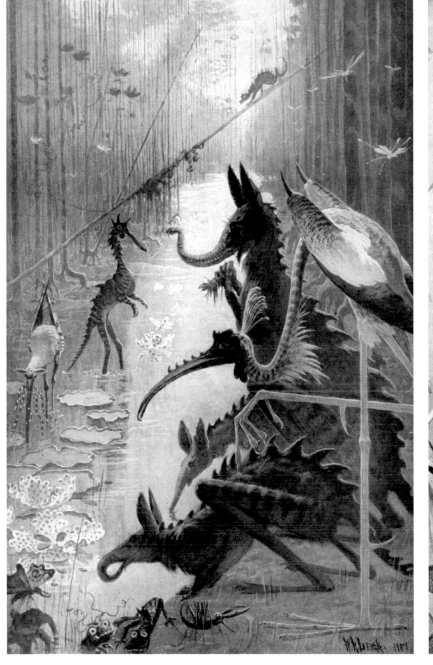

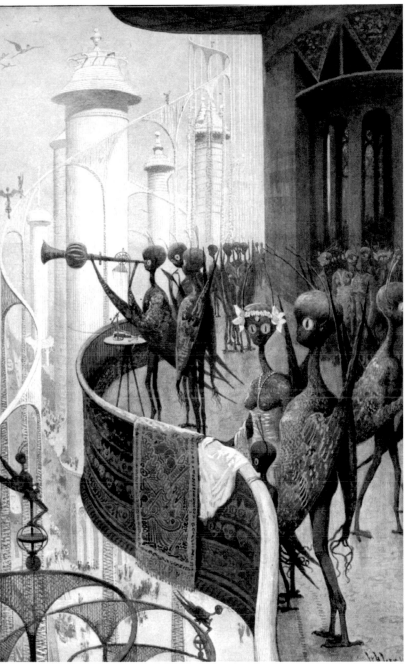

ABOVE LEFT: H. G. Wells wrote a nonfiction article about the possibility of life on Mars. Published in *Cosmopolitan* magazine in 1908, it was accompanied by four spectacular illustrations by noted artist W. R. Leigh. Here we see examples of Martian creatures that, due to the lower gravity of Mars, are "laxer and flimsier and either larger or else slenderer" than the animals of the earth.

ABOVE RIGHT: One of the most appealing of Leigh's illustrations for the H. G. Wells article is this wonderful scene of Martians overlooking their capital city. Because of the colder temperatures on Mars, Wells tells us, "as likely as not they will be covered with feathers or fur. It is no less reasonable to suppose, instead of a hand, a group of tentacles or proboscis-like organs."

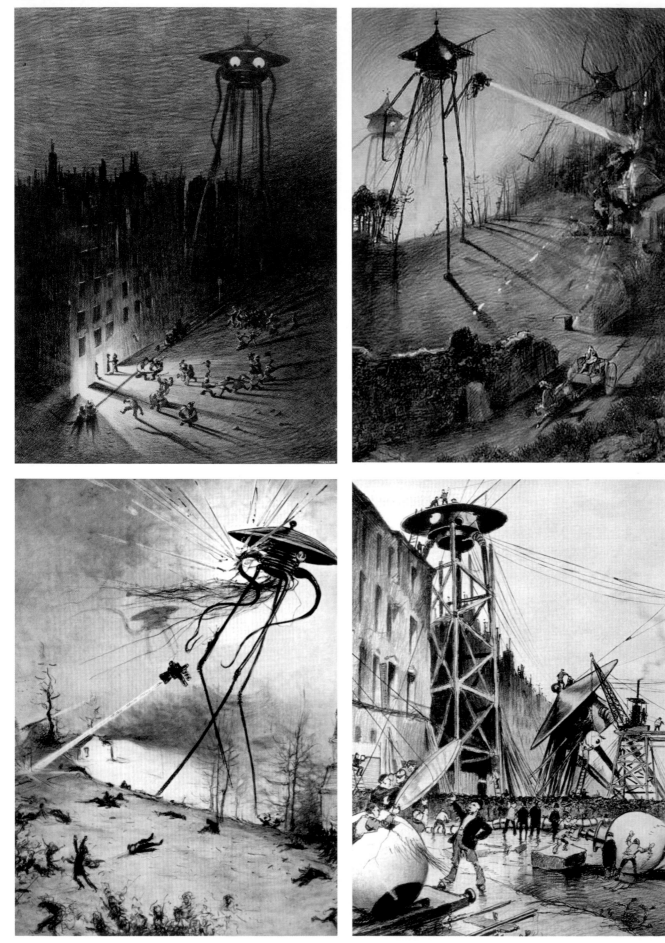

THIS PAGE: When Henrique Alvim Corrêa, a Brazilian artist working in Belgium, was asked to illustrate a 1906 French edition of H. G. Wells's *War of the Worlds*, there has seldom been a better matching of artist and novel. Corrêa's Martians are depicted with a disturbing combination of cartoon and horror, rendered in a style that makes the art look like it was drawn by an eyewitness to the events.

ABOVE: Henrique Alvim Corrêa's *A Woman in the Clutches of a Martian* —a partially nude victim, draped over a globe of the earth as she is being devoured by the tentacled monster —brilliantly brings home in one nightmarish image all the horror of H. G. Wells's classic novel.

RADIO SIGNALS FROM BEYOND:
THE SEARCH FOR E.T.

AS SOON AS HUMANS LEARNED THAT THERE WERE OTHER WORLDS THAN THEIR OWN, THEY BEGAN WONDERING WHAT SORT OF LIFE MIGHT LIVE THERE. BUT IF THERE WERE INDEED INTELLIGENT BEINGS ON OTHER PLANETS, HOW COULD HUMANS ON EARTH COMMUNICATE WITH THEM?

MARTIAN MIRROR

The great German mathematician Carl Friedrich Gauss (1777–1855) thought it might be possible to announce to the universe that intelligent life existed on earth. His plan consisted of planting vast fields of wheat or rye in geometric shapes in the Siberian tundra, creating an enormous diagram illustrating the Pythagorean Theorem. Others suggested digging trenches in the Sahara Desert, filling them with kerosene and igniting it. The blazing message would be visible from far into space.

Around the turn of the twentieth century, following the announcement of Percival Lowell's "discovery" of canals on Mars—and his accompanying theory that sentient creatures had to have been responsible for their design—imaginative plans were suggested as to how to contact the Martians. The French poet and inventor Charles Cros (1842–1888) wanted to build a giant mirror on the earth. It would be used to focus sunlight on Mars, where a message could be burned into a Martian desert, hopefully spelling out, "Sorry about that." So certain was the popular belief that Mars was inhabited that when the wealthy Parisian Clara Gouget Guzman established a prize in 1900 for the first person to communicate with another planet, she specifically omitted Mars because it would apparently be too easy!

RADIO PROGRAMS

The invention of the radio led some scientists to speculate whether this device might be a potential method of communicating with other worlds. Both the Serbian American inventor Nicola Tesla and his archrival Thomas Edison thought they had detected radio signals from space. They were both were mistaken—Tesla's signals were in fact terrestrial broadcasts, while Edison had discovered radio emissions from the sun.

Yet the notion of interplanetary communication had been turned around: instead of trying to send signals to other worlds, it would be infinitely easier and cheaper to listen for signals from other worlds. Following the invention of the radio telescope in the 1930s, and the realization that radio signals could be detected at

"TO CONSIDER THE EARTH AS THE ONLY POPULATED WORLD IN INFINITE SPACE IS AS ABSURD AS TO ASSERT THAT IN AN ENTIRE FIELD SOWN WITH MILLET, ONLY ONE GRAIN WILL GROW."

Metrodorus of Chios, fourth century

interstellar distances, radio astronomers began devoting odd moments to listening for signals that might have an artificial origin.

In 1960, astronomer Frank Drake started using a radio telescope in Green Bank, West Virginia, to scan selected stars, looking for anomalous signals. His search led directly to the creation of the SETI (Search for Extraterrestrial Intelligence) project. Originally a loose organization of volunteers, today the SETI Institute has invested more than $250 million in research and employs 140 people administering more than 100 different projects. Among these is SETI@Home, which enables anyone with a computer to take part in the search for extraterrestrial civilizations.

DEEP SPACE PIONEERS

In the meantime, the desire to announce our own presence to the universe had not died. When it was realized that both the *Pioneer* and *Voyager* spacecrafts—sent to explore the outer planets— would eventually leave the solar system entirely, messages were attached to the vessels. In the case of the two *Pioneer* probes, this took the form of an engraved, gold-plated plaque. Conceived by astronomers Frank Drake and Carl Sagan, the artwork—designed by Sagan's then-wife Linda Salzman— depicted male and female human beings along with a diagram of the earth's location in space.

Launched in 1972 and 1973, by 2010 the spacecrafts were deep into interstellar space. *Pioneer 10* had reached a point 100 times farther from the sun than the earth, more than twice as far as Pluto. Even so, it still has 2,700 times farther than that to go before reaching the nearest star—nearly 108,000 years from now. Given this enormous amount of time and distance, is it truly inconceivable that the vehicle might one day find another life-form to which it can deliver humankind's message?

TOP: Other worlds may have their own SETI programs capable of detecting electromagnetic signals from the earth. The discovery of intelligence elsewhere in the universe would surely be as exciting to an alien species as it would be for us. Perhaps that distant rocket arcing into the sky could be on its way to earth…?

BOTTOM LEFT: With the recently discovered continents of the New World as alien as Mars or Jupiter might be to us, European artists and writers 500 years ago invented bizarre inhabitants of these lands that are as strange as anything that might have stepped out of a UFO.

BOTTOM RIGHT: The Allen Telescope Array is a joint effort by the SETI Institute and the Radio Astronomy Laboratory at the University of California, Berkeley, to construct a radio interferometer dedicated to both astronomical observations and a simultaneous search for extraterrestrial intelligence.

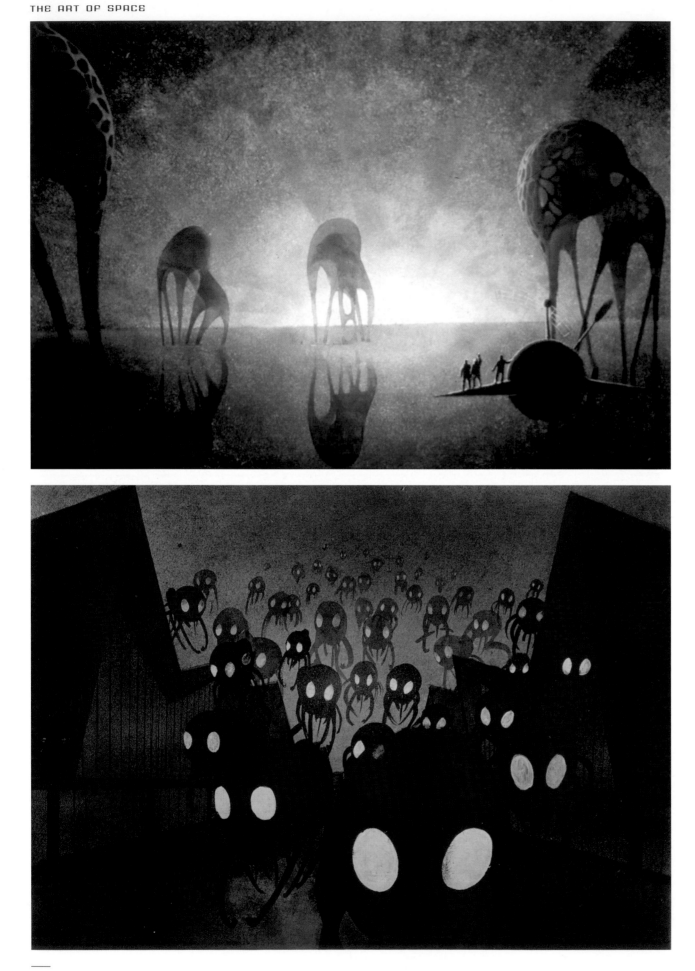

TOP LEFT: The great Russian space artist Andrei Sokolov shows here the meeting of earthly visitors and wholly alien life-forms as an event of lyrical beauty and hope.

BOTTOM LEFT: In this painting, Andrei Sokolov presents the luminous-eyed octopoids so beloved of science fiction with a distinctly individual sense of whimsy, perhaps inspired by traditional fairy tales.

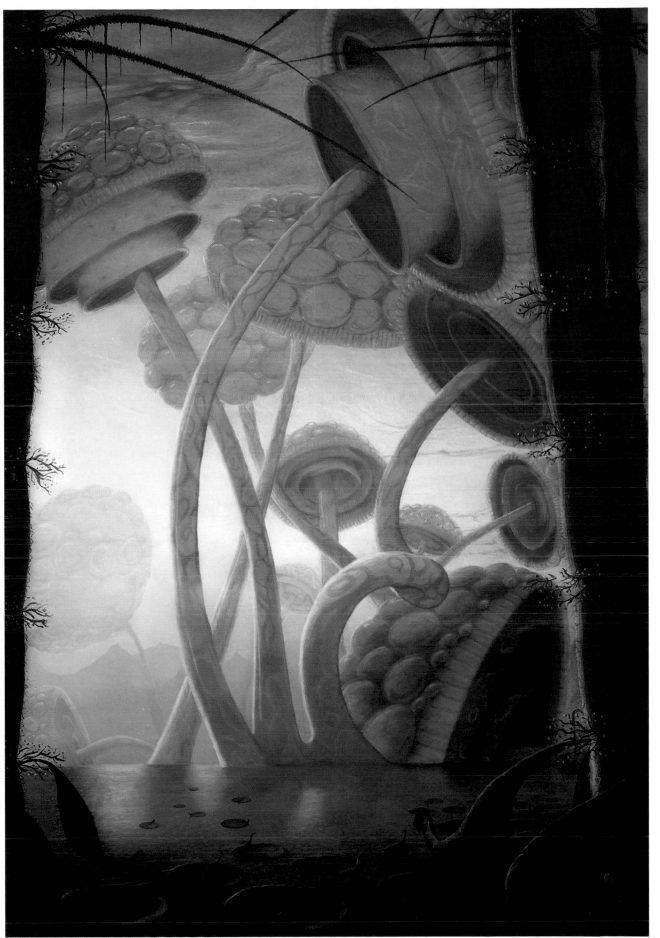

RIGHT: With a PhD in astrophysics, Mark Garlick brings a special brand of knowledge and realism to his space art. In *Aquefungoids*, however, he has loosened the fetters of his imagination —with the result being an alien world that might make Lewis Carroll's Alice feel at home.

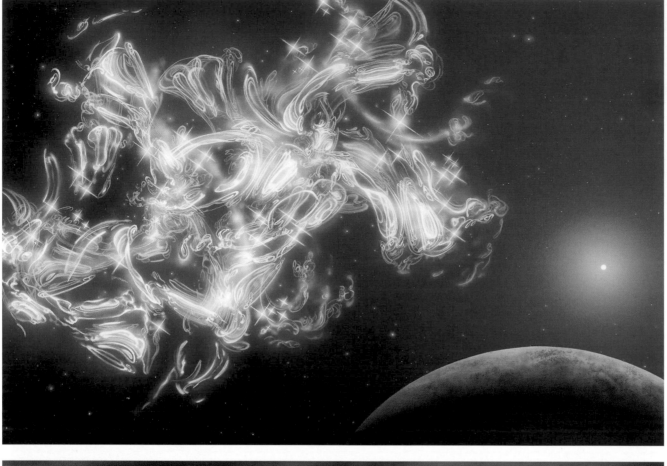

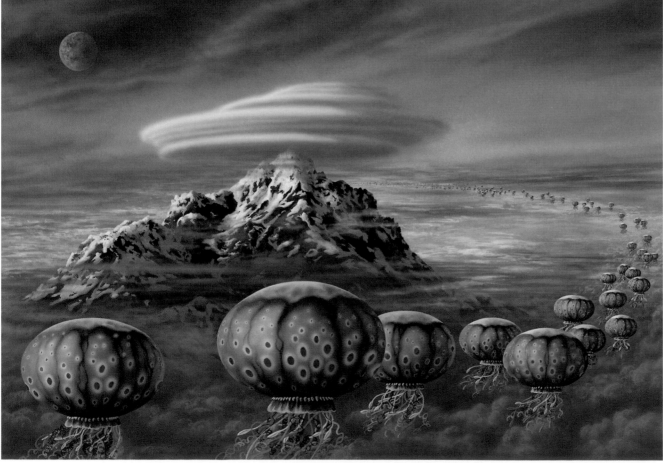

TOP LEFT: Lynette Cook's *Intelligent Light Being* speculates on the possibility of non-corporeal alien life-forms existing as pure energy. The result is a lyrical image of haunting beauty.

BOTTOM LEFT: Several space artists have wondered what sort of creature might evolve in the dense atmosphere of an alien world. Here, Lynette Cook's "Floaters" drift among the aerial currents of their planet, possibly never descending to the solid surface. Like balloons, they may keep afloat by filling themselves with a light gas like hydrogen, or perhaps with hot air heated by their own metabolisms.

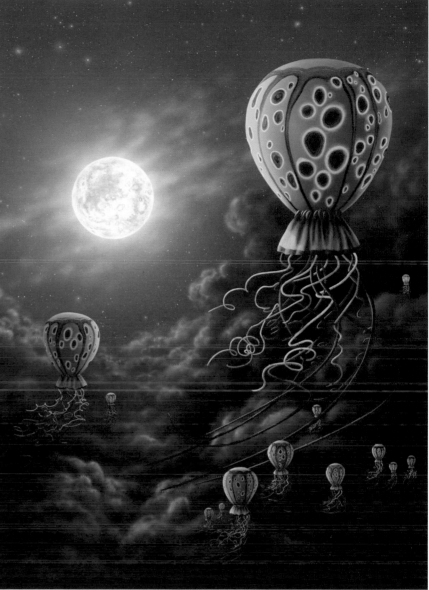

TOP LEFT: Scientist-artist Dan Durda presents his take on "gas bag" creatures in this painting illustrating a life-form that might exist in our own solar system, within the dense clouds of Jupiter. There has even been serious speculation that similar creatures live in the upper atmosphere of the earth and are the source for most UFO reports.

BOTTOM LEFT: The "Noron" is only one member of an entire population of alien life-forms created by Karl Kofoed as part of his book, *Galactic Geographic* (2003). An aquatic, star-faring species, the Noron are partners with humans in a mutual exploration of the universe.

ABOVE RIGHT: Lynette Cook gives us another look at her balloon-like "Floaters" as they bask lazily in the alien light of their moon.

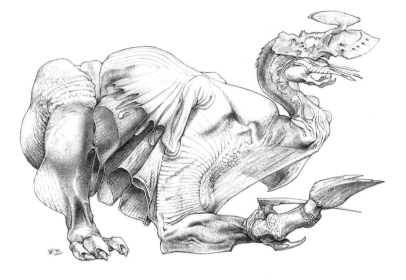

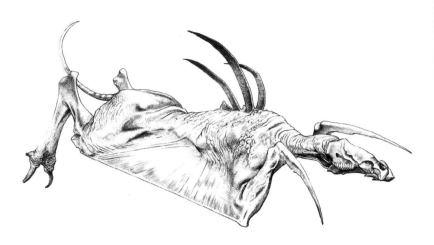

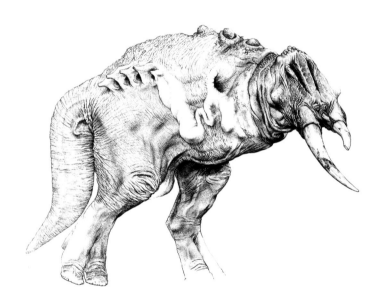

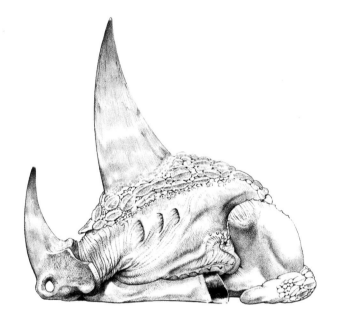

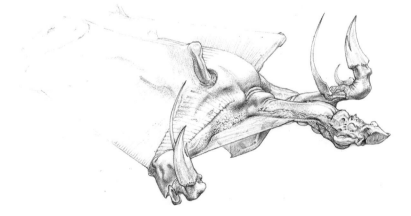

THIS PAGE: These pencil sketches illustrate the detailed thinking that lies behind Wayne Barlowe's imaginary creatures. Each is not merely strange for the sake of being strange, but carefully worked out anatomically and structurally to fit logically into a complex ecosystem.

ABOVE: Hugo Award–winning illustrator Stephen Hickman has always had a deft hand at depicting alien creatures. This painting was created specifically for the Heinlein Trust and depicts a stirring scene from Robert Heinlein's classical novel, *Between Planets*.

LEFT: Kelly Freas was one of the most beloved and honored science-fiction illustrators to have ever lived. He created this portrait of an alien con artist for the cover of *Rails Across the Galaxy* (1982) by Andrew Offutt and Richard Lyon.

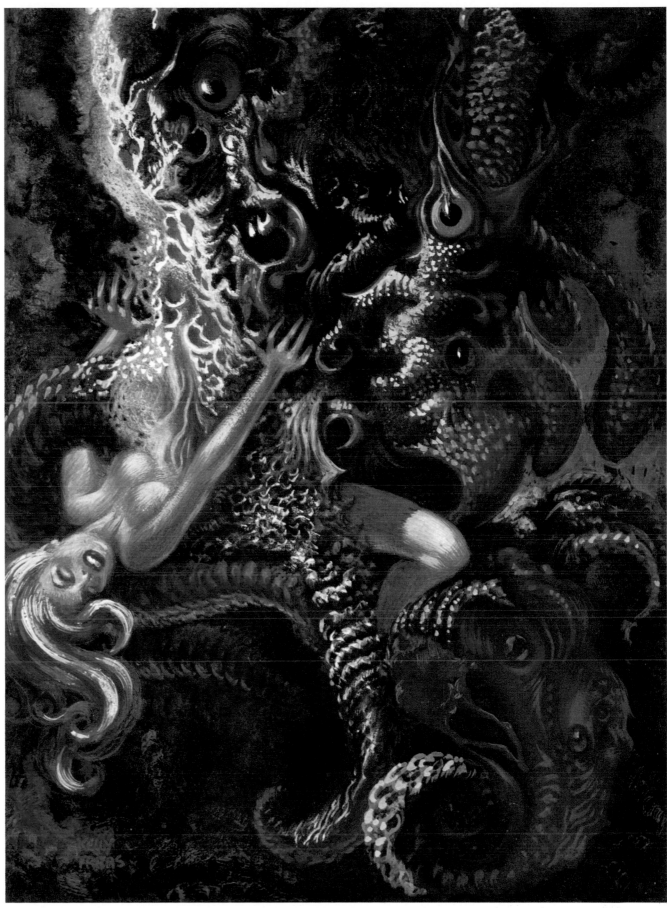

RIGHT: A powerful—and disturbing—image of alien seduction by Kelly Freas was created for the cover of *Identity Seven* (1974) by Robert Lory. The artist himself claimed that "I have always blown hot and cold about monsters… when the world fails to provide them, we manufacture our own."

OTHERWORLDLY CREATURES:
EDD CARTIER'S "INTERSTELLAR ZOO"

EDD CARTIER, ONCE DESCRIBED AS "A LEGEND, ONE OF THE GREATEST ILLUSTRATORS IN THE HISTORY OF SCIENCE FICTION," CREATED NEARLY 1,000 PULP ILLUSTRATIONS OVER THE COURSE OF HIS 30-YEAR CAREER. AMONG HIS MOST PRIZED ARE THE "INTERSTELLAR ZOO" ALIENS, WHICH OVER A CENTURY LATER STILL LOOK JUST AS FRESH, IMAGINATIVE, AND FUTURISTIC.

A graduate of Pratt Institute, Cartier began illustrating for the pulp magazines in the mid-1930s and almost immediately became the definitive artist for *The Shadow*. He also provided art for John W. Campbell Jr., the legendary editor of *Astounding Science-Fiction*. In 1939, Campbell invited Cartier to contribute to a new magazine to be called *Unknown*. "That's where he really shined," says Robert Weinberg, publisher and sci-fi/fantasy art expert. "He had a deft caricature style, and he was able to draw not just very expressive people but expressive creatures like fairies, gnomes, and gods."

It was in that last area that Cartier's work was unique. Unlike any other science-fiction artist, he had a knack for creating otherworldly creatures that were truly *alien*. And not just weird for weird's sake, but aliens that appeared to be utterly plausible. There seemed to be a rationale behind their design that reflected a genuinely alien biology. Science-fiction fans had never before seen anything like Cartier's extraterrestrials.

ALIEN MENAGERIE

In 1951, author David Kyle and Cartier collaborated on a special pictorial chapter to be included in a book called *Travelers of Space*. Published by the legendary Gnome Press, *Travelers of Space* was an anthology of fact and fiction devoted to the subject of extraterrestrial life. Kyle, now in his nineties, was at the time one of science fiction's most active fans. Together with Cartier, he invented the "Interstellar Zoo." In Kyle's story, two children—Don and Harriet Murray—are taken by their mother on a visit to the fabulous Interstellar Zoo. Most of the story is taken up with quotes from a guidebook the family picks up, interspersed with the children's comments and questions.

"The Interstellar Zoo" is accompanied by 16 astonishing illustrations created by Cartier. He manages to depicts aliens that are genuinely otherworldly… something Hollywood has only managed to accomplish three or four times in the past century.

"'BUT *HERE*,' HE SAID DRAMATICALLY, POINTING TO A METAL CASE IN THE CENTER OF THE FLOOR, 'IS THE SMALLEST INTELLIGENT BEING KNOWN. YOU'VE GOT TO PEER AT HIM THROUGH THE EYEPIECE OF THAT MICROSCOPE AT THE TOP.'"
David Kyle, "The Interstellar Zoo," 1951

There is nothing remotely humanoid about most of Cartier's creatures, and more than one is downright disturbing in its sheer unearthliness. All are products of their alien environments. The artworks' unusual coloring— the result of Cartier providing hand-painted separations for the printer—only serves to heighten their impact.

SIZE MATTERS

The zoo includes such creatures as a balloon-like Venusian, designed to "float above the semi-liquid surface of the planet," an insect/elephantine galactic being, and a Martian who surely could have claimed a Metalunan mutant from the film *This Island Earth* (1955) as a distant relative. The exhibits are graded by size, with the largest extraterrestrials displayed first and a microscopic alien last. Oddly enough, all of the beings in the zoo are of a high level of intelligence, which certainly provides some food for thought for Don and Harriet. "Were there zoos on other worlds with humans on display?," they ask. "Yes, indeed!," replies Mom—for every alien on display, there is apparently a human volunteer in an extraterrestrial zoo.

The extraterrestrials include a wide array of chemistries and biologies. The Mercurian is a silicon-based life-form, for instance, as is the crystalline inhabitant of Io. Some creatures are simpler to explain to the children than others. The exhibit from Tau Ceti represents a species with 28 sexes, which intrigues nine-year-old Don. Mom hustles him away quickly, however. "It'll be all right to go into that next year," she tells him…

ABOVE LEFT: Here, Edd Cartier presents an ammonia-breathing creature from one of the gas giants of our own solar system. The alien is 30 feet (nine meters) tall and equipped with a trunk it uses like a hand.

ABOVE RIGHT: In the imagination of Edd Cartier, aliens came in all shapes and sizes. In contrast to its giant counterpart pictured left, this miniscule alien can be observed only through the lens of a microscope.

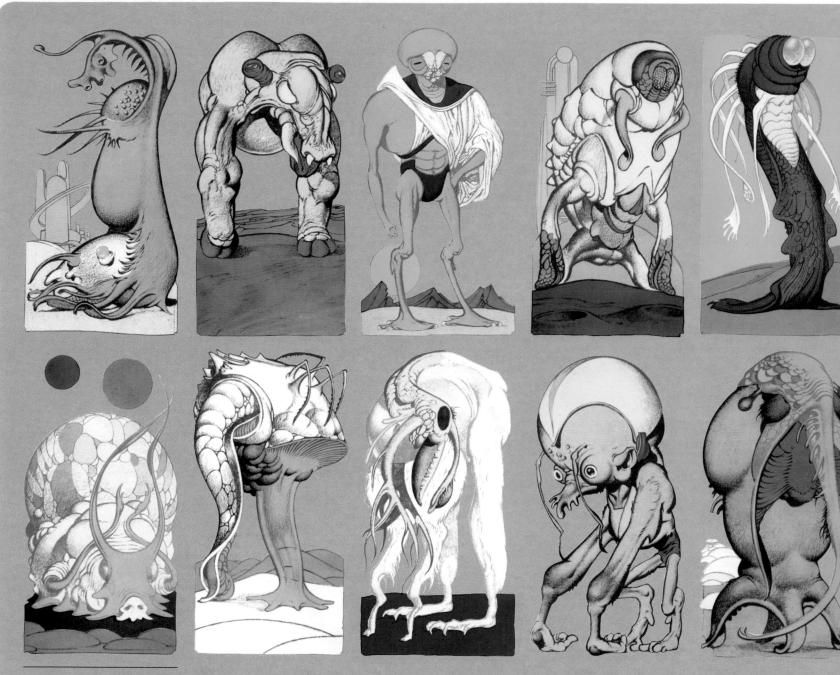

LEFT TO RIGHT, TOP TO BOTTOM: Here we have almost all the inhabitants of the fabulous Interstellar Zoo: a two-foot (0.6-meter) tall native of Luyten 789-6; one of the inhabitants of Jupiter; a ten-foot-(three-meter-)tall Martian; a crystalline native of Io; an iridescent worm creature from Titan; another ammonia-breather, this time from a plant of 61 Cygni; a creature only an inch (2.5 centimeters) tall from one of the Messier galaxies; an extragalactic being from outside our Milky Way; this being, just two inches (five centimeters) tall, comes from a race that wanders the galaxy, its homeworld having long since vanished; and this inhabitant of a planet of Tau Ceti, which belongs to a species with 26 sexes.

ABOVE LEFT: One of the inhabitants of Mercury, as imagined by Edd Cartier. A body chemistry based on silicon helps the alien resist the tremendous heat, which it also tries to avoid by living largely underground.

ABOVE RIGHT: Cartier was one of the first to illustrate one of the balloon-like creatures that have recently attracted so many modern space artists. This one was designed to live within the clouds of Venus, where it serenely floats above the semiliquid surface of the planet.

OPPOSITE: *Tertiary Node* is a personal work of art by Jim Burns and is a compellingly evocative depiction of a meeting between a human and a wholly alien species. This is a subject that has fascinated artists for decades, some of whom have shown it producing only catastrophe for one or both species, while a smaller number have viewed the event more benignly.

ABOVE: This striking painting of a marine alien was created by Jim Burns for the British science-fiction and fantasy magazine *Interzone* in 2013.

ABOVE: Like Karl Kofoed and Wayne Barlowe, artist Joel Hagen has made a specialty of designing alien creatures. In his case, however, he works sculpturally, creating skeletons of extraterrestrial animals that are as carefully mounted and displayed— and as convincing—as anything you might find in a museum. This is a partial skull of the "saberjaw," a predator that hunts among the tangled labyrinths of vine-covered chasms in the temperate regions of its planet.

ABOVE: The "paddefin" is a pelagic predator that inhabits the inland seas of its planet. A single powerful appendage propels the creature like a paddle and can also protect vulnerable organs. The articulated tail aids in propulsion and is also used to flick prey toward its beak-like jaw. Rows of pits line the front of the skull—sensor vesicles to track bioelectrical signatures of prey.

ABOVE LEFT: Swiss surrealist H. R. Giger was the ideal choice to design the eponymous creature for the motion picture *Alien* (1979). He received an Academy Award for his contribution to the film's special effects. Director Ridley Scott was introduced to Giger's work when he was shown a copy of the book *H. R. Giger's Necronomicon*, by the film's screenwriter, Dan O'Bannon.

ABOVE RIGHT: By combining biological and organic shapes with imagery taken from industry and technology, Giger's work takes on a disturbing quality that elicits the same discomfort humans might feel upon encountering the truly unearthly. While his aliens may not be as carefully developed anatomically as Wayne Barlowe's or Karl Kofoed's, Giger invokes a reaction to the genuinely *alien*.

ABOVE: Impressed by what he'd seen in *Necronomicon*, Ridley Scott found numerous images he wanted Giger to follow as he developed the alien creature, especially the paintings titled *Necronom IV* (above) and *Necronom V*.

INDEX

image credits

The publisher would like to thank the following people and organizations. Every effort has been made to trace the copyright holders of the artworks in this book, but one or two have proved unreachable. Elephant Book Company would be grateful if the artists concerned would contact them, in order for any errors or omissions to be corrected in future editions.

Front Cover: © 2014 the estate of Peter Elson.

Back Cover: Background, BR: Reproduced courtesy of Bonestell LLC. ML: © Wayne Barlowe. MR: Ron Miller. TR: Pat Rawlings © SAIC. CM: Aldo Spadoni—Aerospace Imagineering.

Endpapers: Shutterstock/Vadim Sadovski.

Allsorts Licensing: 113.

© Wayne Barlowe: 192; 193; 194; 195; 206.

Alan Bean: 37: TR.

Joe Bergeron: 49: R.

© John Berkey Art Ltd/John Berkey.com: 120; 121.

From an original painting by Richard Bizley www.bizleyart.com: 125: T.

Reproduced courtesy of Bonestell LLC: 13: L, R; 24: R; 26–27; 28; 29: TR, B; 49: L; 65: L, R; 66; 67; 101: R; 104: BR; 111: TL, BL; 117: TL, BL, TR; 118: TL, TR; 119.

British Interplanetary Society: 90; 91; 112: L; 140–141; 145: L.

Jim Burns: 132; 133: B; 214; 215.

Michael Carroll: 21: TL; 25; 150.

© Lynette Cook, www.lynettecook.com, all rights reserved: 68: T; 69; 70; 71; 76: B; 80: L; 82; 86; 87; 92–93; 170; 171: BR; 204; 205: TR.

Reproduced with kind permission of the Dan Dare Corporation Ltd: 106–107; 148.

Don Davis: 152; 153; 168–169; 174: R.

Buck Rogers® is a registered trademark owned by the Dille Family Trust and used under license from the "Trust." Copyright © 2014 Dille Family Trust All Rights Reserved: 173: TR.

Don Dixon: 32; 54: BL; 88; 174: L.

Art by Christopher Doll: 125: BL.

Courtesy of Dan Durda/FIAAA: 35: T; 171: BL; 205: TL.

© 2014 the estate of Peter Elson: 134; 135.

© ChrisFossArt.com: 136: Slan, 1974. © ChrisFossArt.com; 136–137 Concept Ships, 1985. © ChrisFossArt.com; 178: Cities in Flight: A Clash of Cymbals, 1974. © ChrisFossArt.com.

Marilynn Flynn: 41; 54: TL, R.

Estate of Frank Kelly Freas: 124; 127: TR; 208; 209.

Mark A. Garlick: 80: TR; 180–181; 203.

H. R. Giger: 218; 219.

Models by Joel Hagen: 216; 217.

© David A. Hardy/AstroArt.org: 145: BR; 179: T.

Robin Hart: 97.

William K. Hartmann: 33: BL; 52; 58: BR; 73.

Stephen Hickman: 207.

Steven Hobbs: 39: B.

© 2005–2014 B. E. Johnson & Joy Alyssa Day, all rights reserved – http://glasssculpture.org/: 15: R

© 2005–2014 B. E. Johnson & Joy Alyssa Day, all rights reserved – http://sphericalmagic.com/: 126.

Julie Rodriguez Jones: 114.

Karl Kofoed: 205: BL.

Simon Kregar, Jr: 14; 115: R.

Pamela Lee: 23.

Library of Congress, Washington, D.C.: 21: BL; 58: L; 63; 64: L, R.

Mary Evans Picture Library: 188; 189; 190: L; 199.

Ron Miller: 35: B; 42; 43; 44–45; 55; 57; 60–61; 74–75; 77; 83; 84–85; 89; 133: T; 171: T; 176–177.

From the collection of Ron Miller: 9: L, R; 10: L, R; 11: L, R; 12; 16–17; 19: L, R; 20: L, TR, BR; 21: ML, R; 24: L; 26; 30; 31: TL, TR; 33: TL; 37: TL (Vladimir Dzhanibekov), BM (Andrei Sokolov); 38: L, R; 39: TL, TR; 47: T, BR; 48: L, R; 60–61; 80: BR (Josef Minsky); 81: BL (Gennady Golobkov); 98–99 (Poplovski); 101: L; 102: L, TR, BR; 103: TL, R; 104: TR; 105; 110; 111: R; 112: R; 117: BR; 118: B; 143: R (Fagyev); 144: TR; 145: TR; 146; 147; 163: L, TR, BR; 167: BL; 169: R (Andrei Sokolov); 172; 173: TL, ML, M, MR, BM; 179: B; 183; 184; 185; 186; 187; 190; 191; 196: TR; 197; 198; 201: ML; 202: TL (Andrei Sokolov), BR (Andrei Sokolov); 211 (Edd Cartier); 212 (Edd Cartier); 213 (Edd Cartier).

Thomas O. Miller/Atomic Art: 2–3.

NASA: 117: BM; 143: L; 154–155; 157; 160 (Don Davis); 161–162 (Don Davis); 167: BR; 177: TR.

National Geographic: 156; 158; 159.

Images used with the acknowledgment of the Frank R. Paul Estate: 144: L, BR; 163: BM; 196: TL, BL.

Ludek Pesek: 22; 31: BR; 50; 56; 79: B.

"Living Moons" by Jon Ramer, IAAA: 40.

© Pat Rawlings, © SAIC: 33: R; 34; 51; 108; 109; 122–123; 149; 150–151; 166; 167: T; 201: T.

Rex Features/Everett Collection: 29: TL; 103: BL.

Rex Features/SNAP: 164; 165.

Frans W. Roetman: 104: TL, BL.

Michelle Rouch: 115: L.

Science Photo Library/RIA Novosti: 37: BR; 58: TR.

Science Photo Library/Dr Seth Shostak: 201: BR.

From the collection of Robert Skotak: 129; 130; 131.

Smithsonian National Air and Space Museum: 173: TR.

Aldo Spadoni—Aerospace Imagineering: 127: BR; 175.

Matthew P. Stricker: 72; 81: TL; 93: B; 96.

Nikola Subic: 127: L.

Kara Szathmary: 15: TL, BL.

© Dirk Terrell: 68: B; 76: T.

"Cosmic Titans"—Copyright Michael C. Turner—Galactic Visions Space Art: 59.

© 2014 Lucy West: 53; 79: T; 93: T; 94; 95.

Chris Williams: 81: TR, BR.

Maciej Wojtala: 138–139.

FURTHER RESOURCES

SELECTED LIST OF SPACE ART BOOKS

Cooke, Hereward Lester, and James D. Dean. *Eyewitness to Space*. New York: Abrams, 1971.

DiFate, Vincent. *Infinite Worlds*. New York: Penguin Studio, 1997.

Garlick, Mark A. *Cosmic Menagerie*. New York: Sterling, 2013.

Halpern, Paul, and Lynette R. Cook. *Faraway Worlds: Planets Beyond Our Solar System*. Watertown, MA: Charlesbridge, 2004.

Hardy, David A. *Visions of Space*. London: Paper Tiger, 1989.

Ley, Willy, and Chesley Bonestell. *The Conquest of Space*. New York: Viking, 1949.

Ley, Willy, and Wernher von Braun. *The Exploration of Mars*. New York: Viking, 1956.

McCall, Robert. *The Art of Robert McCall: A Celebration of Our Future in Space*. New York: Bantam, 1992.

Miller, Ron. *Space Art*. New York: Starlog, 1978.

Moore, Patrick, and David A. Hardy. *The New Challenge of the Stars*. New York: Rand McNally, 1978.

Ordway, Frederick Ira, III. *Visions of Spaceflight*. New York: Four Walls Eight Windows, 2001.

Rudaux, Lucien. *Sur les autres mondes*. Paris: Larousse, 1937.

Ryan, Cornelius, and Joseph A. Kaplan *Across the Space Frontier*. New York: Viking, 1952.

Smith, R. A., and Arthur C. Clarke. *The Exploration of the Moon*. New York: Harper, 1954.

Stanek, Bruno, and Ludek Pesek. *Bildatlas des Sonnensystems*. Bern: Hallwag, 1974.

von Braun, Wernher, and Cornelius Ryan. *Conquest of the Moon*. New York: Viking, 1953.

ARTISTS' WEBSITES

Wayne Barlowe, waynebarlowe.wordpress.com
Joe Bergeron, www.joebergeron.com
Richard Bizley, www.bizleyart.com
Chesley Bonestell, www.bonestell.org
Jim Burns, www.alisoneldred.com/artistJimBurns.html
Michael Carroll, stock-space-images.com
Jack Coggins, www.jackcoggins.info
Lynette Cook, extrasolar.spaceart.org
Don Davis, www.donaldedavis.com
Joy Day, sphericalmagic.com
Christopher Doll, www.christopher-doll.com
Dan Durda, www.3dimpact.com
Peter Elson, www.peterelson.co.uk
Marilynn Flynn, www.tharsisartworks.com
Chris Foss, www.chrisfossart.com
Kelly Freas, www.kellyfreas.com
Mark Garlick, www.space-art.co.uk
H. R. Giger, www.hrgiger.com
Joel Hagen, www.ainet.com/hagen
David A. Hardy, www.astroart.org
William K. Hartmann, www.psi.edu/about/staff/hartmann
Stephen Hickman, www.stephenhickman.com
Steven Hobbs, www.stevenhobbsphoto.com.au
B. E. Johnson, sphericalmagic.com
Karl Kofoed, www.memories-restored.net/GG.html
Julie Rodriguez Jones, www.artfromthesoul.com
Ron Miller, www.black-cat-studios.com
Thomas O. Miller, www.atomicart.com
Pierre Mion, www.pierremion.com
Ludek Pesek, www.ludekpesek.ch
Pat Rawlings, www.patrawlings.com
Frans Roetman, members.home.nl/f.w.roetman
Michelle Rouch, www.rouch.com

Matthew Stricker, www.visiblesounds.com
Nikola Subic, bashoo.deviantart.com
Kara Szathmary, www.champlaincollege.qc.ca/kbaszk
Dirk Terrell, www.boulder.swri.edu/~terrell
Lucy West, www.lucyweststudios.com
Maciej Wojtala, www.wojtala.com

WHERE TO SEE SPACE ART

Adler Planetarium, Chicago, Illinois, www.adlerplanetarium.org
EMP Museum, Seattle, Washington, www.empmuseum.org
Kennedy Space Center, Cape Canaveral, Florida, www.kennedyspacecenter.com
Smithsonian National Air and Space Museum, Washington, DC, airandspace.si.edu

ORGANIZATIONS

The International Association of Astronomical Artists, iaaa.org
The Association of Science Fiction and Fantasy Artists, www.asfa-art.org

ACKNOWLEDGMENTS

I will be forever grateful to the unstinting generosity of the members of the International Association of Astronomical Artists, without whom this book would literally have been impossible. Igor Bezyaev was instrumental in locating many of the Russian artists. Thanks are also due to Fred Durant and Bruno Stanek. I also owe a debt of gratitude to Dan Durda, Carolyn Porco, and my friends at Bonestell, LLC. And this is all to say nothing of the infinite patience—and talents— of my colleagues at Elephant Book Company: Will Steeds, Magda Nakassis, Susannah Jayes, and Paul Palmer-Edwards.
R.M.

contributor bios

Ron Miller is an illustrator and author living in South Boston, Virginia. Before becoming a freelance illustrator in 1977, he was the art director for the Smithsonian National Air and Space Museum's Albert Einstein Planetarium. His primary work today entails the writing and illustration of books specializing in astronomical, astronautical, and science-fiction subjects. His special interest is in exciting young people about science and in recent years he has focused on writing books for young adults. To date he has more than 50 titles to his credit. His work has also appeared on scores of book jackets, book interiors, and in magazines such as *National Geographic, Reader's Digest, Scientific American, Smithsonian, Air & Space, Sky & Telescope, Newsweek, Natural History, Discover*, and *Geo*.

Miller's books include the Hugo Award–nominated *The Grand Tour, Cycles of Fire, In the Stream of Stars*, and *The History of Earth*. All of these have been Book of the Month Club Feature Selections (as well as selections of the Science, Quality Paperback, and Astronomy Book Clubs) and have seen numerous translations. They have received numerous commendations and awards as well. His "Worlds Beyond" series received the prestigious American Institute of Physics Award of Excellence; *The Art of*

Chesley Bonestell received a Hugo Award and the Astronomical Society of the Pacific has called *The Grand Tour* "a modern classic."

Considered an authority on Jules Verne, Miller has translated and illustrated new, definitive editions of Verne's *20,000 Leagues Under the Sea* and *Journey to the Center of the Earth*, as well as a major companion/atlas to Verne's works: *Extraordinary Voyages*. He has acted as a consultant on Verne for Disney Imagineering and A&E's Biography series. Miller is also considered an authority on the early history of spaceflight. His *Dream Machines*, a comprehensive, 250,000-word, 744-page history of manned spacecraft, was nominated for the prestigious IAF Manuscript Award and won the Booklist Editor's Choice Award. He designed a set of 10 commemorative stamps for the United States Postal Service, one of which is attached to the *New Horizons* spacecraft, currently bound for Pluto. He has also been a production illustrator for motion pictures, notably *Dune* and *Total Recall*. He has done preproduction concepts, consultation, and special-effects matte art for David Lynch, George Miller, John Ellis, UFO Films, and James Cameron. He designed and codirected the computer-generated show ride film *Impact!* for SimEx. He has taken part in numerous international space art

workshops and exhibitions, including seminal sessions held in Iceland and the Soviet Union (where he had been invited by the Soviet government to take part in the 30th anniversary celebration of the launch of *Sputnik*), and has lectured on space art and space history in the United States, France, Japan, Italy, and Great Britain. Miller has been on the faculty of the International Space University. His original paintings are in numerous private and public collections, including the Smithsonian Institution and the Pushkin Museum (Moscow).

Miller has also written several novels, including a tetralogy of fantasy novels—*Palaces and Prisons, Silk and Steel, Hearts and Armor*, and *Mermaids & Meteors*. The first of these won a Silver Award for best fiction from *ForeWord* magazine. Another novel, *Bradamant*, won the Violet Crown Award from the Writer's League of Texas. In addition to these, there is Velda, which consists of a hard-boiled detective novel, a collection of short stories, and a series of comic books. Miller is a contributing editor for *Air & Space/Smithsonian* magazine and is a life member, fellow, and former trustee of the International Association for the Astronomical Arts.

Dan Durda is one of the few space artists who is also a professional astronomer. Formerly a planetary scientist at the University of Arizona, he is now a principal scientist in the Department of Space Studies at the Southwest Research Institute in Boulder, Colorado. His fields of study include, among other things, the evolution of main-belt and near-earth asteroids, Vulcanoids, Kuiper belt comets, and interplanetary dust; the formation and detection of asteroidal satellites; and the global distribution of ejecta from Chicxulub, the asteroid impact that triggered a global climactic catastrophe.

Durda has authored more than 70 scientific papers as well as numerous articles for books and magazines, popularizing planetary science and human exploration of space. As an artist, his work has been featured in magazines such as *Sky & Telescope* and *Astronomy*, web news stories, and books, and has also been exhibited internationally. He is a fellow and a former member of the board of trustees of the International Association of Astronomical Artists. Asteroid 1992 YC3 was renamed 6141 Durda (1998) in his honor.

Durda is also an active pilot with nearly 300 hours of flight time logged in over a dozen types of aircraft including the F/A-18 Hornet and the F-104 Starfighter, and was a finalist in the 2004 NASA astronaut selection. He serves as a flight astronomer for the SWUIS-A

airborne astronomical imaging system flown aboard NASA and military high-performance, high-altitude aircraft and has spent over 110 minutes of time in zero-gravity conducting experiments on NASA's KC-135 Reduced Gravity Research Aircraft. Durda is one of three Southwest Research Institute payload specialists who will fly on multiple suborbital spaceflights on Virgin Galactic's *Enterprise* and XCOR Aerospace's *Lynx*.

Carolyn Porco is the leader of the imaging science team on the *Cassini* mission presently in orbit around Saturn. In the 1980s she was an imaging scientist for the *Voyager* mission, and is one of the imaging scientists on the *New Horizons* mission currently on its way to Pluto and the Kuiper Belt. She has coauthored more than 115 scientific papers and her popular science articles appear in magazines and newspapers internationally.

She has been responsible for leading the *Cassini* imaging team in a host of seminal discoveries on Jupiter and its ring during *Cassini*'s flyby of that planet in 2000/2001, and on Saturn and its rings and moons since the spacecraft's arrival there in 2004.

Porco's own special field of study during most of her career has been planetary rings and the interactions between these rings and a planet's moons.

However, most recently, she has focused on

Enceladus, a moon of Saturn, and its mysterious geysers. Her survey of the moon's south polar terrain with the *Cassini* cameras and her findings of roughly 100 geysers erupting from its famed "tiger stripe" fractures point to a subsurface, salty, organics-rich sea of liquid water beneath Enceladus's ice shell that supplies the geysers and the heat observed by *Cassini*.

Porco is the creator/editor of the CICLOPS website where *Cassini* images are posted, and for which she writes her "Captain's Log." A popular speaker, Porco gives many public lectures and presentations and also makes frequent appearances on television.

She was the character consultant on the 1997 film *Contact*, as well as a consultant on the 2009 *Star Trek* movie, where she advised the director on planetary imagery.

She is the namesake of Asteroid (7231) Porco and was selected by the London *Sunday Times* as one of 18 scientific leaders of the twenty-first century. She was awarded the Carl Sagan Medal in 2010, presented by the American Astronomical Society for Excellence in the Communication of Science to the Public. And in 2012, she was named one the 25 most influential people in space by *Time* magazine.